Twenty-first Edition
THE BEST OF NEWSPAPER DESIGN

Society for News Design

Society for News Design

129 Dyer Street
Providence, R.I. 02903-3904

Judging takes place at the S.I. Newhouse School of Public Communications, Syracuse University, Syracuse, N.Y.

First printed in the U.S.A. by Rockport Publishers, Inc. Gloucester, Mass.

SPECIAL THANKS:

S.I. Newhouse School of Public Communications
Syracuse University

JUDGING ASSISTANTS:

G.W. Babb, design director, Austin American-Statesman, Austin, Texas

Erin Banning, page designer, Sarasota Herald-Tribune, Sarasota, Fla.

Stephen Cavendish, ANE, The Washington Post, Washington, D.C.

Steve Dorsey, design & graphics director, Detroit Free Press, Detroit, Mich.

Bill Dunn, visual content editor, Star Tribune, Minneapolis, Minn.

Kelly Frankeny, consultant, Kelly Frankeny Design, San Francisco, Calif.

Dave Gray, SND executive director, Providence, R.I.

Darcy Drew Greene, associate professor, School of Journalism, Michigan State University, East Lansing, Mich.

Scott Goldman, sports layout editor, The Washington Post, Washington, D.C.

Barbara Hines, Department of Journalism chair, Howard University, Washington, D.C.

Tim Harrower, design consultant, Portland, Ore.

Teresa Kriegsman, assistant director/news design, The News & Observer, Raleigh, N.C.

David Kordalski, AME/visuals, The Plain Dealer, Cleveland, Ohio

Joanne Marciano, Blackstone Valley News Bureau, The Providence Journal, Providence, R.I.

Marshall Matlock, associate professor, S.I. Newhouse School of Public Communications, Syracuse, N.Y.

Kenny Monteith, ANE, The Washington Post, Washington, D.C.

Cheryl Pell, graphics specialist, School of Journalism, Michigan State University, East Lansing, Mich.

Andrew Phillips, graphics editor, The Star-Ledger, Newark, N.J.

Debra Page-Trim, editorial designer, The Boston Globe, Boston, Mass.

Susan Santoro, SND membership assistant, Providence R.I.

Jami Smith, copy editor/designer, San Jose Mercury News, San Jose, Calif.

David Stedwell, photojournalism instructor, School of Journalism, Michigan State University, East Lansing, Mich.

Tony Sutton, president, News Design Associates, Georgetown, Ont., Canada

Shamus Walker, judging audit director, Syracuse University, Syracuse, N.Y.

Michael Whitley, news projects designer, The Charlotte Observer, Charlotte, N.C.

Syracuse University Students: Jessica Brown, Jason Chudy, Wayne Clark, Jeri Clayton, Russell Cooley, Larry Dailey, Greg Davis, Sterling Gray, Jr., Greg Hedges, Matthew Hevezi, Robert Houlihan, Jason Huffine, Michelle Hunter, Mark Jaskulski, Danielle Johnson, Michael Jones, Preston Keres, Jeremy Lock, Lauren King, Michelle Leonard, Kathy Mason, Andrew Myers, Jared Paventi, Randell Robinson, Jane Rushmore, Steph Slater, Keith Stevenson, Dana Vaccaro, Gary Yaerger

Michigan State University Students: Kathy Dykhouse, Derrick Tolbert, Randy Yeip, Karen Zelt

Detroit Free Press: Elio Leturia, Rick Nearse, Gabriela Schmidt

THE SOCIETY FOR NEWS DESIGN

21 YEARS OF SERVICE TO VISUAL JOURNALISM

- For anyone with an interest in news and journalism design
- Founded in 1979
- More than 2,500 members in 50 countries
- Student and professional affiliates worldwide
- Quarterly DESIGN journal, frequent newsletters and other publications
- Workshops, Quick Courses and MacLabs in print, new media and information design
- Books, slides, tapes, videos, CDs, and other teaching resources
- Annual Best of Newspaper Design, Malofiej information graphics and student design contests
- Scholarship and research awards and grants to students and faculty through the SND Foundation.
- Online book browser, consultants directory, speakers bureau, membership directory, workshop and seminar signup, job bank and media design connections via the web at http://www.snd.org

2000 SND OFFICERS

President
Jean Dodd
Kansas City Star
Kansas City, Mo.

First Vice President
Lucie Lacava
Lacava Pub. Design Inc.
Montreal, Canada

Second Vice President
Svenåke Boström
WebView Co.
Sundsvall, Sweden

Treasurer
Warren Watson
American Press Institute
Reston, Va.

Secretary
Susan Mango Curtis
Northwestern University
Evanston, Ill.

Past President
Ed Kohorst
Dallas Morning News
Dallas, Texas

Executive Director
Dave Gray
The Society for News Design
Providence, R.I.

Society for News Design
129 Dyer Street
Providence, R.I. 02903-3904
Telephone: 401-276-2100
FAX: 401-276-2105
snd@snd.org
http: //www.snd.org

Other distribution by:
Rockport Publishers, Inc.
Gloucester, Mass 01930-5089
www.rockpub.com

ISBN 1-56496-708-5
ISBN 1-878107-10-0 (Softcover editon)
ISSN: 1520-4251

CONTENTS

Book Credits

Designer & Editor:
C. Marshall Matlock
S.I. Newhouse School of Public Communications
Syracuse University

Associate Designer:
Shamus Walker
Syracuse, N.Y.

Production Consultants:
Steve Dorsey
Detroit, Mich.

Dave Gray
Providence, R.I.

Welcome

Having been involved with the SND awards for eight years, I've seen the best — and the rest.

So when I was selected to coordinate the 21st edition of The Best of Newspaper Design, I wanted to round up an excellent team of visual journalists to scour an unprecedented 14,136 entries and shake out the best.

In the past, four 5-person teams of judges evaluated entries. This year, to handle the increase in submissions, another team was added.

SND tries to set a higher standard with each ensuing year. And in shaking out the best entries of 1999, these top-notch teams have mightily raised the bar of excellence.

The proof: the coveted World's Best-Designed Newspapers designation went to only three newspapers this year out of a total of 322 entering newspapers from 29 countries. That's down from 17 winners the previous year.

Only seven Gold Medals were given.

Only four Judges' Special Recognition awards were presented.

This year there was no Best of Show.

I'm not highlighting this point to prove the judges were stingy. Rather, that they were keen and selective. In all my years of involvement in this competition, I have never seen higher expectations.

So when you flip through this book, keep in mind that these pages were judged the best by a group of visual journalists that didn't settle for less than superior. This is what they think excellence looks like.

Don't be discouraged if your entries didn't place as well as you had hoped. We publish the award-winners as a way to challenge newspapers and visual journalists worldwide to dig deeper, work harder.

That extra push is necessary in a new millennium of visual communication — one that is especially competitive with the newest member of the media: the Internet.

May this book be your guidebook of motivation, the reference you reach for when you feel stale or when you are eager to size up the best and outdo them. The work deemed best by this year's 26 judges has, indeed, done that for me.

SPECIAL THANKS:

The 21st Edition judging was cosponsored by the S.I. Newhouse School of Public Communications at Syracuse University, Syracuse, N.Y. This was the 12th consecutive year Syracuse has hosted the event. Marshall Matlock, Shamus Walker and dozens of SU students worked tirelessly for weeks to make everything run smoothly throughout the contest.

I also want to thank:

– Competition Committee members and assistants for their continued dedication to the event and their guidance and ideas, without which this event would lack consistency and style.

– SND Executive Director Dave Gray and assistants Susan Santoro and Barbara Hines for never panicking and making everything seem easy in working with the data.

– Students and advisers from the Michigan State University SND student affiliate for making the trek to Syracuse and pitching in like pros.

– My bosses, co-workers and staff at the Detroit Free Press for their patience and assistance as the duties of Edition Coordinator slowly ate into my daily work schedule. Also, Rick Nease, for his creative and speedy assistance illustrating the Call for Entries cover as well as his patient consultation.

Thank you all.

Steve Dorsey, *21st edition coordinator*

Bienvenidos

Durante los últimos ocho años, he tenido la oportunidad de ser testigo de la selección de premios de los mejores periódicos del mundo, lo cual me ha permitido apreciar cientos de ganadores entre miles de participantes.

Por lo tanto, cuando fui seleccionado para coordinar la vigésimaprimera edición de The Best of Newspaper Design, quería involucrar a un excelente equipo de periodistas visuales que exploraran una cantidad, sin precedentes, de 14,136 páginas y pudiesen seleccionar lo mejor.

En el pasado, cuatro equipos de cinco jueces cada uno evaluaron las páginas. Este año, para poder hacerse cargo de la gran cantidad de participantes, fue necesario agregar otro equipo.

SND trata de elevar el nivel de la competencia cada año. Así, las páginas elegidas como las mejores del año 1999 representan la manera en que un equipo de magníficos profesionales han superado dicho nivel de excelencia.

Como prueba: Los codiciados premios World's Best-Designed Newspapers fueron otorgados, tan sólo a tres periódicos entre un total de 322 participantes provenientes de 29 países. Solamente tres este año, a diferencia de 17 en el pasado.

Solamente siete medallas de oro fueron otorgadas.

Sólo cuatro "Mención especial de los jueces".

Este año no hubo ningun premio "Lo mejor del concurso".

No estoy enfatizando este punto para hacer pensar que los jueces fueron mezquinos. Por el contrario, han tenido un carácter perspicaz y selectivo. En todos los años que llevo participando en esta competencia, nunca había presenciado expectativas tan grandes.

Por lo tanto, mientras hojee este libro, tenga en cuenta que las páginas seleccionadas fueron juzgadas como las mejores por un grupo de expertos visuales que no se conformaron con nada que no fuese de una calidad superior. Esto es como consideran que la excelencia se debe ver.

No se sienta decepcionado si sus páginas no obtuvieron un lugar tan bueno como esperaba. Nosotros publicamos a los ganadores del concurso como una manera de retar tanto a los periódicos como a los periodistas visuales de todo el mundo a trabajar más intensamente.

Esa energía extra es necesaria en un nuevo milenio de comunicación visual — siendo ésta especialmente competitiva con el miembro más reciente de los medios: el Internet.

Esperamos que este libro sea una guía para motivarse; la referencia a la cual consulte cuando se sienta falto de ideas o cuando se sienta deseoso de analizar a los mejores y superarlos. El trabajo juzgado como lo mejor por los 26 jueces de este año, sin duda, ha logrado este efecto en mí.

AGRADECIMIENTO ESPECIAL:

El concurso para la vigésimoprimera edición fue patrocinado en parte por la S.I. Newhouse School of Public Communications en la Syracuse University en Syracuse, N.Y. Este fue el décimosegundo año consecutivo que Syracuse ha albergado el evento. Marshall Matlock, Shamus Walker y docenas de estudiantes de SU trabajaron arduamente durante semanas para asegurarse que todo marchase sobre ruedas durante la contienda.

También deseo agradecer a:

– Los miembros y asistentes del Comité de Competencia, por su continua dedicación al evento, sus sugerencias e ideas, sin las cuales este evento hubiese carecido de continuidad y estilo.

– Dave Gray, Director Ejecutivo de SND y sus asistentes Susan Santoro y Barbara Hines por hacer del trabajo y manejo de información algo sencillo, sin crear o presentar pánico alguno.

– A los estudiantes y consejeros de Michigan State University y estudiantes afiliados de SND por hacer el viaje a Syracuse y ayudar en todo lo posible.

– A mis jefes y compañeros de trabajo del Detroit Free Press por su paciencia y ayuda mientras mi trabajo como Coordinador de edición me mantenía alejado, en ocasiones, de mis deberes cotidianos en el periódico. También agradezco a Rick Nease por su creativa y rápida asistencia elaborando las ilustraciones de la portada para el folleto Call for Entries, su continuo apoyo y sugerencias.

Gracias a todos.

Steve Dorsey, *coordinador de la 21ra. edición*

Introduction

Twenty-one years old: a rite of passage and still a state of majority in a lot of places in the world. Finally, a chance to be recognized as an "adult."

When we were pre-teens, we didn't think much about what we were doing by running a design contest for newspapers. By the time we got into our teens, we thought we knew it all, and that the "older" organizations just didn't understand us. But now that we're "mature" and have "arrived," we're sure the newspapers' way to nirvana is to follow our lead. But before we pass into middle age dotage, let us tell you what it took to get to where we are.

More than 5,000 hours of work by almost 100 people went into preparing, coordinating and conducting the contest. Twenty-six judges and more than 50 assistants worked over a long weekend in Syracuse, N.Y., with 14,136 entries in the 21st Edition competition, categories two through 21. Anyone who has attended the judging, as a judge, worker, staff or student helper, will agree the days are long and the work intensive.

Five judges, on a separate weekend, decided the winners from the 322 category one entries. They were required to look at design as well as content. Despite their long and sometimes frustrating deliberations, they found three winners and 36 finalists that received the "World's Best-Designed Newspapers" designation, representing publications of every size, persuasion and geography.

Those interested in knowing a winning publication's circulation size should note the (A), (B) or (C) designation in the cutline. (A) represents those with a circulation of 175,000 or more. (B) indicates a circulation between 50,000 to 174,999. (C) represents a circulation of 49,999 or less. There were 581 winners in (A), 253 in (B) and 99 in (C).

Judges may give as many awards as they wish in each of the 21 categories represented in the competition. Award definitions remain constant year after year but the numbers granted continue to change from year to year, depending on the judging's dynamics and the judges' predilections and preferences. The groupings of judges and the categories they judged are indicated in this book.

The judges' guidelines were:

– A **Gold Medal** is for work that defines the state of the art. The entry should stretch the limits of creativity and it should be impossible to find anything deficient. Judges awarded seven Gold Medals this year.

– A **Silver Medal** is for work that goes "beyond excellence" and should stretch the limits of the medium. Sixty-two Silver Medals were awarded.

– An **Award of Excellence** is for work that is excellent and that goes beyond competency. An Award of Excellence need not be "perfect," but can honor work for being daring and innovative if the entry is outstanding, but less than perfect, in other aspects. There were 820 entries receiving this award.

– The **Judges' Special Recognition** can be awarded by teams of judges or by all the judges for work that is outstanding in a particular aspect, such as design or the use of photography, informational graphics or typography throughout a body of work. The work may be a whole publication, section or sections by an individual or by a staff. The special recognition is an adjunct to any Award of Excellence, or to any Silver or Gold medal. This year, four Judges' Special Recognition (JSRs) were given.

In addition, a Best of Show may be given when special circumstances warrant. No Best of Show was awarded this year.

When some categories have too many entries to be displayed all at once, a "first cut" is done by having judges pick the pages they'd like to see again in a smaller group. It takes only one vote for an entry to remain in the contest.

Once a first cut has been completed and all the entries in a category can be viewed at one time, each judge casts his or her votes with a chip, color coded for that judge, by placing the chip in either a "Yes" or a "No" cup. Cups are placed upside down with slits in the top so that no judge sees how any other judge has voted.

If a conflict occurs because a judge comes across an entry from their publication, a publication where they have performed recent (18 months or less) consulting work, or a publication with which they compete, the judge places a yellow cup on the entry signifying to the team captain a conflict exists. At this point, a "floating" judge votes for or against the entry in lieu of the judge with the conflict.

It takes three or more "Yes" votes to remain in the contest.

– Entries receiving three votes receive an Award of Excellence.

– Entries receiving four or more votes in the first round go directly into the medal round.

During the "Medal Round:"

– Any entry receiving four votes is awarded a Silver Medal.

– Any entry receiving five votes (unanimous vote of the panel) is awarded a Gold Medal.

– At the end of the entire judging, all the judges re-examine the Silver and Gold Medal winners. Medal winners can be renegotiated up or down the award scale, and a Best of Show, if any, is also awarded at this time.

In the following pages, the medal the entry won is indicated above the name of the publication. Publications without any medal reference won an Award of Excellence.

Twenty-one and still growing. Remember how full of life you felt then? What there will be to look forward to in future competitions, books and images, we can't begin to imagine. As we reach out further and further in future years for more representation in the contest among the worlds' newspapers, we can only hope that the results will more faithfully reflect the true "state of the art" in newspaper design.

David B. Gray, *SND Executive Director*

Caption key:
(A) = 175,000 or more circulation
(B) = 50,000 to 174,999 circulation
(C) = 49,999 or less circulation
Captions with no award above the publication name are Awards of Excellence.

Leyenda:
(A) = Circulación de 175,000 o rmás
(B) = Circulación entre 50,000 y 174,999
(C) = Circulación de 49,999 o menos
Si no está marcado con otro título, los ganadores han recibido un Premio de Excelencia.

Introdución

Veintiún años: Un momento clave de transición y aún el indicador de mayoría de edad en muchos países del mundo. Finalmente, la oportunidad de ser reconocido como un "adulto".

Cuando éramos pre-adolescentes, no pensábamos mucho acerca de lo que estábamos haciendo metidos en un concurso de diseño para periódicos. Cuando llegamos a la adolescencia, pensamos que ya lo sabíamos todo, y que las organizaciones más antiguas que la nuestra no nos entendían. Pero ahora que somos "maduros" y que ya hemos "alcanzado" nuestro cometido, estamos seguros que los demás deben imitar nuestro ejemplo para llegar a Nirvana. Pero antes que envejezcamos, déjenos contarle cómo hemos llegado aquí.

Más de 5,000 horas de trabajo por casi 100 personas se emplearon en preparar, coordinar y dirigir el concurso. Veintiséis jueces y más de 50 asistentes trabajaron durante un largo fin de semana en Syracuse, N.Y., con 14,136 páginas participantes en la 21ra. competencia, categorías 2 a la 21. Cualquiera que ha participado como juez, empleado, miembro o estudiante asistente, está de acuerdo que esos días son largos y el trabajo intensivo.

Cinco jueces, en un fin de semana separado, escogieron a los ganadores de las 322 categorías individuales. Ellos juzgaron tanto el diseño como el contenido. A pesar de sus largas y, algunas veces, frustrantes deliberaciones, ellos escogieron tres ganadores y 36 finalistas que recibieron la designación de "Los periódicos mejor diseñados del mundo," los cuales representaban publicaciones de diferente circulación, temática y origen.

Aquellos que estén interesados en conocer la circulación de una publicación ganadora deben tomar en cuenta la designación (A), (B) o (C) en la leyendaeva pág anterior. (A) representa aquellos con una circulación de 175,000 o más. (B) indica una circulación entre 50,000 y 174,999. (C) representa una circulación de 49,000 o menor. Hubo 581 ganadores en (A), 253 en (B) y 99 en (C).

Los jueces pueden otorgar cuantos premios deseen en cada una de las 21 categorías que establece la competencia. La definición de los premios permanece constante año tras año pero el número de ganadores varía, dependiendo en la dinámica del jurado, sus gustos y sus preferencias. El agrupamiento de los jueces y las categorías que juzgaron se encuentran indicadas en este libro.

Las reglas de los jurados fueron:

– La **Medalla de Oro** se otorga al trabajo que define lo mejor de lo mejor. El participante debe estrechar los límites de la creatividad y debe ser imposible encontrar algo deficiente. Los jueces otorgaron siete medallas de oro este año.

– La **Medalla de Plata** es para el trabajo que va "más allá de la excelencia" y debe ser sobresaliente. Sesenta y dos medallas de plata fueron entregadas.

– El **Premio de Excelencia** es para el trabajo que es realmente excelente y que sobrepasa lo competente. Un premio de excelencia no necesita ser "perfecto", pero debe ser atrevido e innovador. 820 páginas recibieron este honor.

– El **Reconocimiento Especial del Jurado** es otorgado por equipos de jueces o por todos los jueces a trabajos que sobresalen en un aspecto particular. Puede ser por el diseño, uso de la fotografía, infografía o tipografía dentro de un trabajo. Este puede ser la publicación en su totalidad, una sóla sección o secciones trabajadas por un individuo o por un equipo. El reconocimiento especial es un adjunto a cualquier Premio del Excelencia, Medalla de Plata u Oro. Este año, Reconocimientos Especiales de los Jueces fueron entregados.

Adicionalmente, el premio Lo Mejor del Show puede ser otorgado cuando las condiciones lo ameritan. Este año no fue otorgado.

Cuando algunas categorías presentan demasiados participantes, una primera selección se lleva a cabo. Los jueces entonces, escogen las páginas que quieren volver a ver lo cual reduce el número de participantes. Sólo toma un voto por participante para permanecer en el concurso.

Una vez que la primera selección se ha llevado a cabo y todos los participantes en una categoría han sido vistos a la vez, cada juez expresa su voto con una ficha de un color determinado para cada juez. La ficha es colocada en un vaso, ya sea en el que tenga el letrero "Sí" o "No." Los vasos son colocados bocaabajo, para que nadie vea cuántos votos tiene cada participante.

Si ocurre un conflicto debido a que algún juez se encuentra juzgando la publicación para la cual trabaja, para la que ha trabajado en los últimos 18 meses, para la que es consultor o para la publicación que es su directa competencia, el juez coloca un vaso amarillo en la página participante para dar cuenta del conflicto. En este momento, un juez "flotante" vota a favor o en contra de dicha página en conflicto.

Toma tres o más "Sí" para permanecer en concurso.

– Los participantes que reciben tres "Sí" reciben un Premio de Excelencia.

– Los participantes que que reciben cuatro o más votos en la primera vuelta pasan directo a la ronda de medallas.

Durante esta ronda de medallas:

– Los participantes con cuatro votos reciben la Medalla de Plata.

– Los participantes con cinco votos (voto unánime) obtiene la Medalla de Oro.

– Al final de la competencia, todos los jueces reexaminan a los ganadores de las medallas de plata y de oro. Estas medallas pueden ser renegociadas, y es aquí cuando también se decide el premio de Lo Mejor del Show.

En las páginas siguientes usted podrá apreciar qué tipo de medalla ha ganado cada participante pues se indica encima del nombre de la publicación. Las publicaciones sin ninguna referencia a medallas han ganado un Premio de Excelencia.

Veintiún años y aún seguimos creciendo. ¿Recuerda cuán lleno de vida nos sentíamos entonces? No podemos siquiera imaginar que es lo que nos espera en el futuro del mundo de las competencias, libros e imágenes. En la medida en que sigamos expandiéndonos en los próximos años y alcancemos mayor representación entre todos los periódicos del mundo, esperamos que los resultados reflejen con mayor objetividad al verdadero "lo mejor de lo mejor" en el diseño de periódicos.

David B. Gray, *diretor executivo de SND*

Category One

Juan Antonio Giner

Alan Jacobson

Rolf Rehe

Vivienne Sosnowski

Mette Terkelsen

Juan Antonio Giner, partner-director of the Innovation International Media Consulting Group, Detroit, Mich, is author of Innovations in Newspapers (1999-2000), and The Latin-American Newspaper Industry (1997). He is editor of Innovación Periodística, a newsletter about world trends in newspapers. He is former vice-dean at the School of Journalism, University of Navarra, Pamplona, Spain. He is founder of the SND Spanish Chapter and the Malofiej Infographics Awards and past SND Spanish director.

Alan Jacobson has more than 20 years' experience in the communications industry working as a photographer, designer, editor, project manager and publishing systems analyst. He has redesigned more than 50 newspapers and received honors from SND for his work across America, including a Judges' Special Recognition for the overall design of five newspapers in a single year.

Rolf F. Rehe was trained as a typographer in Germany and as a journalist in the United States. To him, typography is the most important and the most neglected visual element in newspapers. He currently writes a regular column on typography for SND's Design magazine and has has been active as a design consultant in 35 countries working out of his Vienna, Austria, office.

Vivienne Sosnowski, executive editor of the National Post, has also been managing editor at both Vancouver papers, The Province and The Vancouver Sun. The National Post is owned by Hollinger Inc., which owns a number of daily newspapers across Canada. Her present position involves working with newspapers across the country to ensure a complete national agenda of news.

Mette Terkelsen is a managing editor at Kristeligt Dagblad, a national daily Danish newspaper. She worked eight years at Berlingske Tidende, rising to AME in 1992. She has worked at Politiken and BT, a national Danish tabloid. Terkelsen is a jury member in the Danish Newspaper Pages of the Year contest and a jury member in the SND-Scandinavia news design contest.

Juan Antonio Giner, director adjunto de Innovation International Media Consulting Group, Detroit, Mich., es autor del libro Innovations in Newspapers (1999-2000), y The Latin-American Newspaper Industry (1977). Es editor de Innovación Periodística, una publicación sobre tendencias a nivel mundial en periódicos. Anteriormente fue subdirector de la escuela de Periodismo en la Universidad de Navarra en Pamplona, España. Es fundador del Capítulo Español de los premios de Infografía Malofiej, así como exdirector de SND en España.

Alan Jacobson tiene más de 20 años de experiencia en la industria de la comunicación, trabajando como fotógrafo, diseñador, editor, director de proyectos y analista de sistemas de impresión. Ha rediseñado más de 50 periódicos y ha recibido honores de SND por su trabajo en toda America, incluyendo la "Mención especial de los jueces" por el diseño integral de cinco periódicos en un solo año.

Rolf F. Rehe tiene entrenamiento como tipógrafo en Alemania y como periodista en los Estados Unidos. Para él la tipografía es el elemento visual más importante y a la vez el más descuidado en los periódicos. Actualmente escribe con regularidad una columna sobre tipografía para la revista de diseño de SND. Al mismo tiempo, se ha mantenido activo como consultor de diseño para 35 países desde su oficina en Viena, Austria.

Vivienne Sosnowski, es directora ejecutiva del National Post. También ha sido directora editorial para los dos periódicos de Vancouver: The Providence y The Vancouver Sun. The National Post pertenece a Hollinger Inc., la cual es dueña de varios diarios en Canadá. Su puesto actual es el de asegurar que dichos periódicos tengan una agenda completa de noticias a nivel nacional.

Mette Terkelsen es directora editorial en Kristeligt Dagblad, un diario nacional danés. Trabajó ocho años en el Berlingske Tidende, hasta ser AME en 1992. Ha trabajado tambien para Politiken y BT, diarios nacionales de formato tabloide. Terkelsen es miembro del jurado en la competencia anual danesa de páginas de periódicos, así como miembro del jurado en la competencia escandinava de SND.

BEST-DESIGNED & JSRs

World's Best

**We the
undersigned...**

Juan Antonio Giner

Alan Jacobson

Rolf Rehe

Vivienne Sosnowski

Mette Terkelsen

The newspaper clings to life in the emergency ward. It requires immediate resuscitation if it is to live in this millennium.

That's the conclusion of the five judges for the World's Best-Designed Newspapers. We selected 39 finalists, then from those, three newspapers were chosen by unanimous vote for the final awards.

It's a small number given the entries from 322 newspapers from 29 countries.

As we sat down to judge we agreed there were certain issues we wanted to address. We wanted to avoid euphemistic support for an ailing patient who needs to hear the truth about the hemorrhaging of readership from our industry.

Although we saw papers we admire and respect what we did not find were many innovations that could revive the patient.

The strong medicines we believe that this industry needs are:

Reduce the information overload. Readers don't specify smaller newspapers, they just cite too often they have no time to read. They're frustrated when they do not read much of the information they've purchased.

We believe that the broadsheet format is being seriously challenged around the world by the tabloid-sized paper, but that much of the industry has yet to recognize this. All signs are that the more tightly edited, more rigorously chosen news agendas are more appealing and manageable. The slimming of broadsheet newspapers is the interim phase of that evolution.

We noted newspapers that contained excellent photojournalism – particularly those from England, Scotland and Australia – didn't rise to the winner's standards in other ways.

We need to address inside page design. So many fronts and section fronts are attractive, but the design collapses as soon as the cover page is turned. Modular advertisements are a necessity today to allow clean, designable space. It's almost impossible to design around pyramid placements.

We excluded from our consideration newspapers with anything less than excellent reproduction and presswork. If a newspaper is to sell to a reader who has many other forms of beautifully presented information at hand, we need to be firm with ourselves about shoddy production.

We decided as judges to hold strict standards for typography and color.

We were very uncomfortable with the claim that we were judging the World's Best-Designed Newspapers. We were simply judging the best designed newspapers that were entered in the contest. Dozens of countries with great newspapers were not represented or were under-represented. All five of us recommend that SND consider an alternative form of call to entry to encourage worldwide participation. This will increase the credibility of these awards.

A distinction needs to be made between weekly and daily newspapers, given the time and resources available to each of them.

And we need to address the challenge of judging newspapers with non-Roman alphabets, of which there are more than 50 in the world.

Immediate efforts need to be made to include the design of websites in the annual contest.

In 21 years of competition, SND has never failed to honor a newspaper from the United States for overall design or place them amongst the world's best-designed until now. Why? Although the work of many American designers is illuminating papers in the U.S. and abroad, their best work does not appear this year in their own country.

Die Zeitung ringt um ihr Leben in der Intensivstation. Sie bedarf einer sofortigen Wiederbelebung, wenn sie in diesem Millennium überleben soll.

Das ist die Schlußfolgerung der fünf Juroren des Wettbewerbs 'World's Best-Designed Newspapers'. Wir haben 39 Finalisten ausgesucht, von denen dann einstimmig drei Zeitungen für die Preisverleihung bestimmt wurden.

Das ist eine geringe Zahl wenn man bedenkt, daß 322 Zeitungen aus 29 Ländern am Wettbewerb teilgenommen haben.

Vor der Beurteilung kamen wir überein, bestimmte Punkte zu berücksichtigen. Wir wollten es vermeiden, einem kränkelnden Patienten euphemistische Hilfestellung zu leisten. Der Patient muß die Wahrheit hören über das stetige Schwinden der Leserschaft in unserer Industrie.

Obwohl wir Zeitungen zu sehen bekamen, die unsere Bewunderung und unseren Respekt verdienten, fanden wir doch nicht viele Innovationen, die imstande gewesen wären, dem Patienten neues Leben einzuhauchen.

Die starke Medizin, die diese Industrie braucht, ist, wie wir glauben, folgende:

Verringern Sie die Informationsüberladung. Die Leser verlangen zwar nie direkt weniger umfangreiche Zeitungen, aber was sie oft anmerken, ist, daß sie keine Zeit zum Lesen haben. Sie sind frustriert, wenn sie einen Großteil der Informationen, die sie gekauft haben, nicht lesen können.

Wir sind der Meinung, daß weltweit das Großformat ernsthaft vom Kleinformat (Tabloid) herausgefordert wird. Allerdings muß dies noch von einem großen Teil der Industrie erkannt werden. Alles deutet darauf hin, daß knapper redigierte und sorgfältiger ausgewählte Nachrichten mehr Anklang finden und leichter aufgenommen werden. Die Verkleinerung der Breite der Großformatzeitung ist nur eine Zwischenstufe in dieser Entwicklung.

Wir stellten fest, daß Zeitungen mit ausgezeichnetem Fotojournalismus – insbesondere aus England, Schottland und Australien – in anderer Hinsicht nicht dem Niveau der Gewinner entsprachen.

Wir müssen uns mit dem Design der Innenseiten befassen. Es gibt viele attraktive Titelseiten und Aufschlagsseiten. Das Design bricht allerdings

El diario trata de sobrevivir en la sala de emergencia. Si quiere sobrevivir en este milenio necesita una resucitación inmediata.

Esta es la conclusión de los cinco jueces de los Diarios Mejor Diseñados del Mundo. Seleccionamos 39 finalistas y de estos elegimos tres periódicos que fueron escogidos con el voto unánime para los premios.

Se trata de un número pequeño si se tiene en cuenta que hubo como candidatos a 322 periódicos de 29 países.

Tan pronto como empezamos a juzgar, nos pusimos de acuerdo en algunos asuntos que deseábamos abordar. Queríamos evitar el apoyo eufemístico a un paciente enfermo que necesita escuchar la verdad acerca de la hemorragia de lectores que sufre nuestra industria.

Aunque vimos periódicos que admiramos y respetamos, lo cierto es que no encontramos demasiadas innovaciones que hagan revivir al paciente.

Creemos que estos son los enérgicos remedios que esta industria necesita:

Reducir la sobrecarga de información. Los lectores no piden diarios más breves, pero sencillamente alegan que muy a menudo no tienen tiempo para leer. Y se sienten frustrados cuando no leen mucha de la información que compraron.

Creemos que el formato sábana está siendo seriamente contestado en todo el mundo por el periódico de tamaño tabloide y, sin embargo, gran parte de nuestra industria todavía no es consciente. Todos los signos son que resulta más manejable y atractiva una edición noticiosa más sintética fruto de una selección más rigurosa. El estrechamiento vertical de los diarios sábana es una fase intermedia de esta evolución.

Detectamos periódicos que con un excelente fotoperiodismo, particularmente en Inglaterra, Escocia y Australia, no fueron capaces de equipararse a los ganadores en otros aspectos gráficos.

Tenemos que plantearnos el diseño de las páginas interiores. Muchas primeras páginas de diarios y secciones son atractivas, pero su diseño colapsa tan pronto dejamos atrás esas portadas. La modulación de los anuncios es hoy una necesidad para hacer posible páginas con espacio para un diseño claro. Es casi imposible diseñar alrededor de inserciones piramidales.

Excluimos de nuestra consideración aquellos periódicos con nada que fuera menos que una excelente calidad de impresión. Si un diario debe venderse a un lector que tiene a mano otras formas bellísimas de presentar la información, tenemos que auto-exigirnos firmemente ante la impresión de baja calidad.

Decidimos como jueces que mantendríamos también estándares estrictos para el uso de la tipografía y el color.

Nos sentimos incómodos con la presunción de que estábamos juzgando los Diarios Mejor Diseñados del Mundo. Simplemente estábamos juzgando sobre los diarios mejor diseñados que se presentaron a esta competición. Docenas de países con grandes diarios no estaban representados o no lo estaban suficientemente. Los cinco jueces recomendamos que la SND considere un modo distinto para conseguir y promover una participación realmente mundial. Esto aumentará la credibilidad de los premios.

Es necesario hacer una distinción entre periódicos diarios y semanales, dado el tiempo y recursos disponibles en cada caso.

Y debemos abordar el desafío de juzgar diarios con alfabetos no-latinos, que son más de 50 en el mundo.

Esfuerzos inmediatos deben hacerse para incluir en esta competición anual el diseño de websites.

En los 21 años de esta competición, la SND nunca hasta ahora dejó de honrar a periódicos de Estados Unidos de Norteamérica por el conjunto de su diseño o por situarlos entre los mejor diseñados del mundo. La razón es que aunque el trabajo de muchos diseñadores norteamericanos ilumina a diarios de Estados Unidos y de otros países, sus mejores trabajos no aparecieron este año en su propio país.

zusammen, sobald man die erste Seite umgeblättert hat. Eine modulare Anordnung der Anzeigen ist notwendig, um ein sauberes, gestaltetes Layout zu ermöglichen. Es ist fast unmöglich, um eine pyramidenförmige Anordnung der Anzeigen herum gutes Layout zu erzielen.

Wir schlossen von unseren Überlegungen Zeitungen aus, die nicht eine ausgezeichnete Reproduktions- und Druckqualität aufwiesen. Wenn eine Zeitung von einem Leser gekauft werden soll, dem viele andere Formen von ansprechend präsentierter Information zur Verfügung stehen, dann müssen wir selber minderwertige Produktionsqualität strikt ablehnen.

Wir als Juroren beschlossen, Typografie und Farbe nach strengen Maßstäben zu beurteilen.

Wir fühlten uns unbehaglich mit der Behauptung, daß wir die bestgestalteten Zeitungen der Welt zu beurteilen hatten. Wir beurteilten einfach nur die bestgestalteten Zeitungen, die zu diesem Wettbewerb eingereicht wurden. Dutzende von Ländern mit großartigen Zeitungen waren entweder gar nicht oder zu wenig vertreten. Alle fünf Juroren empfehlen, daß SND sich eine alternative Form von Aufruf zum Wettbewerb überlegt, um eine wirklich weltweite Teilnahme zu gewährleisten. Dadurch wird auch die Glaubwürdigkeit dieser Auszeichnungen verstärkt.

Eine klare Unterscheidung zwischen Wochen- und Tageszeitungen muß gemacht werden, da zwischen den beiden Kategorien große Unterschiede in Produktionszeit und verfügbaren Ressourcen bestehen.

Außerdem ist es notwendig, uns mit Zeitungen zu befassen, die nicht-lateinische Schriften benützen. Es gibt davon weltweit mehr als 50 Variationen.

Dringend erscheint uns auch die Aufgabe, Website-Design in den jährlichen Wettbewerben einzubeziehen.

In der 21-jährigen Geschichte des Wettbewerbs hat SND es niemals unterlassen, eine Zeitung aus den USA für ihr Design zu würdigen oder eine solche unter den bestgestalteten zu plazieren — bis auf diesesmal. Warum? Obwohl die Arbeit vieler amerikanischer Designer wegbereitend für Zeitungen in den USA und weltweit ist, erschienen ihre besten Arbeiten dieses Jahr nicht in ihrem eigenen Land.

– German translation by Rolf F. Rehe

Mural
Zapopan, México (C)

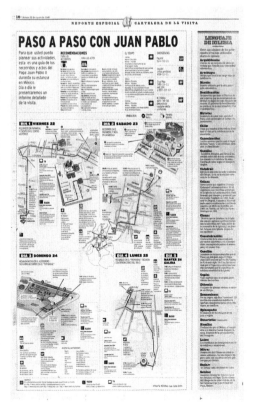

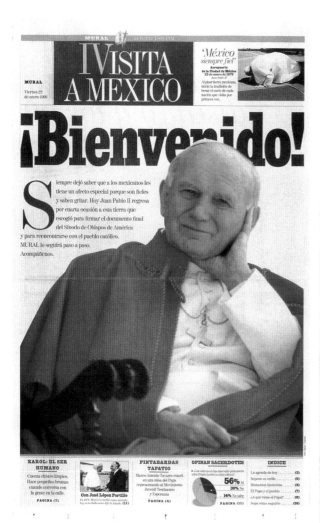

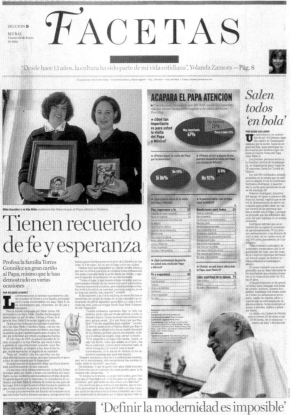

Die Woche
Hamburg, Germany (B)

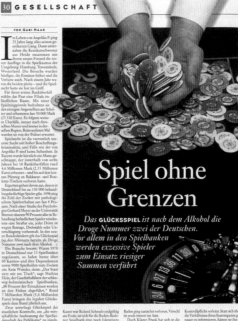

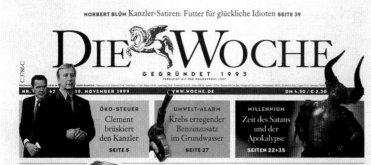

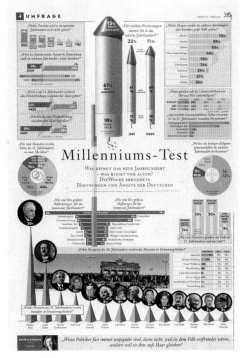

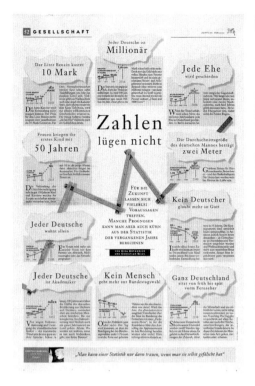

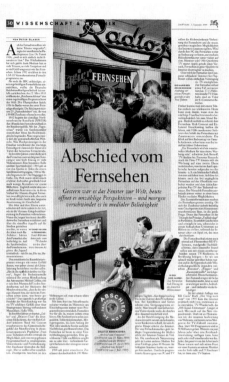

Abschied vom Fernsehen

Gestern war es das Fenster zur Welt, heute öffnet es unzählige Perspektiven – und morgen verschwindet es in medialer Beliebigkeit

Die Befreiung vom Körper

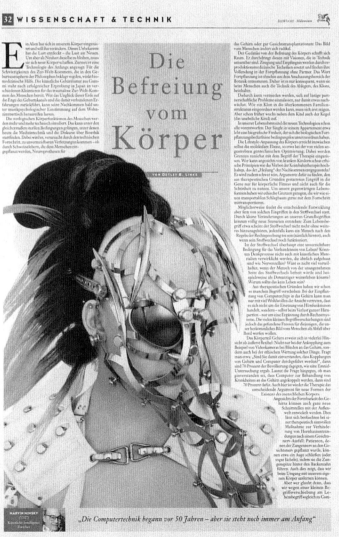

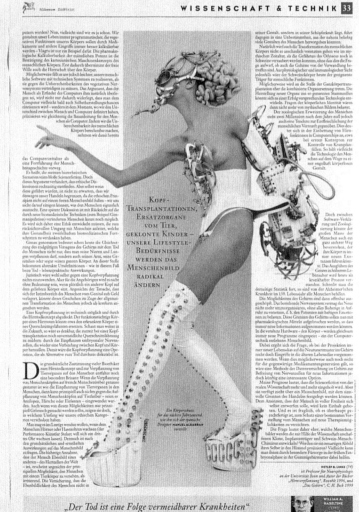

KOPF-
TRANSPLANTATIONEN,
ERSATZORGANE
VOM TIER,
GEKLONTE KINDER –
UNSERE LIFESTYLE-
BEDÜRFNISSE
WERDEN DAS
MENSCHENBILD
RADIKAL
ÄNDERN

"Die Computertechnik begann vor 50 Jahren – aber sie steht noch immer am Anfang"

"Der Tod ist eine Folge vermeidbarer Krankheiten"

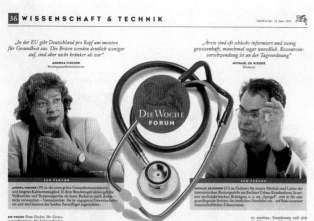

36 WISSENSCHAFT & TECHNIK

"In der EU gibt Deutschland pro Kopf am meisten für Gesundheit aus. Die Briten wenden deutlich weniger auf, sind aber nicht kränker als wir"
ANDREA FISCHER
Bundesgesundheitsministerin

"Ärzte sind oft schlecht informiert und wenig gewissenhaft, manchmal sogar unredlich. Ressourcenverschwendung ist an der Tagesordnung"
MICHAEL DE RIDDER
Klinikarzt

„Das ist keine Revolution"

Bundesregierung, Ärzte und Krankenkassen ringen um die GESUNDHEITSREFORM – die Patienten sind ratlos. DIEWOCHE lud die Kontrahenten zum Streitgespräch

Bausteine der Reform
Die Ziele der Bonner Koalition

30 AUSLAND

Jubel und Hass

Die Rückkehr

Nato-Einmarsch ins Kosovo: WOCHE-Reporter JOHANNES DIETERICH begleitete eine Exil-Albanerin auf der Fahrt in die Heimat

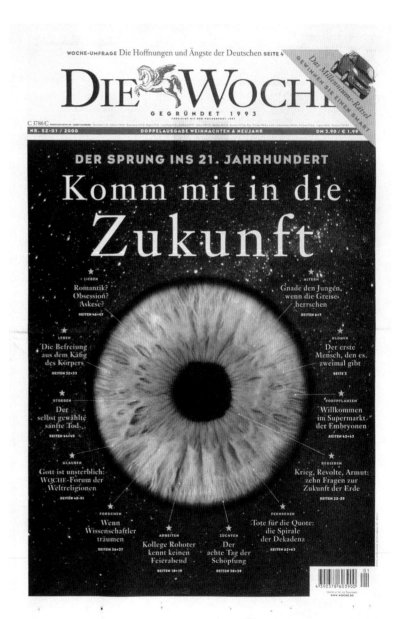

WOCHE-UMFRAGE Die Hoffnungen und Ängste der Deutschen SEITE 4

DIE WOCHE
GEGRÜNDET 1993

NR. 52-01 / 2000 DOPPELAUSGABE WEIHNACHTEN & NEUJAHR DM 3.90 / € 1.99

DER SPRUNG INS 21. JAHRHUNDERT

Komm mit in die Zukunft

★ LIEBEN
Romantik? Obsession? Askese?
SEITEN 46+47

★ ALTERN
Gnade den Jungen, wenn die Greise herrschen
SEITEN 6+7

★ LEBEN
Die Befreiung aus dem Käfig des Körpers
SEITEN 32+33

★ KLONEN
Der erste Mensch, den es zweimal gibt
SEITE 5

★ STERBEN
Der selbst gewählte sanfte Tod
SEITEN 44+45

★ FORTPFLANZEN
Willkommen im Supermarkt der Embryonen
SEITEN 42+43

★ GLAUBEN
Gott ist unsterblich: WOCHE-Forum der Weltreligionen
SEITEN 48-51

★ REGIEREN
Krieg, Revolte, Armut: zehn Fragen zur Zukunft der Erde
SEITEN 22-25

★ FORSCHEN
Wenn Wissenschaftler träumen
SEITEN 36+37

★ ARBEITEN
Kollege Roboter kennt keinen Feierabend
SEITEN 18+19

★ ZÜCHTEN
Der achte Tag der Schöpfung
SEITEN 38+39

★ FERNSEHEN
Tote für die Quote: die Spirale der Dekadenz
SEITEN 62+63

Die Zeit
Hamburg, Germany (A)

Nach den Skandalen

Jetzt brauchen wir eine strengere Aufsicht über Parteien und Firmen/Von HELMUT SCHMIDT

Nach dem Geständnis

Helmut Kohl, das Gesetz und die Nation/VON ROBERT LEICHT

Das Vertrauen in die Politiker

Austriator

MURSCHETZ

18. November 1999 DIE ZEIT Nr. 47 45

WISSEN

Digitale Lüge
Die Bilder sind schön – aber die Saurier sahen anders aus

AUCH DAS KLIMA ermittelt die Bücher – wie diese Handschrift auf Birkenrinde aus dem 14. Jahrhundert

Das große Datensterben

Von wegen Infozeitalter: Je neuer die Medien, desto kürzer ist ihre Lebenserwartung/Von DIETER E. ZIMMER

Bildungshunger
Geist geht durch den Magen

Die Katastrophe vollzieht sich fast unbemerkt

→ Fortsetzung auf Seite 46

17. Juni 1999 DIE ZEIT Nr. 25 49

REISEN

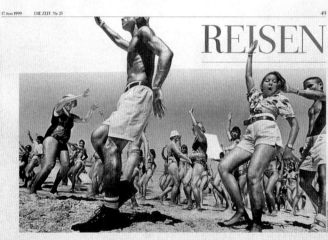

Pauschal an die Playa

Trotz Bombendrohungen und Verkehrsstaus – der Urlaub von der Stange ist beliebt wie nie zuvor/VON BERND LOPPOW

→ Fortsetzung auf Seite 50

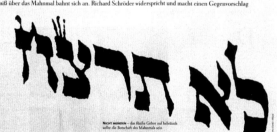

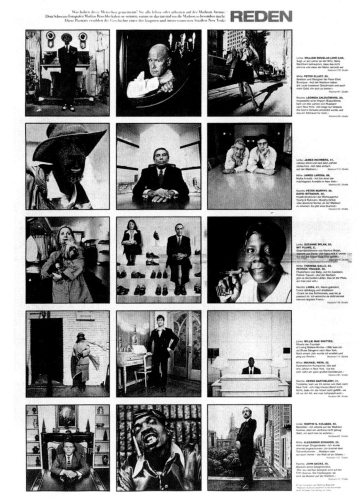

Gift für das Vertrauen

Der Dioxinskandal in Belgien hat Industrienahrung in Verruf gebracht – zu Unrecht / Von Jörg Blech und Hans Schuh

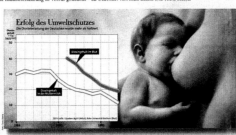

Erfolg des Umweltschutzes
Die Dioxinbelastung der Deutschen wurde mehr als halbiert

Industrialisierung

Reise zur Insel der Stabilität

Kernphysiker erschaffen zwei neue Elemente und erschüttern geltende Theorien / Von Rainer Scharf

Stimmt's?
Gefährliche Bratwurst

Victor Ninov

Joschka Fischer und seine Vision: Europa braucht eine Verfassung (Seite 3)

DIE ZEIT

WOCHENZEITUNG FÜR POLITIK · WIRTSCHAFT · WISSEN UND KULTUR

Nr. 4
21. Januar 1999
54. Jahrgang

Alptraum für den Westen

Im Kosovo entscheidet sich die Zukunft der Nato – und der europäischen Außenpolitik
VON CONSTANZE STELZENMÜLLER

Jede Option ist mit enormen Risiken verbunden

Das Massaker von Račak hat den prekären Frieden im Kosovo vorerst beendet

Die Tränen der Macht

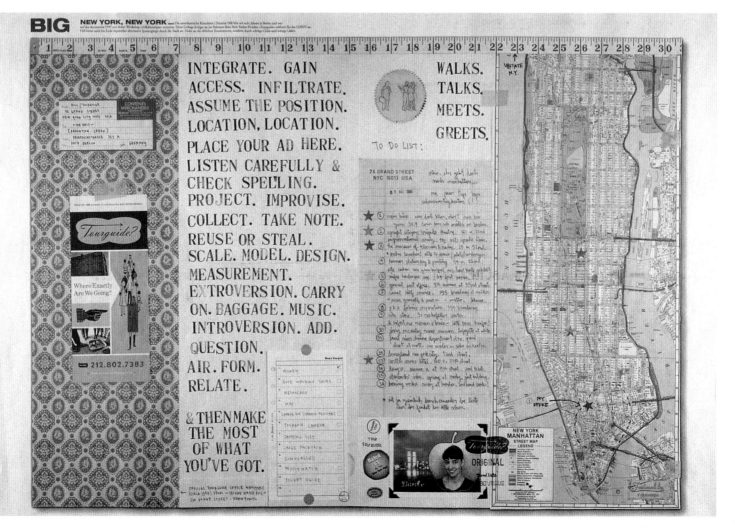

BIG NEW YORK, NEW YORK...

INTEGRATE. GAIN ACCESS. INFILTRATE. ASSUME THE POSITION. LOCATION, LOCATION. PLACE YOUR AD HERE. LISTEN CAREFULLY & CHECK SPELLING. PROJECT. IMPROVISE. COLLECT. TAKE NOTE. REUSE OR STEAL. SCALE. MODEL. DESIGN. MEASUREMENT. EXTROVERSION. CARRY ON. BAGGAGE. MUSIC. INTROVERSION. ADD. QUESTION. AIR. FORM. RELATE.

WALKS. TALKS. MEETS. GREETS.

& THEN MAKE THE MOST OF WHAT YOU'VE GOT.

Algonquin Sun
Naperville, Ill. (C)

The Australian
Sydney, Australia (B)

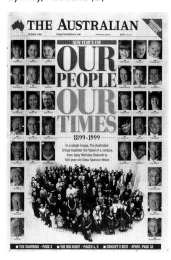

The Ball State Daily News
Muncie, Ind. (C)

Berliner Zeitung
Berlin, Germany (A)

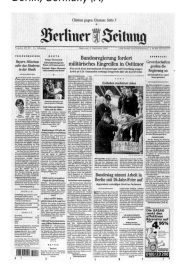

Centre Daily Times
State College, Pa. (C)

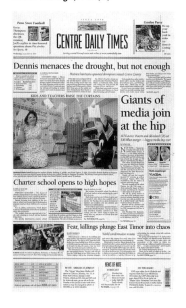

Construire
Zürich, Switzerland (A)

Correio Braziliense
Brasilia, Brazil (B)

Daily Camera
Boulder, Colo. (C)

Detroit Free Press
Detroit, Mich. (A)

Le Devoir
Montréal, Que., Canada (C)

Diario de Noticias
Huarte-Pamplona, Spain (C)

Diario de Sevilla
Sevilla, Spain (C)

Dimanche.ch
Lausanne, Switzerland (C)

The Globe and Mail
Toronto, Ont., Canada (A)

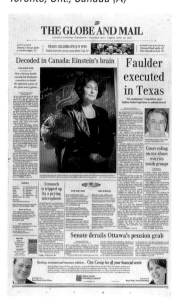

The Guardian
London, England (A)

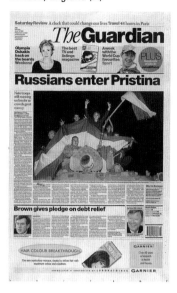

The Independent
London, England (A)

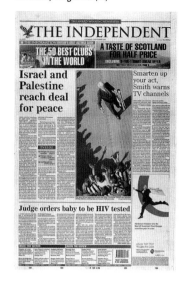

Jungle World
Berlin, Germany (C)

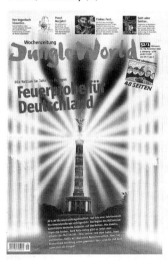

L'actu
Paris, France (C)

Marca
Madrid, Spain (A)

National Post
Don Mills, Ont., Canada (A)

The New York Times
New York, N.Y. (A)

El Norte
Monterrey, México (B)

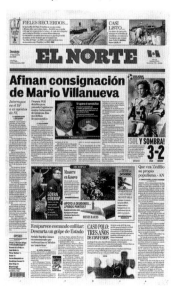

NRC Handelsblad
Rotterdam, The Netherlands (A)

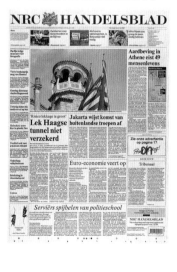

The Observer
London, England (A)

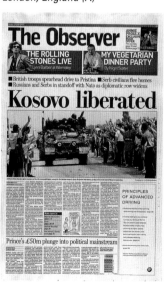

Scotland on Sunday
Edinburgh, Scotland (B)

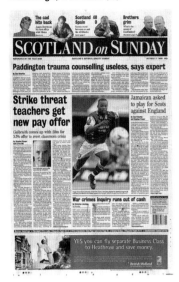

El Siglo
Santo Domingo,
Dominican Republic (C)

St. Louis Post-Dispatch
St. Louis, Mo. (A)

Sun Journal
Lewiston, Maine (C)

Svenska Dagbladet
Stockholm, Sweden (A)

Taipei Times
Taipei, Taiwan (C)

The Tribune
San Luis Obispo, Calif. (C)

El Universal
Caracas, Venezuela (B)

La Vanguardia
Barcelona, Spain (A)

To Vima
Athens, Greece (C)

The Virginian-Pilot
Norfolk, Va. (A)

Die Welt
Berlin, Germany (A)

The **Judges' Special Recognition** award (JSR) was given by one or more team of judges listed on Pages 245-249.
The JSR judging is not related to the World's Best-Designed Newspapers competition judged by the team listed on page 8.

El premio de Reconocimiento Especial de los Jueces (JSR) fue otorgado por uno o más equipos de jueces que están presentados en las páginas 245 a la 249.
La premiación JSR no está relacionada a la competencia de los Periódicos Mejor Diseóados del Mundo, juzgados por el equipo de jueces indicado en la página 8.

Silver & JSR
Clarín
Buenos Aires, Argentina (A)

Iñaki Palacios, Art Director; **Jaime Serra**, Graphic Director; **Aldo Chiappe**, Artist; **Alejandro Tumas**, Artist
• **Silver** for Informational Graphics Portfolio

This is a clean and easy-to-follow cinematic progression. The design takes you through from start to finish using intelligent devices. This winner contains a clarity of narrative storytelling, unintrusive use of graphic devices and beautifully rendered images that place it above the rest, meriting the decision of awarding it a Judges' Special Recognition (JSR).

Se trata de una progresión cinemática clara y fácil de seguir. Los diseñadores capturan nuestro interés de principio a fin, al utilizar inteligentes mecanismos. Reconocemos a este participante por su clara narración de las historias, su preciso uso de elementos gráficos, y sus imágenes hermosamente presentadas.

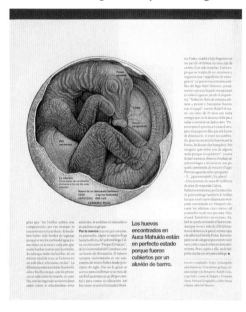

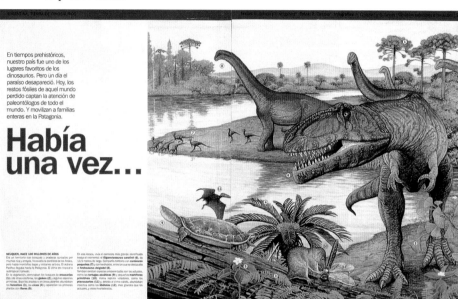

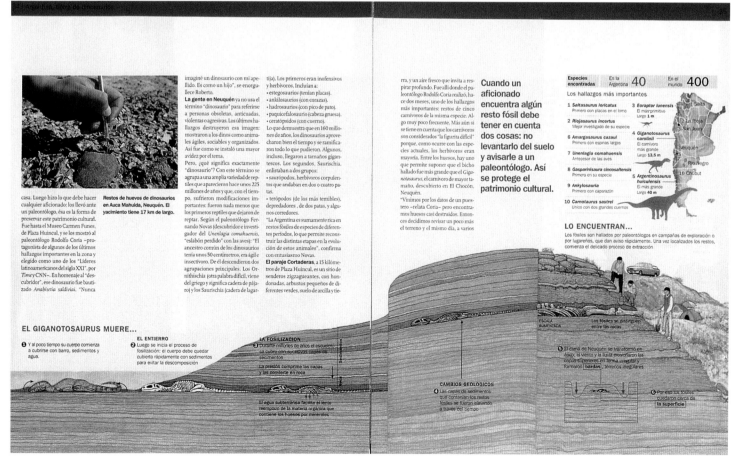

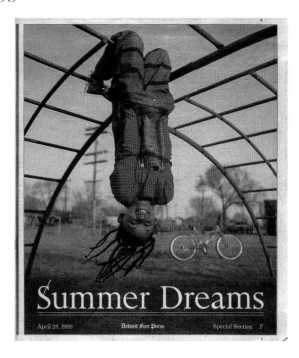

GOLD & JSR
Detroit Free Press
Detroit, Mich. (A)

J. Kyle Keener, Photographer/Deputy Photo Director; **Karolyn Cannata-Winge**, Designer
• **Gold** for Photo Series

The judges awarded a Judges' Special Recognition (JSR) to J. Kyle Keener for his impressive volume of illustrative portraits. The work reflects his thoughtful planning, attention to detail and clever conceptual imagery.

Los jueces otorgaron un REJ (Reconocimiento Especial de los Jueces) a J. Kyle Keener por su impresionante volumen de retratos ilustrativos. Su trabajo refleja su profundo planeamiento y un especial manejo de la imagen conceptual.

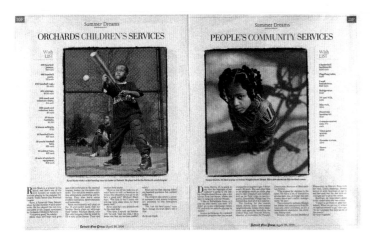

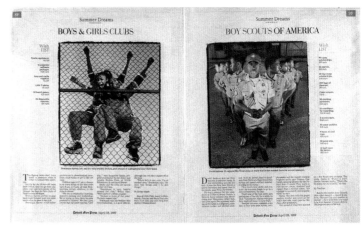

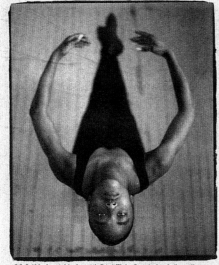

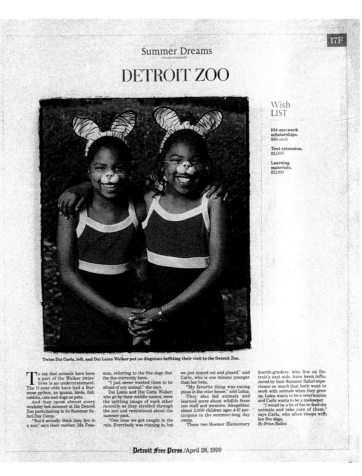

• **Silver** for Photo Portfolio by **J. Kyle Keener**

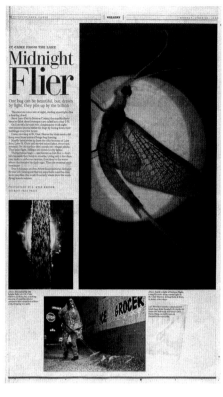

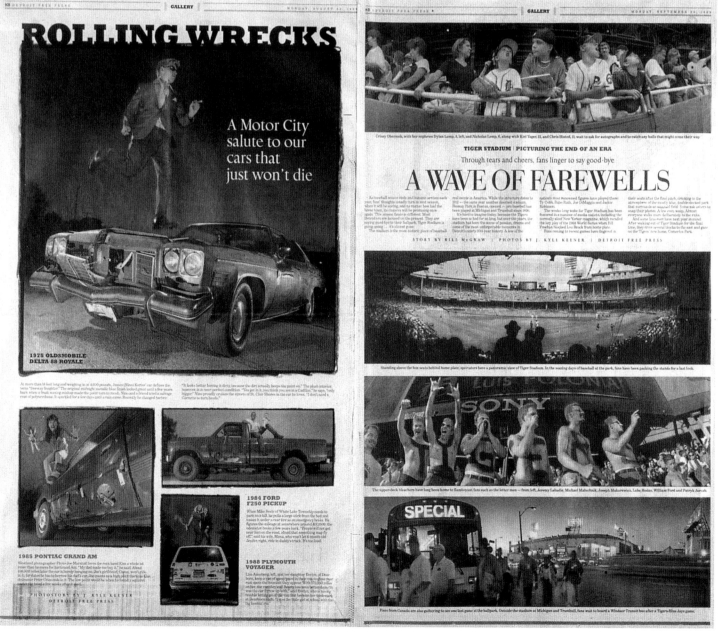

Silver & JSR
Svenska Dagbladet
Stockholm, Sweden (A)
Hans Ottosson, Editor; **Lars Andersson**, Design Editor; **Bjorn Larsson Ask**,
Photographer
• **Silver** for Special News Topics

These pages are powerful, evocative and larger than life and
break the boundaries of traditional design with elements that
continue to lead you into the package, thereby meriting the
awarding of a Judges' Special Recognition (JSR). We were
impressed with the highly refined template that reflects a great
editorial package of fine typography and the thoughtful dis-
play of the photography. These larger-than-life events are com-
municated in a scale proportional to their historical importance
to Sweden. Items like a daily timed series box create a sense of
time and motion that pull the readers into future sections.
These pages display a bold, masterful design.

Poderosas y evocadoras, éstas páginas rompen las fronteras
del diseño tradicional e incorporan elementos que permiten
una presentación muy coherente. Los jueces estuvieron impre-
sionados por su rejilla altamente refinada, la cual refleja una
gran presentación editorial, con fina tipografía y un apropiado
manejo fotográfico. Estos grandiosos eventos se comunican
en una escala proporcional a la importancia histórica para
Suecia. Elementos tales como tablas de tiempo diaria ofrecen
movimiento y un sentido temporal que anima a los lectores a
buscar secciones que aparecerán en el futuro.
Estas páginas presentan un diseño magistral y poderoso.

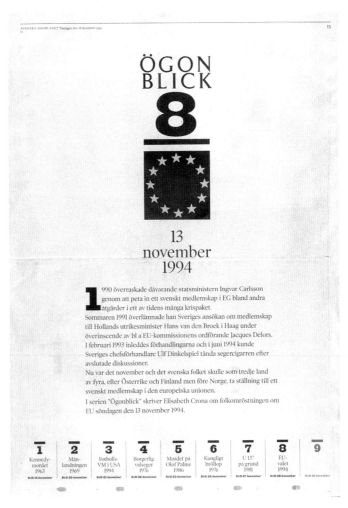

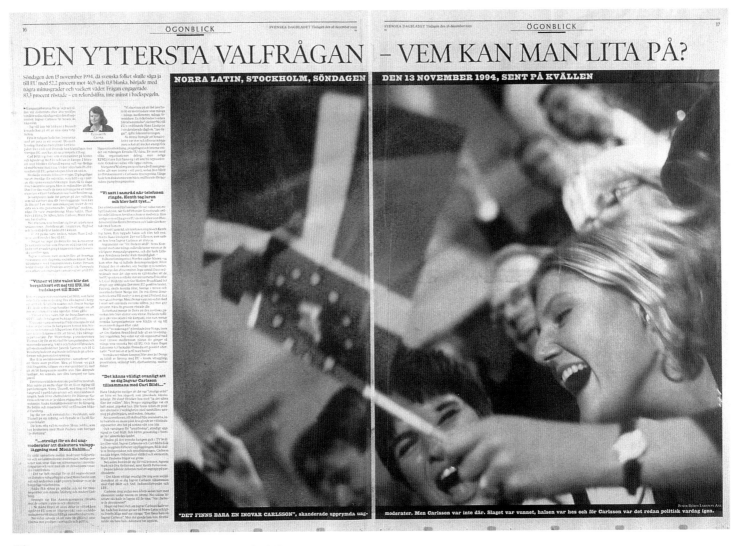

• **Award of Excellence** for Special News Topics

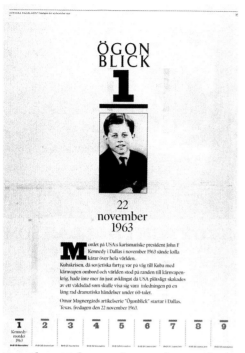

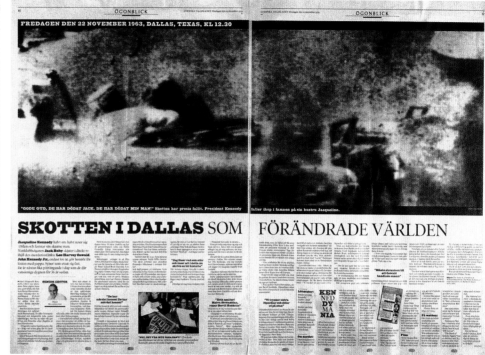

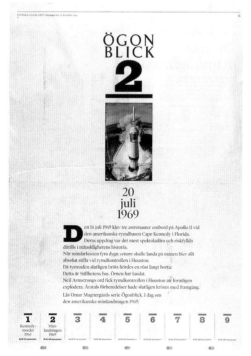

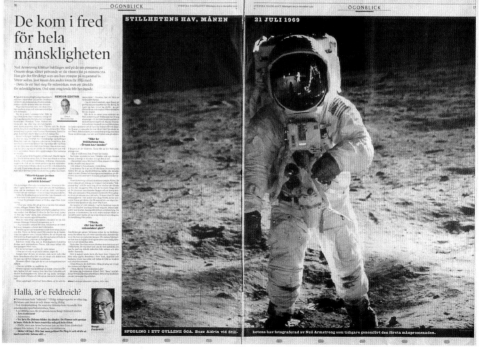

• **Award of Excellence** for Special News Topics

Gold & JSR
The Spokesman-Review
Spokane, Wash. (B)

Brian Plonka, Photographer; **John Sale**, Photo Editor; **John Nelson**, Design Editor; **Ralph Walter,** Designer
• **Gold** for Photo Series

The judges awarded photographer Brian Plonka a Judges' Special Recognition (JSR) for his technical excellence and the range of compositional creativity exhibited in his photographic essays. His ability to apply the appropriate artistic approach to each of his photographs exhibits a mastery of his craft.

Los jueces otorgaron al fotógrafo Brian Plonka un reconocimiento especial por su excelente técnica y su variedad en su creativa composición de sus ensayos fotográficos. Su habilidad para aplicar el estilo artístico apropiado en cada una de sus obras presenta la excelencia de un experto.

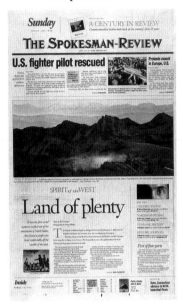
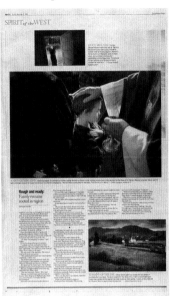
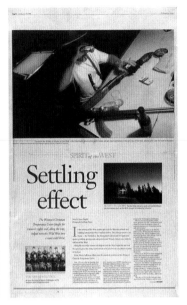
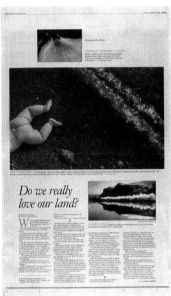

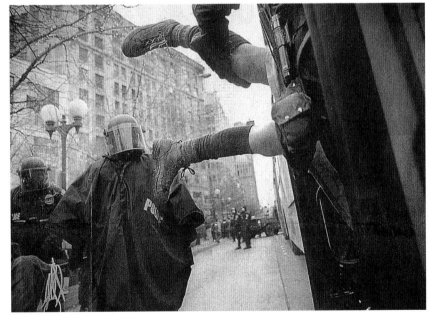

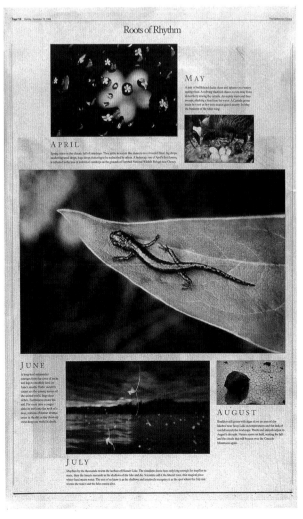

Silver
The Spokesman-Review
Spokane, Wash. (B)

Brian Plonka, Photographer
• **Silver** for Photo Portfolio

The portfolio contained all of the elements of a well-rounded photojournalist. Content and creativity came together with a high level of visual storytelling that represented news, sports and features.

Este portafolio contiene todos los elementos de un sazonado fotoperiodista. El contenido y la creatividad se conjugan con un gran nivel de narración visual que representa noticias, deportes y features.

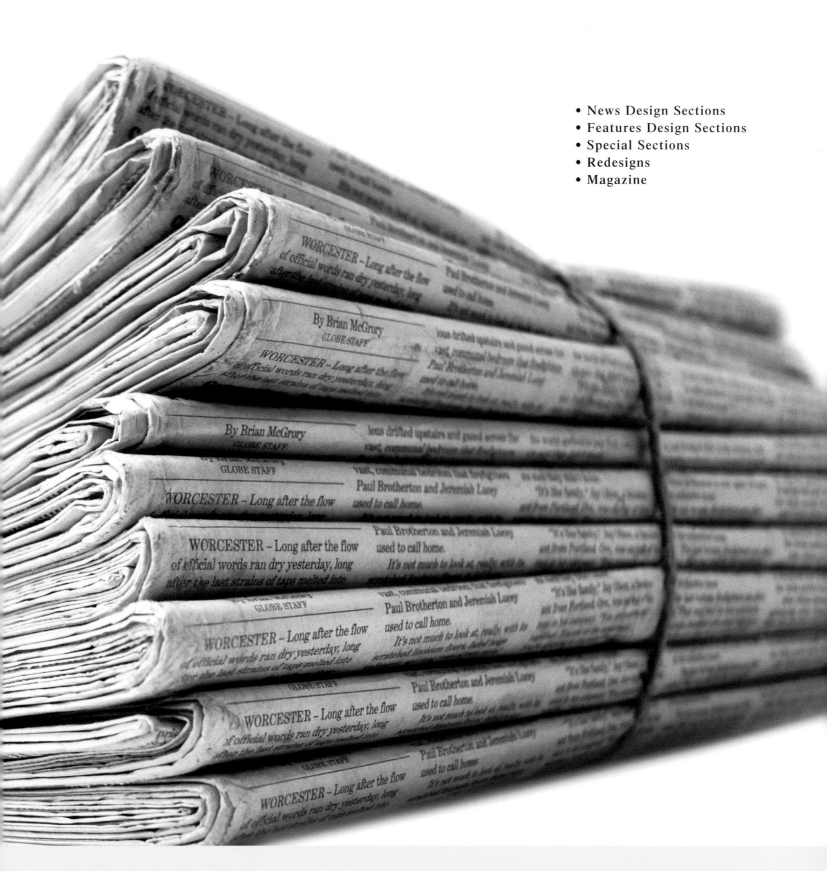

chapter two

SECTIONS

The Guardian
London, England (A)
Staff

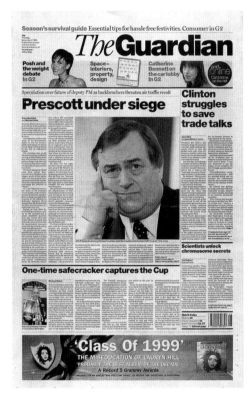

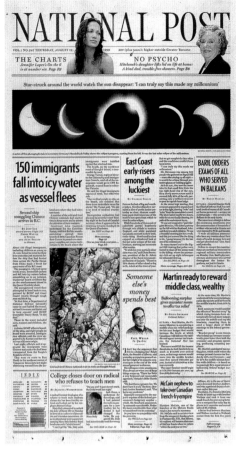

National Post
Don Mills, Ont., Canada (A)

Gayle Grin, Design Director/Designer; **Steve Meurice**, Designer/Copy Editor; **Martin Newland**, Deputy Editor; **Kenneth Whyte**, Editor-in-Chief; **Steve Maurice**, Copy Editor

• also an **Award of Excellence** for Breaking News

The News & Observer
Raleigh, N.C. (B)

J. Damon Cain, Director of News Design; **Teresa Kriegsman**, Assistant Director/News Design; **Wendy Mondello**, Lead Metro Designer; **Al Kraft**, Designer; **Maria Rodriguez**, Designer; **London Nelson**, Designer; **Amy Seeley**, Designer; **Carol Jenkins**, Designer; **Lesley Williams**, Designer; **Danny Hooley**, Designer

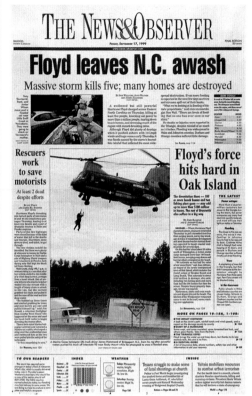

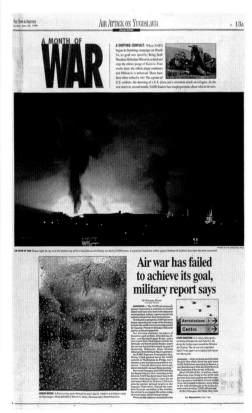

Politiken
Copenhagen, Denmark (B)
Staff

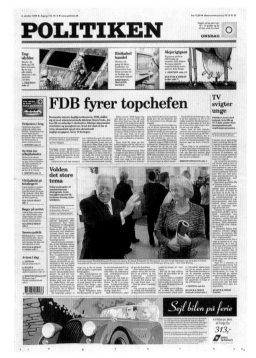

Reforma
Mexico City, México (B)

Alejandro Sosa, Section Designer; **Miguel Antonio Vadillo**, Section Designer; **Salvador Camarena**, Section Editor; **Emilio Deheza**, Art Director; **Eduardo Danilo**, Design Consultant; **Staff**

The Scotsman
Edinburgh, Scotland (B)
Staff

The Tribune
San Luis Obispo, Calif. (C)
Staff

The Tribune
San Luis Obispo, Calif. (C)
Staff

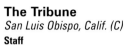

LOCAL

Land purchases fill council agenda

Courage under fire

A golfer's dream assignment

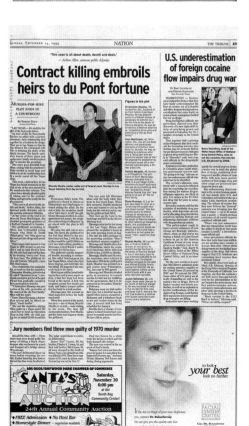

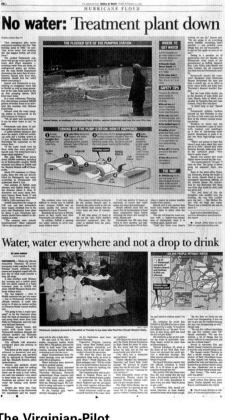

No water: Treatment plant down

Water, water everywhere and not a drop to drink

The Virginian-Pilot
Norfolk, Va. (A)
Staff

OPINION

It's OK to charge for a convenience

Is the time here for Senate consensus-building?

Spare students the killer classrooms

Davis is piling up campaign funds

• also an **Award of Excellence** for Local News Page

Silver
Reforma
Mexico City, México (B)

Oscar Yañez, Section Designer; **Alberto Fabela,** Designer; **Gonzalo Pérez,** Designer; **Carlos Escamilla,** Designer; **Ricardo del Castillo,** Graphics Editor; **Héctor Zamarrón,** Section Editor; **Alejandro Ramos,** Editor; **Carlos Almazán,** Editor; **Emilio Deheza,** Art Director; **Eduardo Danilo,** Design Consultant

These are metro covers that break away from the template mentality. Breaking news drives these pages, and the use of graphic devices, a restrained color palette and typography create dynamic pages that rival most A-1 sections.

Estas son portadas de información metropolitana que se alejan de la mentalidad de rígida estructura. Estas páginas presentan informaciones muy actuales, y el uso de elementos gráficos, una restringida tipografía y paleta de color crean páginas dinámicas que compiten con muchas de sus primeras páginas.

Silver
Sunday Herald
Glasgow, Scotland (B)

Donald Cowey, Sports Editor; **David Dick,** Deputy Sports Editor; **Jonathon Jobson,** Page Designer; **Rod Sibbald,** Picture Editor; **Neil Bennet,** Picture Editor; **Simon Cunningham,** Design Editor; **Simon Esterson,** Design Editor

This entry takes sports design to another level. The photography is brilliant, the use of typography is extremely sophisticated, and the layering and graphic devices make every story special.

Este participante lleva a la sección de deportes a un nivel superior. La tipografía es brillante, el uso de tipografía es extremadamente sofisticado, los niveles de información y los recursos gráficos hacen especial a cada historia o artículo.

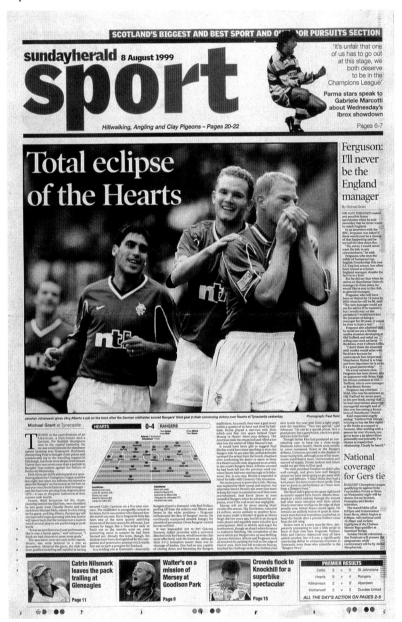

The New York Times
New York, N.Y. (A)

Lee Yarosh, Designer; **Wayne Kamidoi**, Designer; **Joe Ward**, Graphics Editor; **Bedel Saget**, Graphics; **Staff**

The Scotsman
Edinburgh, Scotland (B)
Staff

Sport
Barcelona, Spain (B)

Luciano Cukar, Art Director; **Miquel Herre**, Art Director; **Félix Alonso**, Art Director; **José Luis Merino**, Design Consultant; **Fernando Carballo**, Design Consultant; **Antoni Cases**, Project Manager

Star Tribune
Minneapolis, Minn. (A)

Tim Wheatley, Sports Section Coordinator; **Kevin Bertels**, Night Sports Section Coordinator; **Anders Ramberg**, Design Director; **Glen Crevier**, Sports Editor; **Derek Simmons**, Sports Design Editor; **Mark Hvidsten**, Sports Designer; **Bill Dunn**, Visual Content Editor

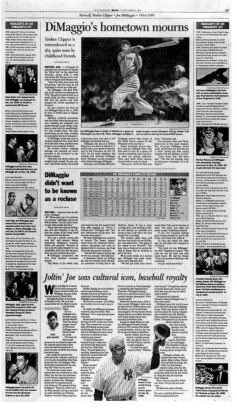

The Virginian-Pilot
Norfolk, Va. (A)

Staff

Denver Rocky Mountain News
Denver, Colo. (A)

Randall Roberts, Design Director; **Michael Apuan**, Designer

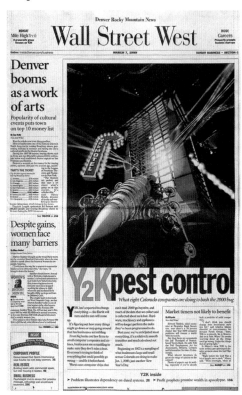

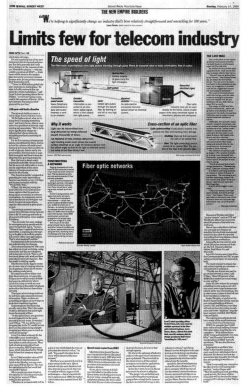

National Post
Don Mills, Ont., Canada (A)

Gayle Grin, Design Director; **Graeme Parley,** Sports Editor; **Ron Wadden,** Deputy Sports Editor; **Kenneth Whyte,** Editor-in-Chief

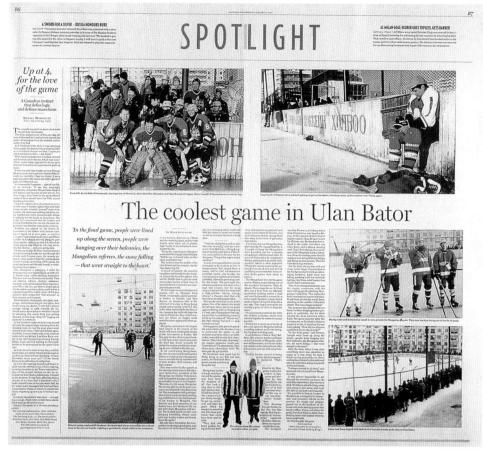

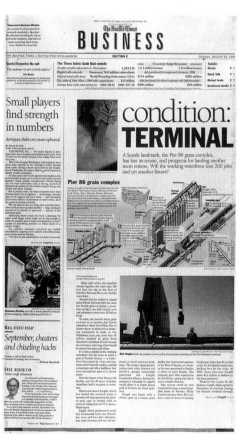

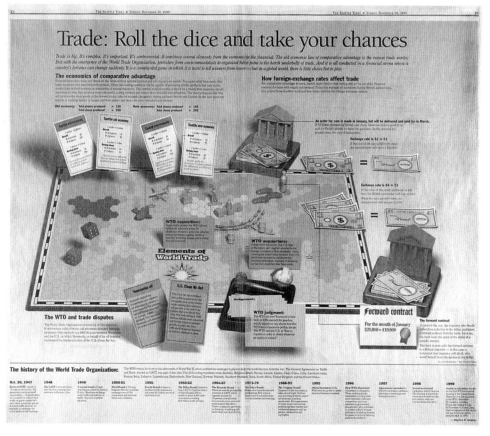

The Seattle Times
Seattle, Wash. (A)

Desmond Toups, Designer; **Jeff Neumann,** Designer; **Tracy Porter,** Designer; **Elliot Rosenstein,** Graphic Artist; **Rob Weisman,** Editor; **Mark Nowlin,** Graphic Artist

National Post
Don Mills, Ont., Canada (A)

Roland-Yves Carignan, Deputy Design Director; **Chris Watson,** Deputy M.E.; **Denyse Armour,** Page Editor; **Howard Intrador,** Deputy Editor; **Kenneth Whyte,** Editor-in-Chief; **Doug Kelly,** Assistant Deputy Editor; **Al Zabas,** Copy Editor

El Siglo
Santo Domingo, Dominican Republic (C)

Mario Garcia, Design Consultant; **Miguelangel Ferry,** Design Director; **Angel Rojas,** Designer; **Fausto Rosario Adames,** Editor

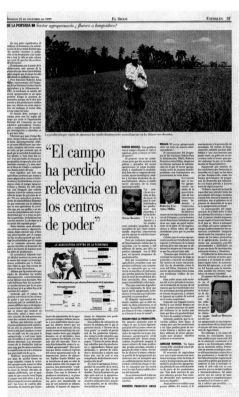

The News & Observer
Raleigh, N.C. (B)

Adelaide Nash, Lead Business Designer; **Mary Cornatzer,** Section Editor

Silver
Sunday Herald
Glasgow, Scotland (B)

Simon Esterson, Design Consultant; **Tony Sutton**, Design Consultant; **Richard Walker**, Deputy Editor; **Rod Sibbald**, Picture Editor; **Simon Cunningham**, Design Editor; **Roxanne Sooroshian**, Page Editors; **Liz Carr**, Page Editors; **Jonathon Jobson**, Page Editors; **Phil Gates**, Page Editors; **Stephen Khan**, Page Editors

This opinion section felt very lively: it is well organized, clean looking and uses white space very well. The design helps the reader quickly identify items of interest.

Este participante presenta una sección de opinión muy vivaz. Se encuentra muy bien organizada, claramente diseñada, con un buen uso del espacio en blanco. Su diseño ayuda a que el lector identifique lo que le intereza con rapidez.

Silver
DN Lörd
Stockholm
Pompe Hed

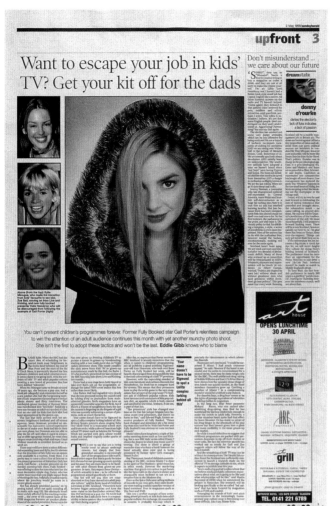

Want to escape your job in kids' TV? Get your kit off for the dads

Don't misunderstand ... we care about our future

donny o'rourke

A big speech needs big ideas to stop the voters drifting off

rob brown

counterblast

powerplay

iain macwhirter

Off the peg plan to get male secrets out of the closet

privateaye

Frankie goes to Holyrood

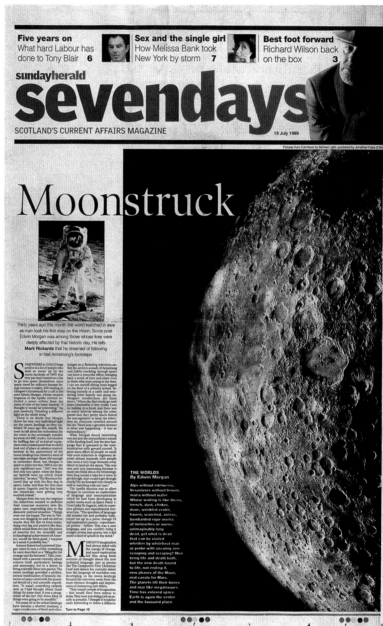

Five years on
What hard Labour has done to Tony Blair **6**

Sex and the single girl
How Melissa Bank took New York by storm **7**

Best foot forward
Richard Wilson back on the box **3**

sundayherald
sevendays
SCOTLAND'S CURRENT AFFAIRS MAGAZINE
18 July 1999

Moonstruck

Thirty years ago this month the world watched in awe as man took his first steps on the moon. Scots poet Edwin Morgan was among those whose lives were deeply affected by that historic day. He tells **Mark Rickards** that he dreamed of following in Neil Armstrong's footsteps

THE WORLDS
By Edwin Morgan

La Nación
Buenos Aries,
Norberto J. Lem

Silver
DN på stan
Stockholm, Sweden (A)
Ebba Bonde, Art Director; **Magnus Naddermier,** Art Director

We liked the use of color and how the black and white mixed with the color effortlessly and seamlessly. Each spread was pleasingly unique.

A los jueces le gustó el uso del color y cómo el equipo del DN på stan mezclaron el blanco y negro con el color parejamente. Cada composición fue agradable y única.

»Om de startade ett förlag skulle de kunna göra billiga utställningar i bokform. En sjättedels miljon senare är den första här.«

JACOB DAHLGREN OCH ANDREAS ERIKSSON, SID 21

| da boss | trattoria | nattskrik | kalendariet |

Bengt Ohlsson: En holmgång kärlek.

»Tantens leende förvandlas på en halv sekund och hon skriker: – Hoppas du får cancer!«

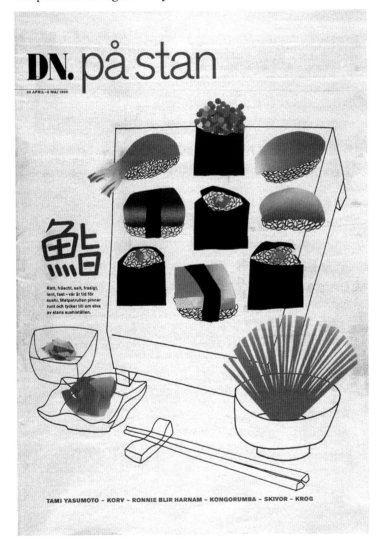

DN. på stan
30 APRIL–6 MAJ 1999

Rätt, fräscht, salt, frasigt, lent, fast – vår är tid för sushi. Matpatrullen pinnar runt och tycker till om elva av stans sushiställen.

TAMI YASUMOTO – KORV – RONNIE BLIR HARNAM – KONGORUMBA – SKIVOR – KROG

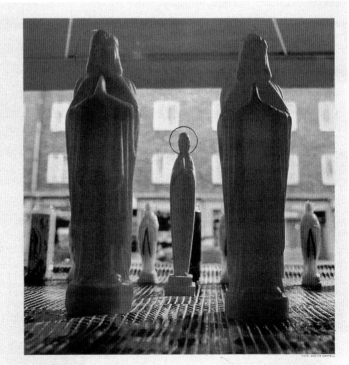

kristen kitsch

Jesus Maria. Religiösa symboler säljer, återgivna på allt ifrån nyckelringar till trosor. Men hur kul är det egentligen?

National Post
Don Mills, Ont., Canada (A)

Gayle Grin, Design Director; **Peter Scowen,** Toronto Editor; **Diane Defenoyl,** Life Editor; **Tim Rostron,** Arts Editor;
Graeme Parley, Sports Editor; **Kenneth Whyte,** Editor-in-Chief; **Leanne Shapton,** Avenue Editor

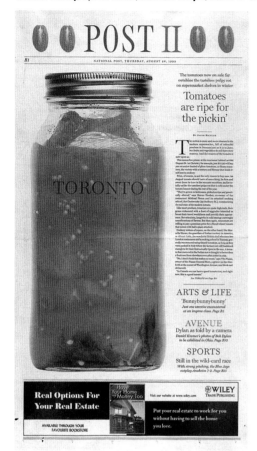

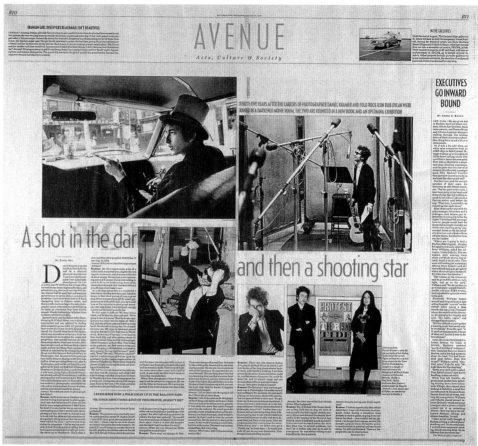

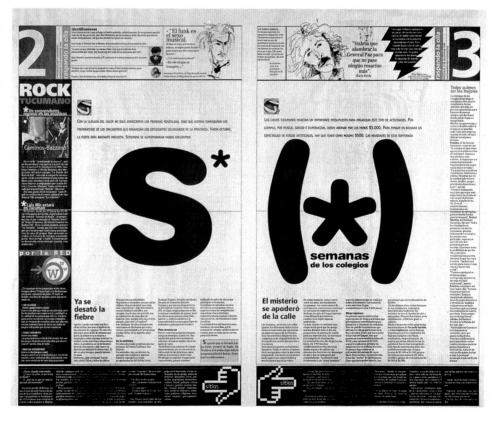

La Gaceta
San Miguel de Tucumán, Argentina (B)

Sebastian Rosso, Designer; **Sergio Fernandez,** Art Director; **Mario Garcia,** Design Consultant

The Globe and Mail
Toronto, Ont., Canada (A)

David Woodside, Designer

TV's little white lies

A devilishly talented man of the theatre

If director Daniel Brooks were a filmmaker, he'd be as famous as Atom Egoyan. But he has chosen to remain working in "the dirty little rooms of Toronto, places that welcome big ideas — even if the wages are paltry.

ARTS&LIFE

NATIONAL POST, MONDAY, JUNE 7, 1999

AVENUE
Post! Buddy, I got two golds left and I can let you have 'em for... Pages D6 and D7

WORKPLACE
If you don't schmooze, you lose. Page D13

Something akin to hockey

A family-owned Spanish shoe company is now an international phenomenon, with a diverse line that inspires cultish collecting

Happy Campers

Finding a haven from the hurting

In Alberta, seniors who are the victims of abuse now have a safe place to turn for help

ARTS

ALL MONEY, ALL THE TIME

Unforthcoming attractions

Albert Nerenberg would rather make a trailer than a film

There's no play like this play, anyplace

Silver lining to SilverCity

National Post
Don Mills, Ont., Canada (A)

Gayle Grin, Design Director; **Diane Defenoyl**, Life Editor; **Tim Rostron**, Arts Editor; **Kenneth Whyte**, Editor-in-Chief

Politiken
Copenhagen, Denmark (A)

Søren Nyeland, Design Editor; **Marianne Gram**, Editor; **Kristoffer Østerbye**, Designer; **Tomas Østergren**, Designer; **Anne Hemp**, Designer; **Elisabeth S. von Eyben**, Designer; **Anette Vestergaard**, Copy Editor; **Annette Nyvang**, Copy Editor

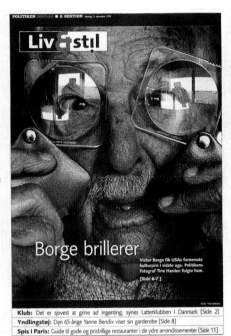

Liv & stil

Borge brillerer

Victor Borge fik USAs fornemste kulturpris i sidste uge. Politikens fotograf Tine Harden fulgte ham.
[Side 6-7]

Klub: Det er sjovest at grine ad ingenting, synes Latterklubben i Danmark [Side 2]

Yndlingstøj: Den 65-årige Yanne Bendix viser sin garderobe [Side 8]

Spis i Paris: Guide til gode og prisbillige restauranter i de ydre arrondissementer [Side 11]

Stadig i tvivl

The Tribune
San Luis Obispo, Calif. (C)

Joe Tarica, Presentation Editor; **Beth Anderson**, Page Designer; **Dennis Steers**, Page Designer

Dimanche.ch
Lausanne, Switzerland (C)

Antoni Cases, Project Manager; **Paula Galli**, Graphic Director; **Víctor Gil**, Graphic Project; **Sergio Ibáñez**, Graphic Project; **Renata Libal**, Executive Editor; **Christophe Passer**, Executive Editor; **Marino Trotta**, Art Director; **Xavier Cerdá**, Designer; **Alain Deppierraz**, Designer; **Yann Mercanton**, Designer

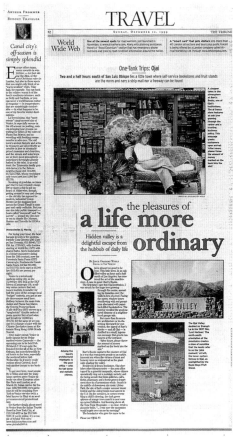

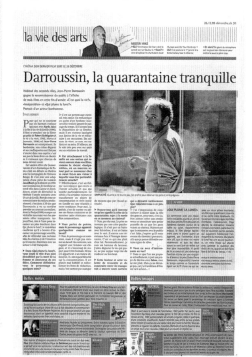

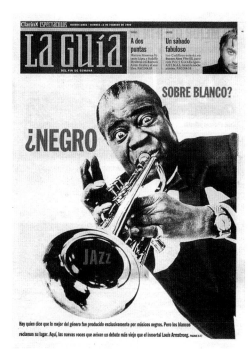

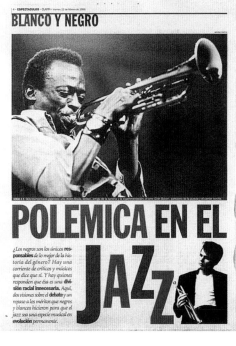

Clarín
Buenos Aires, Argentina (A)

Iñaki Palacios, Art Director; **Tea Alberti**, Design Editor; **Oscar Bejarano**, Graphic Designer; **Valeria Castresana**, Graphic Designer; **Silvina Fuda**, Graphic Designer; **Maria Heinberg,** Graphic Designer; **Omar Olivella**, Graphic Designer; **Matilde Oliveros**, Graphic Designer; **Pablo Ruiz**, Graphic Designer; **Carolina Wainsztok**, Graphic Designer

Silver
Diario de Sevilla
Sevilla, Spain (C)

Ferrán Grau, Art Director; **Miguel Moreno**, Section Coordinator; **Juan Carlos Zambrano**, Design Coordinator; **Rafael Avilés**, Designer; **José Manuel Barranco**, Designer; **Manuel González**, Designer; **José Antonio Sánchez**, Designer; **José María Ruiz**, Designer

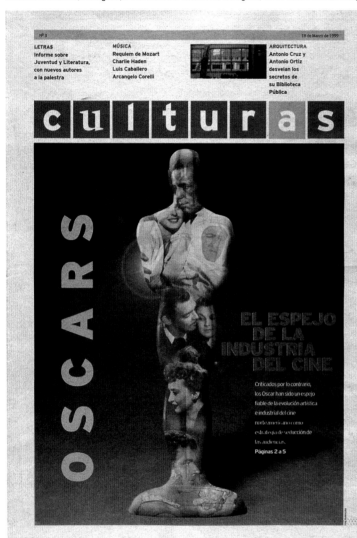

This publication is wonderfully consistent in its packaging and organization from issue to issue. The listings are excellent. Typographical design and white space are used judiciously to create the look of a high-caliber publication.

Esta publicación es maravillosamente consistente en su presentación y organización, de número a número. Los listados son excelentes. El diseño tipográfico y el espacio en blanco son utilizados juiciosamente para crear una publicación de alto calibre.

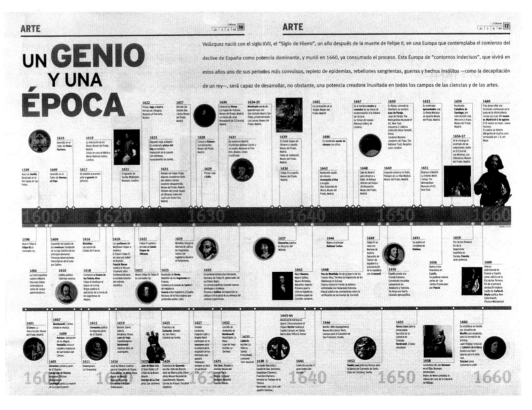

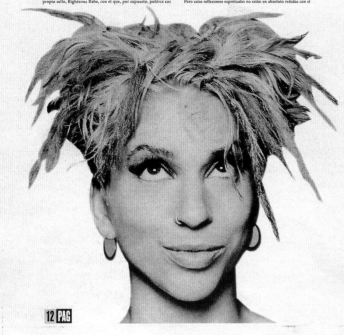

MUSICA

ES LA ESPOSA QUE NINGUNA MADRE QUERRIA PARA SU HIJO. la nieta que daría crónicos quebraderos de cabeza a cualquier abuela en su sano juicio y la novia que sólo un hombre muy seguro de sí mismo podría soportar durante, pongamos, más tres días. Y es que Ani DiFranco, seamos sinceros, da bastante miedo. Un terror, desde luego, atractivo y basado en esa fortaleza que la convierte en una especie de guerrillera de la vida cotidiana y le da un aura distante que, a priori, infunde respeto. Pero, como suele ocurrir en estos casos, en cuanto abre la boca, se rompe el encanto.

Esta agresiva chica, que en su nuevo disco, titulado

ANI DIFRANCO

ESTA DESGARBADA NORTEAMERICANA FOLK, REVOLUCIONARIA Y FEMINISTA VISITA NUESTRO PAIS CON SU ALBUM MAS INTIMISTA, «UP, UP, UP, UP, UP»

Up up up up up up, lanza violentas diatribas contra las injusticias de la sociedad, emplea un tono de voz dulce e incluso cae en momentos de verdadera vulnerabilidad cuando se trata de hablar de temas tan serios como su papel en la industria discográfica (lleva ya 10 años al frente de su propio sello, Righteous Babe, con el que, por supuesto, publica sus

trabajos), la doble moral, la hipocresía de la sociedad norteamericana y los problemas que acompañan a todas las religiones oficiales.

El asunto de la espiritualidad preocupa especialmente a esta artista nacida en Buffalo (Nueva York), que lanzó su primer álbum en 1990 (aunque sin demasiado éxito). «En otros de mis trabajos anteriores —declara— me preocupaba más por hablar de los asuntos que me rodean, por cuestiones sociales o por aquellas que me inquietaban. Pero en este último disco he mirado más hacia mi interior, intento ocuparme de mi espiritualidad. Pero no lo hago en un sentido religioso al uso, se trata más bien de una cuestión personal. Para mí, la única religión que existe es el arte. Gracias a mi actividad artística encuentro respuestas a algunas de nuestras preguntas, y las expresiones de otros artistas también me ayudan a sentir esa paz de la que algunos hablan cuando se refieren a las diferentes religiones».

Pero estas reflexiones espirituales no están en absoluto reñidas con el

carácter combativo de una mujer que se ha hecho a sí misma. A la temprana edad de 16 años, justo después de que sus padres se divorciaran, ella consiguió la emancipación legal y se dedicó a viajar y a estudiar por su cuenta en diversas escuelas de arte.

TODA AMERICA ES UN ENORME PRESIDIO. Esa independencia, conseguida a una tan corta edad, la ayudó, según confiesa, a entender más fácilmente las debilidades de la gente y los problemas de los menos afortunados, una comprensión que le ha llevado a colaborar muy activamente con organizaciones como Critical Resistance (dedicada a apoyar a los reclusos que han tenido defensas jurídicas insuficientes o que han sufrido condenas a todas luces son injustas).

«El manager que tengo actualmente —explica DiFranco— trabajaba antes como abogado defensor, y él ha sido el que me ha ayudado a darme cuenta de lo injusto y terrible que puede llegar a ser el sistema judicial norteamericano. La mayor parte de la gente que está en las cárceles es pobre y, casi siempre, de raza negra».

Y la cantante incide en la misma desoladora visión: «La justicia de mi país funciona tan mal que cualquier culpable con un buen abogado se libra de prisión y un inocente con la defensa inadecuada (que suele serlo cuando se trata de un letrado de oficio) puede entrar en la cárcel. Que a alguien se le prive de su libertad me parece lo peor que le puede de ocurrir, por eso intento ayudar a gente desprotegida y débil que se ve obligada a luchar contra la potentísima estructura del estado norte-

americano, que cada año mete a más y más gente en la cárcel porque es un magnífico negocio y así incentiva el sistema represivo y policial que quiere imponer en todo el mundo. Así es completamente consciente de esa imagen dura y agresiva que transmite. De hecho, se siente orgullosa de ello y confiesa que no le molesta en absoluto que la incluyan dentro de ese numeroso grupo de cantautoras combativas, feministas (lo cual, en algunos sectores concretos, parece que va unido al término lesbianas) y «protestonas».

«Hay bastantes mujeres en Norteamérica que, efectivamente, defienden con su música ideas políticas radicales, pero no me parece que haya las suficientes. El feminismo es una actitud natural que, en mi opinión, debería tener todo aquel que no odie a las mujeres (sea del género masculino o femenino). Por eso no logro entender que no haya más gente que tenga posiciones radicalmente feministas».

Su estilo, que los críticos de todo el mundo han definido como una mezcla entre punk y folk (a lo que habría que añadirle ciertos toques de trip hop), se aleja considerablemente de las líneas maestras del resto de sus compañeras de viaje (léase la más comercial y asequible Sheryl Crow o la pionera y más cruda y ácida Liz Phair), aunque la filosofía vital y esa tendencia a la desnudez instrumental de todas ellas sean parecida.

POR SILVIA GRIJALBA. FOTOS DE ANDREW MACPHERSON

Silver
El Mundo La Luna
Madrid, Spain (A)

Rodrigo Sánchez, Art Director & Designer; **Francisco Dorado**, Designer; **Chano del Rio,** Designer; **Carmelo Caderot,** Design Director
• also an **Award of Excellence** for Entertainment Page

 This winner displays a strong confidence in typography, with good use of white space. It is powerful and gripping for its youthful target audience. The staff appears willing to take risks without losing control.

El ganador demuestra mucha confianza en su manejo tipográfico y utiliza bien el espacio en blanco. Es poderoso y cautivador para su joven público objetivo. El equipo toma riesgos sin perder el control.

Silver
The Seattle Times
Seattle, Wash. (A)

Jeff Neumann, Designer, A.M.E. Graphics; **Jane Keller**, Editor
• also an **Silver** for Entertainment Page

This section does what all the other weekend sections do, but it manages to do it with a new life. Sections appear user friendly with an appeal to a wide audience. The staff seems to be able to handle massive amounts of material well.

Hace lo mismo que hacen otras secciones de fin de semana, pero ofreciéndole nueva vida. Las secciones son fáciles de seguir y atraen a una gran audiencia. EL equipo de The Seattle Times maneja increíbles cantidades de material con efectividad.

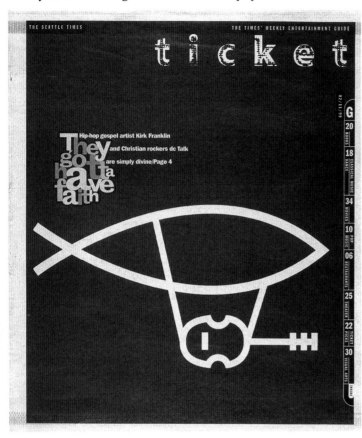

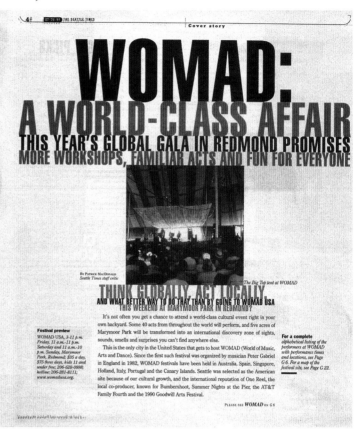

Politiken
Copenhagen, Denmark (B)

Søren Nyeland, Design Editor; **Charlotte Sejer Pederson,** Editor; **Else Bjørn,** Editor; **Stig Dyre,** Editor; **Tomas Østergren,** Designer; **Kristoffer Østerbye,** Designer; **Elisabeth S. von Eyben,** Designer; **Katinka Bukh,** Designer; **Karina Kofoed,** Designer; **Mikkel Henssel,** Designer

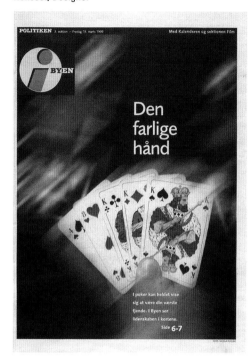

The Independent
London, England (A)

Kevin Bayliss, Art Director; **Himesh Patel,** Deputy Art Director; **Rebecca Carswell,** Picture Editor

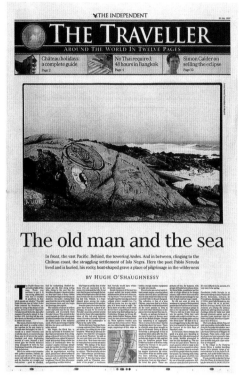

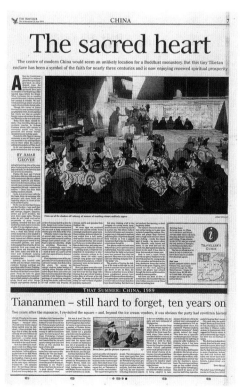

Die Welt
Berlin, Germany (A)

Ulrich Baron, Editor; **Tilman Krause,** Editor; **Elmar Krekeler,** Editor; **Jacques Schuster,** Editor; **Katja Wischnewski,** Designer

Clarín
Buenos Aires, Argentina (A)

Iñaki Palacios, Art Director; **Tea Alberti,** Design Editor;
Oscar Bejarano, Graphic Designer; **Valeria Castresana,**
Graphic Designer; **Silvina Fuda,** Graphic Designer;
Maria Heinberg, Graphic Designer; **Omar Olivella,**
Graphic Designer; **Matilde Oliveros,** Graphic Designer;
Pablo Ruiz, Graphic Designer; **Carolina Wainsztok,**
Graphic Designer

Dagens Nyheter
Stockholm, Sweden (A)
Maria Hunt, Page Designer

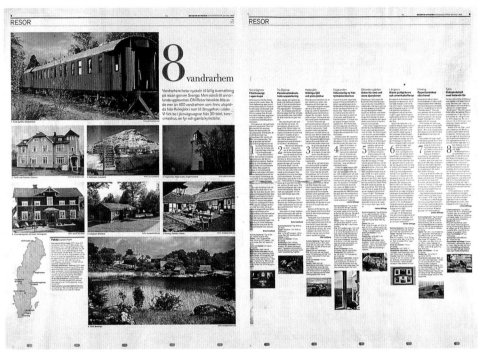

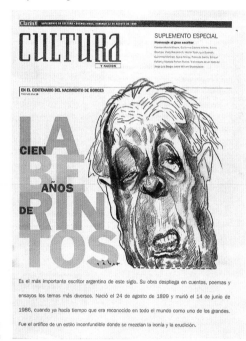

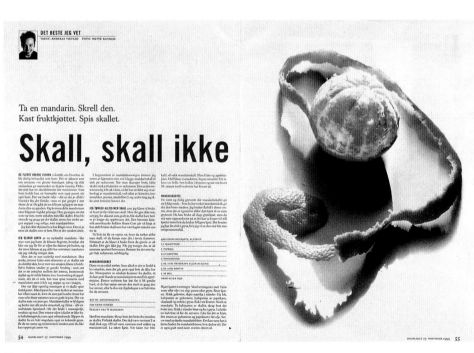

Dagbladet
Oslo, Norway (A)

Torfinn Solbrekke, Designer and Art Director; **Grete Sivertsen,** Designer; **Cecile Campos,** Designer;
Eirik Vale Frogner, Designer

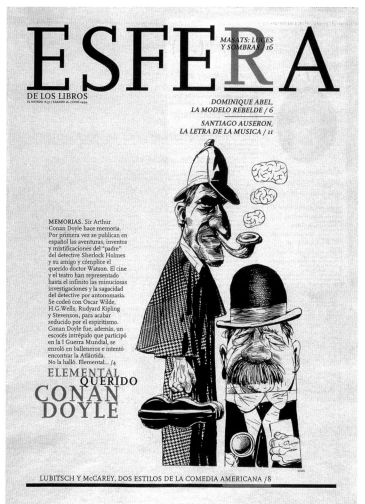

Silver
El Mundo
Madrid, Spain (A)

Carmelo Caderot, Design Director; **Manuel De Miguel,** Art Director & Designer; **Jose Carlos Saiz,** Designer

This page has wonderful hierarchy of typography, using the levels of type well to convey the content. Despite being very controlled, the feeling remains very lively.

Esta página presenta una maravillosa jerarquía en la tipográfía para comunicar efectivamente el contenido. A pesar de ser muy controlada, el sentimiento permanece muy vivaz.

Silver
El Mundo
Madrid, Spain (A)
Carmelo Caderot, Design Director & Designer; **Manuel De Miguel**, Art Director & Designer; **Jose Carlos Saiz**, Designer

The staff appears to have maintained a high level of energy for the project, despite a story content that might have led to boredom. A lot of car sections die under weight of their content, and this section attacks cars in a very unique way.

El equipo de El Mundo mantuvo siempre el nivel de energía a pesar que el contenido de las historias pudieron habernos llevado al aburrimiento. Muchas secciones sobre automóviles fenecen bajo el peso del contenido. Esta sección utiliza un ataque único.

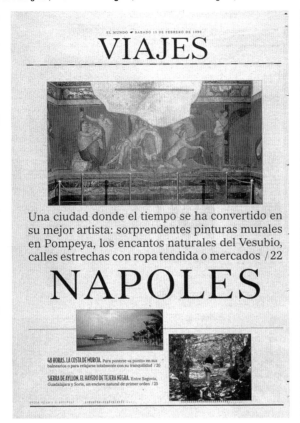

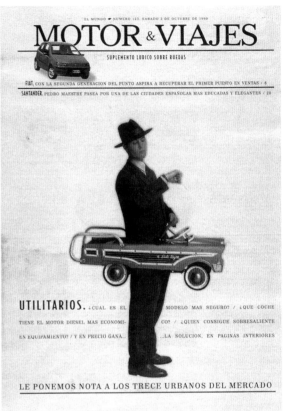

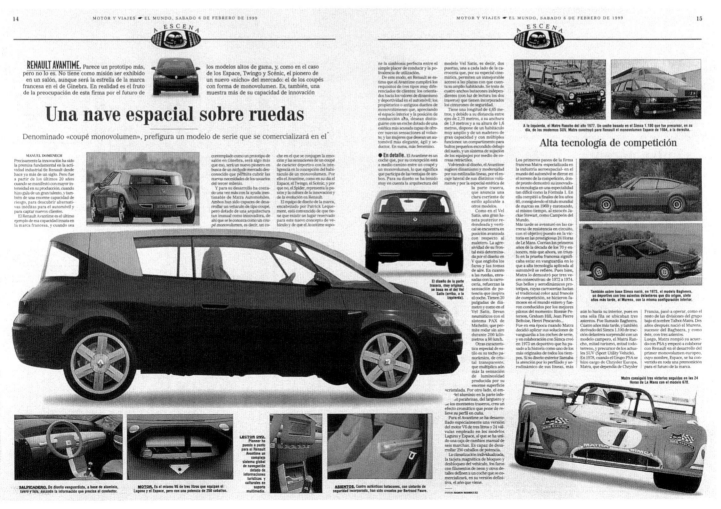

• also an **Award of Excellence** for Illustration

El Mundo
Madrid, Spain (A)

Carmelo Caderot, Design Director/Designer; **Manuel De Miguel**, Art Director & Designer; **Jose Carlos Saiz**, Designer; **Ulises Culebro**, Artist

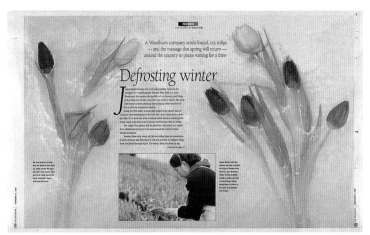

The Oregonian
Portland, Ore. (A)

Joan Carlin, Visuals Editor -Homes & Gardens; **JoLene Krawczak**, Editor; **Réne Eisenbart**, Illustrator
• also an **Award of Excellence** for Home / Real Estate page

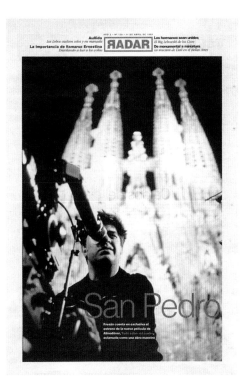

Página/12
Buenos Aires, Argentina (B)

Alejandro Ros, Art Director; **M. Florencia Helguera**, Art Director & Designer

La Gaceta
San Miguel de Tucuman, Argentina (B)
Sergio Fernandez, Art Director & Designer; **Andrés Tula
Molina,** Designer; **Sebastian Rosso,** Designer; **Mario
García,** Design Consultant

Die Zeit
Hamburg, Germany (A)
Thomas Brackvogel, Deputy Editor; **Arwed Voss,** Art
Director

Página/12
Buenos Aires, Argentina (B)
Alejandros Ros, Art Director; **M. Florencia Helguera,**
Art Director & Designer

The Boston Globe
Boston, Mass. (A)

Lucy Bartholomay, Art Director; **Janet L. Michaud,** Designer; **Ande Zellman,** Editor; **Kimberly Johnson,** Research; **Leanne Burden,** Picture Editor; **Susan Wadlington,** Picture Editor; **George Patisteas,** Copy Editor; **Dan Zedek,** Editorial Design Director

The Baltimore Sun
Baltimore, Md. (A)

Staff

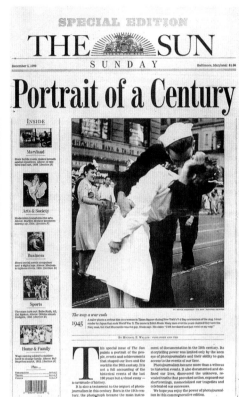

The Australian
Sydney, Australia (B)

Geoff Hiscock, Editor; **Simon Pipe,** Art Director; **Lee Anthony,** Layout and Production; **Darrel Croker,** Layout

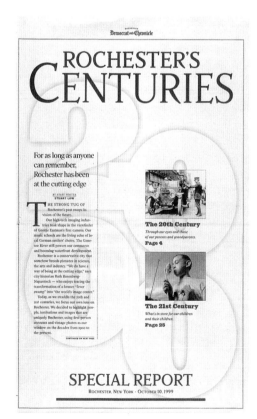

The New York Times Magazine
New York, N.Y. (A)

Nicholas Blechman, Art Director; **Jonn Collidge,** Cover Photographer; **Richard Bryant,** Cover Photographer; **Pilar Viladas,** Editor

Democrat and Chronicle
Rochester, N.Y. (A)

Steve Boerner, Assistant Presentation Editor; **Dennis R. Floss,** A.M.E./Presentation; **Stan Wischnowski,** Deputy M.E.

The News Tribune
Tacoma, Wash. (B)

Lee Waigand, Presentation Team Leader; **Derrik Quenzer, Fred Matamoros, Roy Gallop,** Graphic Artists; **Reggie Myers,** Art/Graphyics Team Leader; **Casey Madison, Craig Sailor,** Picture Editors; **Michael Winkelhorst,** Copy Editor; **Michael Gilbert,** Section Editor; **Photo Staff**

The Star-Ledger
Newark, N.J. (A)

Andrew Phillips, Graphics Editor/Designer; **Chris D'Amico,** Sports Editor; **Kevin Whitmer,** A.M.E. of Sports; **Chris Faytok,** Photographer

La Vanguardia
Barcelona, Spain (A)

Carlos Pérez de Rozas Arribas, Art Director; **Rosa Mundet Poch,** Editor-in-Chief/Design & Graphics; **Joan Corbera Palau,** Designer; **Anna Belil Boladeras,** Designer; **Carolina Téllez Garbayo,** Designer

The Wall Street Journal
New York, N.Y. (A)

James Steinberg, Illustrator; **Pat Minczewski,** Designer; **Joe Dizney,** Design Director

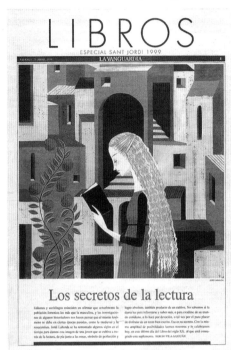

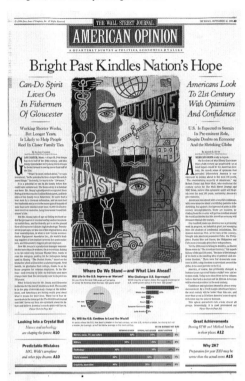

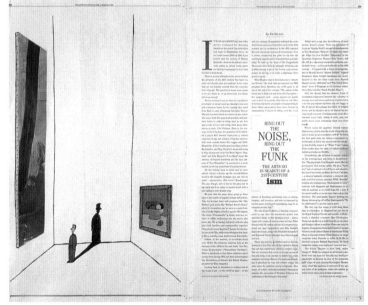

The Boston Globe
Boston, Mass. (A)

Joe Sullivan, Senior Assistant Sports Editor; **Janet L. Michaud,** Art director/Designer; **Chuck Pyle,** Illustrator; **Ken Fratus,** Asst. Sports Editor; **Don Skwar,** Sports Editor; **John Carney,** Copy Editor; **Jeff Wagenheim,** Copy Editor; **Dan Zedek,** Editorial Design Director

The Boston Globe
Boston, Mass. (A)

Lucy Bartholomay, Art Director; **Janet L. Michaud,** Designer; **Ande Zellman,** Editor; **George Patisteas,** Copy Editor; **Gary Clement,** Illustrator; **Dan Zedek,** Editorial Design Director

The Wall Street Journal Reports
New York, N.Y. (A)

Vera Naughton, Art Director; **Chrisophe Vorlet,** Illustrator

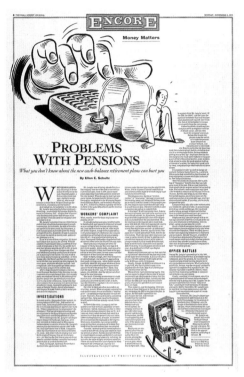

The Columbus Dispatch
Columbus, Ohio (A)

Scott Minister, Art Director & Designer; **Becky Kover,** Section Coordinator; **Richard Lillash,** Illustrator

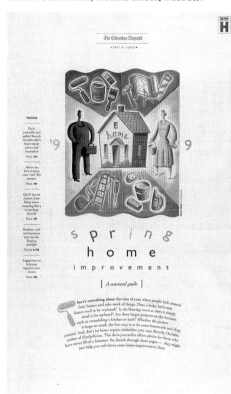

El Mundo
Madrid, Spain (A)

Carmelo Caderot, Design Director/Designer; **Manuel De Miguel,** Art Director & Designer; **Jose Carlos Saiz,** Designer

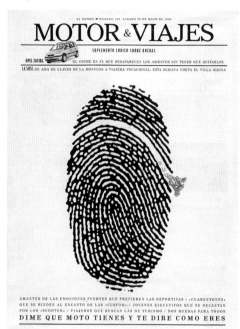

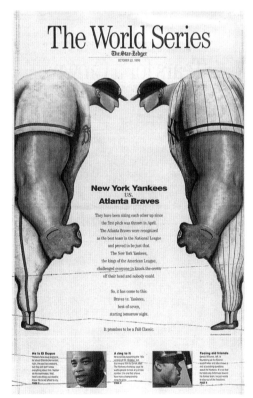

The Star-Ledger
Newark, N.J. (A)

Sharon Russell, Designer; **Andre Malok,** Illustrator; **Mike Scott,** Designer; **Kevin Whitmer,** A.M.E. Sports

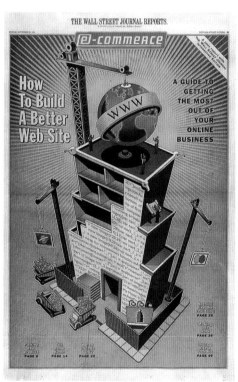

The Wall Street Journal Reports
New York, N.Y. (A)

Orlie Kraus, Art Director; **Peter Hoey,** Illustrator

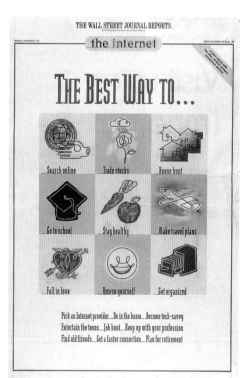

The Wall Street Journal Reports
New York, N.Y. (A)

Orlie Kraus, Art Director; **Otto Steininger,** Illustrator

Detroit Free Press
Detroit, Mich. (A)

Deborah Withey, Design Consultant; **Bryan Erickson,** Deputy Design Director / Features; **Steve Dorsey,** Design & Graphics Director; **Dave Robinson,** Deputy M.E. / Sports and Operations; **Staff**

Before

After

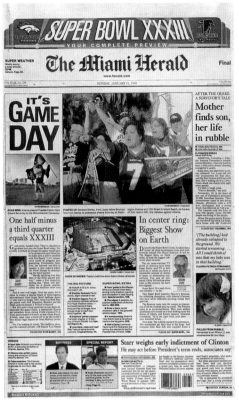

Before

After

The Miami Herald
Miami, Fla. (A)

Nuri Ducassi, Design Director; **Juan Lopez,** Senior Features Designer; **Hiram Henriquez,** Deputy Graphics Editor; **Kris Strawser,** News Design Editor

The Tribune
San Luis Obispo, Calif. (C)

Joseph Kieta, Presentation Editor; **Deborah Withey,** Design Consultant

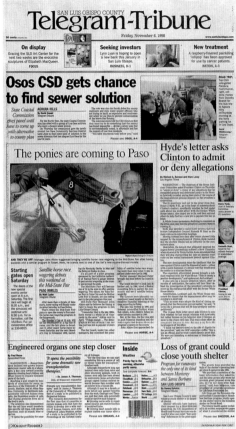

Before

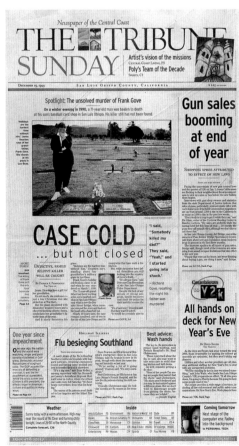

After

Austin American-Statesman
Austin, Texas (A)

Gladys Rios, Lead Features Designer

Before

Before

After

After

Chicago Tribune
Chicago, Ill. (A)

Elizabeth Taylor, Editor; **Carolyn Alessio,** Deputy Director; **Judie Anderson,** Art Director; **Chuck Rancom,** Illustrator

El Deber
Santa Cruz, Bolivia (C)

Carlos Pérez-Díaz, Design Consultant Director; **Andrés Gilibert,** Design Consultant; **Montserrat Ortiz,** Design Consultant

Before

After

DN Lördag Söndag
Stockholm, Sweden (A)

Pompe Hedengren, Art Director; **Peter Alenäs,** Art Director; **Magnus Naddermier,** Art Director; **Torkel Rosmusson,** Editor; **Rolf Stohr,** Technical Support; **Martin Vårdstedt,** Features Editor

Before

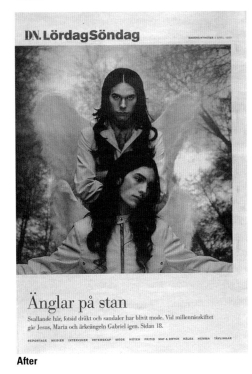

After

Before

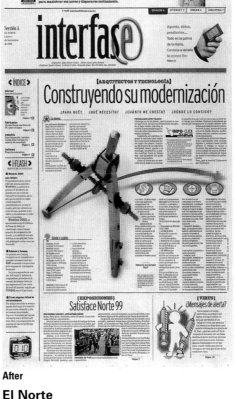

After

El Norte
Monterrey, México (B)

Ramón Alberto Garza, General Editor Director; **Cármen Escobedo,** Design Manager Editor; **Guillermo Reyes,** Design Editor; **Eduardo Danilo,** Section Editor; **Juan Carloss Zamora,** Section Editor; **Juan Antonio Gallont,** Editor Director; **Jorge Meléndez,** Editor Director

Star Tribune
Minneapolis, Minn. (A)

Tim Wheatley, Sports Section Coordinator; **Bill Dunn,** Visual Content Editor; **Anders Ramberg,** Design Director; **Glen Crevier,** Sports Editor; **Derek Simmons,** Sports Design Editor; **Mark Hvidsten,** Sports Designer

Before

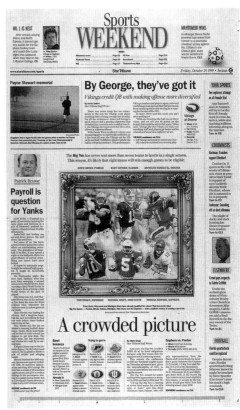

After

Star Tribune
Minneapolis, Minn. (A)

Susie Hooper, A.M.E. Graphics/Features; **Lee Svitak Dean**, Taste Editor; **Anders Ramberg**, Design Director; **Rhonda Prast**, Designer; **Randy Miranda**, Coordinator/Special Sections

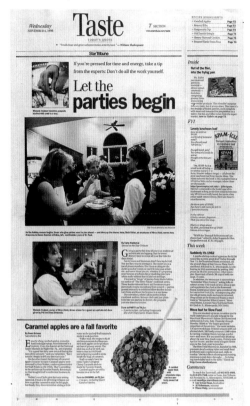

Before

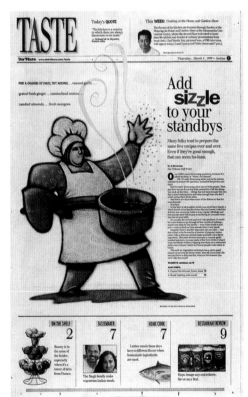

After

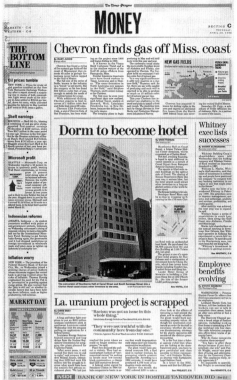

Before

After

The Times-Picayune
New Orleans, La. (A)

George Berke, Design Director; **Susan Ocampo Koenig**, News Design Editor; **Michael Kleinschrodt**, Systems Editor; **Dan Shea**, A.M.E.; **Robert Scott**, Money Editor; **Kim Quillen**, Assistant Money Editor; **Robert Landry**, Designer

The Tribune
San Luis Obispo, Calif. (C)

Joseph Kieta, Presentation Editor; **Greg Manifold**, Page Designer; **Eric Burdick**, Sports Editor; **Deborah Withey**, Design Consultant

Before

After

The Tribune
San Luis Obispo, Calif. (C)

Joseph Kieta, Presentation Editor; **Joe Tarica,** Senior Copy Editor; **Beth Anderson,** Page Designer; **Deborah Withey,** Design Consultant

Before

After

Before

After

The Washington Post
Washington, D.C. (A)

Kelly Doe, Art Director & Designer; **Michael Keegan,** Art Director

Detroit Free Press
Detroit, Mich. (A)

Deborah Withey, Design Consultant; **Bryan Erickson,** Deputy Design Director/Feature; **Steve Dorsey,** Design & Graphics Director; **Staff**

Before

After

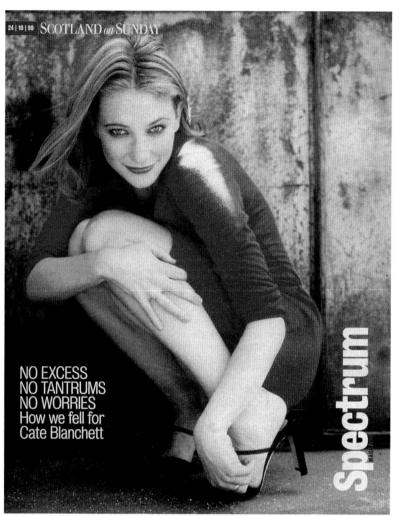

24 | 10 | 99 SCOTLAND on SUNDAY

NO EXCESS
NO TANTRUMS
NO WORRIES
How we fell for
Cate Blanchett

Spectrum

Silver
Scotland on Sunday
Edinburgh, Scotland (B)
Staff

This publication has a consistent, clean, sophisticated style that is carried throughout, issue after issue. It contains a well-conceived, solid style that brings surprises. The reader finds uniqueness with each spread through the good use of photographs and illustrations.

Esta publicación presenta un estilo claro y sofisticado, el cual se evidencia ejemplar tras ejemplar. Tiene un estilo muy bien concebido que nos ofrece sorpresas. Cada composición posee un carácter diferente, con un buen uso de fotografías e ilustraciones.

ALAN TAYLOR

Getting to the root canal of it

What's worse, eating less sugar or putting fluoride in our water? The choice is not yours

LIFE is logjammed with dilemmas, or maybe even dilemmi. Tea or coffee? Red or white or rosé? Carnivore or vegibore? My country right or wrong? To inhale or not? Happily most things come down to a matter of personal taste and are easily resolved in the privacy of one's own home. Some, however, are seized upon by our moral arbiters – wheel clampers, bartenders, meenisters and politicians, to name but the worst offenders – and we are made to fall in line or be slung out into the cold or locked up in the slammer. This, sadly, seems to be what is happening in the case of whether or not we should provide fluoride with our tap water.

Normally, I'm all for anything that's free, with the possible exceptions of bumph that falls out of the newspaper and the vinegar they put on your chips when your back's turned. Air, for instance, is all the more wonderful because it costs nothing. Were I to be charged for it, would I appreciate it quite so much? I doubt it. You won't catch me coughing up in one of those Californian oxygen bars. The old adage – that all the best things in life are free – still rings true, even if now we have to pay for them.

But before the pedants point out that, actually, the water we drink is not free, I confess I do know that. Who do they think I am? Chris Tarrant? There may be water, water everywhere with plenty of drops to drink but we're still paying for it through the nose. I dare say that if fluoride were to be added to it, we'd pay for that too, only we wouldn't notice it at first. But for the sake of argument, let's agree that water that doesn't come in a green bottle with a

squirt of fizz is free. The question then is, do we want it if it's got fluoride in it?

As in the best debates, the nub soon disappears in a welter of contrary and irrelevant information. The otherwise admirable Susan Deacon, health wallah at our peedie parliament, says that it is a tragedy that because there is no fluoride in the water, children arrive at primary school with missing teeth and fillings falling out.

Better that, though, says Dr Sheila Gibson of the Homeopathic Hospital in Glasgow, than an upsurge in still-born babies and infant mortality. Apparently, in Chile, where fluoride was put in the water, child deaths have risen dramatically.

Emotive stuff and near as damn it worthless. As is researching why teeth go bad, when everyone knows the answer is staring you in the mirror. Fluoride may stave off the inevitable but the longer we go on eating sugar-coated toast and drinking gallons of Irn Bru and other 'soft'

Today's dentists are pussycats and their surgeries more like cappuccino bars than the torture chambers of yore

drinks, the sooner we're all going to end up looking like Jimmy Johnstone or Shane McGowan. That's the real truth but not what people want to hear these days when cure is preferable to prevention. So if you are fat, you needn't stop eating; simply drop by your obliging local surgeon and he'll lop a lump off. Failing that, there are

always pills which will wend their way like Scud missiles through the alimentary canal and destroy your appetite.

I talk from experience, at least on the teeth front, though not with quite the same authority as Martin Amis who was pilloried for spending a fortune to save his teeth from the knacker's yard. Had I grown up today when dentists are pussycats and their surgeries look more like cappuccino bars than the torture chambers of yore, I suspect I would not be facing a gummy future. As it is, I am paying the price of adult neglect and childhood excess, not to mention the traumatic fallout of being dragged kicking and screaming to my neighbourhood dentist who, at his Gormenghast of a house, would give me of whiff of gas and send me sickeningly into oblivion.

Extraction was the name of his game which, alas, was terrible and irrevocable. Now I learn from the blessed Flann O'Brien that it need not have been so. Back in the olden days in Italy, he once recalled in a column in the Irish Times, there was a dentist who perfected a method of removing teeth, repairing them, and putting them back in again. For wealthy Florentines, it was the ultimate chic to be seen strolling around toothless for a day or so. On occasion, however, teeth would get mixed up in a tray and the wrong ones would find their way into the wrong mouths with desperate consequences. That said, it was probably better than being forced fluoride.

El Mundo Magazine
Madrid, Spain (A)

Rodrigo Sánchez, Art Director & Designer; **Javier Sanz**, Designer; **Carmelo Caderot**, Design Director

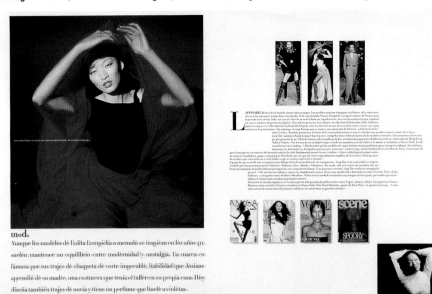

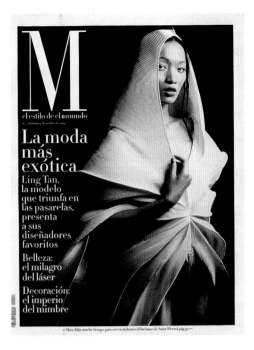

El Mundo Magazine
Madrid, Spain (A)

Carmelo Caderot, Design Director; **Rodrigo Sánchez**, Art Director & Designer; **Maria González**, Designer; **Amparo Redondo**, Designer

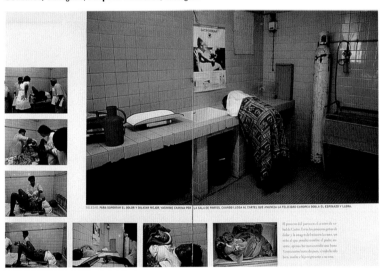

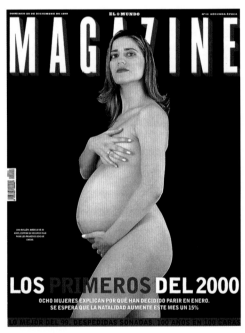

NRC Handelsblad
Rotterdam, The Netherlands (A)

Reynoud Homan, Art Director; **Claudia V. Rouendal**, Designer

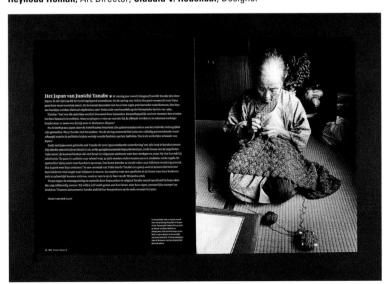

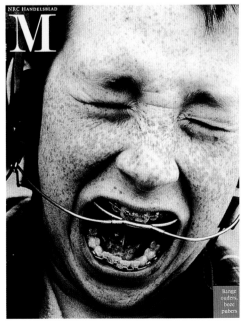

The Observer Magazine
London, England (A)
Staff

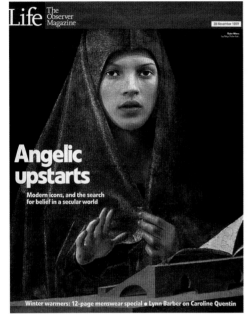

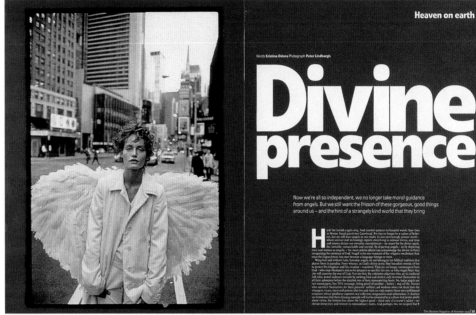

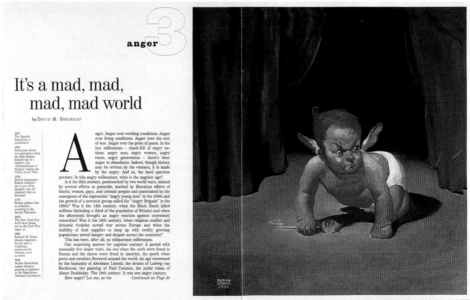

The Boston Globe
Boston, Mass. (A)

Lucy Bartholomay, Design Director; **Catherine Aldrich,** Art Director; **Jane Martin,** Art Director; **Lane Turner,** Photographer; **Ande Zellman,** Editor; **Thomas Lauder,** Assistant Art Director; **Dan Zedek,** Editorial Design Director
• also an **Award of Excellence** for Magazine Cover

El Mundo Metropoli
Madrid, Spain (A)

Carmelo Caderot, Design Director; **Rodrigo Sánchez,**
Art Director and Designer; **María González,** Designer;
Daniel Amade, Designer

Chicago Tribune
Chicago, Ill. (A)

David Syrek, Art Director; **Sandro** Photographer;
Elizabeth Taylor, Editor; **Nancy Watkins,** Associate
Editor

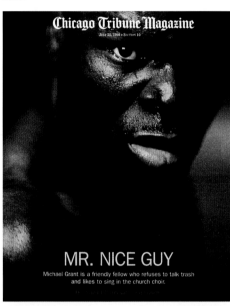

El Mundo Metropoli
Madrid, Spain (A)

Carmelo Caderot, Design Director; **Rodrigo Sánchez,**
Art Director and Designer; **María González,** Designer;
Daniel Amade, Designer

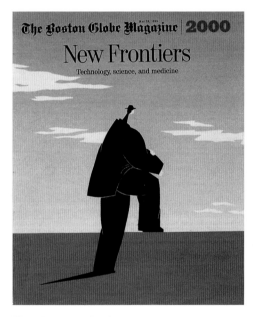

The Boston Globe
Boston, Mass. (A)

Lucy Bartholomay, Design Director; **Catherine Aldrich,**
Art Director; **Cindy Daniels,** Art Director; **Thomas
Lauder,** Assistant Art Director; **Craig Frazier,** Illustrator;
Ande Zellman, Editor; **Dan Zedek,** Editorial Design
Director

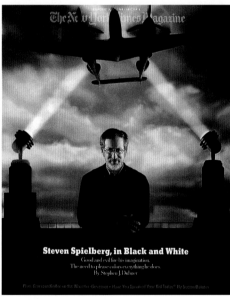

The New York Times Magazine
New York, N.Y. (A)

Janet Froelich, Art Director; **Nancy Harris,** Designer;
Kathy Ryan, Photo Editor; **Dan Winters,** Photographer

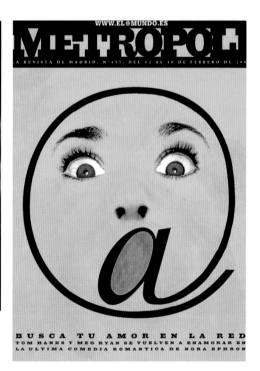

El Mundo Metropoli
Madrid, Spain (A)

Carmelo Caderot, Design Director; **Rodrigo Sánchez,**
Art Director and Designer; **María González,** Designer;
Daniel Amade, Designer; **José Belmonte,** Illustrator

The New York Times Magazine
New York, N.Y. (A)

Janet Froelich, Art Director; **Claude Martel,** Designer; **Kathy Ryan,** Photo Editor; **Andrew Eccles,** Photographer

The New York Times Magazine
New York, N.Y. (A)

Janet Froelich, Art Director; **Catherine Gilmore-Barnes,** Designer; **Kathy Ryan,** Photo Editor; **Christoph Niemann,** Illustrator

The New York Times Magazine
New York, N.Y. (A)

Janet Froelich, Art Director; **Claude Martel,** Designer; **Kathy Ryan,** Photo Editor; **Tom Schierlitz,** Photographer

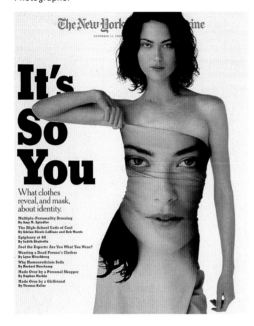

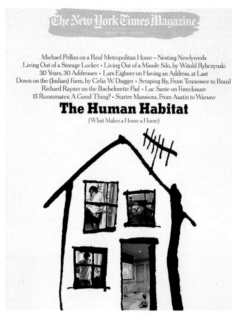

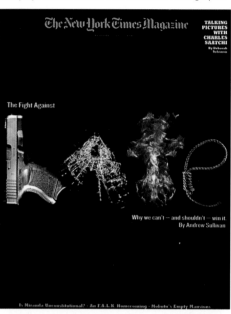

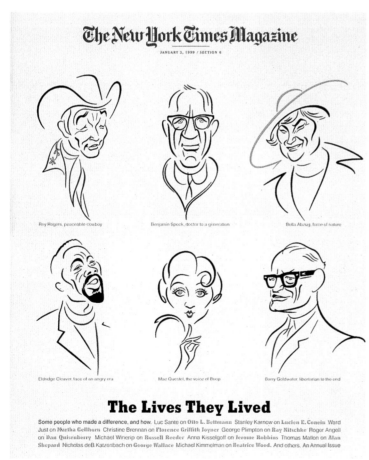

The New York Times Magazine
New York, N.Y. (A)

Janet Froelich, Art Director; **Nancy Harris,** Designer; **John Kascht,** Illustrator

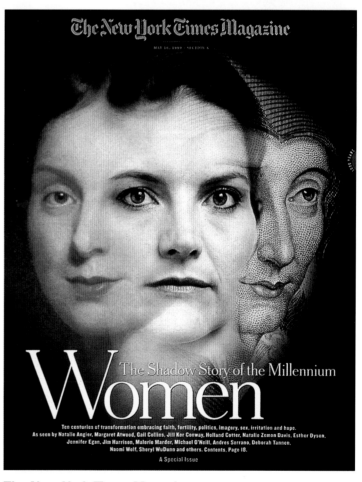

The New York Times Magazine
New York, N.Y. (A)

Janet Froelich, Art Director; **Joele Cuyler,** Project Art Director; **Kathy Ryan,** Photo Editor; **Ignacio Rodriguez,** Designer; **Sarah Harbutt,** Project Photo Editor

El Mundo/La Revista
Madrid, Spain (A)
Rodrigo Sánchez, Art Director & Designer; **Maria González,** Designer; **Amparo Redondo,** Designer; **Carmelo Caderot,** Design Director

El Mundo/La Revista
Madrid, Spain (A)
Rodrigo Sánchez, Art Director & Designer; **Maria González,** Designer; **Amparo Redondo,** Designer; **Carmelo Caderot,** Design Director

The Philadelphia Inquirer Magazine
Philadelphia, Pa. (A)
Chrissy Dunleavy, Art Director/Designer; **Susan Syrnick,** Assistant Art Director; **Ron Tarver,** Photographer

Clarín/VIVA
Buenos Aires, Argentina (A)
Iñaki Palacios, Art Director; **Gustavo Lo Valvo,** Art Director; **Sergio Juan,** Art Editor; **Adriana Di Pietro,** Graphic Designer

chapter three

NEWS

Army Times
Springfield, Va. (B)

Tobias Naegele, Executive Editor; **Christopher L. Lawson**, Editor; **Brian Mac Keil**, News Editor; **Lance H. Marburger**, Art Director & Designer; **Kate Patterson**, Photo Director

Bergensavisen
Bergen, Norway (C)

Dag Bjorndal, Desk Editor; **Dagrun Hauge**, Typographer

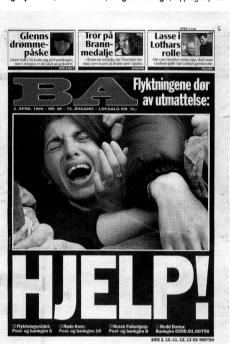

The Cincinnati Enquirer
Cincinnati, Ohio (A)
Staff

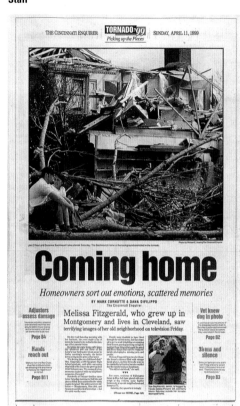

The Cincinnati Enquirer
Cincinnati, Ohio (A)

Ron Huff, Senior Designer; **Lisa Griffis**, Art Director; **Joe Powell**, Designer; **Beryl Love**, Designer

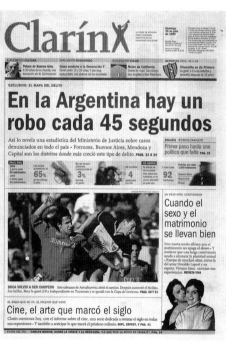

Clarín
Buenos Aires, Argentina (A)

Iñaki Palacios, Art Director; **Javier Vera Ocampo**, Design Editor; **Juan Elissetche**, Design Editor; **Federico Sosa**, Design Editor

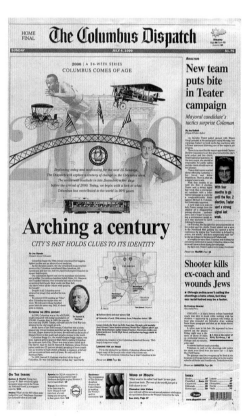

The Columbus Dispatch
Columbus, Ohio (A)

Todd Bayha, Editorial Artist

Correreio Braziliense
Brasilia, Brazil (B)

Ricardo Noblat, News Room Director; **Francisco Amaral,** Art Director & Executive Editor; **Cláudio Versiani,** Photo Editor; **Chico Régis,** Illustrator

Correio Braziliense
Brasilia, Brazil (B)

Ricardo Noblat, News Room Director; **Francisco Amaral,** Art Director & Executive Editor; **Cláudio Versiani,** Photo Editor; **Varilandes Jr.,** Page Designer

Correio Braziliense
Brasilia, Brazil (B)

Ricardo Noblat, News Room Editor; **Francisco Amaral,** Art Director & Executive Editor; **Ségio Amaral,** Photo Editor; **Cláudio Versiani,** Photo Editor; **Walter Firmo,** Photographer; **João Bosco Adelino,** Page Designer • also an **Award of Excellence** for Breaking News

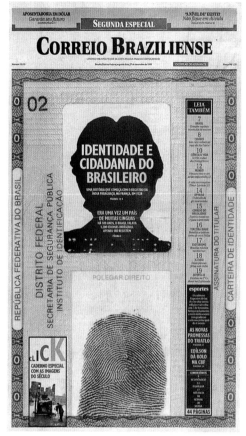

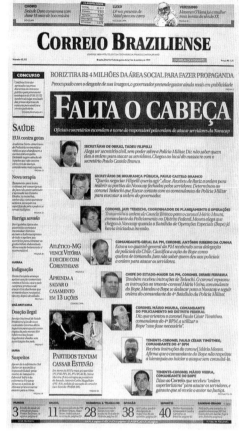

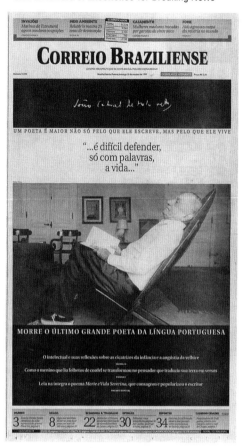

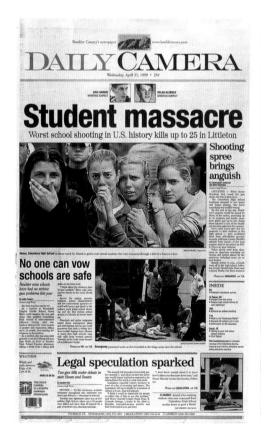

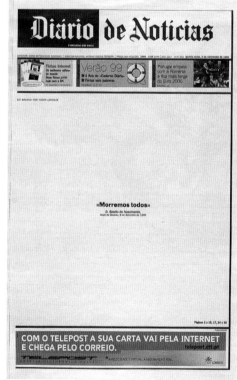

Daily Camera
Boulder, Colo. (C)

Joyce-Marie Andy, Designer; **Scott Luxor,** DME

Daily Times-Call
Longmont, Colo. (C)

Joe Hanel, News Editor

Diario de Noticias
Lisbon, Portugal (B)

Mário Bettencourt Resendes, Editor-in-Chief; **José Maria Ribeirinho,** Art Director & Designer; **António Ribeiro Ferreira,** Deputy Editor-in-Chief; **Carlos Jorge,** Designer

Detroit Free Press
Detroit, Mich. (A)

Ken McDonald, Designer; Steve Dorsey, Design & Graphics Director; Steve Anderson, Designer; Thom Fladung, News Editor
• also an Award of Excellence for Special News Topic

Diario de Sevilla
Sevilla, Spain (C)

Ferrán Grau, Art Director; Miguel Moreno, Section Coordinator; Juan Carlos Zambrano, Design Coordinator; Rafael Avilés, Designer; José María Ruiz, Designer; José Manuel Barranco, Designer; José Antonio Sánchez, Designer; Manuel González, Designer

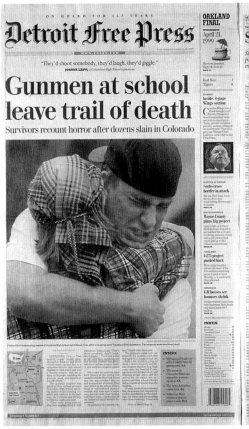

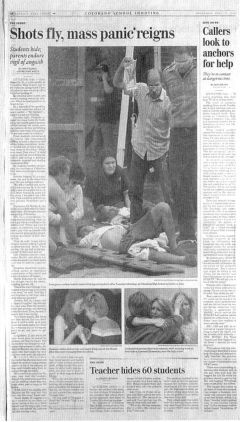

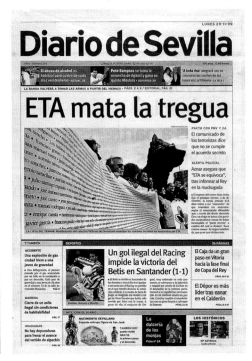

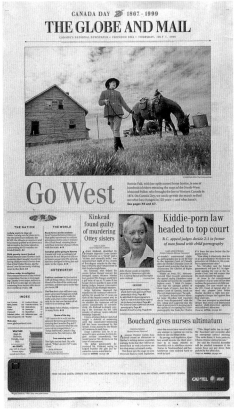

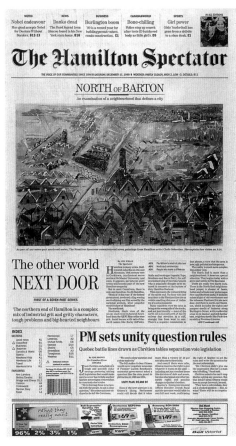

Folha de São Paulo
São Paulo, Brazil (A)

Fernanda Cirenza, Art Director; Eleonora de Lucena, M.E.; Moacir Lopes, Jr., Photographer; João Bittar, Photo Editor; Fernanda Godoy, Deputy Front Page Editor; Moacir de Almeida, Page Designer

The Globe and Mail
Toronto, Ont., Canada (A)

Carl Neustaedter, Deputy Art Director; Erin Elder, Photo Editor; Chris Procaylo, Photographer

The Hamilton Spectator
Hamilton, Ont., Canada (B)

Colleen Baxter, Art Director & Designer; Chelo Sebastian, Illustrator; Glenn Lowson, Photographer; Jim Poling, Editor

The Hartford Courant
Hartford, Conn. (A)

Ingrid Muller, Designer; **Stephanie Heisler,** Photo Editor; **Christian Potter Drury,** Art Director

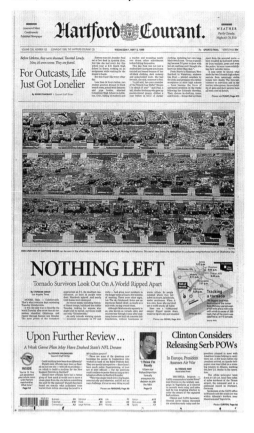

The Hartford Courant
Hartford, Conn. (A)

Ingrid Muller, Designer; **Stephanie Heisler,** Photo Editor; **Christian Potter Drury,** Art Director
• also an **Award of Excellence** for Breaking News

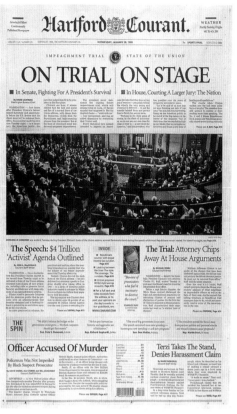

The Honolulu Advertiser
Honolulu, Hawaii (B)

David Montesino, A.M.E. Graphics/Design; **Stephen Downes,** Art Director; **Lorna Lim,** Presentation Editor; **John Bender,** Page Designer; **Cory Lum,** Photographer; **Ken Rickard,** Page Designer
• also an **Award of Excellence** for Breaking News

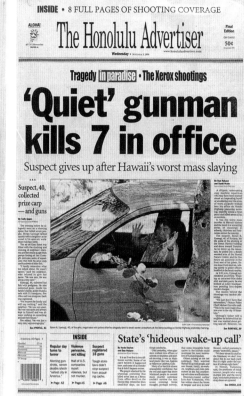

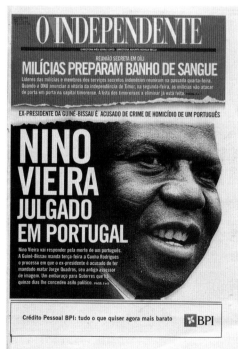

O Independente
Lisbon, Portugal (B)

Jorge Silva, Art Director & Designer; **João Francisco Vilhena,** Photo Editor

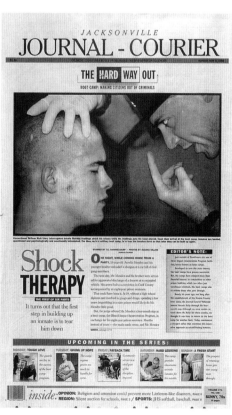

Jacksonville Journal-Courier
Jacksonville, Ill. (C)

Mike Miner, Editor/Designer

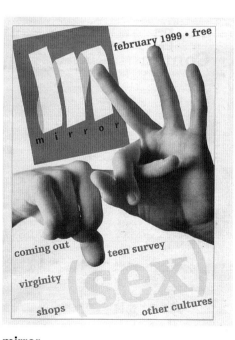

mirror
Seattle, Wash. (C)

Andy James, Art Director/Designer/Illustrator

Mural
Zapopan, México (C)

Renata González, Designer; **Gustavo Belmán,** Graphics Editor; **José Merino,** Graphics Editor; **Jorge Vidrio,** Art Director; **Eduardo Danilo,** Design Consultant

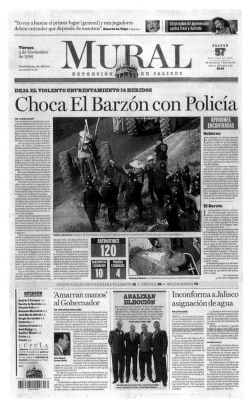

El Mundo Deportivo
Barcelona, Spain (B)

Pablo Martin, Art Director & Designer; **Joan Lanuza,** Designer; **Salvador Huertas,** Designer; **Xavier Roca,** Designer

El Mundo Deportivo
Barcelona, Spain (B)

Clara Figueras, Designer

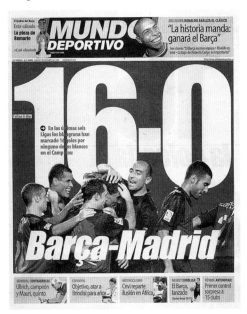

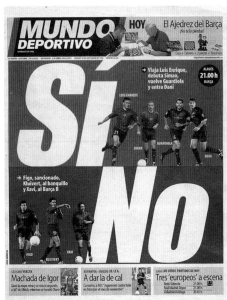

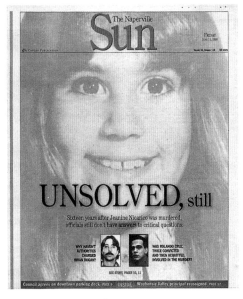

The Naperville Sun
Naperville, Ill. (C)

Robb Montgomery, Design Editor

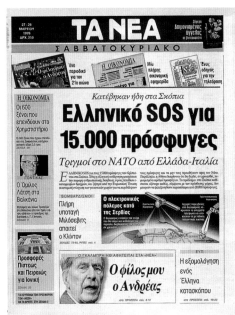

Ta Nea
Athens, Greece (B)

Dimitris Nikas, Art & Graphics Director

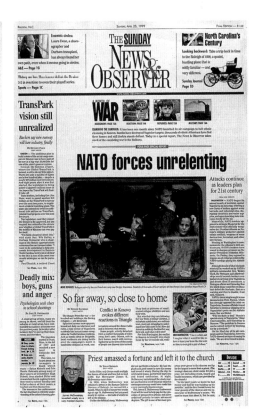

The News & Observer
Raleigh, N.C. (B)

J. Damon Cain, Director of News Design; **Kim Cable,** Copy Editor

El Norte
Monterrey, México (B)

Adrián Alvarez, Designer & Design Editor; **Juan Flores,** Photographer; **Eugenio Torres,** Editor; **Alexandro Medrano,** Design Manager/Editor; **Martín Pérez Cerda,** Editor Director; **Ramón Alberto Garza,** General Editor Director; **Eduardo Danilo,** Consultant Designer

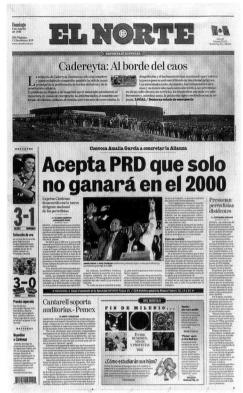

The Oregonian
Portland, Ore. (A)

Galen Barnett, Presentation Team Leader; **Michelle Wise,** Designer

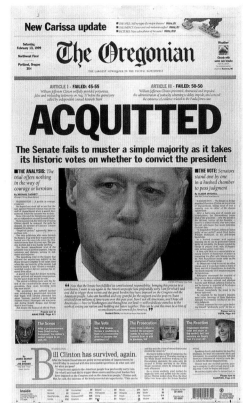

San Jose Mercury News
San Jose, Calif. (A)

Jami Smith, Mike Mayer, News Designers; **Bryan Monroe,** A.M.E. News, Visuals & Technology; **Scott Demuesy, Patty Yablonski,** Photo Editors; **Geri Migielicz,** Photo Director; **Susan Steade,** News Designer
• also an **Award of Excellence** for Breaking News & Special News Topics

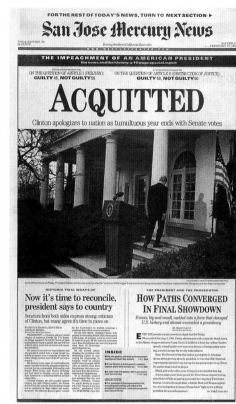

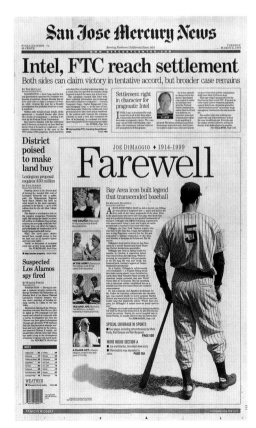

San Jose Mercury News
San Jose, Calif. (A)

Mike Mayer, News Designer; **Annette Vázquez,** News Designer; **Geri Migielicz,** Director/Photography; **Bryan Monroe,** A.M.E. News, Visuals & Technology; **Scott DeMuesy,** Photo Editor

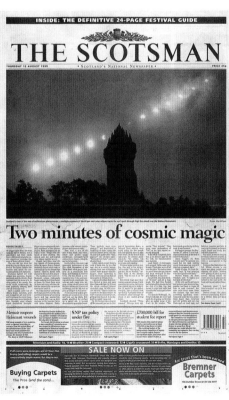

The Scotsman
Edinburgh, Scotland (B)

Staff

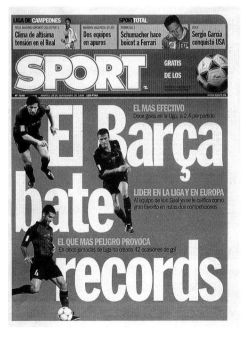

Sport
Barcelona, Spain (B)

Luciano Cukar, Art Director; **Miquel Herre,** Art Director; **Félix Alonso,** Art Director; **José Luis Merino,** Design Consultant; **Fernando Carballo,** Design Consultant; **Antoni Cases,** Project Manager

St. Petersburg Times
St. Petersburg, Fla. (A)

Jennifer Wright, News Designer; **Don Morris,** Art Director; **Sonya Doctorian,** A.M.E./Photography

Svenska Dagbladet
Stockholm, Sweden (A)

Jonas Askergren, Graphic Artist; **Richard Frank,** Graphic Artist; **Ann Dahl,** Researcher; **Kristofer Gustafsson,** Graphics Editor; **Annika Nilsson,** Researcher

The Toronto Star
Toronto, Ont., Canada (A)

Fred Kuntz, Saturday Star Editor; **Alan Marshall,** Page One Saturday Editor; **Staff**

El Universal
Caracas, Venezuela (B)

Vicente Correave, Photographer; **Staff**
• also an **Award of Excellence** for Spot News Photography & Breaking News

La Vanguardia
Barcelona, Spain (A)

Carlos Pérez de Rozas Arribas, Art Director; **Rosa Mundet Poch,** Editor-in-Chief/Design & Graphics; **Jose Alberola Garcia,** Designer; **Staff**

The Virginian-Pilot
Norfolk, Va. (A)

Julie Elman, Designer; **Paul Nelson,** News Editor; **Harry Brandt,** Designer; **Norm Shafer,** Picture Editor
• also an **Award of Excellence** for Special News Topics

The Boston Globe
Boston, Mass. (A)

Daigo Fujiwara, Infographic Designer; **Joe Sullivan**, Editor; **Ken Fratus**, Editor; **Dan Zedek**, Editorial Design Director

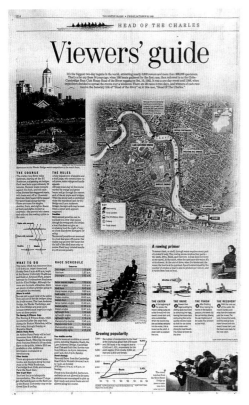

El Comercio
Lima, Perú (B)

Xavier Diaz de Cerio, Designer; **Claudia Burga Cisneros**, Art Editor; **Xavier Conesa**, Art Director & Designer

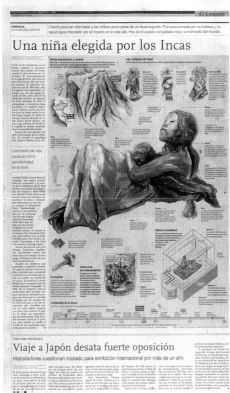

Correio Braziliense
Brasilia, Brazil (B)

Ricardo Noblat, News Director; **Francisco Amaral**, Art Director; **Carlos Silva**, Photo EditoR & Photographer; **André Rodrigues**, Art Editor; **Joelson Miranda**, Graphic Artist; **João Bosco Adelino**, Page Design

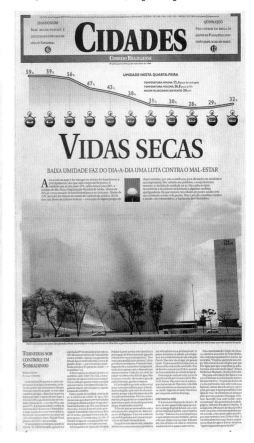

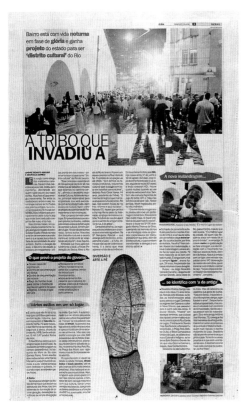

O Dia
Rio de Janeiro, Brazil (A)

André Renato Malvar, Designer; **André Hippertt**, Art Director; **Paulo Toscano**, Photographer; **Miriam Monteiro**, Photographer; **Carlos Mesquita**, Photographer; **Ricardo Lima**, Graphic Artist; **Ary Moraes**, Graphic Director; **Marcelo Ahmed**, News Editor

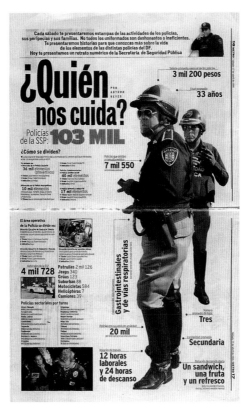

Metro
Mexico City, México (C)

Daniel Esqueda, Designer/Graphic Coordinator; **Gustavo A. Hernández**, Editor; **Emilio Deheza**, Art Director; **Eduardo Danilo**, Design Consultant

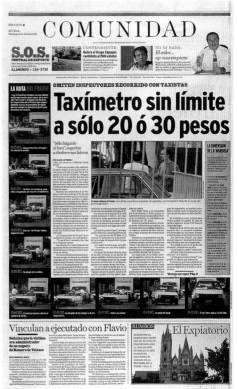

Mural
Zapopan, México (C)

Renata González, Designer; **Gustavo Belmán**, Graphics Editor; **José Merino**, Graphics Editor; **Jorge Vidrio**, Art Director; **Eduardo Danilo**, Design Consultant; **Héctor Moreno**, Editor

El Norte
Monterrey, México (B)

Erick Gallegos, Designer; **Carlos Arce,** Design Editor; **Cinthia Romero,** Illustrator; **Alexandro Medrano,** Design Manager/Editor; **Martín Pérez Cerda,** Editor Director; **Ramón Alberto Garza,** General Editor Director; **Eduardo Danilo,** Consultant Designer; **Fernando Zapata,** Photographer; **Norma Rodriguez,** Section Editor; **Ana Padua,** Photo Artist

El Norte
Monterrey, México (B)

Hugo Malacara, Designer; **Carlos Arce,** Design Editor; **Guillermo Castillo,** Illustrator; **Alexandro Medrano,** Design Manager/Editor; **Humberto Castro,** Section Editor; **Ramón Alberto Garza,** General Editor Director; **Eduardo Danilo,** Consultant Designer; **Martin Perez Cerda,** Editor Director; **Juan Flores,** Photographer

El Norte
Monterrey, México (B)

Erick Gallegos, Designer; **Carlos Arce,** Design Editor; **Cinthia Romero,** Illustrator; **Alexandro Medrano,** Design Manager/Editor; **Norma Rodriguez,** Section Editor; **Ramón Alberto Garza,** General Editor Director; **Eduardo Danilo,** Consultant Designer; **Martin Perez Cerda,** Editor Director; **Fernando Zapata,** Photographer; **Isaac deCoss,** Illustrator

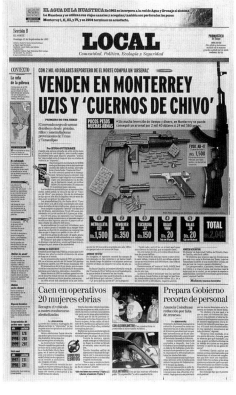

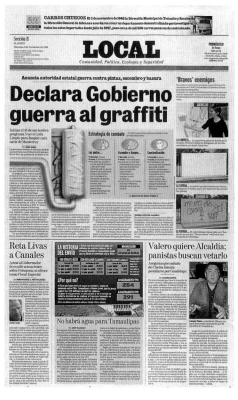

El Norte
Monterrey, México (B)

Erick Gallegos, Designer; **Carlos Arce,** Design Editor; **Eddie Macías,** Illustrator; **Cinthia Romero,** Illustrator; **Omar Valdez,** Photographer; **Sergio Muñiz,** Photographer; **Humberto Castro,** Section Editor; **Alexandro Medrano,** Design Manager Editor; **Martín Pérez Cerda,** Editor Director; **Ramón Alberto Garza,** General Editor Director

El Norte
Monterrey, México (B)

Jorge Obregon, Designer; **Carlos Arce,** Design Editor & Designer; **Lorenzo Encinas,** Photographer; **Alexandro Medrano,** Design Manager/Editor; **Humberto Castro,** Section Editor; **Ramón Alberto Garza,** General Editor Director; **Eduardo Danilo,** Consultant Designer; **Martin Perez Cerda,** Editor Director

El Norte
Monterrey, México (B)

Alexandro Medrano, Designer & Design M.E.; **Carlos Arce,** Design Editor & Designer; **César dePauli,** Photographer; **Ramón Alberto Garza,** General Editor Director; **Humberto Castro,** Section Editor; **Martin Pérez Cerda,** Editor Director; **Eduardo Danilo,** Consultant Designer; **Karla Garcia,** Photo Artist

Reforma
Mexico City, México (B)

Oscar Yañez, Designer; **Carlos Almazán**, Editor; **Ricardo del Castillo**, Graphics Editor; **Héctor Zamarrón**, Section Editor; **Emilio Deheza**, Art Director; **Eduardo Danilo**, Design Consultant; **Agustín Marquez**, Photographer; **Jose Luis Guzmán**, Photographer

Reforma
Mexico City, México (B)

Oscar Yañez, Section Designer; **Eduardo Danilo**, Design Consultant; **Juan Jesús Cortés**, Illustrator; **Carlos Escamilla**, Designer; **Ricardo del Castillo**, Graphics Editor; **Héctor Zamarrón**, Section Editor; **Jorge Andrés Gómez**, Editor; **Emilio Deheza**, Art Director

St. Petersburg Times
St. Petersburg, Fla. (A)

Lyra Solochek, News Designer; **Sue Morrow**, Design Director; **Mike Pease**, Photographer

St. Petersburg Times
St. Petersburg, Fla. (A)

Lyra Solochek, News Designer; **Don Morris**, Art Director

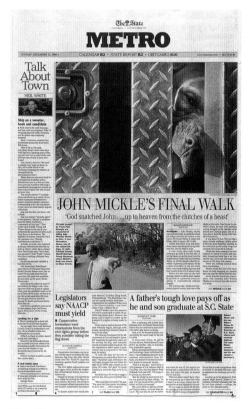

The State
Columbia, S.C. (B)

Janet Kahler, Page Designer

El Tiempo
Santa Fe De Bogota, Colombia (A)

Beiman Pinilla, Graphics Editor; **Sandra Rojas**, Designer; **Carlos Morales**, Infographics Editor

El Tiempo
Santa Fe De Bogota, Colombia (B)

Beiman Pinilla, Graphics Editor; **Sandra Rojas,** Designer; **Carlos Morales,** Infographic Editor

The Toronto Star
Toronto, Ont., Canada (A)

Catherine Pike, Designer; **Chris Van Es,** Illustrator; **Neil Ballantyne,** Deputy City Editor; **Jonathan Ferguson,** City Editor

Die Welt
Berlin, Germany (A)

Peter Dausend, Editor; **Patricia Plathe,** Designer; **Berndt Skott,** Illustrator

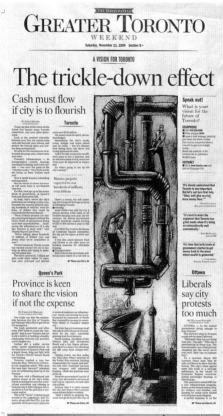

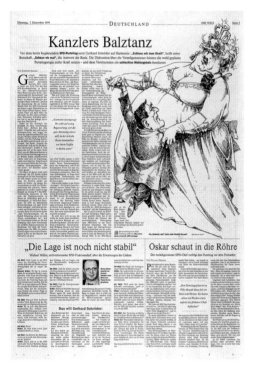

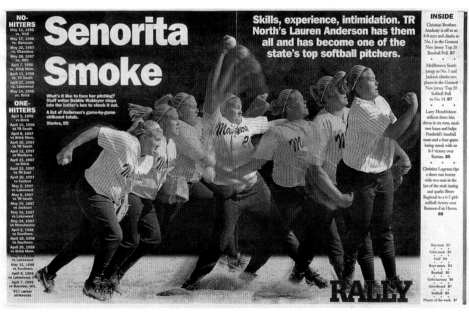

Asbury Park Press
Neptune, N.J. (B)

Andrew Prendimano, Art and Photo Director; **Harris Siegel,** M.E./Design & Photography; **Jennifer Lieving,** Designer/Illustrator; **Peter Ackerman,** Photographer; **Joe Zedalis,** Editor; **Karen Wall,** Editor; **Jeff Colson,** Visual Effects

Asbury Park Press
Neptune, N.J. (B)

Andrew Prendimano, Art and Photo Director; **Harris Siegel,** M.E./Design & Photo, Designer; **John Quinn,** M.E./Sports; **Gary Potosky,** Assistant Sports Editor

The Beacon-News
Aurora, Ill. (C)

David Spoehr, Designer/Illustrator; **Don Renfroe,** Design Director

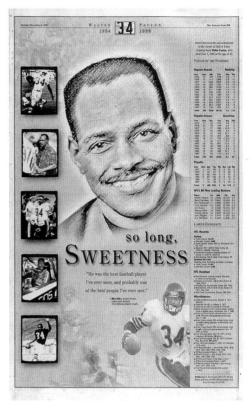

Silver
La Gaceta
San Miguel de Tucuman, Argentina (B)

Sebastian Rosso, Designer; **Sergio Fernandez,** Art Director; **Mario Garcia,** Design Consultant

This page captures the persona of Mike Tyson: bold, strong and with high impact. The in-your-face execution was perfect, right down to the gold tooth.

Esta página captura el carácter de Mike Tyson. Es fuerte, abrupta con un gran impacto. La presentación "en su cara" es perfecta, hasta en su diente de oro.

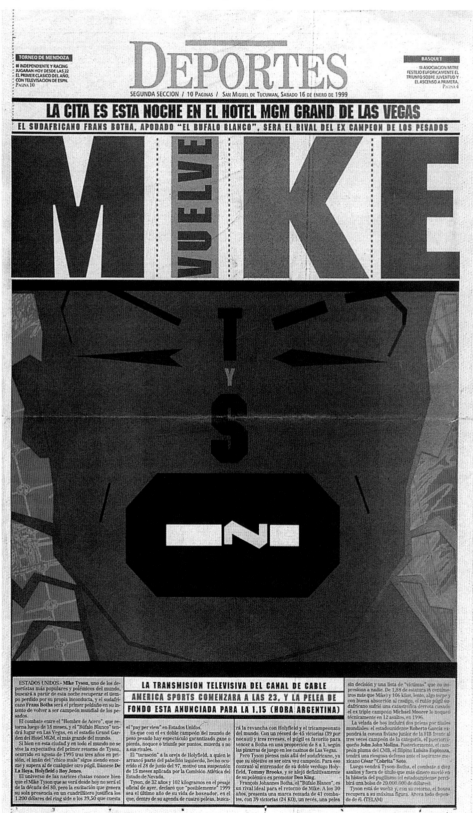

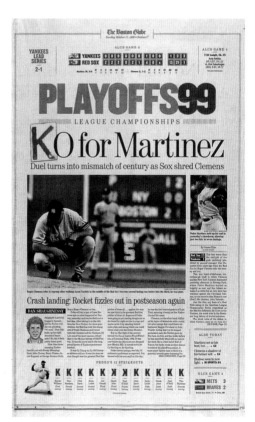

The Boston Globe
Boston, Mass. (A)

Jason McKean, Art Director & Designer; **Jim Davis,** Photographer; **Barry Chin,** Photographer; **Ken Fratus,** Assistant Sports Editor; **Dan Zedek,** Editorial Design Director

Silver
The Virginian-Pilot
Norfolk, Va. (A)
Courtney Murphy Price, Designer; **Chic Riebel**, Sports Editor; **Bill Kelly III**, Photo Editor; **Tom White**, Sports Editor

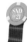

This page is easy to read, well organized and wonderful in its simplicity.

Esta página es fácil de leer, bien organizada y maravillosa en su simplicidad.

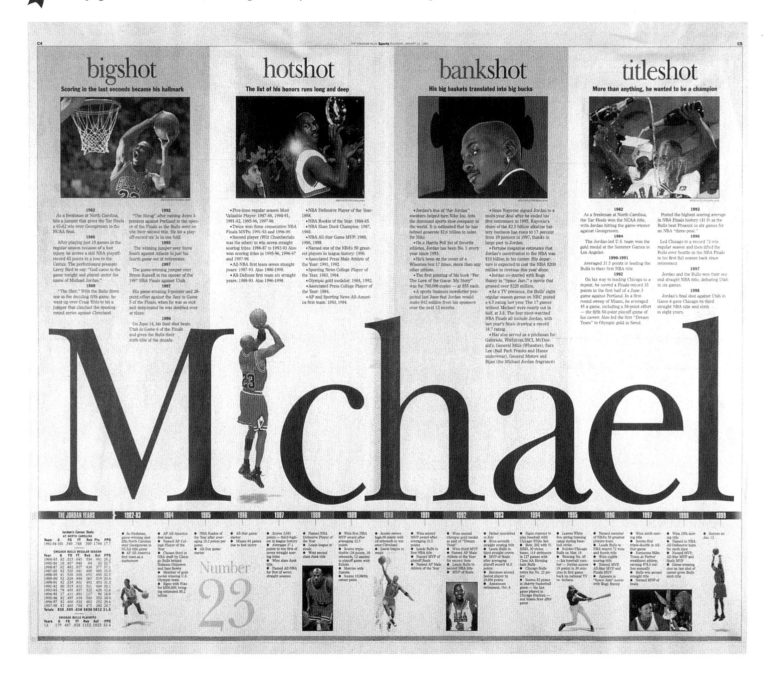

The Boston Globe
Boston, Mass. (A)

Joe Sullivan, Senior Assistant Sports Editor; Janet L. Michaud, Art director/Designer; Chuck Pyle, Illustrator; Ken Fratus, Assistant Sports Editor; Don Skwar, Sports Editor; Dan Zedek, Editorial Design Director

Clarín
Buenos Aires, Argentina (A)

Iñaki Palacios, Art Director; Federico Sosa, Design Editor; Juan Elissetche, Design Editor

Clarín
Buenos Aires, Argentina (A)

Iñaki Palacios, Art Director; Pablo Salomone, Designer; Juan Elissetche, Design Editor; Federico Sosa, Design Editor

Detroit Free Press
Detroit, Mich. (A)

Brian James, Designer; Rick Nease, Art Director/Illustrations; Gene Myers, Sports Editor

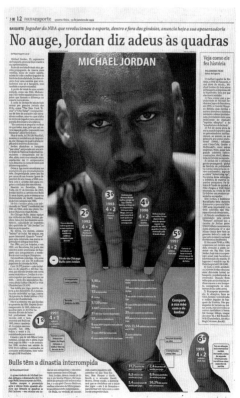

Folha de São Paulo
São Paulo, Brazil (A)

Fernanda Cirenza, Art Director; Adilson Secco, Infographic; Melchiades Filho, Sports Editor

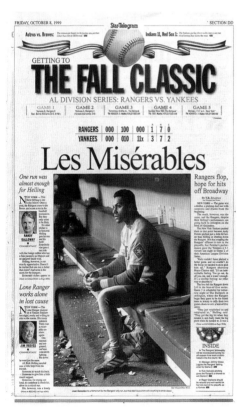

Fort Worth Star-Telegram
Fort Worth, Texas (A)

Cody Bailey, Assistant Sports Editor

La Gaceta
San Miguel de Tucuman, Argentina (B)
Sebastian Rosso, Designer; **Sergio Fernandez,** Art Director; **Mario Garcia,** Design Consultant

La Gaceta
San Miguel de Tucuman, Argentina (B)
Sebastian Rosso, Designer; **Sergio Fernandez,** Art Director; **Mario Garcia,** Design Consultant; **Guillermo Monti,** Editor

La Gaceta
San Miguel de Tucuman, Argentina (B)
Sebastian Rosso, Designer; **Sergio Fernandez,** Art Director; **Mario Garcia,** Design Consultant; **Guillermo Monti,** Editor

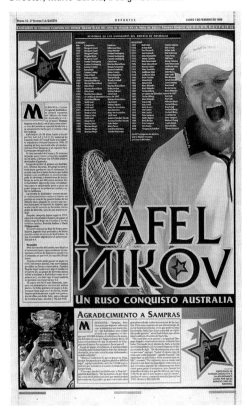

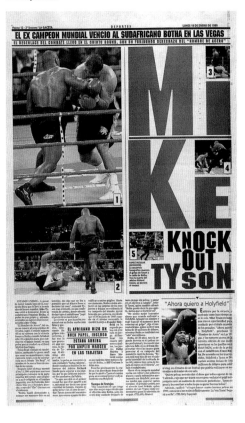

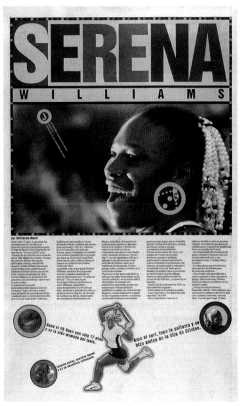

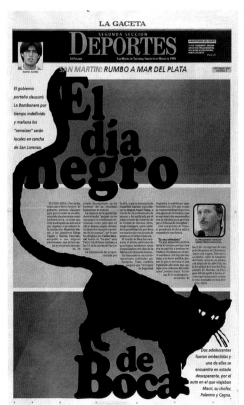

La Gaceta
San Miguel de Tucuman, Argentina (B)
Ruben Falci, Designer; **Sergio Fernandez,** Art Director; **Mario Garcia,** Design Consultant

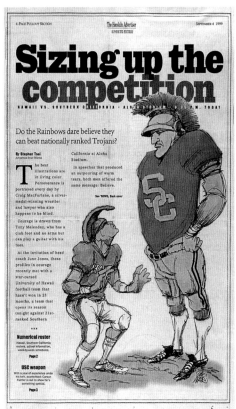

The Honolulu Advertiser
Honolulu, Hawaii (B)
David Montesino, A.M.E. Graphics/Design; **Stephen Downes,** Art Director; **Lorna Lim,** Presentation Editor; **Dick Adair,** Illustrator

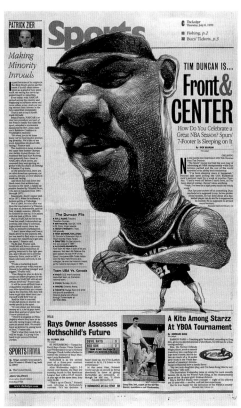

The Ledger
Lakeland, Fla. (B)
Steve Antley, Design Editor

Marca
Madrid, Spain (A)

José Juan Gámez, Graphics Editor; **Pablo Maria Ramirez**, Graphic Artist

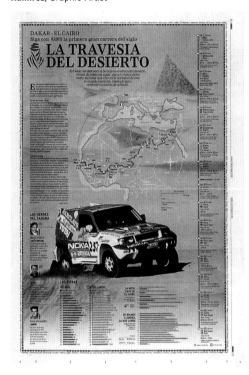

The New York Times
New York, N.Y. (A)

Wayne Kamidoi, Designer; **G. Paul Burnett**, Photographer; **Joe Zeff**, Illustrator
• also an **Award of Excellence** for News Portfolio

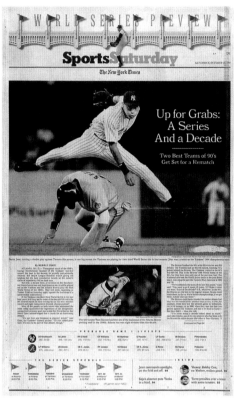

El Norte
Monterrey, México (B)

Rodolfo Jiménez, Graphic Designer; **José Grajeda**, Design Editor; **Ricardo Garza**, Section Editor; **Alexandro Medrano**, Design Manager/Editor; **Martín Pérez Cerda**, Editor Director; **Ramón Alberto Garza**, General Editor Director; **Eduardo Danilo**, Consultant Designer

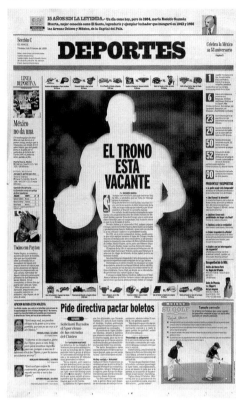

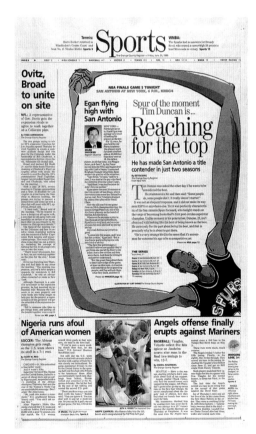

The Orange County Register
Santa Ana, Calif. (A)

Kurt Snibbe, Artist; **Kris Viesselman**, Art Director; **Scott Albert**, Designer

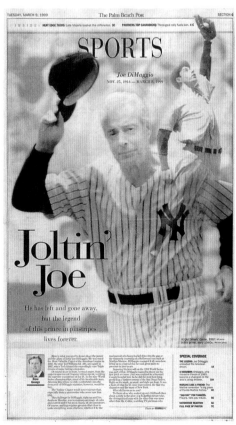

The Palm Beach Post
West Palm Beach, Fla. (A)

Sarah Franquet, Designer; **Tim Burke**, Executive Sports Editor

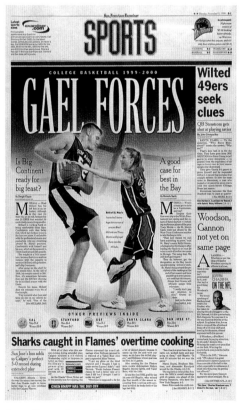

San Francisco Examiner
San Francisco, Calif. (B)

Matt Petty, Designer; **Nan Bisher**, Art Director; **Kurt Rogers**, Photographer; **Glen Schwarz**, Sports Editor

El Sol
Monterrey, México (C)

Andrés Viveros, Section Designer; **Guillermo Castillo,**
Illustrator; **Eliseo López,** Design Editor; **Adrián Navarro,**
M.E.; **Gil Jesús Chávez,** Editor Director; **Alexandro
Medrano,** Design Managing Editor; **Ramón Alberto
Garza,** General Editor Director

Savannah Morning News
Savannah, Ga. (B)

Stephen D. Komives, Sports / Features planning editor

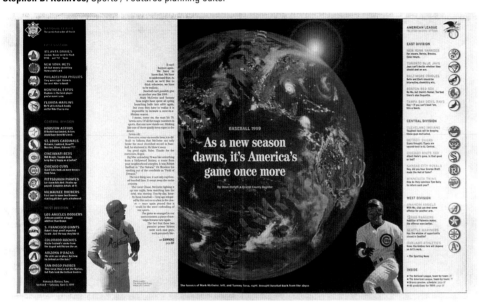

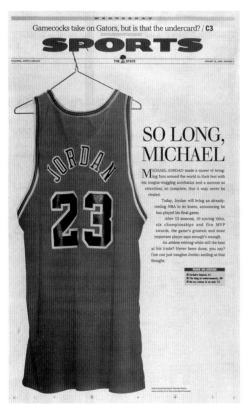

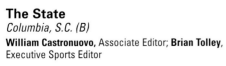

The State
Columbia, S.C. (B)

William Castronuovo, Associate Editor; **Brian Tolley,**
Executive Sports Editor

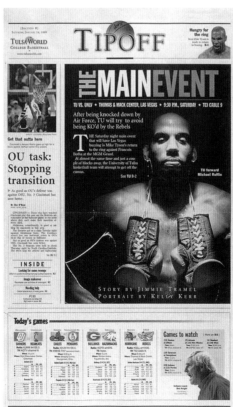

Tulsa World
Tulsa, Okla. (B)

Phill Spiker, Sports Designer; **Kelly Kerr,** Photographer;
Burl Spencer, Assistant Sports Editor

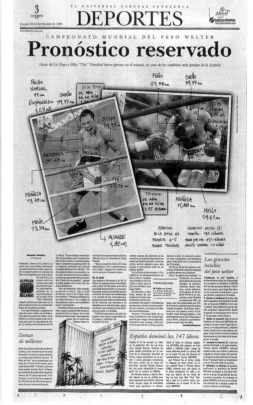

El Universal
Caracas, Venezuela (B)

Felipe Saldivia, Art Director

The Boston Globe
Boston, Mass. (A)

Anthony Schultz, Designer & Illustrator; **Dan Zedek,**
Editorial Design Director

The Charlotte Observer
Charlotte, N.C. (A)

Danielle Parks, Designer; **George Breisacher,** Staff Artist; **David Coburn,** Business Editor; **Elizabeth Gelgud,** Copy
Editor

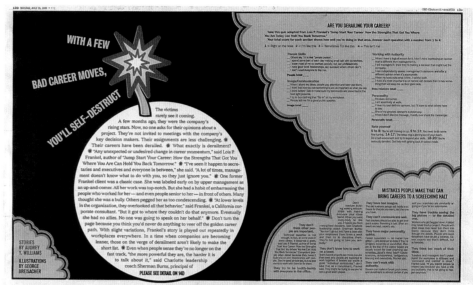

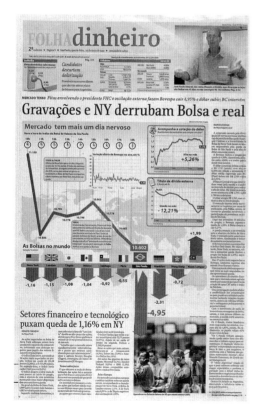

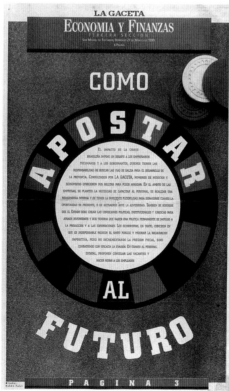

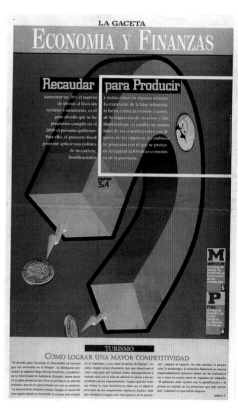

Folha de São Paulo
São Paulo, Brazil (A)

Fabio Marra, Art Editor; **Neivaldo José Geraldo,**
Business Assistant Editor; **Alex Argozino,** Infographic

La Gaceta
San Miguel de Tucuman, Argentina (B)

Ruben Falci, Designer; **Sergio Fernandez,** Art Director;
Mario Garcia, Design Consultant

La Gaceta
San Miguel de Tucuman, Argentina (B)

Sebastian Rosso, Designer; **Sergio Fernandez,** Art
Director; **Mario Garcia,** Design Consultant; **Daniel
Fontanarrosa,** Photo Illustrator

La Gaceta
San Miguel de Tucuman, Argentina (B)

Andrés Tula Molina, Designer; **Sergio Fernandez,** Art Director; **Mario Garcia,** Design Consultant

O Independente
Lisbon, Portugal (B)

Andre Carrilho, Illustrator; **Jorge Silva,** Art Director; **Sonia Matos,** Designer

Ta Nea
Athens, Greece (B)

Dimitris Nikas, Art & Graphics Director; **Staff**

The Orange County Register
Santa Ana, Calif. (A)

Bonita Clark, Designer; **Kris Viesselman,** Art Director; **Amy Ning,** Artist

The News & Observer
Raleigh, N.C. (B)

Adelaide Nash, Lead Business Designer; **Mary Cornatzer,** Section Editor; **Jim Bounds,** Photographer

The Orange County Register
Santa Ana, Calif. (A)

Galie Jean-Louis, Designer/Art Director; **Kris Viesselman**, Art Director; **Sharon Henry**, Artist

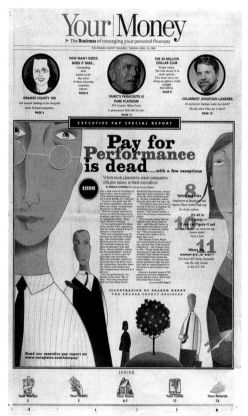

Reforma
Mexico City, México (B)

Daniel Barbosa, Designer; **Alejandro Páez**, Editor; **Marco Sotomayor**, Photographer; **Ricardo Peña**, Section Designer; **Emilio Deheza**, Art Director; **Eduardo Danilo**, Design Consultant; **Ernesto Carrillo**, Graphics Editor

Reforma
Mexico City, México (B)

Gabriel Ortíz, Designer; **Alejandro Páez**, Editor; **Julio López**, Illustrator; **Ricardo Peña**, Section Designer; **Emilio Deheza**, Art Director; **Eduardo Danilo**, Design Consultant; **Ernesto Carrillo**, Graphics Editor; **José Carlos Martínez**, Editor

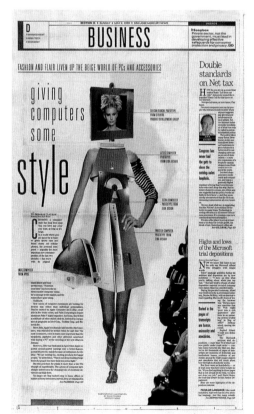

San Jose Mercury News
San Jose, Calif. (A)

David Frazier, Designer/Illustrator

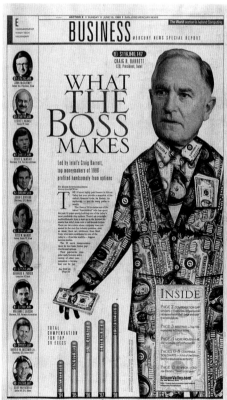

San Jose Mercury News
San Jose, Calif. (A)

David Frazier, Designer/Illustrator

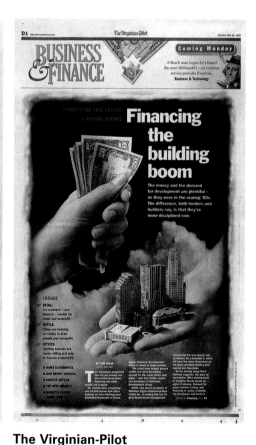

The Virginian-Pilot
Norfolk, Va. (A)

Terry Chapman, Projects Designer; **John Corbitt**, Illustrator

The Wall Street Journal
New York, N.Y. (A)

Liz Shura, Art Director; **Elizabeth Brandt,** Illustrator; **Joe Dizney,** Design Director

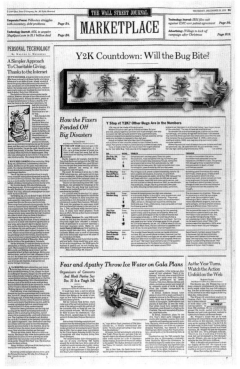

Clarín
Buenos Aires, Argentina (A)

Iñaki Palacios, Art Director; **Tea Alberti,** Design Editor; **Oscar Bejarano,** Graphic Designer; **Valeria Castresana,** Graphic Designer; **Silvina Fuda,** Graphic Designer; **Maria Heinberg,** Graphic Designer; **Omar Olivella,** Graphic Designer; **Matilde Oliveros,** Graphic Designer; **Pablo Ruiz,** Graphic Designer; **Carolina Wainsztok,** Graphic Designer

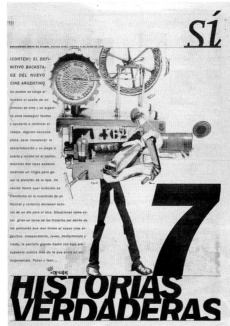

The Denver Post
Denver, Colo. (A)

Linda Shapley, News Designer; **Blair Hamill,** Graphics Editor

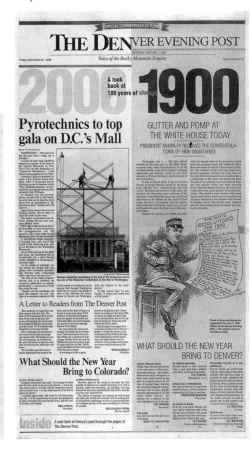

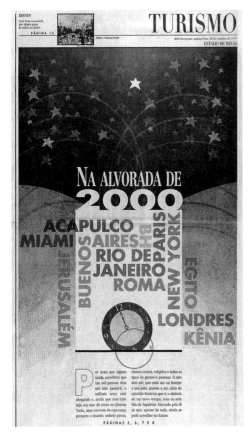

Estado de Minas
Belo Horizonte, Brazil (B)

Álvaro Duarte, Graphics Editor/Artist; **Rogério Carnevali,** Design Editor; **Alexandre Coelho,** Illustrator; **Glauro Menezes,** Designer; **Carlos Felipe,** Assistant Editor; **Wilson Frade,** News Editor

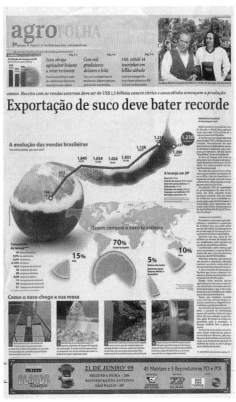

Folha de São Paulo
São Paulo, Brazil (A)

Fabio Marra, Art Editor; **Mario Kanno,** Infographic; **Elio Himori,** Infographic; **Bruno Blecher,** Supplement Editor

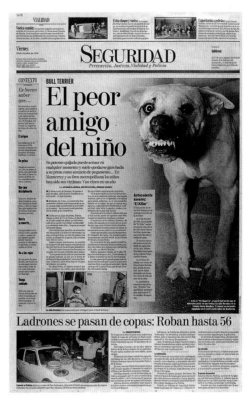

El Norte
Monterrey, México (B)

Rodolfo Santos, Designer; **Carlos Arce,** Design Editor/Designer; **Antonio Ordaz,** Photographer; **Alexandro Medrano,** Design Manager/Editor; **Carlos Estrada,** Photo Artist; **Ramón Alberto Garza,** General Editor Director; **Eduardo Danilo,** Consultant Designer; **Martin Pérez Cerda,** Editor Director; **Mario Rodriguez,** Section Editor

The Palm Beach Post
West Palm Beach, Fla. (A)

Sarah Franquet, Designer; **Richard Graulich,** Photographer

El Sol
Monterrey, México (C)

Alejandro Valdéz, Section Editor; **Arturo López,** Photographer; **Eliseo López Aguirre,** Design Editor; **Raúl Urdiales,** M.E.; **Gil Jesús Chávez,** Editor Director; **Alexandro Medrano,** Design Managing Editor; **Ramón Alberto Garza,** General Editor Director

Le Soleil
Quebec, P.Q., Canada (B)

André Bernard, Designer

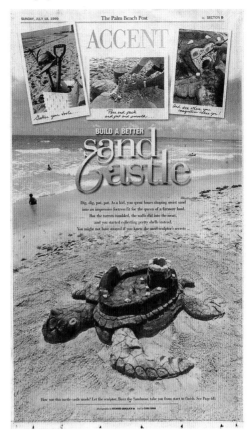

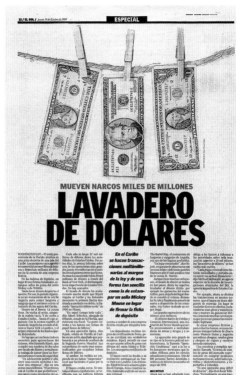

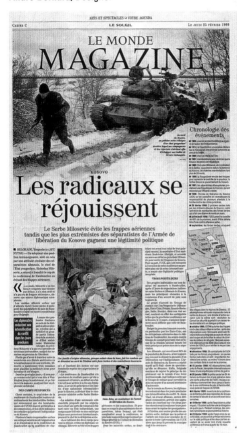

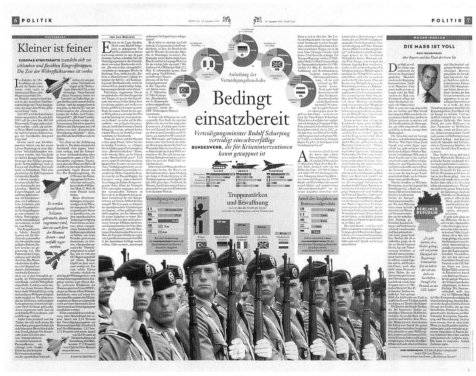

The Tampa Tribune
Tampa, Fla. (A)

Sherry Hutchinson, Designer; **Greg Williams,** Art Director for Design; **Pat Mitchell,** Senior Editor for Presentation; **Paul Glaviano,** Early Sunday Editor

Die Woche
Hamburg, Germany (B)

Manfred Bissinger, Editor-in-Chief; **Kurt Breme,** Executive Editor; **Hans-Ulrich Joerges,** Executive Editor; **Andreas Schomberg,** Art Director; **Armin Ogris,** Designer; **Stefan Semrau,** Designer; **Jessica Winter,** Designer; **Florian Poehl,** Infographic Designer; **Reinhard Schulz-Schaeffer,** Infographic Designer

Die Woche
Hamburg, Germany (B)

Manfred Bissinger, Editor-in-Chief; **Kurt Breme**, Executive Editor; **Hans-Ulrich Joerges**, Executive Editor; **Andreas Schomberg**, Art Director; **Armin Ogris**, Designer; **Stefan Semrau**, Designer; **Jessica Winter**, Designer; **Florian Poehl**, Designer/Informational Graphics; **Reinhard Schulz-Schaeffer**, Designer/Informational Graphics

a.m. De León
Léon, México (C)

Alejandro Belman, Designer; **Beatriz Zambrano**, Art Director

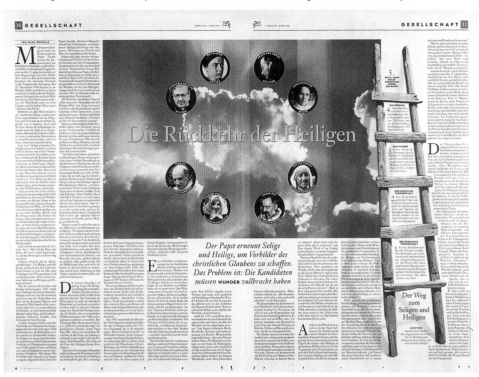

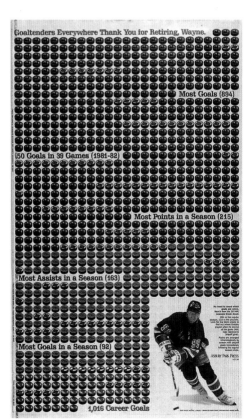

Asbury Park Press
Neptune, N.J. (B)

Andrew Prendimano, Art and Photo Director; **Harris Siegel**, M.E./Design & Photo, Designer; **John Quinn**, M.E./Sports

Asbury Park Press
Neptune, N.J. (B)

Andrew Prendimano, Art and Photo Director; **Harris Siegel**, M.E./Design & Photo, Designer; **John Quinn**, M.E./Sports; **Michael J. Treola**, Photographer; **Toni Misthos**, Illustrator; **Mark Voger**, Visual Effects

El Imparcial
Hermosillo, México (C)

José Arce, Designer/Illustrator; **Santos Guzmán,** Editor;
Sergio Serrano, Art Director

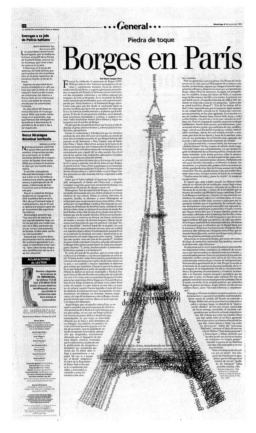

El Imparcial
Hermosillo, México (C)

Damián Martinez, Designer; **Santos Guzmán,** Editor;
Sergio Serrano, Art Director; **Chiara Bautista,** Illustrator

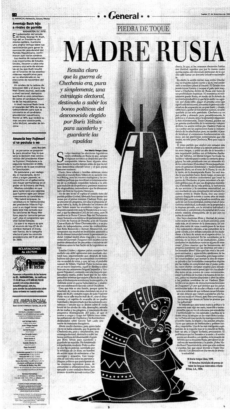

Mural
Zapopan, México (C)

Alexander Probst, Designer; **Gustavo Belmán,** Graphics
Editor; **José Merino,** Graphics Editor; **Jorge Vidrio,** Art
Director; **Eduardo Danilo,** Design Consultant; **Alfredo
Valle,** Illustrator; **Héctor Moreno,** Editor

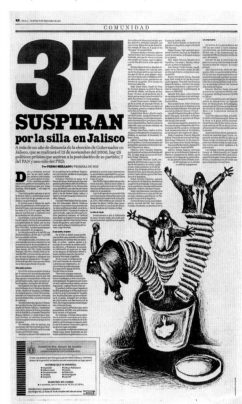

Mural
Zapopan, México (C)

Alexander Probst, Designer; **Gustavo Belmán,** Graphics
Editor; **José Merino,** Graphics Editor; **Jorge Vidrio,** Art
Director; **Eduardo Danilo,** Design Consultant; **Héctor
Moreno,** Editor

Mural
Zapopan, México (C)

Jose Juan González Morales, Designer; **Gustavo
Belmán,** Graphics Editor; **José Merino,** Graphics Editor;
Jorge Vidrio, Art Director; **Eduardo Danilo,** Design
Consultant; **Guillermo Navarro,** Infographics

El Norte
Monterrey, México (B)

Eduardo Danilo, Design Consultant; **Adrián Alvarez,**
Designer/Design Editor; **Irineo Morales,** Editor;
Alexandro Medrano, Design Manager Editón; **Martín
Pérez Cerda,** Editor Director; **Ramón Alberto Garza,**
General Editor Director; **Veronica Alvarez,** Designer

Reforma
Mexico City, México (B)

Alejo Nájera, Section Designer; **Ana Luisa Garcés,** Section Editor; **Ernesto Carrillo,** Graphics Editor; **Emilio Deheza,** Art Director; **Eduardo Danilo,** Design Consultant

Ta Nea
Athens, Greece (B)

Dimitris Nikas, Art and Graphics Director; **Vangelis Karakasis,** Graphic Designer; **Staff**

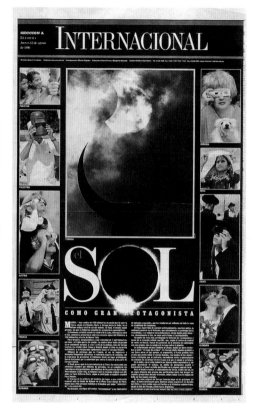

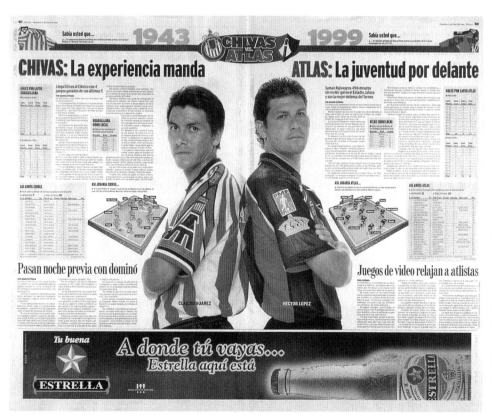

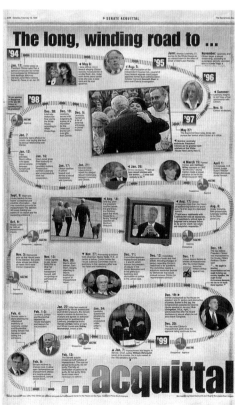

Mural
Zapopan, México (C)

Gabriel Parra, Designer; **Gustavo Belmán,** Graphics Editor; **José Merino,** Graphics Editor; **Jorge Vidrio,** Art Director; **Eduardo Danilo,** Design Consultant

The Sacramento Bee
Sacramento, Calif. (A)

Nam Nguyen, Assistant Art Director; **Robert Casey,** Weekend Editor; **Jack Vaughn,** Wire Editor; **Mark Morris,** Director/Photography; **Pam Dinsmore,** A.M.E. News; **Howard Shintaku,** Art Director; **Mort Saltzman,** A.M.E. Graphics; **Joyce Terhaar,** M.E.; **Rick Rodriguez,** Executive Editor

The News & Observer
Raleigh, N.C. (B)

J. Damon Cain, Director of News Design; **Teresa Kriegsman,** Assistant Director/News Design; **Grey Blackwell,** Graphics Editor; **Bonnie Jo Mount,** Director of Photography; **Eric Frederick,** Front Page Editor; **Melanie Sill,** Managing Editor

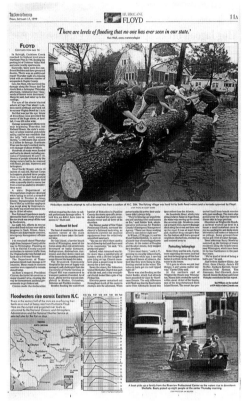

Taipei Times
Taipei, 104, Taiwan (C)

Alicia Beebe, Design Editor; **Anthony Lawrance,** M.E.; **Jessica Chang,** Designer; **June Hsu,** Designer; **Chengchang Chen,** Photographer; **Ying-ying Chiang,** Photographer; **George Tsorng,** Photographer; **Richard Mercier,** Copy Editor; **Andrew Perrin,** Copy Editor; **Erin Prelypchan,** Page Editor

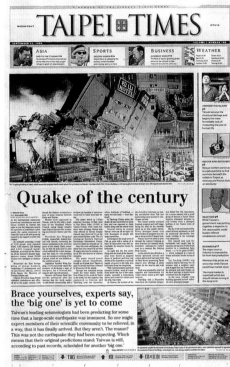

The Virginian-Pilot
Norfolk, Va. (A)

Paul Nelson, News editor; **Denis Finley,** DME Presentation; **Darren Smith,** Designer; **Julie Elman,** Designer; **Buddy Moore,** Designer; **Jim Haag,** Designer; **Alex Burrows,** Director/Photography; **Norm Shafer,** Photo Editor
• also an **Award of Excellence** for Front Page

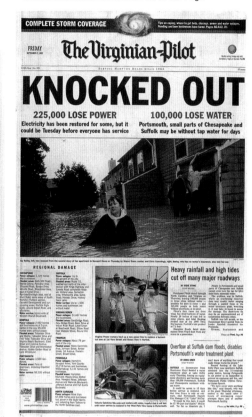

Power News
Taipei, Taiwan (C)

Luc Chen, Editor; **Jimmy Kao,** Editor; **Shu-pin Wang,** Designer

The Virginian-Pilot
Norfolk, Va. (A)

Stacy Addison, Designer; **Jim Haag,** Designer; **Paul Nelson,** News Editor; **Jim Collins,** Photo Editor

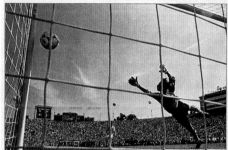

Austin American-Statesman
Austin, Texas (A)

Sandra Santos, Designer; **Alex Brown,** Designer

The Gazette
Colorado Springs, Colo. (B)
Staff

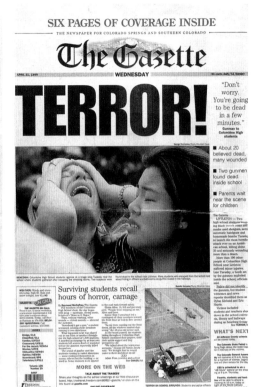

National Post
Don Mills, Ont., Canada (A)

Gayle Grin, Design Director/Designer; **John Racovali,** Foreign Editor; **Martin Newland,** Deputy Editor; **Kenneth Whyte,** Editor-in-Chief

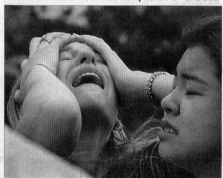

Reforma
Mexico City, México (B)

Victor Cruz, Designer; **Jaime Correa,** Section Designer; **Jorge Peñaloza,** Illustrator; **Homero Fernández,** Editor; **Emilio Deheza,** Art Director; **Eduardo Danilo,** Design Consultant; **Fermín Vázquez,** Editor

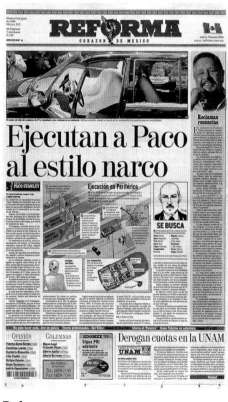

The Orange County Register
Santa Ana, Calif. (A)

Brenda Shoun, Design Editor/Visuals; **Kris Viesselman,** Art Director; **Neil Pinchin,** Designer; **Karen Kelso,** Designer; **Andrea Voight,** Designer; **Bill Cunningham,** Designer; **Mike Pilgrim,** Photo Editor

National Post
Don Mills, Ont., Canada (A)

Gayle Grin, Design Director; **John Racovali,** Foreign Editor; **Martin Newland,** Deputy Editor; **Kenneth Whyte,** Editor-in-Chief

San Jose Mercury News
San Jose, Calif. (A)

Annette Vázquez, Designer; **Herschel Kenner,** A.M.E. News/Nights; **Bryan Monroe,** A.M.E. News, Visuals & Technology; **Scott DeMuesy,** Photo Editor; **Patty Yablonski,** Photo Editor; **Staff**

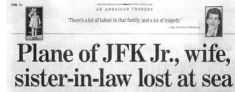
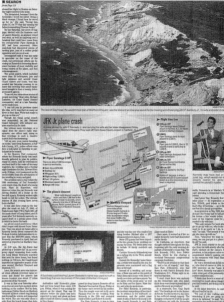

The Virginian-Pilot
Norfolk, Va. (A)

Paul Nelson, News editor; **Denis Finley,** DME Presentation; **Darren Smith,** Designer; **Terry Chapman,** Designer; **Buddy Moore,** Designer; **Eric Seidman,** Creative Director

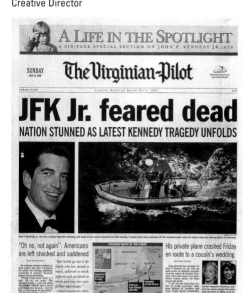

Silver
Democrat and Chronicle
Rochester, N.Y. (A)

Gary Piccirillo, Deputy Presentation Editor; **Dennis R. Floss,** A.M.E./Presentation; **Stan Wischnowski,** Deputy M.E.; **Henry Howard,** News Editor

Typography takes the lead in this clean, easy to read package. Headlines are well thought out with a balance of subheads playing against the labeling. This package pays a great deal of attention to detail, including the selection of the muted red for the color addition to an otherwise black and white solution.

La tipografía realmente toma la batuta en este paquete visual claro y fácil de leer. Presenta buenos titulares con un buen equilibrio en los subtitulares. Esta presentación presta mucha atención a los detalles, incluyendo la selección de un sutil color rojo como el único color adicional a lo que sólo pudiera haber sido una página en blanco y negro.

The Providence Journal
Providence, R.I. (B)

Anne Peters, Page Designer/Photo Editor; **Lynn Rognsvoog,** Page Designer/Photo Editor; **Bill Ostendorf,** M.E./Visuals

The Times-Picayune
New Orleans, La. (A)

George Berke, Design Director; **Doug Parker,** Photo Editor; **Laura Jayne,** News Editor; **Dan Shea,** M.E./News

The Virginian-Pilot
Norfolk, Va. (A)

Paul Nelson, Designer; **Denis Finley,** News Editor; **Jim Collins,** Photo Editor
• also an **Award of Excellence** for News Portfolio

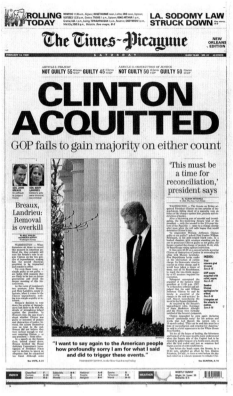

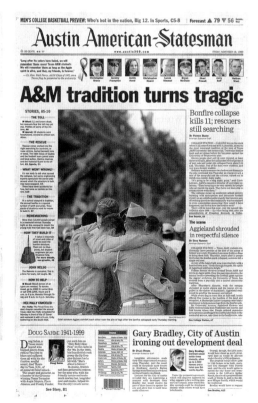

Clarín
Buenos Aires, Argentina (A)

Iñaki Palacios, Art Director; **Juan Elissetche,** Design Editor; **Federico Sosa,** Design Editor

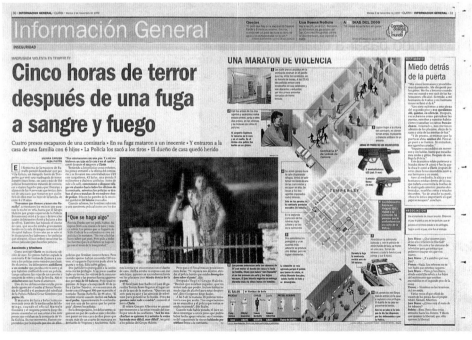

Austin American-Statesman
Austin, Texas (A)

Sandra Santos, Designer; **Robert Quigley,** Designer; **Roberto Villalpando,** Designer

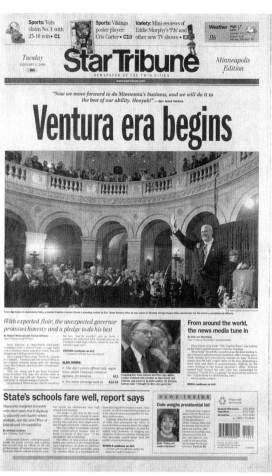

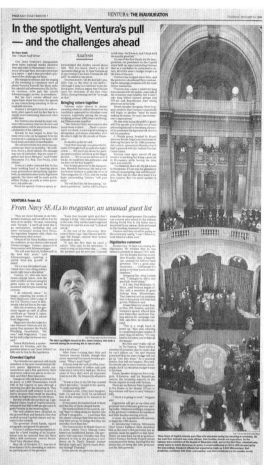

Silver
Star Tribune
Minneapolis, Minn. (A)

Bill Dunn, A.M.E. Visuals; **Hal Sanders**, A Section Layout Editor; **Anders Ramberg**, Design Director; **Terry Sauer**, A Section Coordinator; **Ray Grumney**, Graphic Director; **Steve Rice**, Photo Director

The body of work demonstrated is terrific. To do local news right, the entire staff has to be at the top of their game. In this case, photo, design and graphics combine for a complete, solid package. Robust, energetic, this is everything breaking news coverage and display should be.

El portafolio de trabajo es excelente. Para producir buenas noticias locales, el equipo completo del Star Tribune tiene que situarse en la cúspide. En este caso, foto, diseño e infografía se combinaron en un sólido y completo paquete visual. Robusto y energético, ésta es la manera cómo las noticias de último minuto deben presentarse.

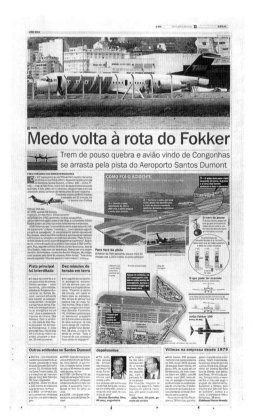

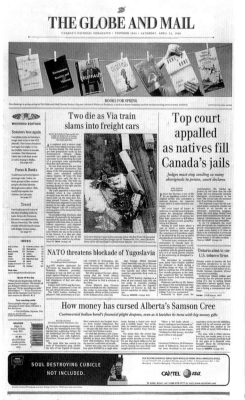

O Dia
Rio de Janeiro, Brazil (A)

Samuel De Andradé, Sidinei Nunes, Designers; **André Hippertt**, Art Director; **Eny Miranda**, Photographer; **Carlos Mesquita**, Photo Editor; **André Provedel, Ivan Luiz**, Graphic Artists; **Alexandre Freeland**, News Editor; **Ary Moraes**, Graphic Director; **Janey** Graphic Artist

The Globe and Mail
Toronto, Ont., Canada (A)

John Quinlan, Night Editor; **Carl Neustaedter**, Deputy Art Director; **Dean Tweed**, Graphic Artist

News-Leader
Springfield, Mo. (B)

John L. Dengler, Graphics Editor; **Todd Seifert**, News Editor; **Cheryl Whitsitt**, Assistant Managing Editor

This is a very solid, clean and informative graphic for breaking news. It's difficult to convey election previews in a way that grabs your attention like this one has accomplished. A sophisticated color palette, combined with typography that is both restrained and well handled, completes this effective package.

El diseño de El Clarín es muy claro y la información muy sólida, con gráficos para noticias de último minuto. Resulta complicado presentar resúmenes de elecciones de una manera que atraiga la atención del lector de la manera que esta publicación lo hace. Una paleta de color sofisticada y restringida mas bien ejecutada tipografía, completan esta efectiva presentación visual.

Silver

Clarín

Buenos Aires, Argentina (A)

Iñaki Palacios, Art Director; **Pablo Salomone,** Designer; **Juan Elissetche,** Design Editor; **Federico Sosa,** Design Editor; **Carlos Vazquez,** Designer; **Maureen Holboll,** Designer; **Victoria Quintiero,** Designer; **Soledad Calvo,** Designer; **Osvaldo Estevao,** Designer; **Francisco Jurado Emery,** Designer

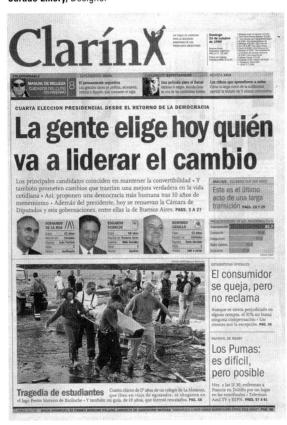

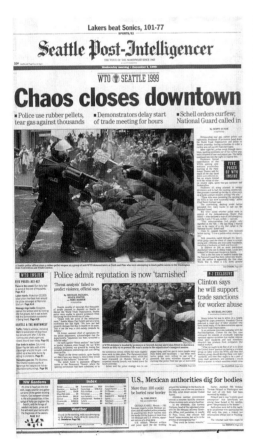

Seattle Post-Intelligencer
Seattle, Wash. (A)

Kurt Schlosser, Page Designer

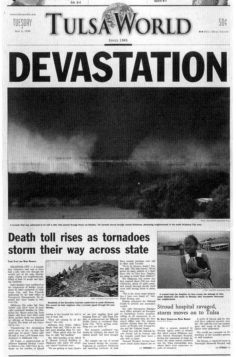

Tulsa World
Tulsa, Okla. (B)

Billy Berkenbile, Page Designer; **Daryl Wilson,** Assistant Chief Photographer; **Brandi Stafford,** Photographer

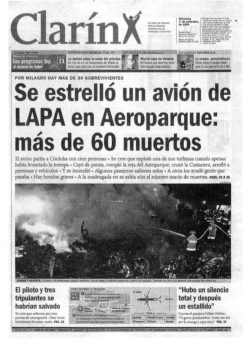

Clarín
Buenos Aires, Argentina (A)

Iñaki Palacios, Art Director; **Pablo Salomone,** Designer; **Juan Elissetche,** Design Editor; **Federico Sosa,** Design Editor; **Carlos Vazquez,** Designer; **Maureen Holboll,** Designer; **Victoria Quintiero,** Designer; **Soledad Calvo,** Designer; **Osvaldo Estevao,** Designer; **Francisco Jurado Emery,** Designer

Diario de Notícias
Lisbon, Portugal (B)

Mário Bettencourt Resendes, Editor-in-Chief; **José Maria Ribeirinho,** Art Director & Designer; **António Ribeiro Ferreira,** Deputy Editor-in-Chief; **Carlos Jorge,** Designer; **Eurico de Barros,** Editor; **Luís Tenreiro,** Designer; **Júlio Gonçalves,** Designer; **José Bandeira,** Artist

St. Louis Post-Dispatch
St. Louis, Mo. (A)

Wade Wilson, Designer

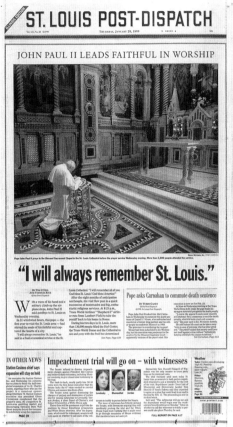

San Jose Mercury News
San Jose, Calif. (A)

Rick Nobles, News Designer; **Bryan Monroe,** A.M.E. News, Visuals & Technology; **Scott DeMuesy,** Photo Editor; **Pankaj Paul,** Assistant Graphics Editor

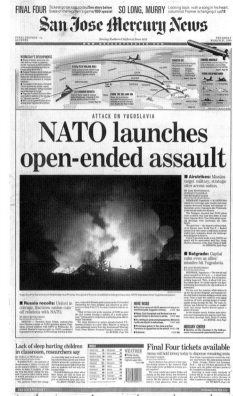

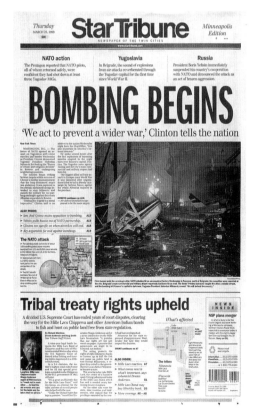

Star Tribune
Minneapolis, Minn. (A)

Greg Branson, A1 Designer/Assistant Graphics Director; **Hal Sanders,** Layout editor; **Anders Ramberg,** Design Director; **Terry Sauer,** A section coordinator; **Ray Grumney,** Graphic Director; **Steve Rice,** Photo Director; **Bill Dunn,** A.M.E. Visuals

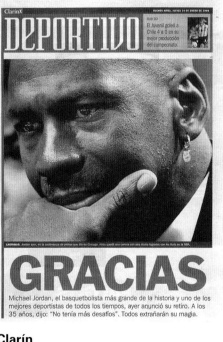

Clarín
Buenos Aires, Argentina (A)

Iñaki Palacios, Art Director; **Pablo Salomone,** Designer; **Juan Elissetche,** Design Editor; **Federico Sosa,** Design Editor; **Carlos Vazquez,** Designer; **Maureen Holboll,** Designer; **Victoria Quintiero,** Designer; **Soledad Calvo,** Designer

The New York Times
New York, N.Y. (A)

Wayne Kamidoi, Designer

Silver
St. Petersburg Times
St. Petersburg, Fla. (A)
Don Morris, Art Director; **Jim Melvin**, Sports Design Director; **Jack Sheppard**, A.M.E. Sports; **Mike Heffner**, Sports Photo Editor

Sports coverage has the advantage of being able to prepare for breaking news events, and this winner demonstrates that planning can make a difference. Judges feel special kudos should be given to the person who keyed in all 3,000 hits. Staff photos, combined with a striking typographic silhouette, gives the impression that you are able to actually touch the image. The overall design says, "baseball."

En deportes, uno tiene la ventaja de estar preparado para un evento noticioso, y el planeamiento puede establecer la diferencia. Los jueces ofrecieron su especial reconocimiento a la persona que mecanografió los 3,000 strikes. Las fotos del staff, combinadas con una impactante silueta tipográfica dan la impresión de que uno puede ser capaz de tocar la imagen. El diseño completo dice "béisbol".

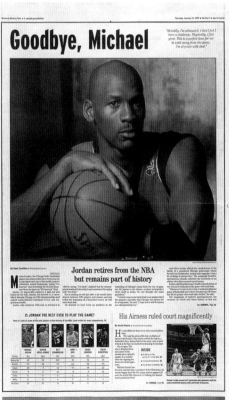

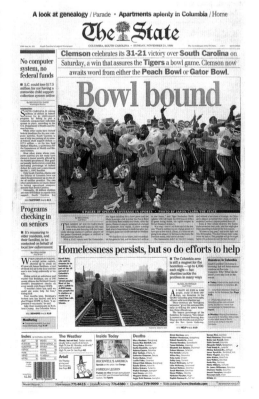

The New York Times
New York, N.Y. (A)
Wayne Kamidoi, Designer

Savannah Morning News
Savannah, Ga. (B)
Christoph Fuhrmans, Sports Planner/Designer

The State
Columbia, S.C. (B)
William Castronuovo, Associate Editor

The Times of Northwest Indiana
Munster, Ind. (B)

Craig Newman, Design Director, Designer; **Matt Erickson,** Design team leader, Designer; **Mike Sansone,** Sports Editor

The State Journal-Register
Springfield, Ill. (B)

Todd Stewart, News Design Editor

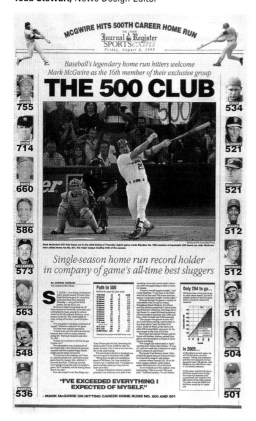

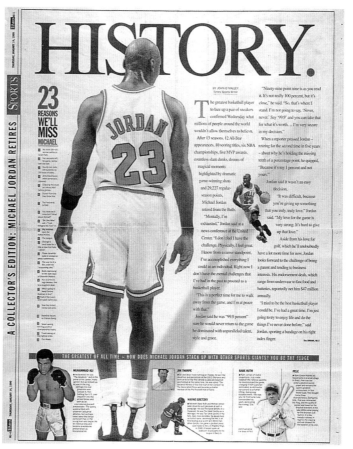

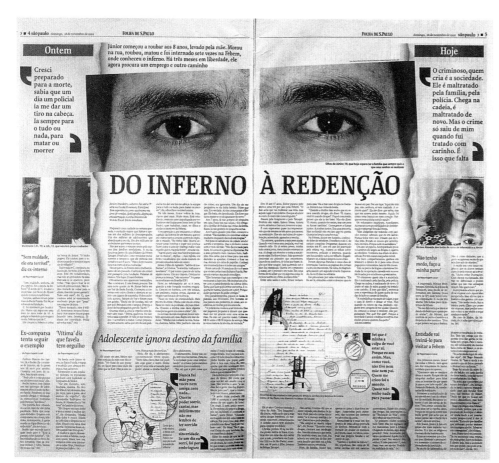

Folha de São Paulo
São Paulo, Brazil (A)

Fabio Marra, Art Editor; **Rogerio Schlegel,** Assistant Editor of Metropolitan Affairs; **Marlene Bergamo,** Photographer

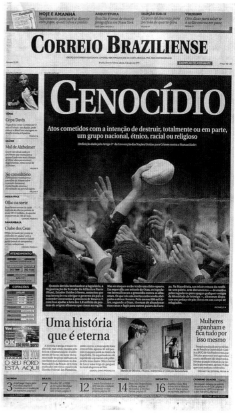

Correio Braziliense
Brasilia, Brazil (B)

Ricardo Noblat, News Room Director; **Francisco Amaral,** Art Director & Executive Editor; **Cláudio Versiani,** Photo Editor; **Yaynes Behrakis,** Reuters Photo; **João Bosco Adelino,** Page Designer

Silver
DN Lördag Söndag
Stockholm, Sweden (A)

Pompe Hedengren, Art Director; **Par Bjorkman**, Picture Editor; **Håkan Burell**, Page Designer

The strong illustrations and photography, with a good use of white space, impressed the judges. The work contained the best characteristics of line work in its illustrations and photography.

La combinación de poderosa ilustración y poderosa fotografía con un buen manejo del espacio en blanco hicieron sobresalir a este periódico. Este participante presenta una buena línea de trabajo con una característica línea de ilustraciones y fotografía.

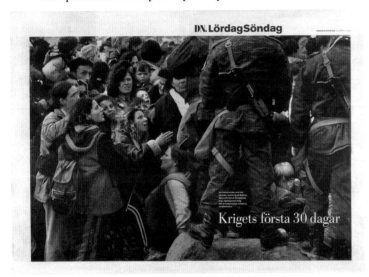

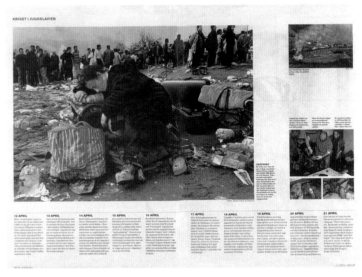

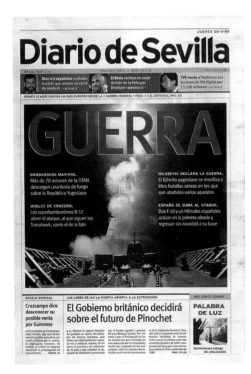

Diario de Sevilla
Sevilla, Spain (C)

Ferrán Grau, Art Director; **Miguel Moreno**, Section Coordinator; **Juan Carlos Zambrano**, Design Coordinator; **Rafael Avilés**, Designer; **José Manuel Barranco**, Designer; **Manuel González**, Designer; **José Antonio Sánchez**, Designer; **José María Ruiz**, Designer

The Ottawa Citizen
Ottawa, Ont., Canada (B)

Kit Collins, Designer; **Robert Cross,** Illustrator; **Lynn McAuley,** Editor, The Weekly; **Neil Reynolds,** Editor, The Citizen; **Russ Mills,** Publisher

The Scotsman
Edinburgh, Scotland (B)
Staff

Svenska Dagbladet
Stockholm, Sweden (A)

Richard Frank, Graphic Artist; **Bergt Salomonson**, Graphic Artist; **Staff**

Svenska Dagbladet
Stockholm, Sweden (A)

Hans Ottosson, Editor; **Lars Andersson**, Design Editor; **Yvonne Asell**, Photographer

Svenska Dagbladet
Stockholm, Sweden (A)

Hans Dahlglen, Designer; **Pål Sommelius**, Photo

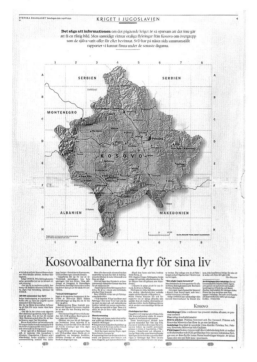

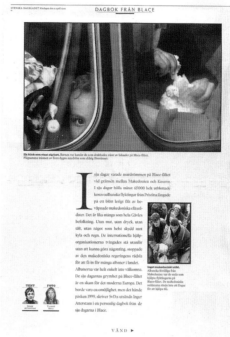

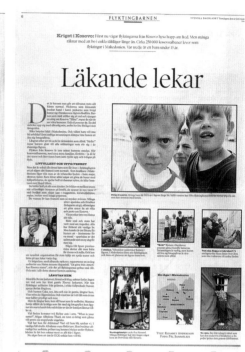

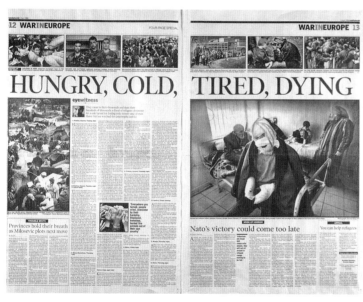

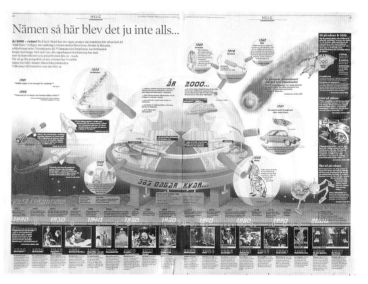

Sunday Herald
Glasgow, Scotland (B)

Richard Walker, Deputy Editor; **Rod Sibbald,** Picture Editor; **Stephen Khan,** Page Editor

Svenska Dagbladet
Stockholm, Sweden (A)

Jens Nordquist, Researcher; **Richard Frank,** Graphic Artist

Silver
Svenska Dagbladet
Stockholm, Sweden (A)
Hans Ottosson, Editor; **Lars Andersson**, Design Editor; **Riber Hansson**, Artist

Commissioning a local artist to reflect on aspects of time was a truly unique solution for encapsulating the Y2K issue. (The artist, Riber Hansson, is responsible for both text and illustration of this magnificent display.) The two packages explored the art of painting, spirituality and printing. The design is simple, elegant and functional, allowing the illustrations to breathe their own life into the pages. This was exceptional down to the pen and ink footed logo.

Esta es un solución innovadora al encapsular el Y2K (la llegada del año 2000) a través de comisionar a que un artista local refleje los aspectos del tiempo. Estos dos paquetes visuales exploran la pintura, la espiritualidad y la impresión. El diseño es simple, elegante y funcional, permitiendo que las ilustraciones respiren vida en las páginas. El artista, Riber Hansson, fue responsable tanto por los textos como por las ilustraciones de esta magnífica presentación. Este fue un logo excepcional.

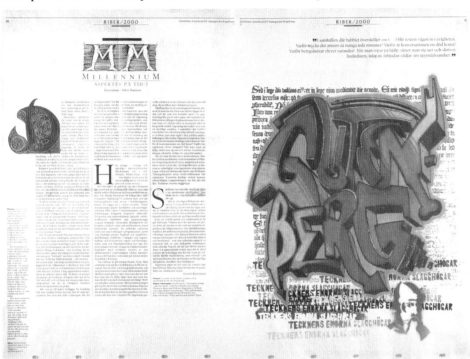

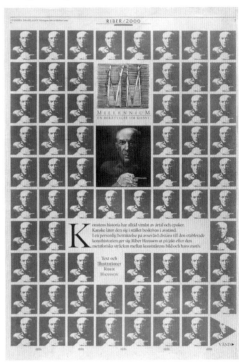

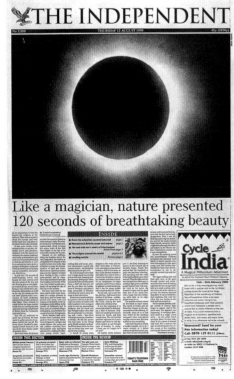

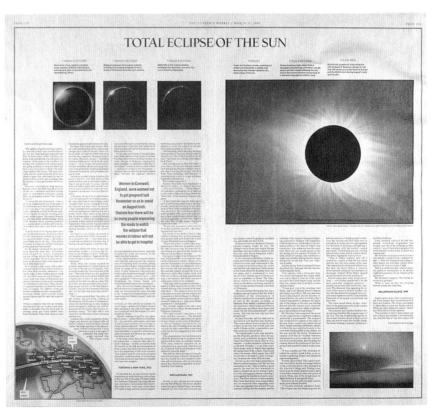

The Independent
London, England (A)
Staff

The Ottawa Citizen
Ottawa, Ont., Canada (B)
Kit Collins, Designer; **Jordan Juby**, Designer; **Lynn McAuley**, Weekly Editor; **Neil Reynolds**, Editor

Dagens Nyheter
Stockholm, Sweden (A)

Pompe Hedengren, Art Director; **Par Bjorkman,** Picture Editor;
Beatrice Lundborg, Photographer; **Anneli Steen,** Page Designer

The Boston Globe
Boston, Mass. (A)

David L. Schutz, Designer; **David Jrolf,** Night Editor;
Geoffrey Forester, Picture Editor; **Dan Zedek,** Editorial
Design Director

Chicago Tribune
Chicago, Ill. (A)
Staff

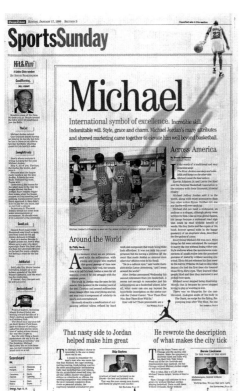

Lexington Herald-Leader
Lexington, Ky. (B)

Paul Wallen, Designer; **Randy Medema,** Designer;
Camille Weber, Artist; **Tonnya Kennedy,** Editor; **Paul
Raup,** Editor; **Kelli Patrick,** Editor; **Ron Garrison,** Photo
Director; **Staff**

Lexington Herald-Leader
Lexington, Ky. (B)
Staff

Pittsburgh Post-Gazette
Pittsburgh, Pa. (A)

Kim Germovsek, Deputy Graphics Editor; **Sharon Eberson**, Magazine Editor; **Ted Crow**, Illustrator

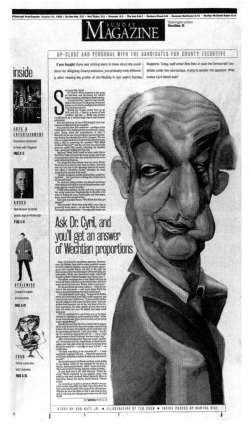

The Spokesman-Review
Spokane, Wash. (B)

Ralph Walter, Designer; **John Nelson**, Design editor; **John Sale**, Photo Editor

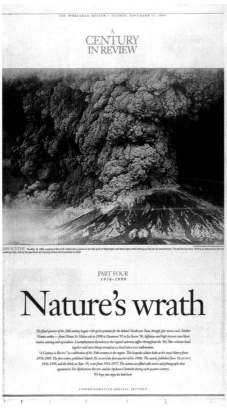

Telegram & Gazette / Sunday Telegram
Worcester, Mass. (B)

Jean Beckwith, Designer; **Tom Hunt**, Creative Director; **Harry Whitin**, Editor; **Don Landgren, Jr.**, Chief Graphic Designer

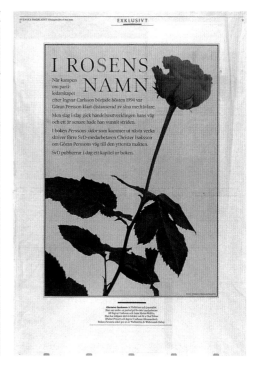

Clarín
Buenos Aires, Argentina (A)

Iñaki Palacios, Art Director; **Pablo Salomone**, Designer; **Juan Elissetche**, Design Editor; **Federico Sosa**, Design Editor; **Carlos Vazquez**, Designer; **Maureen Holboll**, Designer; **Victoria Quintiero**, Designer; **Soledad Calvo**, Designer; **Osvaldo Estevao**, Designer; **Gabriela Cabezón Cámara**, Designer

Svenska Dagbladet
Stockholm, Sweden (A)

Hans Ottosson, Editor; **Lars Andersson**, Design Editor

Silver
Svenska Dagbladet
Stockholm, Sweden (A)

Hans Ottosson, Editor; **Lars Andersson,** Design Editor; **Päl Sommelius,** Photographer; **Bergt Salomonson,** Graphic Artist

The staff uses copy and illustrations to tell a compelling story of a bridge connecting two countries.

El equipo utiliza textos e ilustraciones para contar una provocadora historia sobre un puente que conecta a dos países.

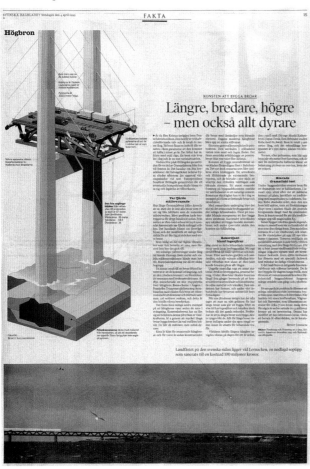

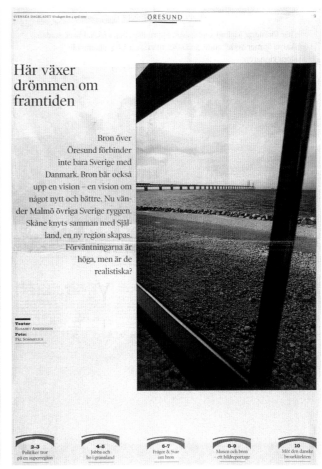

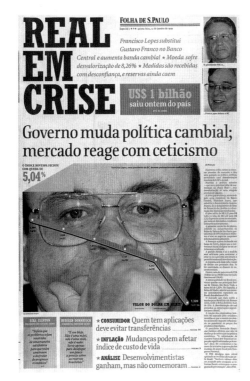

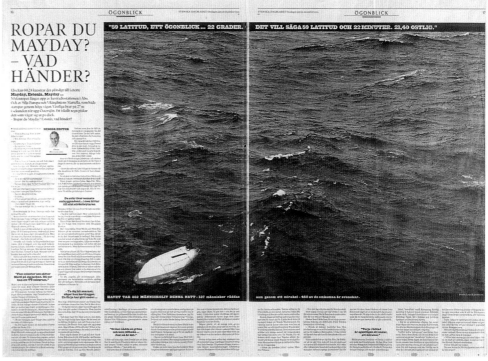

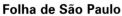

Folha de São Paulo
São Paulo, Brazil (A)

Fernanda Cirenza, Art Director; **Vincenzo Scarpellini,** Art Director; **Juca Varella,** Photographer

Svenska Dagbladet
Stockholm, Sweden (A)

Hans Ottosson, Editor; **Lars Andersson,** Design Editor; **Leif R. Jansson,** Photographer; **Bjòrn Larsson Ask,** Photographer

Reforma
Mexico City, México (B)

Víctor Cruz, Designer; **Luis Enrique López**, Editor; **Jorge Peñaloza**, Illustrator; **José Manuel Mendoza**, Graphics Editor; **Emilio Deheza**, Art Director; **Eduardo Danilo**, Design Consultant

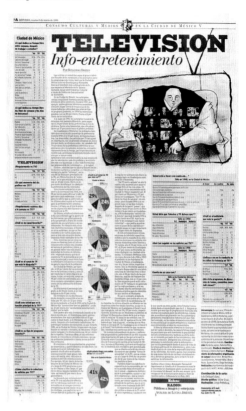

Asbury Park Press
Neptune, N.J. (B)

Andrew Prendimano, Art and Photo Director; **Harris Siegel**, M.E./Design & Photography; **Jim DelCioppo**, Designer; **Gary Potosky**, Assistant Sports Editor; **Daryl Stone**, Photographer

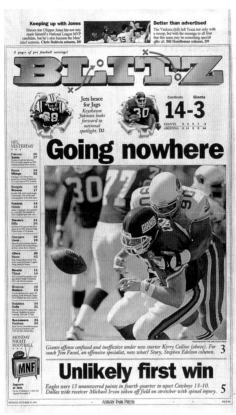

Detroit Free Press
Detroit, Mich. (A)

Brian James, Dave Dombrowski, Designers; **Steve Dorsey**, Design Director; **Bryan Erickson**, Deputy Design Director; **Rick Nease**, Art Director; **Rob Kozloff**, Photo Director; **Caroline Couig, Andrew Johnston**, Picture Editors; **J. Kyle Keener**, Deputy Photo Director

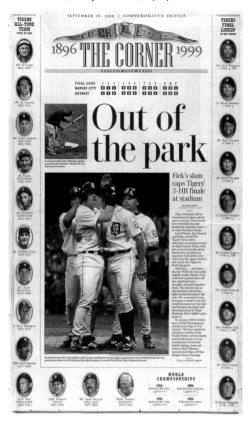

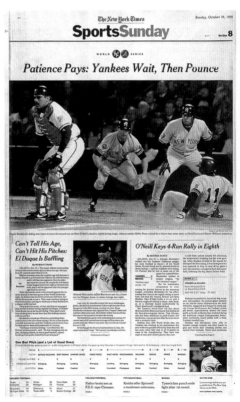

The New York Times
New York, N.Y. (A)

Lee Yarosh, Designer; **Wayne Kamidoi**, Designer; **Joe Ward**, Graphics Editor

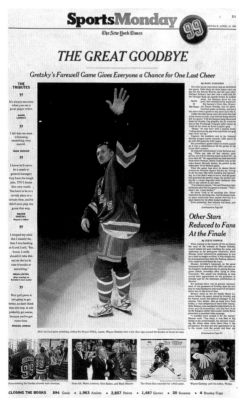

The New York Times
New York, N.Y. (A)

Lee Yarosh, Designer; **Wayne Kamidoi**, Designer; **Joe Ward**, Graphics Editor

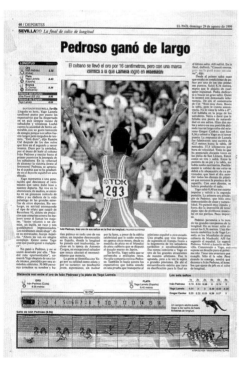

El País
Madrid, Spain (A)

Javier López, Assistant Art Director; **Raúl Cancio**, Photographer; **Ricardo Gutiérrez**, Photographer; **Garcia Cordero**, Photographer; **Tomás Ondarra**, Editor-in-Chief; **Aitor Eguinoa**, Graphic Artist; **M. Angel López**, Editor

Savannah Morning News
Savannah, Ga. (B)

Christoph Fuhrmans, Sports Planner/Designer; **Matt Sharpe**, Sports Planner/Designer; **Stephen D. Komives**, Sports/Feature Planning Editor

St. Louis Post-Dispatch
St. Louis, Mo. (A)

Rob Schneider, Designer; **Tom Borgman**, Design Director

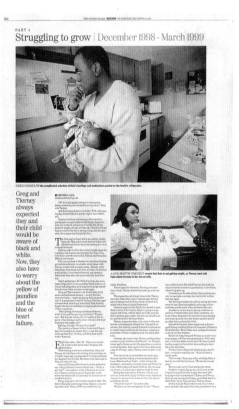

The Baltimore Sun
Baltimore, Md. (A)

Michelle Deal-Zimmerman, Deputy Design Director; **Andre F. Chung**, Photographer; **Joseph Hutchinson**, A.M.E. Graphics/Design; **Jim Preston**, A.M.E. Photographer; **Robert Hamilton**, Deputy Photography Director

The Boston Globe
Boston, Mass. (A)

Janet L. Michaud, Art Director & Designer; **Lucy Bartholomay**, Design Director; **Suzanne Kreiter**, Photographer; **Leanne Burden**, Photo Editor; **Mitchell Zuckoff**, Writer; **Ben Bradlee**, Special Projects Editor; **George Patisteas**, Layout / Copy Editor; **Dan Zedek**, Editorial Design Director

The Hamilton Spectator
Hamilton, Ont., Canada (B)

Colleen Baxter, Art Director & Designer; **Dan Kislenko**, Editor; **Paul Morse**, Designer

Silver
The Columbus Dispatch
Columbus, Ohio (A)
Todd Bayha, Editorial Artist; **Tom Baker**, Editorial Artist

Everything works well together in this clean and nicely organized presentation. The graphics are clearly integrated with the well-placed photos, and the piece contains a nice color palette.

Todo funciona muy bien en esta clara y bien organizada presentación. Los gráficos se encuentran claramente integrados con bien ubicadas fografías y una agradable paleta de color.

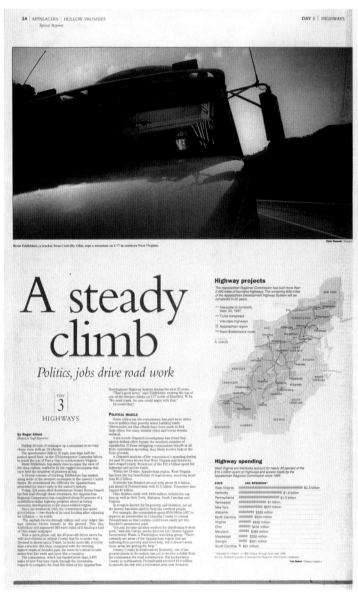

• Features Pages

chapter four

FEATURES

Silver
Palabra
Monterrey, México (C)

Francisco García, Designer; **Carlos Mendoza**, Illustrator; **Vicente León Mata**, Designer/Design Editor; **Sergio Lucio**, Editor; **Eduardo Danilo**, Design Consultant; **Jorge Meléndez**, Editor Director; **Ramón Alberto Garza**, General Editor Director; **Alexandro Medrano**, Design Managing Editor

The illustration and typography work together to create a bold, interesting look.

La ilustración y la tipografía se complementan para crear una interesante y poderosa presentación.

The Boston Globe
Boston, Mass. (A)

Jane Martin, Art director/designer; **Scott Menchin**, Illustrator; **Chris Chinlund**, Editor; **Julie Dalton**, Copy Editor; **Dan Zedek**, Editorial Design Director

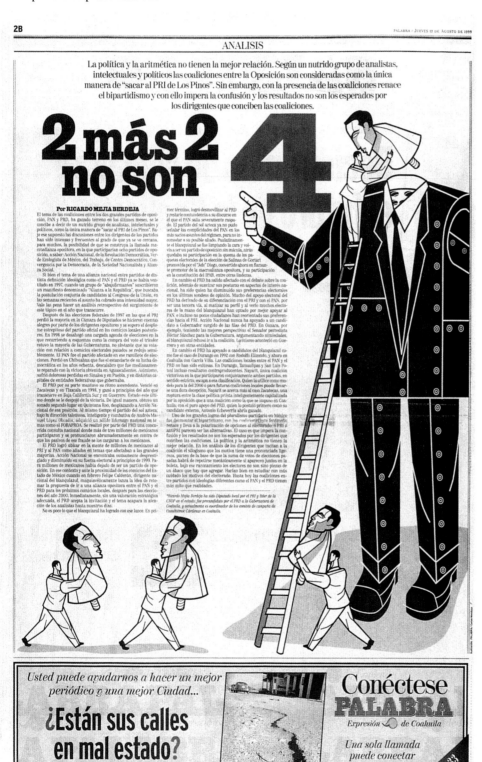

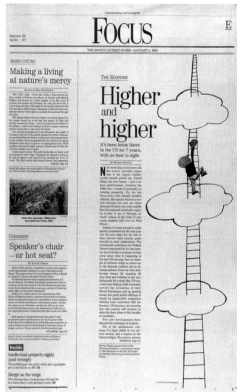

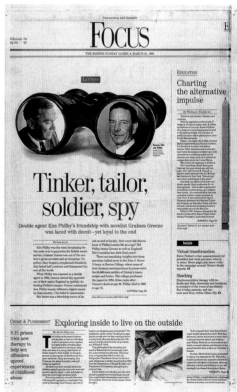

The Boston Globe
Boston, Mass. (A)

Jane Martin, Art Director & Photo Illustrator; **Julie Dalton**, Copy Editor; **Chris Chinlund**, Editor; **Dan Zedek**, Editorial Design Director

The Boston Globe
Boston, Mass. (A)

Jane Martin, Art Director Designer; **Julie Dalton,** Copy Editor; **Chris Chinlund,** Editor; **Dan Zedek,** Editorial Design Director

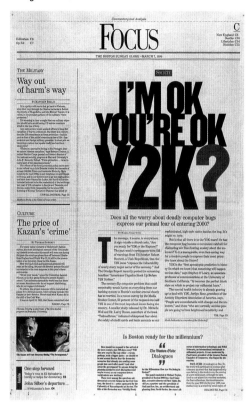

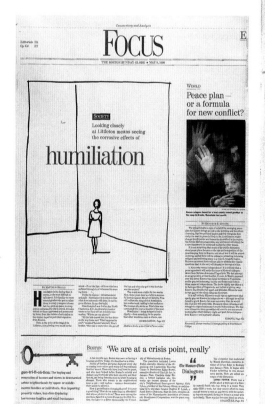

The Boston Globe
Boston, Mass. (A)

Jane Martin, Art Director; **Patrick Blackwell,** Illustrator; **Chris Chinlund,** Editor; **Julie Dalton,** Copy Editor; **Dan Zedek,** Editorial Design Director

Silver
Palabra
Monterrey, México (C)

Delgar Garcia, Designer; **Carlos Mendoza,** Illustrator; **Vicente León** Designer and Design Editor; **Alexandro Medrona,** Design Managing Editor; **Sergio Lucio Burciaga,** Editor; **Eduardo Danilo,** Design Consultant; **Jorge Meléndez,** Editor Director; **Ramón Alberto Garza,** General Editor Director

The integration of the illustration and typography create a bold, unified design.

La integración de la ilustración y la tipografía crean un diseño fuerte y unificado.

Silver
The New York Times
New York, N.Y. (A)

Steven Heller, Art Director; **Richard McGuire,** Illustrator

The color choices are excellent for an overall good concept. The type breaks to evoke a face.

La selección de colores es excelente para tan buen concepto. La disposición tipográfica evoca un rostro.

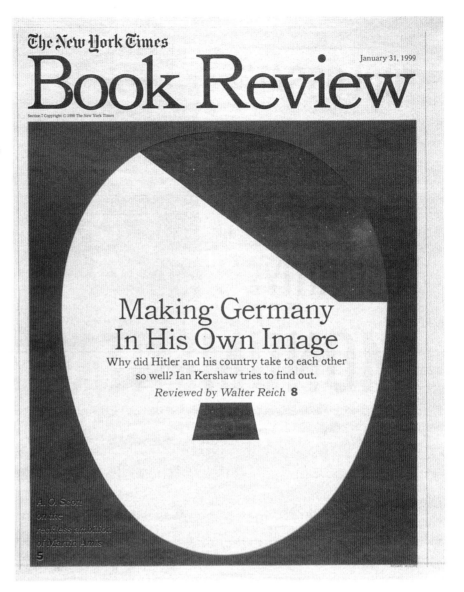

Dagens Nyheter
Stockholm, Sweden (A)

Peter Alenas, Art Director; **Daniel Quarnstrom,** Photo Editor; **Anneli Appelgren,** Page Designer; **Helena Davidsson-Neppelberg,** Illustrator

Göteborgs-Posten
Göteborg, Sweden (A)
Karin Teghammar Arell, Designer

National Post
Don Mills Ont., Canada (A)

Roland-Yves Carignan, Deputy Design Director; **David Olive,** Section Editor; **Gerald Owen,** Copy Editor; **Charles Davis,** Copy Editor; **Ken White,** Editor-in-Chief; **Doug Kelly,** Assistant Deputy Editor

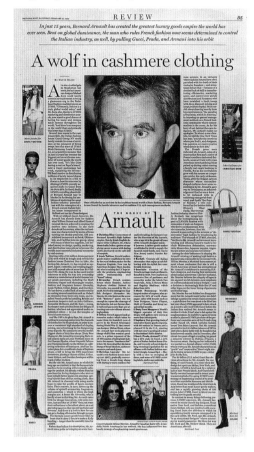

L.A. Weekly
L.A., Calif. (A)

Bill Smith, Art Director; **Robbie Conal,** Artist

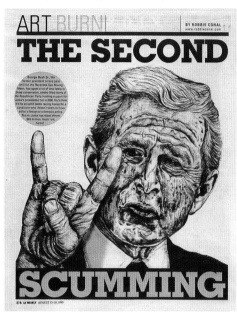

The New York Times
New York, (A)

Steven Heller, Art Director; **Christoph Niemann,** Illustrator

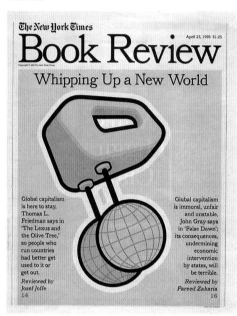

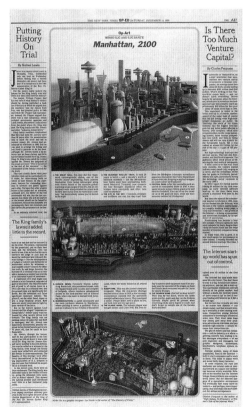

The New York Times
New York, (A)

Nicholas Blechman, Art Director; **Mirko Ilic,** Artist; **Luc Sante,** Artist

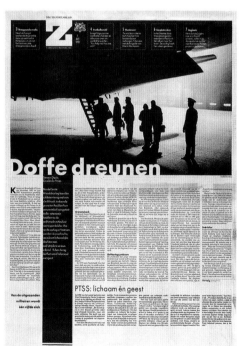

NRC Handelsblad
Rotterdam, The Netherlands (A)

Ris Van Overeem, Page Designer; **Roel Rozenburg,** Photographer

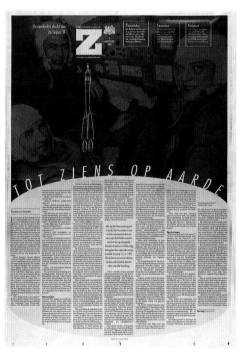

NRC Handelsblad
Rotterdam, The Netherlands (A)

Ris Van Overeem, Page Designer

The Oregonian
Portland, Ore. (A)

Paul Kitagaki, Jr., Photographer; **Cynthia Davis,** Designer

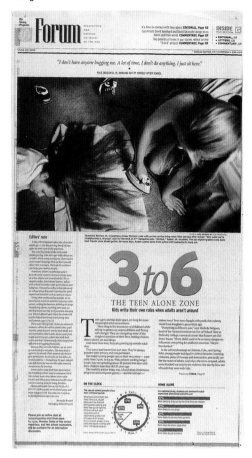

The Tampa Tribune
Tampa, Fla. (A)

Greg Williams, Art Director for Design; **Pat Mitchell,** Senior Editor for Presentation

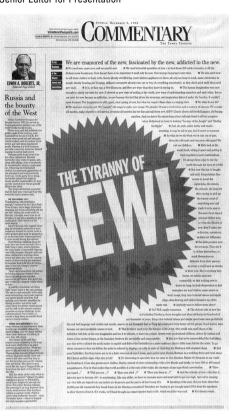

The Toronto Star
Toronto, Ont., Canada (A)

Catherine Pike, Designer; **Andrew Stawicki,** Photographer; **Bill Schiller,** Writer; **Mark Richardson,** Editor

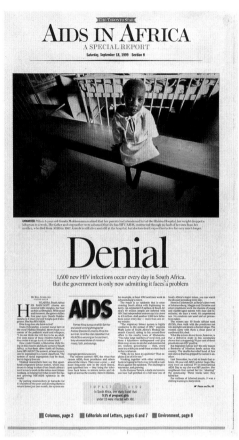

The Toronto Star
Toronto, Ont., Canada (A)

Catherine Pike, Designer; **Steve Russell,** Photographer; **Greg Smith,** Editor; **Laurie Monsebraaten,** Writer; **Elaine Carey,** Writer; **Patricia Orwen,** Writer; **Catherine Farley,** Graphic Artist; **Katie Gillmor,** Copy Editor

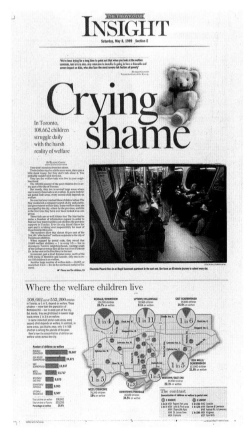

The Toronto Star
Toronto, Ont., Canada (A)

Catherine Pike, Designer; **Andrew Stawicki,** Photographer; **Bill Schiller,** Writer; **Mark Richardson,** Editor

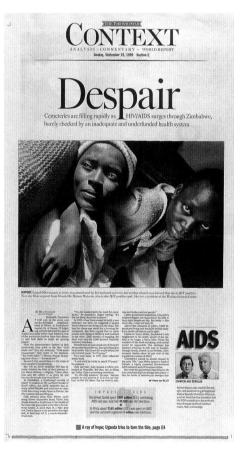

de Volkskrant
Amsterdam, The Netherlands (A)

Lucy Prijs, Designer; **Philippe Remarque,** Foreign Correspondent Berlin

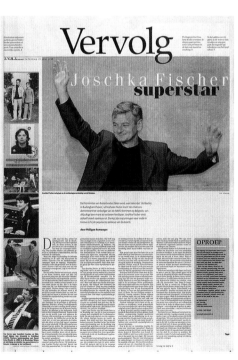

The Washington Post
Washington, D.C. (A)

Bonnie Benwick, Layout Editor; **Peter Alsberg,** Art Director; **Dan Yaccarino,** Illustrator

La Gaceta
San Miguel de Tucumán, Argentina (B)

Sebastian Rosso, Designer; **Sergio Fernandez,** Art Director; **Mario Garcia,** Design Consultant

La Gaceta
San Miguel de Tucumán, Argentina (B)

Sebastian Rosso, Designer; **Sergio Fernandez,** Art Director; **Mario Garcia,** Design Consultant; **Federico Turpe,** Editor

La Gaceta
San Miguel de Tucumán, Argentina (B)

Andrés Tula Molina, Designer; **Sergio Fernandez,** Art Director; **Mario Garcia,** Design Consultant; **Daniel Fontanarrosa,** Illustrator; **Antonio Ferroni,** Photographer

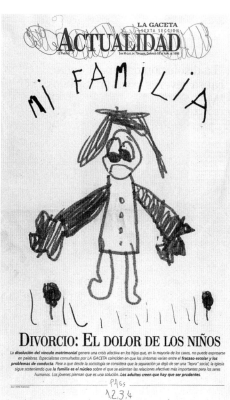

La Gaceta
San Miguel de Tucumán, Argentina (B)

Ruben Falci, Designer; **Sergio Fernandez,** Art Director; **Mario Garcia,** Design Consultant

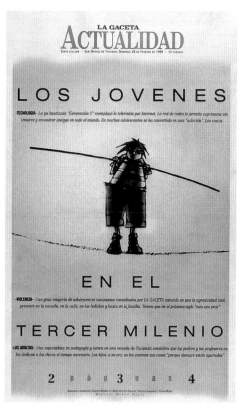

La Gaceta
San Miguel de Tucumán, Argentina (B)

Ruben Falci, Designer; **Sergio Fernandez,** Art Director; **Mario García,** Design Consultant

La Gaceta
San Miguel de Tucumán, Argentina (B)

Sebastian Russo, Designer; **Sergio Fernandez**, Art Director; **Mario Garcia**, Design Consultant; **Clara Murga**, Editor

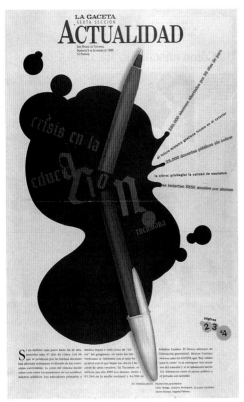

The News & Observer
Raleigh, N.C. (B)

J. Damon Cain, Director of News Design; **Van Denton**, Section Editor; **Burgetta Wheeler**, Assistant Section Editor

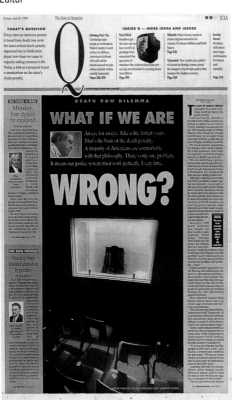

The Providence Journal
Providence, R.I. (B)

Cecilia Prestamo, Page Designer/Photo Editor

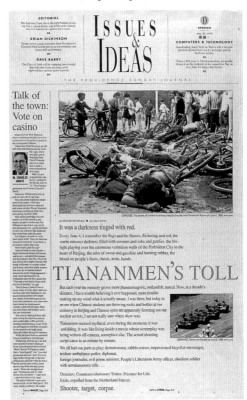

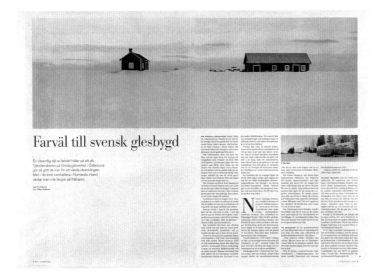

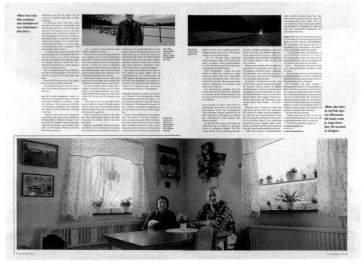

Silver
DN Lördag Söndag
Stockholm, Sweden (A)

Peter Alenas, Art Director; **Peter Hoelstad**, Photographer

The Baltimore Sun
Baltimore, Md. (A)

Victor Panichkul, Features Design Director; **Joseph Hutchinson,** A.M.E. Graphics/Design

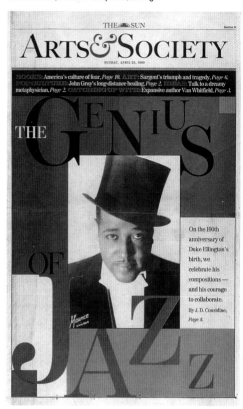

Silver
El Pais
Madrid, Spain (A)

Luis Galáu, Designer; **Jesús Martinez,** Designer

The judges found this winner to be appealing and fresh, with a great illustration and lots of energy. The gray type allowed the sun to really pop to the foreground.

Los jueces encontraron a este participante atractivamente novedoso, con buena ilustración y mucha energía. La tipografía en gris realmente ayuda al sol a destacar.

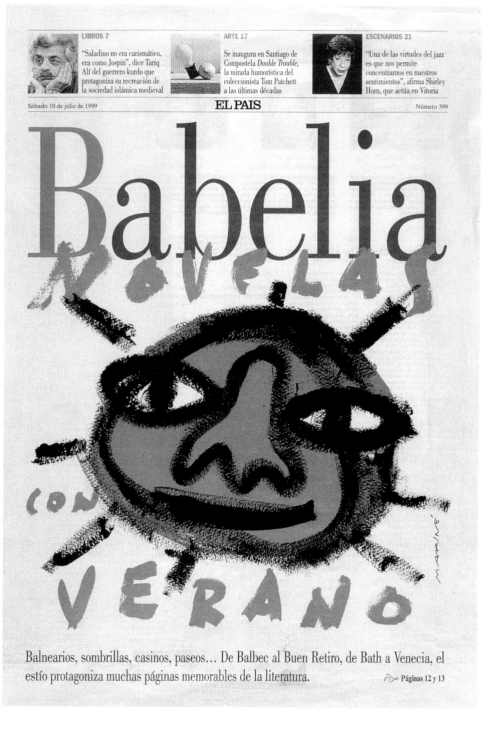

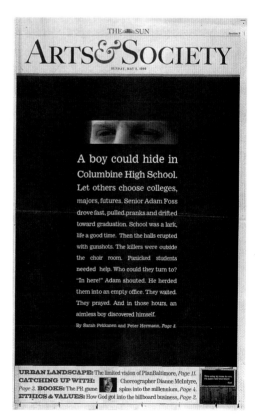

The Baltimore Sun
Baltimore, Md. (A)

Victor Panichkul, Features Design Director; **Joe Hutchinson,** A.M.E. Design & Graphics

The Boston Globe
Boston, Mass. (A)

Jane Martin, Art Director & Designer; **Pam Berry,** Photos and Text; **Fiona Luis,** Editor; **Dan Zedek,** Editorial Design Director

Chicago Tribune
Chicago, Ill. (A)

Joan Cairney, Art Director; **Devin Rose,** Editor; **Charles Osgood,** Photographer

Berlingske Tidende
Copenhagen, Denmark (B)

Bettina Kofmann, Designer

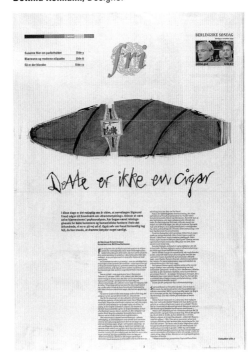

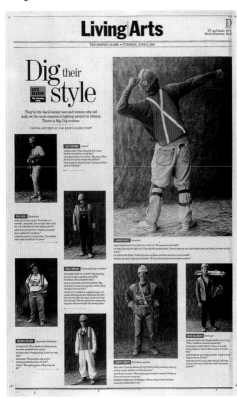

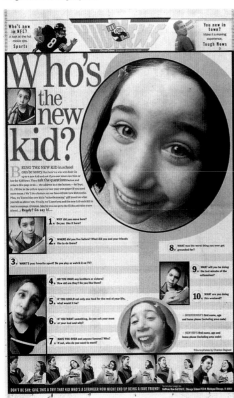

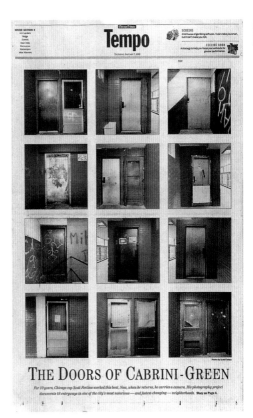

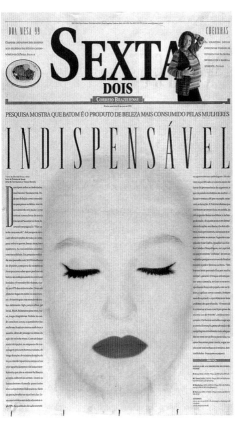

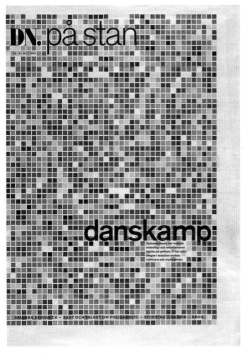

Chicago Tribune
Chicago, Ill. (A)

Scott Fortino, Photographer; **Marsha Peters,** Photo Editor; **Tom Heinz,** Designer; **Tim Bannon,** Tempo Editor

Correio Braziliense
Brasilia, Brazil (B)

Ricardo Noblat, News Room Director; **Francisco Amaral,** Art Director & Executive Editor; **Zuleika deSouza,** Photo Editor; **Carlos Marcelo,** Editor; **Paula Santana,** Sub-Editor; **Chica Magalhães,** Page Designer

DN på stan
Stockholm, Sweden (A)

Ebba Bonde, Art Director/Designer; **Lotta Kühlhorn,** Illustrator

DN Lördag Söndag
Stockholm, Sweden (A)
Magnus Naddermier, Art Director; **Beatrice Lundborg**, Photographer; **Gunilla Klingberg**, Page Designer

DN på stan
Stockholm, Sweden (A)
Ebba Bonde, Art Director; **Christopher Höglund**, Page Designer; **Anette Nantell**, Photographer

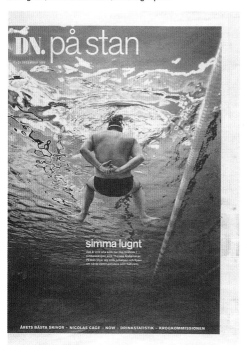

DN på stan
Stockholm, Sweden (A)
Ebba Bonde, Art Director & Designer; **Stina Wirsén**, Illustrator

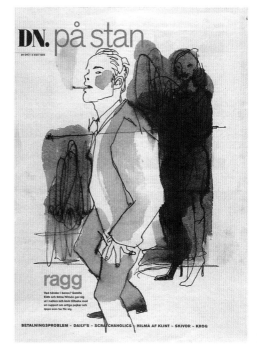

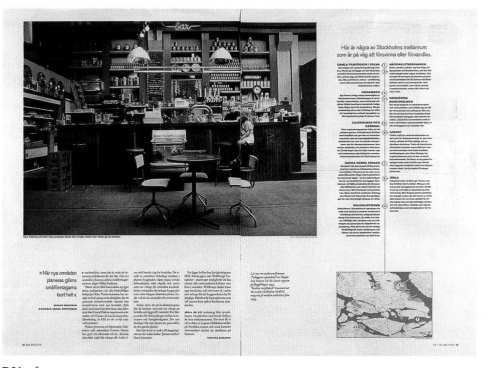

DN på stan
Stockholm, Sweden (A)
Ebba Bonde, Art Director; **Jesper Waldersten**, Art Director; **Magnus Bergstrom**, Photographer

DN på stan
Stockholm, Sweden (A)
Ebba Bonde, Art Director & Designer; **Beatrice Lundborg**, Photographer

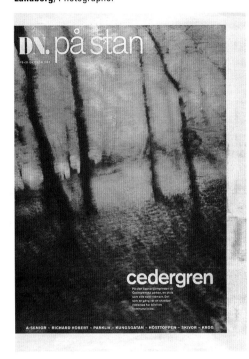

Le Devoir
Montréal, Que., Canada (C)
Christian Tiffet, Art Director

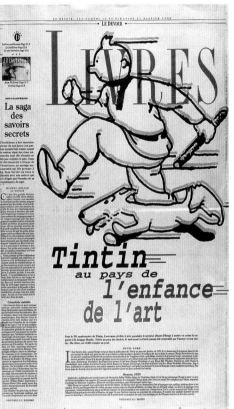

Le Devoir
Montreal, Que., Canada (C)
Diane Précourt, Lifestyle Editor

Le Devoir
Montréal, Que., Canada (C)
Diane Précourt, Lifestyle Editor

Le Devoir
Montréal, Que., Canada (C)
Christian Tiffet, Art Director

La Gaceta
San Miguel de Tucumán, Argentina (B)
Sebastian Rosso, Designer; **Sergio Fernandez**, Art Director; **Mario Garcia**, Design Consultant

La Gaceta
San Miguel de Tucumán, Argentina (B)
Sebastian Rosso, Designer/Illustrator; **Sergio Fernandez**, Art Director; **Mario Garcia**, Design Consultant

La Gaceta
San Miguel de Tucumán, Argentina (B)
Ruben Falci, Designer; **Sergio Fernandez**, Art Director; **Mario Garcia**, Design Consultant

La Gaceta
San Miguel de Tucumán, Argentina (B)
Ruben Falci, Designer; **Sergio Fernandez**, Art Director; **Mario Garcia**, Design Consultant; **Gustavo Rodriguez**, Editor

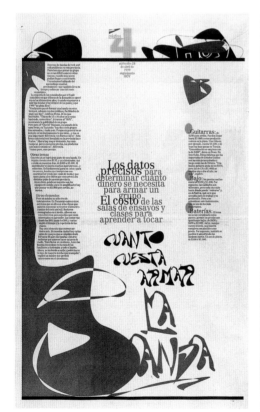

La Gaceta
San Miguel de Tucumán, Argentina (B)
Sebastian Rosso, Designer; **Sergio Fernandez**, Art Director; **Mario Garcia**, Design Consultant

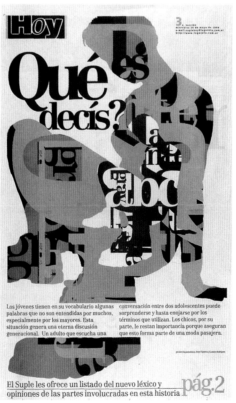

La Gaceta
San Miguel de Tucumán, Argentina (B)
Sebastian Russo, Designer; **Sergio Fernandez**, Art Director; **Mario Garcia**, Design Consultant

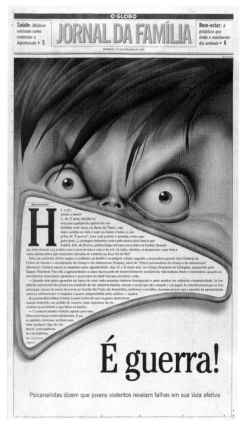

O Globo
Rio de Janeiro, Brazil (A)
Claudio Duarte, Illustrator and Designer

El Imparcial
Hermosillo, México (C)

Zaida Cinco, Designer; **Ariel Medel**, Illustrator; **Sergio Serrano**, Art Director; **Maria Jesús Romero**, Section Coordinator and Editor

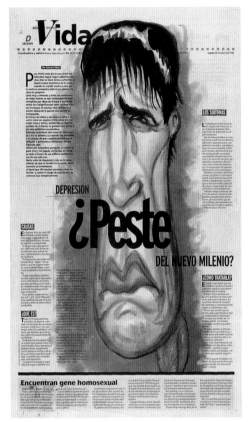

Jacksonville Journal-Courier
Jacksonville, Ill. (C)

Guido Strotheide, Editor/Designer

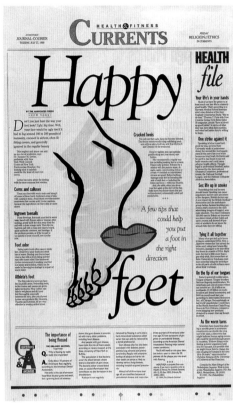

Jacksonville Journal-Courier
Jacksonville, Ill. (C)

Mike Miner, Designer
• also an **Award of Excellence** for Combination Portfolio

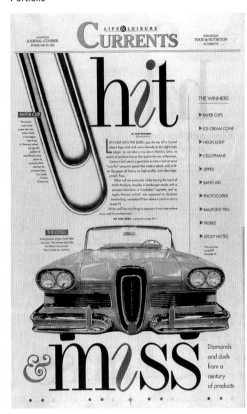

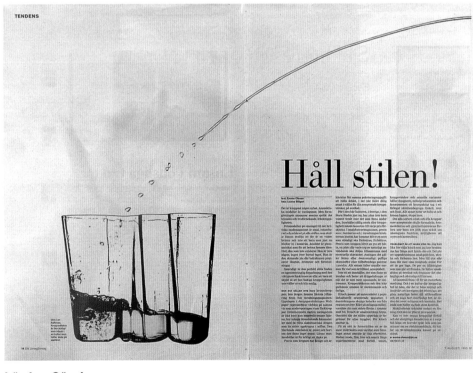

Lördag Söndag
Stockholm, Sweden (A)

Pompe Hedengren, Art Director; **Nina Andén**, Page Designer; **Louise Billgert**, Photographer

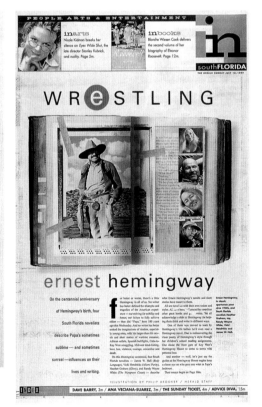

The Miami Herald
Miami, Fla. (A)

Aurora Arrue, Features Designer; **Philip Brooker**, Illustrator; **John Barry**, Section Editor; **Kendall Hamersly**, A.M.E. Features

Missoulian
Missoula, Mont. (C)

Tad Brooks, News Editor

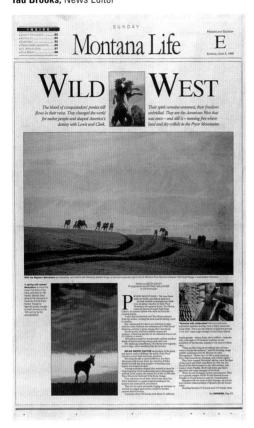

Mural
Zapopan, México (C)

Fernando Jauregui, Designer; **Gustavo Belmán,** Graphics Editor; **José Merino,** Graphics Editor; **Jorge Vidrio,** Art Director; **Eduardo Danilo,** Design Consultant

National Post
Don Mills, Ont., Canada (A)

Gayle Grin, Design Director and Designer; **Kenneth Whyte,** Editor-in-Chief; **Peter Scowen,** Toronto Editor; **Michael Vaughan,** Staff Writer

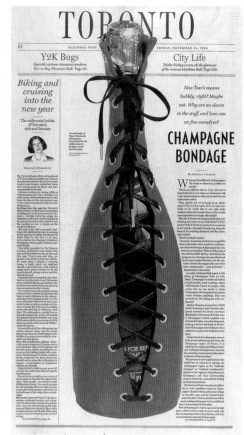

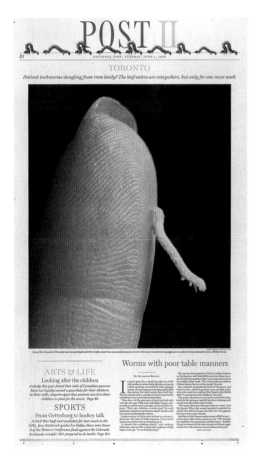

National Post
Don Mills, Ont., Canada (A)

Gayle Grin, Design Director/Designer; **Peter Scowen,** Toronto Editor; **Martin Newland,** Deputy Editor; **Kenneth Whyte,** Editor-in-Chief; **Lynn Wyllie,** Designer

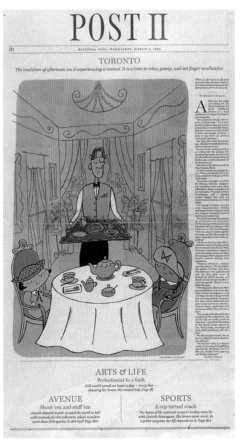

National Post
Don Mills, Ont., Canada (A)

Gayle Grin, Design Director and Designer; **Kenneth Whyte,** Editor-in-Chief; **Peter Scowen,** Toronto Editor; **Rebecca Eckler,** Writer

El Norte
Monterrey, México (B)

Yolanda Costilla de Anda, Section Designer & Photo Artist; **Carolina Sainz,** Photographer; **Eugenio Guzmán Lombard,** Section Editor; **Salvador González,** Section Director; **Alejandro Banuet Guiot,** Design Managing Editor; **Ramón Alberto Garza,** General Editor Director; **Eduardo Danilo,** Consultant Designer

The Orange County Register
Santa Ana, Calif. (A)

Martin Gee, Designer; **Kris Viesselman**, Art Director

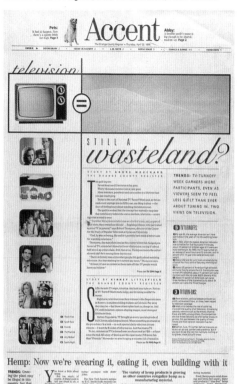

El Norte
Monterrey, México (B)

Yolanda Costilla de Anda, Section Designer & Photo Artist; **Miguel A. Chávez**, Photographer; **Eugenio Guzmán Lombard**, Section Editor; **Salvador González**, Section Director; **Alejandro Banuet Guiot**, Design Managing Editor; **Ramón Alberto Garza**, General Editor Director; **Eduardo Danilo**, Consultant Designer

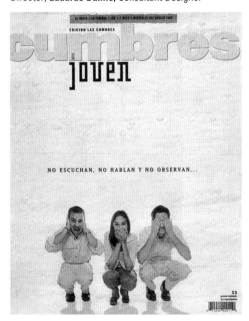

El País
Madrid, Spain (A)

Luis Galáu, Designer; **Jesén Martinez**, Designer

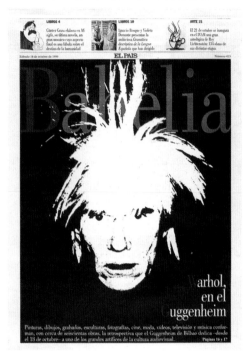

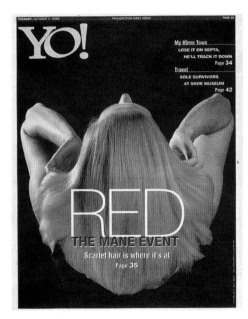

Philadelphia Daily News
Philadelphia, Pa. (B)

Anne Massimiano, Art Director

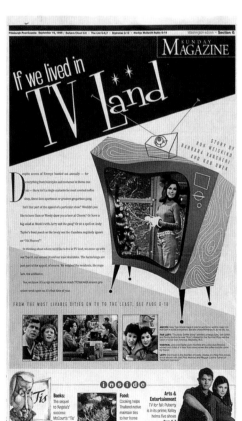

Politiken
Copenhagen, Denmark (B)

Søren Nyeland, Design Editor; **Kristoffer Østerbye**, Designer; **Jesper Friis**, Editor; **Poul Holck**, Artist
• also an **Award of Excellence** for Illustration

Pittsburgh Post-Gazette
Pittsburgh, Pa. (A)

Kim Germovsek, Deputy Graphics Editor; **Sharon Eberson**, Magazine Editor; **Dan Marsula**, Illustrator

San Jose Mercury News
San Jose, Calif. (A)

Rebecca Hall, Designer/Illustrator; **Sue Morrow,** Features Design Director

Politiken
Copenhagen, Denmark (A)

Søren Nyeland, Design Editor; **Marianne Gram,** Editor; **Kristoffer Østerbye,** Designer; **Anette Vestergaard,** Copy Editor; **Annette Nyvang,** Copy Editor

Politiken
Copenhagen, Denmark (A)

Søren Nyeland, Design Editor; **Marianne Gram,** Editor; **Tomas Østergren,** Designer; **Anette Vestergaard,** Copy Editor; **Annette Nyvang,** Copy Editor

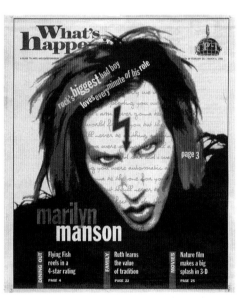

Seattle Post-Intelligencer
Seattle, Wash. (A)

Julie Simon, Designer

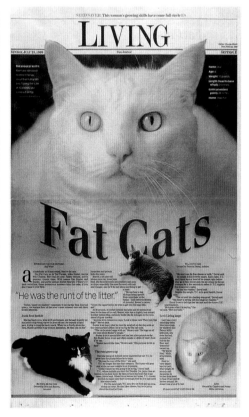

San Jose Mercury News
San Jose, Calif. (A)

Rebecca Hall, Designer; **Sue Morrow,** Features Design Director; **Penny de los Santos,** Photographer

Sun Journal
Lewiston, Maine (C)

Tim Frank, M.E. Design; **Jose Leiva,** Photographer; **Gregory Rice,** Photographer; **Daryn Slover,** Photographer

La Voz del Interior
Córdoba, Argentina (B)

Javier Candellero, Designer/Illustrator; **Miguel De Lorenzi,** Art Director; **Edgardo Litvinoff,** Editor; **Mario García,** Design Consultant

La Voz del Interior
Córdoba, Argentina (B)

Javier Candellero, Designer/Illustrator; **Miguel De Lorenzi,** Art Director; **Edgardo Litvinoff,** Editor; **Mario García,** Design Consultant

La Voz del Interior
Córdoba, Argentina (B)

Javier Candellero, Designer/Illustrator; **Miguel De Lorenzi,** Art Director; **Edgardo Litvinoff,** Editor; **Mario García,** Design Consultant

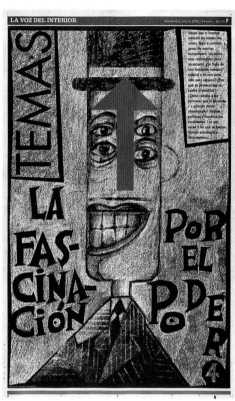

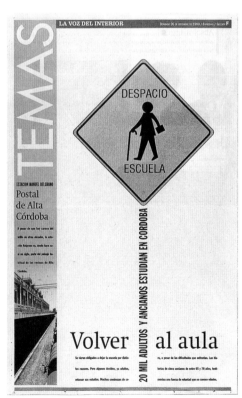

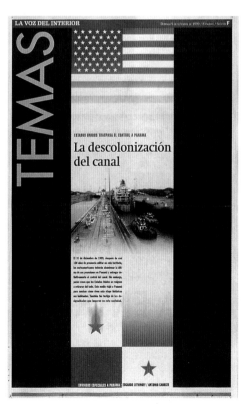

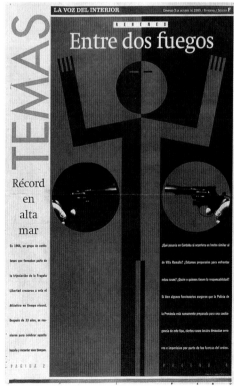

La Voz del Interior
Córdoba, Argentina (B)

Javier Candellero, Designer/Illustrator; **Miguel De Lorenzi,** Art Director; **Edgardo Litvinoff,** Editor; **Mario García,** Design Consultant

La Voz del Interior
Córdoba, Argentina (B)

Javier Candellero, Designer, Illustrator; **Miguel De Lorenzi,** Art Director; **Edgardo Litvinoff,** Editor; **Mario García,** Design Consultant

La Voz del Interior
Córdoba, Argentina (B)

Javier Candellero, Designer/Illustrator; **Miguel De Lorenzi,** Art Director; **Edgardo Litvinoff,** Editor; **Mario García,** Design Consultant

York Daily Record
York, Pa. (C)

Linda Rogers, Artist/Designer

Silver
The Charlotte Observer
Charlotte, N.C. (A)

Kristen Powell, Designer; **Jim Denk,** Design Director; **Ted Yee,** Design Team Leader; **Joanne Miller,** Art Director

This solution looks like an old poster with abused type, yet retains a unified look. It pushes typographic technical limits, yet doesn't look like it was done on a computer. It functions as it should, without any illustration other than what the type itself provides.

Pareciera ser un viejo cartel con tipografía maltratada, pero presenta una apariencia unificada. Va más allá de los límites técnicos de la tipografía sin parecer haber sido hecho por computadora. Funciona perfectamente tal cual, sin necesidad de ningún otro elemento visual.

Anchorage Daily News
Anchorage, Alaska (B)

Greg Epkes, Designer/Illustrator; **Davis Factor,** Photographer

Silver
The Charlotte Observer
Charlotte, N.C. (A)

Chin Wang, Designer; **Jim Denk,** Design Director; **Ted Yee,** Design Team Leader; **Woody Mitchell,** Copy Editor; **Vinny Kuntz,** Editor

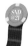 This is a refreshing change for the Hitchcock profile, which is very different from all the other pages we saw. The red letter works well and the hand-drawn type is great. All the little touches and details serve to strengthen the package.

Esta es una refrescante presentación de Hitchcock que es muy diferente de otras páginas que han utilizado su perfil. La letra roja funciona bien y la tipografía caligráfica es buena. Son los pequeños detalles los que fortalecen esta presentación.

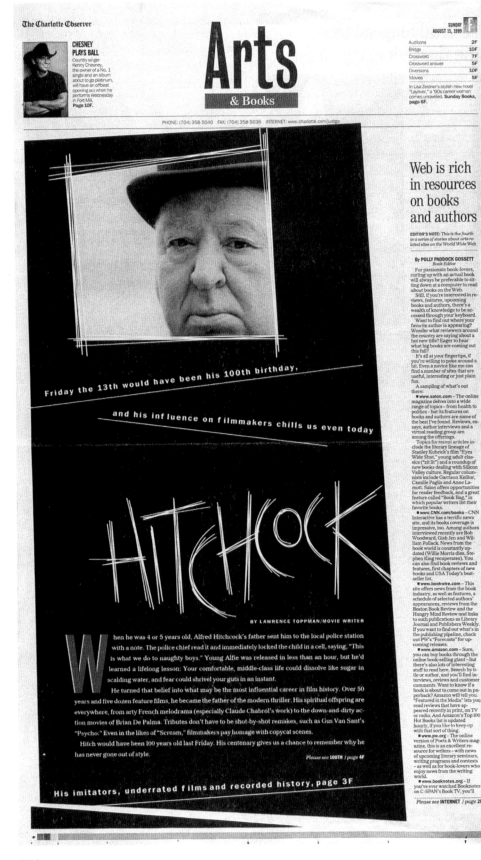

Anchorage Daily News
Anchorage, Alaska (B)

Greg Epkes, Designer/Illustrator

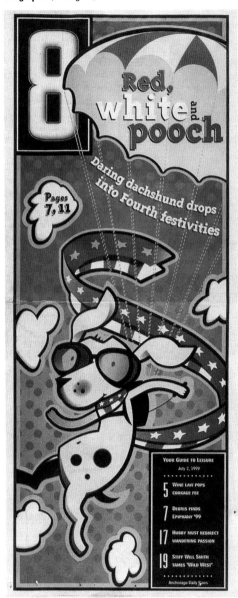

Asbury Park Press
Neptune, N.J. (B)

Andrew Prendimano, Art and Photo Director; **Harris Siegel,** M.E./Design & Photography; **Kathy Dzielak,** Editor; **Adriana Libreros-Purcell,** Designer

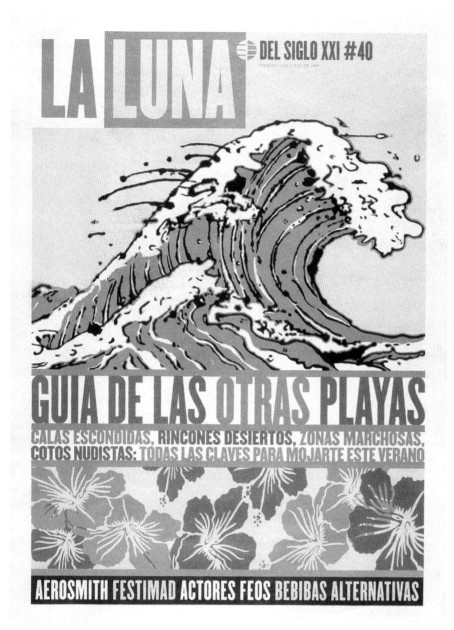

Silver
El Mundo La Luna
Madrid, Spain (A)

Rodrigo Sánchez, Art Director & Designer; **Francisco Dorado**, Designer; **Chano del Rio**, Designer; **Carmelo Caderot**, Design Director

This is a fresh approach and image for showing beaches. It evokes a feeling for the Japanese style with no gray areas.

Este es una novedosa manera de mostrar las playas. Pareciera ser japonés, sin áreas grises.

Asbury Park Press
Neptune, N.J. (B)

Andrew Prendimano, Art and Photo Director; **Harris Siegel**, M.E./Design & Photography; **Kathy Dzielak**, Editor; **Adriana Libreros-Purcell**, Designer

Austin American-Statesman
Austin, Texas (A)

Mike Sutter, Designer & Illustrator

Silver
El País
Madrid, Spain (A)

Luis Galáu, Designer; **José Martin**, Designer; **Nuria Muina**, Designer; **Audry Gilbert**, Designer; **Fernando Riublas**, Editor; **Antou Goiri**, Photographer

The type placement is just about perfect on this page. The piercing turns into a "My lips are sealed" metaphor that functions really well.

La ubicación de la tipografía es perfecta. Los huecos se convierten en "mis labios están sellados", metá fora que funciona muy bien.

The Boston Globe
Boston, Mass. (A)

Natalie Diffloth, Art Director & Designer & Illustrator; **Steve Maas**, Editor; **Dan Zedek**, Editorial Design Director

The Boston Globe
Boston, Mass. (A)

Patty Alvarez, Art Director/Designer; **Scott Powers**, Editor; **Dan Zedek**, Editorial Design Director

Silver
The Seattle Times
Seattle, Wash. (A)
Jeff Neumann, Designer

 The type creates a feeling of rain with lots of energy that makes you want to look inside to see what else is going on.

La tipografía crea una apariencia de lluvia. Existe mucha energía aquí, y nos hace querer mirar adentro para ver qué es lo que está pasando.

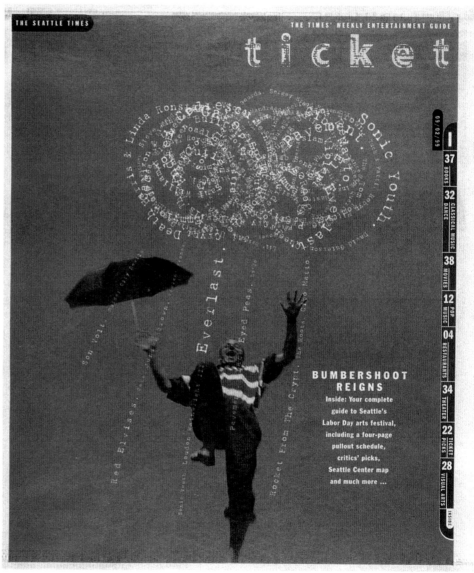

The Charlotte Observer
Charlotte, N.C. (A)
Kristen Powell, Designer; **Jim Denk,** Design Director;
Ted Yee, Design Team Leader

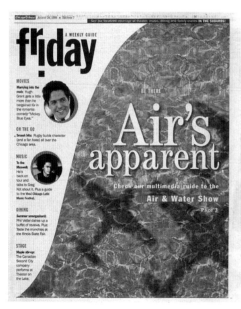

Chicago Tribune
Chicago, Ill. (A)
Kate Elazegui, Art Director; **Kevin Moore,** Editor

Silver
The Seattle Times
Seattle, Wash. (A)
Jeff Neumann, Designer

The staff used a clever way to approach the ever-present food festival: an excellent twist with a feeling that the vendors are able to get the food directly into the mouth of the reader.

El equipo de este periódico utiliza una manera especial para presentar un festival de comidas. Es un excelente giro que permite que los vendedores coloquen la comida en las bocas de los lectores.

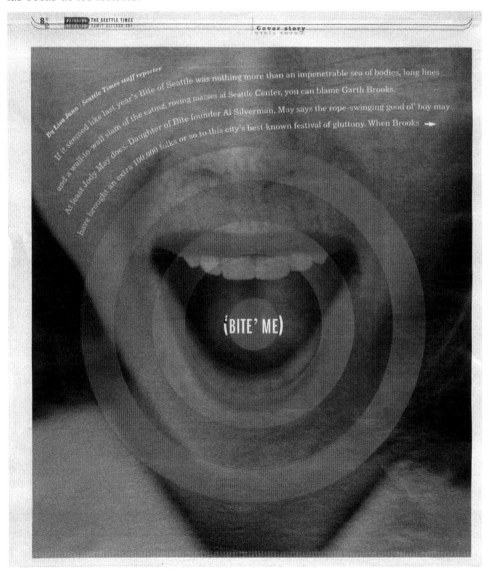

Chicago Tribune
Chicago, Ill. (A)
Kate Elazegui, Art Director; **Robert Reyevsky,** Illustrator; **Kevin Moore,** Editor

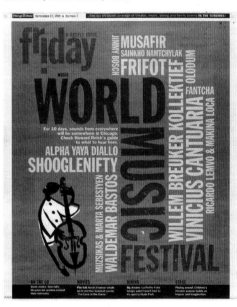

Clarín
Buenos Aires, Argentina (A)
Iñaki Palacios, Art Director; **Tea Alberti,** Design Editor; **Oscar Bejarano,** Graphic Designer; **Valeria Castresana,** Graphic Designer; **Silvina Fuda,** Graphic Designer; **Maria Heinberg,** Graphic Designer; **Omar Olivella,** Graphic Designer; **Matilde Oliveros,** Graphic Designer; **Pablo Ruiz,** Graphic Designer; **Carolina Wainsztok,** Graphic Designer

Clarín
Buenos Aires, Argentina (A)

Iñaki Palacios, Art Director; **Tea Alberti**, Design Editor;
Oscar Bejarano, Graphic Designer; **Valeria Castresana,**
Graphic Designer; **Silvina Fuda,** Graphic Designer;
Maria Heinberg, Graphic Designer; **Omar Olivella,**
Graphic Designer; **Matilde Oliveros,** Graphic Designer;
Pablo Ruiz, Graphic Designer; **Carolina Wainsztok,**
Graphic Designer

Clarín
Buenos Aires, Argentina (A)

Iñaki Palacios, Art Director; **Tea Alberti**, Design Editor;
Oscar Bejarano, Graphic Designer; **Valeria Castresana,**
Graphic Designer; **Silvina Fuda,** Graphic Designer;
Maria Heinberg, Graphic Designer; **Omar Olivella,**
Graphic Designer; **Matilde Oliveros,** Graphic Designer;
Pablo Ruiz, Graphic Designer; **Carolina Wainsztok,**
Graphic Designer

Silver
The State
Columbia, S.C. (B)
Steven A. Long, Staff Artist

The use of one classic, simple and bold image, rather than many, is refreshing in a movie section. The design approaches the hype of star wars quietly.

El uso de una sola imagen en vez de varias es muy refrescante para una sección de cine. Es clásico, sencillo y poderoso. El diseño roza el estilo de "La guerra de las galaxias" de manera calmada.

Silver
Mural
Zapopan, México (C)

Fernando Jauregui, Designer; **Gustavo Belmán**, Graphics Editor; **José Merino**, Graphics Editor; **Jorge Vidrio**, Art Director; **Eduardo Danilo**, Design Consultant; **John Carlos Garda**, Editor

We found this to be an unusual and energetic approach. The photography, typography and organization all compliment each other and work to explain the subject matter.

El jurado encontró a esta publicación como inusual y energética. La fotografía, tipografía y organización se complementan y funcionan bien con el contenido de los artículos.

Clarín
Buenos Aires, Argentina (A)

Iñaki Palacios, Art Director; **Tea Alberti**, Design Editor; **Oscar Bejarano**, Graphic Designer; **Valeria Castresana**, Graphic Designer; **Silvina Fuda**, Graphic Designer; **Maria Heinberg**, Graphic Designer; **Omar Olivella**, Graphic Designer; **Matilde Oliveros**, Graphic Designer; **Pablo Ruiz**, Graphic Designer; **Carolina Wainsztok**, Graphic Designer

Clarín
Buenos Aires, Argentina (A)

Iñaki Palacios, Art Director; **Tea Alberti**, Design Editor; **Oscar Bejarano**, Graphic Designer; **Valeria Castresana**, Graphic Designer; **Silvina Fuda**, Graphic Designer; **Maria Heinberg,** Graphic Designer; **Omar Olivella**, Graphic Designer; **Matilde Oliveros**, Graphic Designer; **Pablo Ruiz**, Graphic Designer; **Carolina Wainsztok**, Graphic Designer

El Comercio
Lima, Perú (B)

Milagros Rivero-Lores, Designer; **Claudia Burga-Cisneros,** Art Editor; **Xavier Conesa,** Art Director

La Gaceta
San Miguel de Tucumán, Argentina (B)

Sebastian Russo, Designer; **Sergio Fernandez,** Art Director; **Mario Garcia,** Design Consultant

El Correo
Bilbao, Spain (B)

Mikel Garcia Macías, Designer; **Mari Carmen Navarro,** Designer; **Pacho Igartua,** Designer; **Aurelio Garrote,** Design Editor; **Diego Zuñiga,** Concept designer; **Jesús Aycart,** Art Director; **Alberto Torregrosa,** Editorial Art & Design Consultant

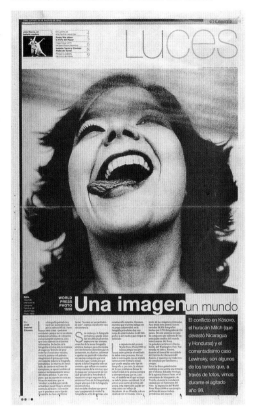

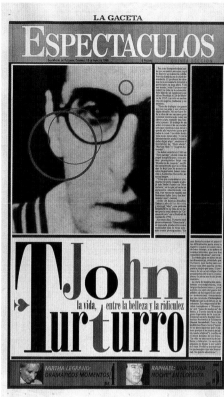

Dayton Daily News
Dayton, Ohio (B)

Randy Palmer, Designer; **Ted Pitts,** Art Director; **James Lloyd,** Section Editor; **John Thompson,** Deputy M.E.

La Gaceta
San Miguel de Tucumán, Argentina (B)

Sebastian Rosso, Designer; **Sergio Fernandez,** Art Director; **Mario Garcia,** Design Consultant

La Gaceta
San Miguel de Tucumán, Argentina (B)

Andrés Tula Molina, Designer; **Daniel Fontanarrosa,** Illustrator; **Sergio Fernandez,** Art Director; **Mario Garcia,** Design Consultant

La Gaceta
San Miguel de Tucumán, Argentina (B)

Sergio Fernandez, Art Director; **Andrés Tula Molina,** Designer; **Mario García,** Design Consultant

La Gaceta
San Miguel de Tucumán, Argentina (B)

Sergio Fernandez, Art Director; **Andrés Tula Molina,** Designer; **Mario García,** Design Consultant

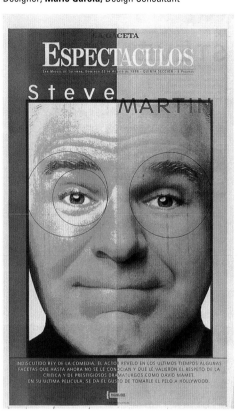

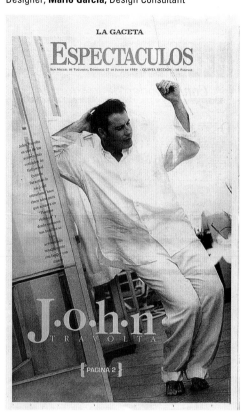

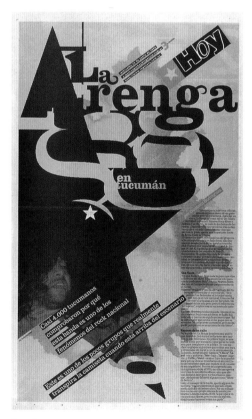

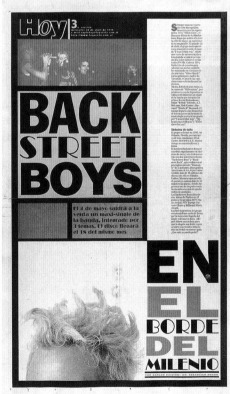

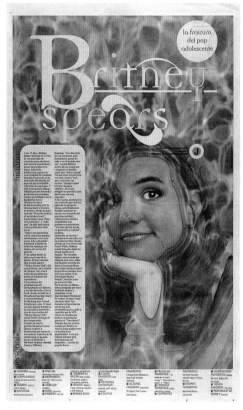

La Gaceta
San Miguel de Tucumán, Argentina (B)

Sebastian Rosso, Designer; **Sergio Fernandez,** Art Director; **Mario Garcia,** Design Consultant

La Gaceta
San Miguel de Tucumán, Argentina (B)

Sebastian Rosso, Designer; **Sergio Fernandez,** Art Director; **Mario Garcia,** Design Consultant

La Gaceta
San Miguel de Tucumán, Argentina (B)

Sebastian Rosso, Designer; **Daniel Fontanarrosa,** Photo Illustrator; **Sergio Fernandez,** Art Director; **Mario Garcia,** Design Consultant

La Gaceta
San Miguel de Tucumán, Argentina (B)
Andrés Tula Molina, Designer; **Sergio Fernandez,** Art Director; **Mario Garcia,** Design Consultant

La Gaceta
San Miguel de Tucuman, Argentina (B)
Sebastian Russo, Designer; **Sergio Fernandez,** Art Director; **Mario Garcia,** Design Consultant

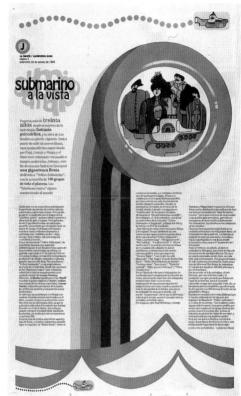

La Gaceta
San Miguel de Tucuman, Argentina (B)
Andrés Tula Molina, Designer; **Sergio Fernandez,** Art Director; **Mario Garcia,** Design Consultant

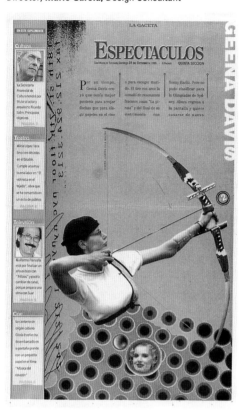

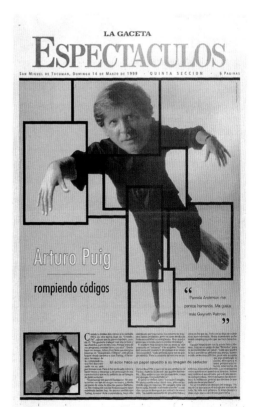

La Gaceta
San Miguel de Tucumán, Argentina (B)
Andrés Tula Molina, Designer; **Sergio Fernandez,** Art Director; **Mario Garcia,** Design Consultant

La Gaceta
San Miguel de Tucumán, Argentina (B)
Andrés Tula Molina, Designer; **Sergio Fernandez,** Art Director; **Mario Garcia,** Design Consultant; **Oscar Ferronato,** Photographer; **Raúl Valverdi,** Illustrator

La Gaceta
San Miguel de Tucumán, Argentina (B)
Sebastian Rosso, Designer; **Sergio Fernandez,** Art Director; **Mario Garcia,** Design Consultant; **Alvaro Aurane,** Editor

The Hartford Courant
Hartford, Conn. (A)
Suzette Moyer, Designer; **Christian Potter Drury,** Art Director; **JoEllen Black,** Photo Editor; **Brad Clift,** Photographer

Göteborgs-Posten
Göteborg, Sweden (A)
Thomas Andersson, Designer

The Hartford Courant
Hartford, Conn. (A)
Suzette Moyer, Designer; **Christian Potter Drury,** Art Director

The Hartford Courant
Hartford, Conn. (A)
Suzette Moyer, Designer; **Christian Potter Drury,** Art Director; **JoEllen Black,** Photo Editor

Herald Sun
Melbourne, Australia (A)
Oliver Hutchison, Designer

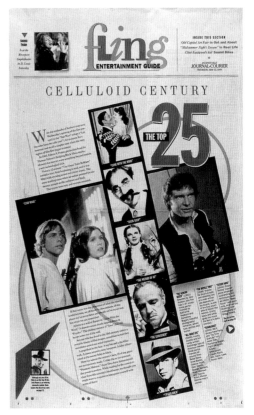

Jacksonville Journal-Courier
Jacksonville, Ill. (C)
Steve Copper, Editor/Designer; **Mike Miner,** Designer

Jacksonville Journal-Courier
Jacksonville, Ill. (C)
Steve Copper, Editor/Designer; **Mike Miner**, Designer

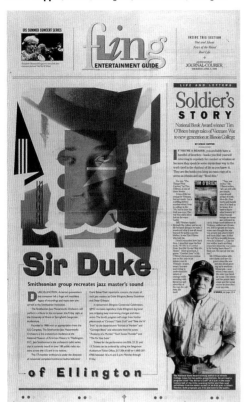

El Mundo La Luna
Madrid, Spain (A)
Rodrigo Sánchez, Art Director & Designer; **Francisco Dorado**, Designer; **Chano del Rio**, Designer; **Carmelo Caderot**, Design Director

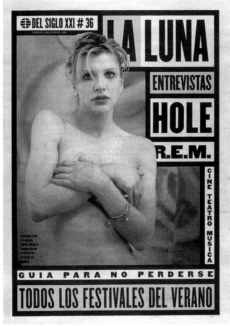

El Mundo La Luna
Madrid, Spain (A)
Rodrigo Sánchez, Art Director & Designer; **Francisco Dorado**, Designer; **Chano del Rio**, Designer; **Carmelo Caderot**, Design Director

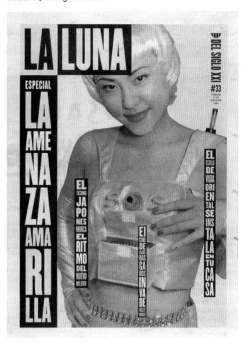

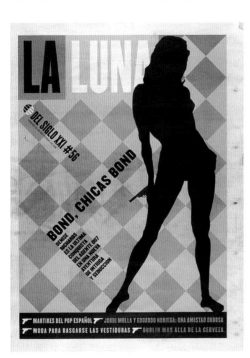

El Mundo La Luna
Madrid, Spain (A)
Rodrigo Sánchez, Art Director & Designer; **Francisco Dorado**, Designer; **Chano del Rio**, Designer; **Carmelo Caderot**, Design Director

El Mundo La Luna
Madrid, Spain (A)
Rodrigo Sánchez, Art Director & Designer; **Francisco Dorado**, Designer; **Chano del Rio**, Designer; **Carmelo Caderot**, Design Director

El Mundo La Luna
Madrid, Spain (A)
Rodrigo Sánchez, Art Director & Designer; **Francisco Dorado**, Designer; **Chano del Rio**, Designer; **Carmelo Caderot**, Design Director

El Mundo La Luna
Madrid, Spain (A)

Rodrigo Sánchez, Art Director & Designer; **Francisco Dorado,** Designer; **Chano del Rio,** Designer; **Carmelo Caderot,** Design Director

El Mundo La Luna
Madrid, Spain (A)

Rodrigo Sánchez, Art Director & Designer; **Francisco Dorado,** Designer; **Chano del Rio,** Designer; **Carmelo Caderot,** Design Director

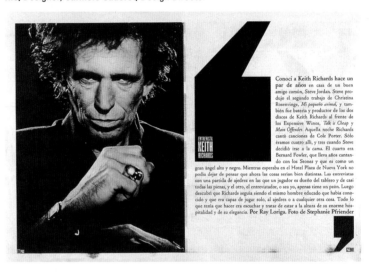

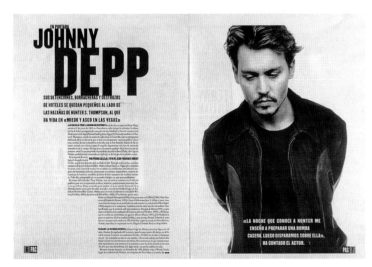

El Mundo La Luna
Madrid, Spain (A)

Rodrigo Sánchez, Art Director & Designer; **Francisco Dorado,** Designer; **Chano del Rio,** Designer; **Carmelo Caderot,** Design Director

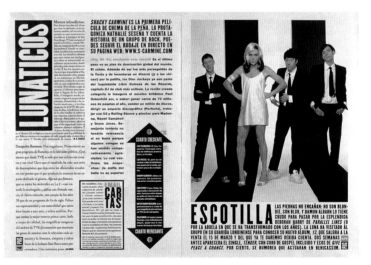

El Mundo La Luna
Madrid, Spain (A)

Rodrigo Sánchez, Art Director & Designer; **Francisco Dorado,** Designer; **Chano del Rio,** Designer; **Carmelo Caderot,** Design Director

El Mundo La Luna
Madrid, Spain (A)

Rodrigo Sánchez, Art Director & Designer; **Francisco Dorado,** Designer; **Chano del Rio,** Designer; **Carmelo Caderot,** Design Director

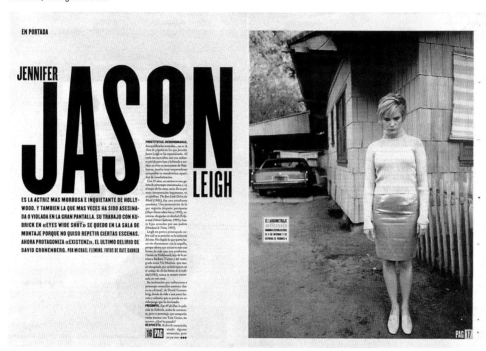

Mural
Zapopan, México (C)

Fernando Jauregui, Designer; **Gustavo Belmán,** Graphics Editor; **José Merino,** Graphics Editor; **Jorge Vidrio,** Art Director; **Eduardo Danilo,** Design Consultant; **John Carlos Garda,** Editor

El Mundo La Luna
Madrid, Spain (A)

Rodrigo Sánchez, Art Director & Designer; **Francisco Dorado,** Designer; **Chano del Rio,** Designer; **Carmelo Caderot,** Design Director

Mural
Zapopan, México (C)

Fernando Jauregui, Designer; **Gustavo Belmán,** Graphics Editor; **José Merino,** Graphics Editor; **Jorge Vidrio,** Art Director; **Eduardo Danilo,** Design Consultant; **Juan Carlos Garda,** Editor

Marca
Madrid, Spain (A)
José Juan Gámez, Art Director; **Miguel A. Linares**, Editor; **Juan C. Fernández**, Graphic Designer

The Orange County Register
Santa Ana, Calif. (A)
Martin Gee, Designer; **Kris Viesselman**, Art Director

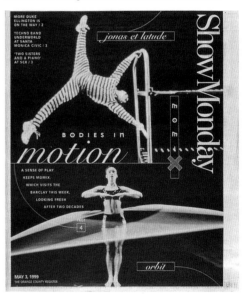

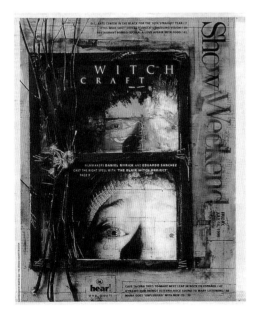

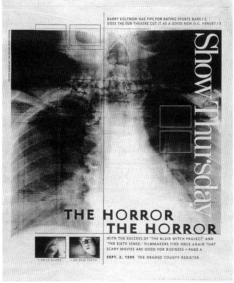

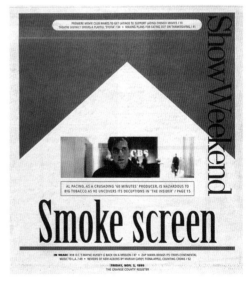

The Orange County Register
Santa Ana, Calif. (A)
Martin Gee, Designer & Illustrator; **Kris Viesselman**, Art Director

The Orange County Register
Santa Ana, Calif. (A)
Martin Gee, Designer & Illustrator; **Kris Viesselman**, Art Director

The Orange County Register
Santa Ana, Calif. (A)
Martin Gee, Designer; **Kris Viesselman**, Art Director

La Presse
Montreal, Que., Canada (A)

André Rivest, Graphic Designer; **Yves De Repentigny**, Section Editor; **Bernard Brault**, Photographer; **Robert Skinner**, Photographer

The Orange County Register
Santa Ana, Calif. (A)

Rick Ngoc Ho, Designer; **Kris Viesselman**, Art Director

The Orange County Register
Santa Ana, Calif. (A)

Peter Nguyen, Designer; **Kris Viesselman**, Art Director

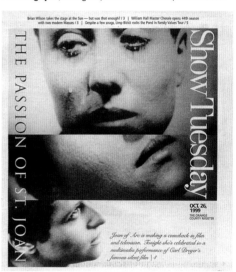

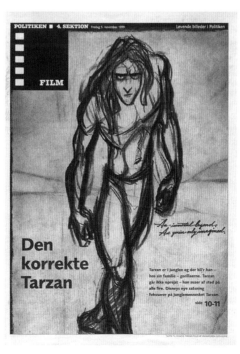

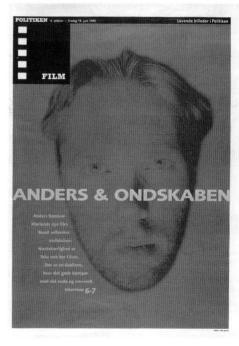

Politiken
Copenhagen, Denmark (A)

Søren Nyeland, Design Editor; **Mikkel Henssel**, Designer; **Charlotte Sejer Pedersen**, Editor; **Else Bjørn**, Editor

Politiken
Copenhagen, Denmark (A)

Søren Nyeland, Design Editor; **Marianne Bahl**, Page Designer; **Stig Dyre**, Editor

Politiken
Copenhagen, Denmark (A)

Søren Nyeland, Design Editor; **Karina Kofoed**, Page Designer; **Stig Dyre**, Editor

de Volkskrant
Amsterdam, The Netherlands (A)

Jos Collignon, Artist

The Seattle Times
Seattle, Wash. (A)

Jeff Neumann, Designer

The Seattle Times
Seattle, Wash. (A)

Jeff Neumann, Designer

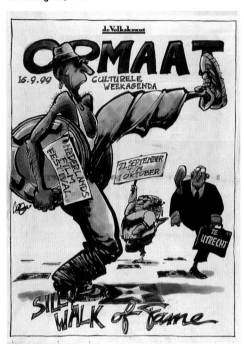

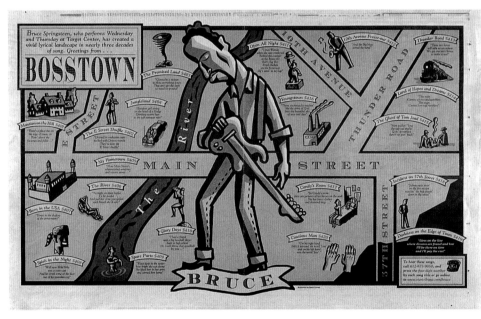

Star Tribune
Minneapolis, Minn. (A)

Denise M. Reagan, Designer/Art Director; **David Cowles,** Illustrator; **Tim Campbell,** Team Leader; **Jon Bream,** Writer; **Anthony Lonetree,** Reporter

de Volkskrant
Amsterdam, The Netherlands (A)

Gonnie Tijs, Designer; **Eric Polman,** Artist; **Ronald Ockhuysen,** Film critic

de Volkskrant
Amsterdam, The Netherlands (A)
Harald Vlugt, Artist; **Edo Kuiopers**, Photographer

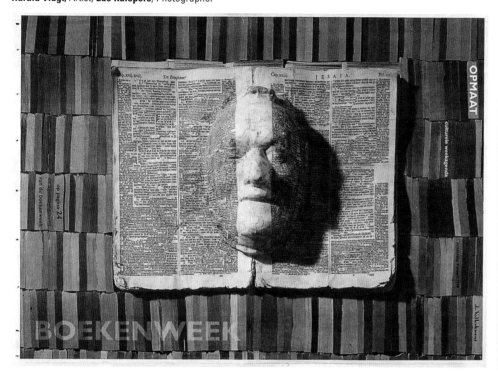

de Volkskrant
Amsterdam, The Netherlands (A)
Michael Ferron, Photographer & designer

de Volkskrant
Amsterdam, The Netherlands (A)
Lucy Prijs, Designer; **Pol Dom**, Artist

The Washington Post
Washington, D.C. (A)
JoEllen Murphy, Art Director; **Diane Teske Harris**, Illustrator

Winnipeg Free Press
Winnipeg, Canada (B)
Gordon Preece, Art Director

Silver
El Norte
Monterrey, México (B)

Lourdes Solis, Editor Director; **Gerardo Garza**, Photographer; **Guillermo Reyes**, Graphic Coordinator; **Dolores Carrillo**, Digital Art; **Eduardo Danilo**, Design consultant; **Ramón Alberto Garza**, General Editor Director; **Martha A. Treviño**, Editor Director; **Carmen Escobedo**, Design Manager Editor; **Gabriela Villarreal**, Designer; **Altagracia Fuentes**, Section Editor

Like the headline, this page is more than rare — it is exotic. The design communicates the idea well with good color. It's pleasingly subtle and funky. It's like music the first time you listen to it, it's just all right, the second time you hear it you begin to recognize the subtleties in the music, and by the third and fourth times you hear it you really start to love it.

Como el titular, esta página es más que rara – es exótica. El diseño comunica esa idea utilizando bien el color. Es sutilmente picante. Es como escuchar un nuevo disco compacto – la primera vez nos parece bien; la segunda vez descubrimos las sutilezas en la música; y la tercera vez nos encanta.

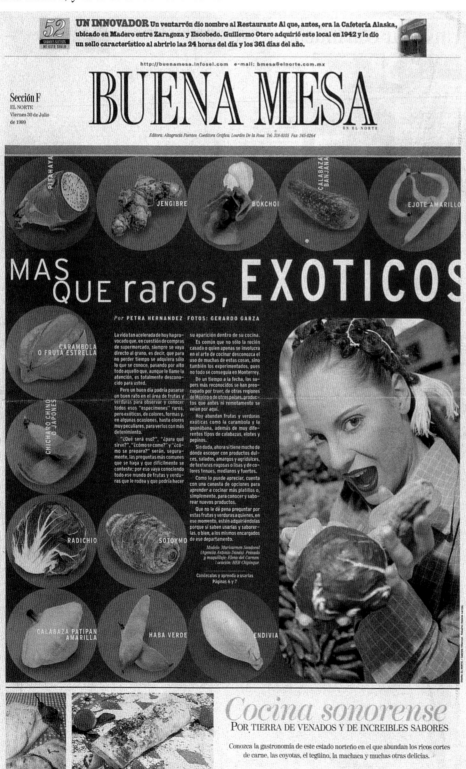

The Boston Globe
Boston, Mass. (A)

Jacqueline Berthet, Designer; **Pam Berry**, Photographer; **Dan Zedek**, Editorial Design Director

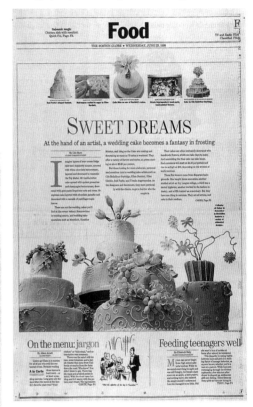

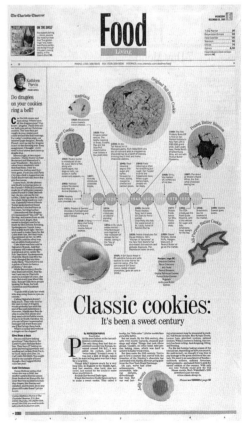

The Charlotte Observer
Charlotte, N.C. (A)

Brenda Pinnell, Designer; **Davie Hinshaw**, Photographer; **Kathleen Purvis**, Food Editor; **Gina Nania**, Copy Editor; **Ted Yee**, Design Team Leader; **Jim Denk**, Design Director

Chicago Tribune
Chicago, Ill. (A)

Kate Elazegui, Art Director; **Bob Fila**, Photographer; **Carol Haddix**, Editor

Silver
The Times-Picayune
New Orleans, La. (A)

Beth Aguillard, Designer; **Ellis Lucia**, Photographer; **Jean McIntosh**, Art Director; **Dale Curry**, Editor; **George Berke**, Design Director; **Kenneth Harrison**, Illustrator

A clever approach to rain, it's also well executed and has a sense of humor you don't often see in many feature pages.

Esta es una inteligente manera de presentar la lluvia. Está muy bien ejecutada, y presenta el humor que no estamos acostumbrados a ver en muchas páginas de features.

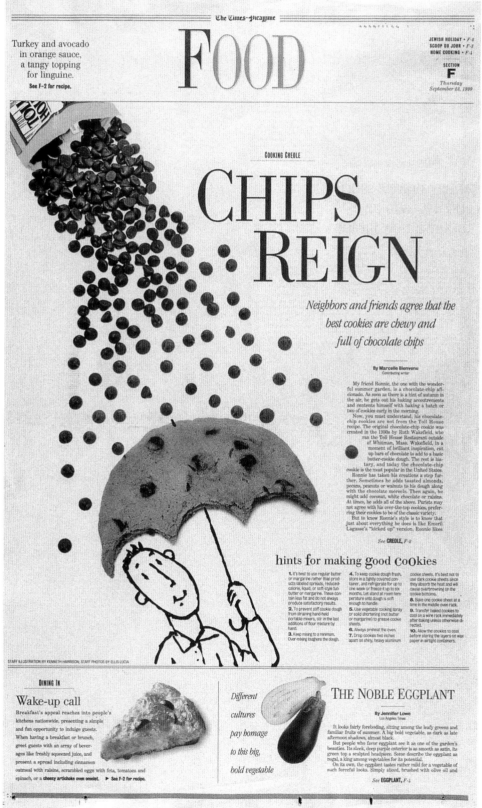

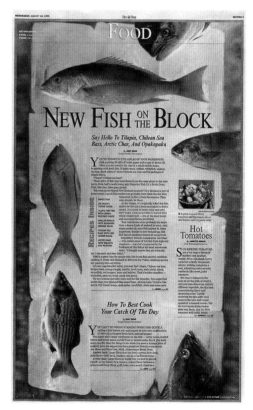

The Day
New London, Conn. (C)

Sara Kaplow, Page Designer; **Karen Ward**, Art Director

Anchorage Daily News
Anchorage, Alaska (B)
Pamela Dunlap-Shohl, Page Designer; **Lin Mitchell**, Photographer

Berlingske Tidende
DK-1147 Copenhagen K, Denmark (B)
Ida Jerichow, Page Designer

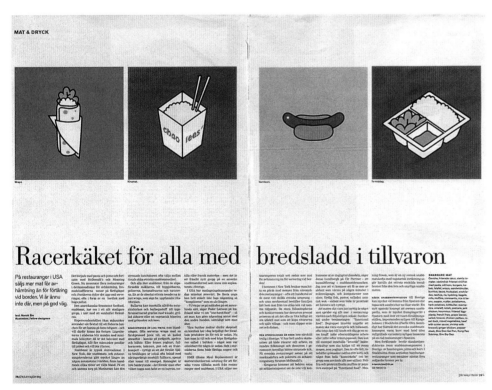

Dagens Nyheter
Stockholm, Sweden (A)
Pompe Hedengren, Art Director; **Rolf Stohr**, Page Designer; **Staff** Illustrators

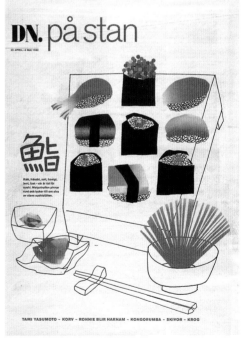

DN på stan
Stockholm, Sweden (A)
Ebba Bonde, Art Director; **Magnus Naddermier**, Art Director; **Stina Wirsén**, Illustrator

La Gaceta
San Miguel de Tucumán, Argentina (B)
Sebastian Rosso, Designer; **Sergio Fernandez,** Art Director; **Mario Garcia,** Design Consultant

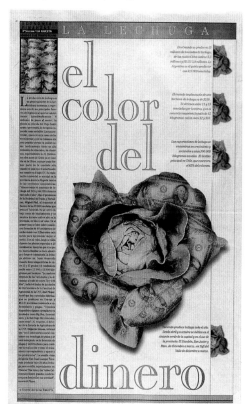

The New York Times
New York, N.Y. (A)
Nicki Kalish, Art Director; **Kiyoshi Togashi,** Photographer

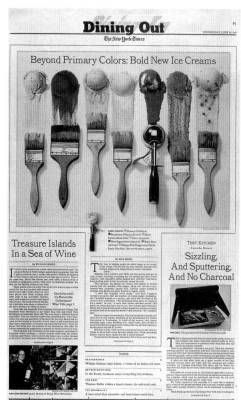

The Register-Guard
Eugene, Ore. (B)
Carl Davaz, Deputy M.E.; **Nicole DeVito,** Photographer

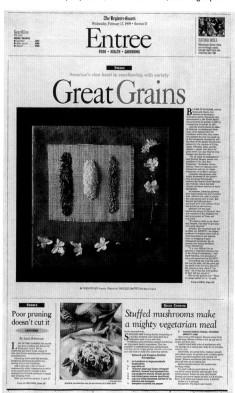

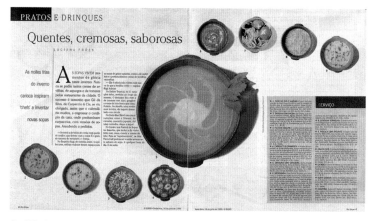

O Globo
Rio de Janiero, Brazil (A)
Leonardo Drumond, Designer; **Claudia Belem,** Editor; **Guto Costa,** Photographer

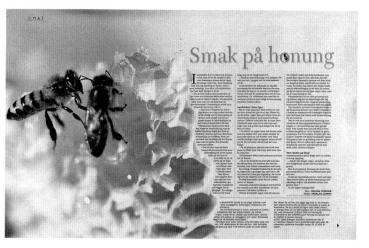

Göteborgs-Posten
Göteborg, Göteborg, Sweden (A)
Honna Anderson, Designer; **Roger Olsson,** Designer; **Nicklas Elminn,** Photographer

The San Diego Union-Tribune
San Diego, Calif. (A)

Martina Schimitschek, Designer; **John Nelson,** Photographer

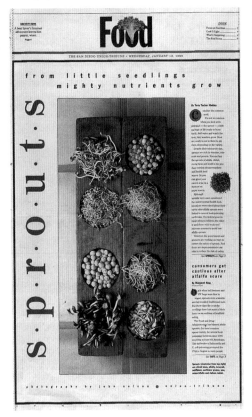

St. Petersburg Times
St. Petersburg, Fla. (A)

Kris Karnopp, Features Designer

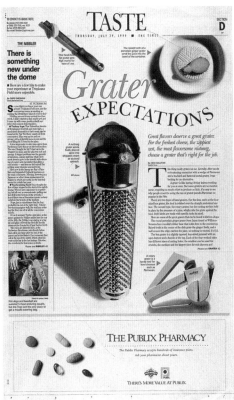

Star Tribune
Minneapolis, Minn. (A)

Rhonda Prast, Designer; **Tom Wallace,** Photographer; **Lee Svitak Dean,** Taste Editor

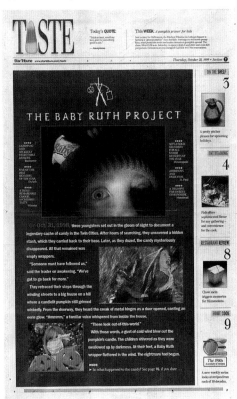

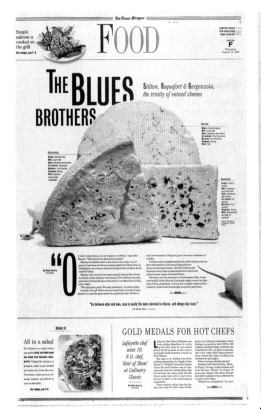

The Times-Picayune
New Orleans, La. (A)

Beth Aguillard, Designer; **Eliot Kamenitz,** Photographer; **Jean McIntosh,** Art Director; **Dale Curry,** Editor; **George Berke,** Design Director

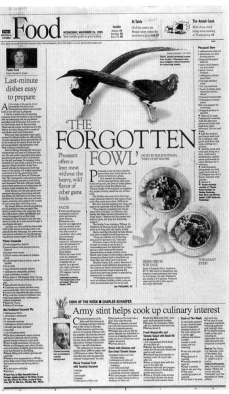

The Times of Northwest Indiana
Munster, Ind. (B)

Catherine Whipple, Design Team Leader/Features Designer

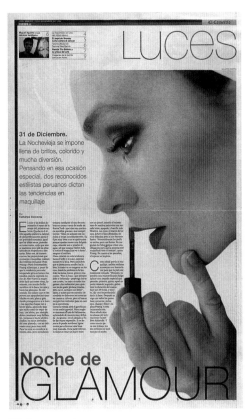

El Comercio
Lima, Perú (B)

Xavier Diaz de Cerio, Designer; **Claudia Burga Cisneros,** Art Editor; **Xavier Conesa,** Art Director

El Imparcial
Hermosillo, México (C)

Zaida Cinco, Designer; **Javier Sandoval**, Photographer; **Sergio Serrano**, Art Director; **Ana Mercedes Espinoza**, Editor

El Imparcial
Hermosillo, México (C)

Zaida Cinco, Designer; **Ana Cé**, Photographer; **Sergio Serrano**, Art Director; **Ana Mercedes Espinoza**, Editor

Denver Rocky Mountain News
Denver, Colo. (A)

Kris Scott, Designer; **Essdras Suarez**, Photographer

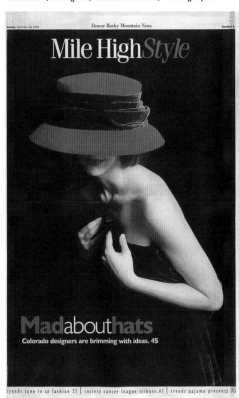

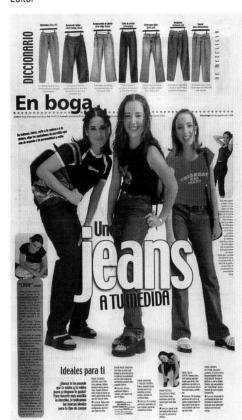

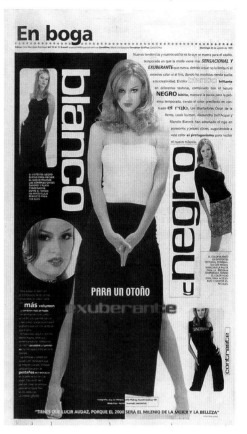

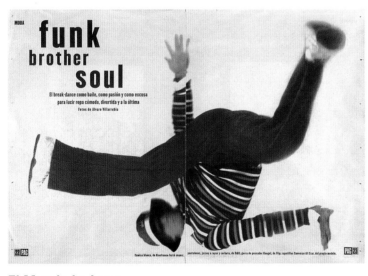

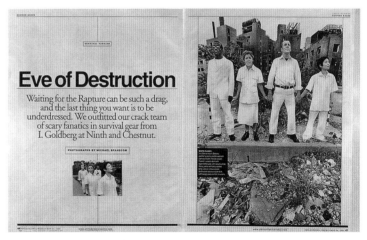

El Mundo La Luna
Madrid, Spain (A)

Rodrigo Sánchez, Art Director & Designer; **Francisco Dorado**, Designer; **Chano del Rio**, Designer; **Carmelo Caderot**, Design Director

Philadelphia Weekly
Philadelphia, Pa. (B)

Alfred Jones, Art Director; **Michael Branscom**, Photographer

El Norte
Monterrey, México (B)

Gabriela Villarreal, Designer; **Claudia Susana Flores**, Photographer; **Guillermo Reyes**, Graphic coordinator; **Diana Marcos Kawas**, Section Editor; **Eduardo Danilo**, Design consultant; **Lourdes Solis**, Editor Director; **Martha A. Treviño**, Editor Director; **Carmen Escobedo**, Design Manager Editor; **Ramón Alberto Garza**, General Editor Director

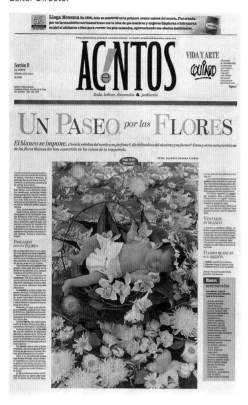

Politiken
Copenhagen, Denmark (A)

Søren Nyeland, Design Editor; **Marianne Gram**, Editor; **Eyben eller Bahl**, Page Designer; **Anette Vestergaard**, Copy Editor; **Annette Nyvang**, Copy Editor

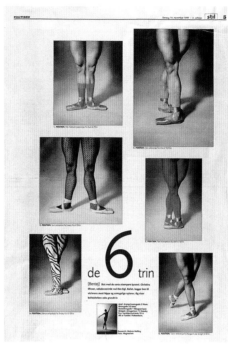

Politiken
Copenhagen, Denmark (A)

Søren Nyeland, Design Editor; **Marianne Gram**, Editor; **Elisabeth S. von Eyben**, Page Designer; **Anette Vestergaard**, Copy Editor; **Annette Nyvang**, Copy Editor; **Peter Hove Olesen**, Photographer

Svenska Dagbladet
Stockholm, Sweden (A)

Anders Lindgren, Designer; **Daniel Burfitt**, Artist

The Boston Globe
Boston, Mass. (A)

Susan Levin, Designer; **Louise Kennedy**, Editor; **Dan Zedek**, Editorial Design Director

The Boston Globe
Boston, Mass. (A)

Debra Page-Trim, Art Director/Designer; **John Tlumacki**, Photographer; **Dan Zedek**, Editorial Design Director

The Columbus Dispatch
Columbus, Ohio (A)

Scott Minister, Art Director & Designer; **Aaron Harden,**
Artist; **Cindy Decker,** Editor

Dagens Nyheter
Stockholm, Sweden (A)

Nima Andén, Page Designer; **Beatrice Lundborg,**
Photographer

The Dallas Morning News
Dallas, Texas (A)

Karen Dee Davis, Designer/Illustrator

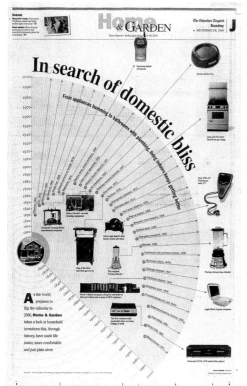

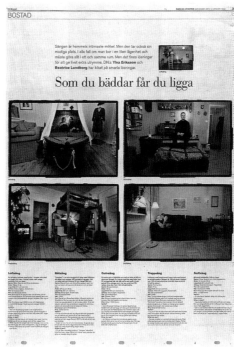

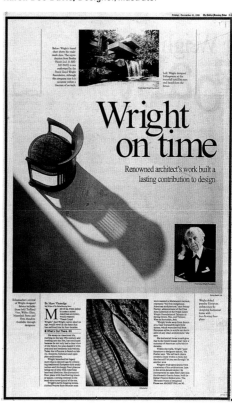

Dagens Nyheter
Stockholm, Sweden (A)

Peter Alenas, Art Director; **Magnus Naddermier,** Art Director; **Louise Billgert,** Photographer;
Franciska Mouyem, Page Designer

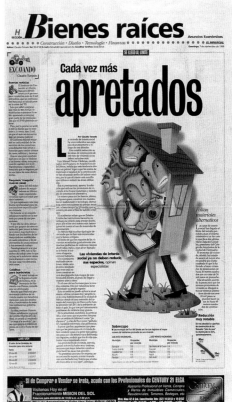

El Imparcial
Hermosillo, México (C)

Zaida Cinco, Designer; **Chiara Bautista,** Illustrator;
Sergio Serrano, Art Director; **Claudio Tiznado,** Editor

The News & Observer
Raleigh, N.C. (B)

Sherry Carwell, Designer; **Laurie Evans,** Editor

San Francisco Examiner
San Francisco, Calif. (B)

Patrick Sedlar, Designer

Morgenavisen Jyllands-Posten
Viby j, Denmark (A)

Lars Pryds, Page/Graphic Designer

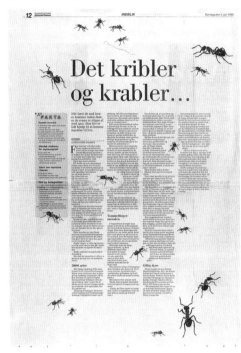

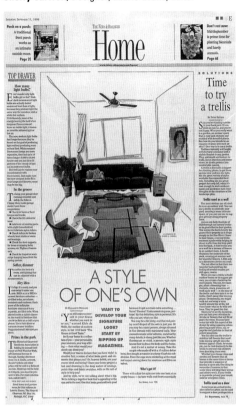

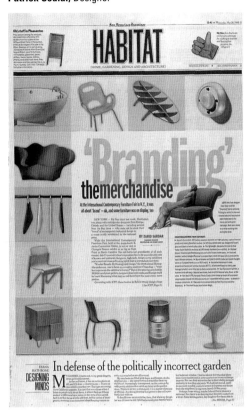

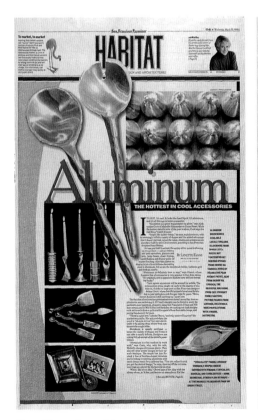

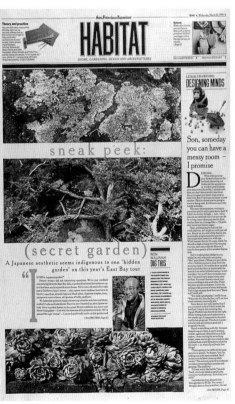

San Francisco Examiner
Livonia, Mich. (B)

Patrick Sedlar, Designer; **Penni Gladstone,**
Photographer; **Katy Raddatz,** Photographer

San Francisco Examiner
Livonia, Mich. (B)

Patrick Sedlar, Designer; **Penni Gladstone,**
Photographer; **Jo Mancuso,** Habitat Editor

The Seattle Times
Seattle, Wash. (A)

Tracy Porter, Designer/Section Coordinator; **Karen
West,** Editor; **James McFarlane,** Illustrator

The Boston Globe
Boston, Mass. (A)

Rena Sokolow, Art Director & Designer; **Patrick Blackwell,** Ilustrator; **Dan Zedek,** Editorial Design Director

The Boston Globe
Boston, Mass. (A)

Keith A. Webb, Art Director & Designer; **Dan Zedek,** Editorial Design Director

The Washington Post
Washington, D.C. (A)

Alice Kresse, Art Director & Designer; **Mark Finkeustaedt,** Photographer

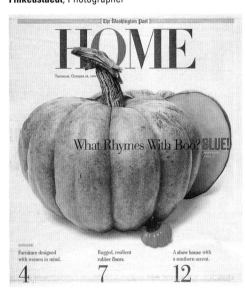

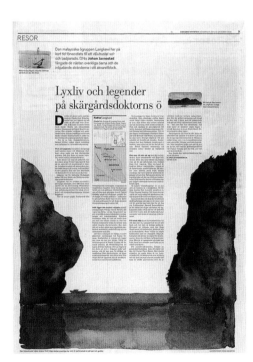

Dagens Nyheter
Stockholm, Sweden (A)

Maria Hunt, Page Designer

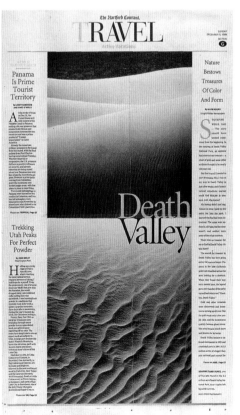

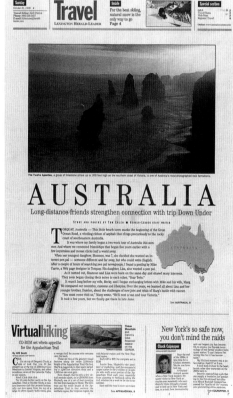

The Hartford Courant
Hartford, Conn. (A)

Melanie Shaffer, Designer; **Christian Potter Drury,** Art Director; **JoEllen Black,** Photo Editor

Lexington Herald-Leader
Lexington, Ky. (B)

Epha Good, Presentation Director

Liberty Times
Taipei, Taiwan (A)

Tung Ku-Ying, Art Director; **Tu Yu-Pei**, Designer

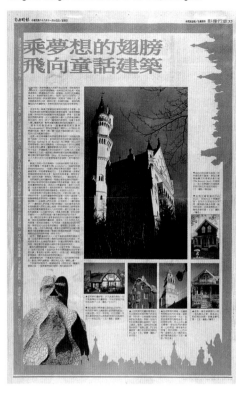

The Miami Herald
Miami, Fla. (A)

Jane Woolridge, Editor; **Ana Lense Larrauri**, Designer/Illustrator; **Nuri Ducassi**, Art Director

The New York Times
New York, N.Y. (A)

Barbara Richer, Art Director; **Olaf Hajek**, Illustrator

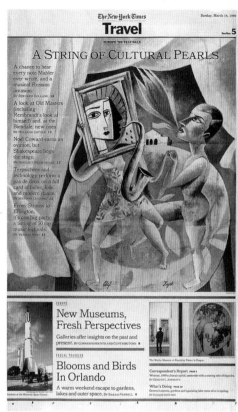

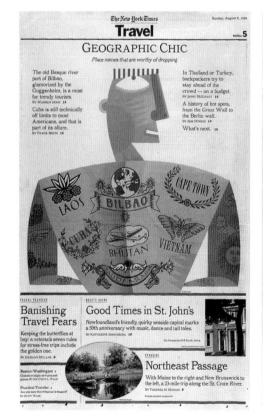

The New York Times
New York, N.Y. (A)

Barbara Richer, Art Director; **Gordon Studer**, Illustrator

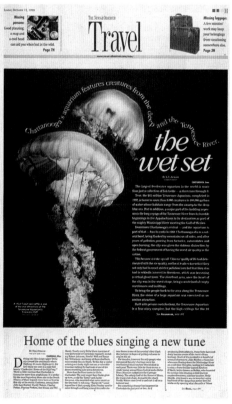

The News & Observer
Raleigh, N.C. (B)

Sherry Carwell, Designer; **David Alff**, Editor

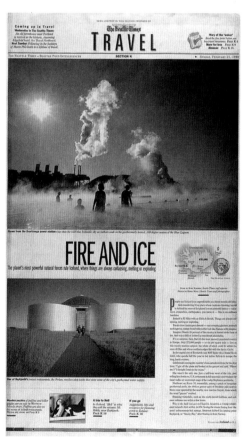

The Seattle Times
Seattle, Wash. (A)

Tracy Porter, Designer; **Barry Wong**, Photographer;
Aldo Chan, Designer
• also an **Award of Excellence** for Feature Photography

Politiken
Copenhagen, Denmark (B)

Søren Nyeland, Design Editor; **Tomas Østergren,** Design/Photos/Words; **Marianne Gram,** Editor

Politiken
Copenhagen, Denmark (B)

Søren Nyeland, Design Editor; **Tomas Østergren,** Design/Photos/Words; **Marianne Gram,** Editor

de Volkskrant
Amsterdam, The Netherlands (A)

Willum Morsch, Graphics Editor; **Aleid Bos,** Designer; **Chris Kijne,** Writer

La Voz del Interior
Córdoba, Argentina (B)

Javier Candellero, Designer; **Miguel De Lorenzi,** Art Director; **María Cristina Navajas,** Editor; **Mario Garcia,** Design Consultant

The Washington Post
Washington, D.C. (A)

Michael Keegan, Art Director; **Marty Barrick,** Designer; **Marc Rosenthal,** Illustrator

Frontera
Tijuana, México (C)
Hugo Torres, Designer/Art Director; **Christian Fortanet,** Design Consultant; **Dianeth Perez,** Editor; **Tomas Escalante,** Photography Coordinator

Silver
The Orange County Register
Santa Ana, Calif. (A)
Peter Nguyen, Designer; **Kris Viesselman,** Art Director

The integrated type works so well in the binary code of 1's and 0's in a clever and effective manner. Even the reefers are integrated into the cover imagery very well.

Esta tipografía integrada funciona bien en código binario de unos y ceros. Es inteligente y efectivo. Inclusive las notas de referencia están expertamente integradas en la imagen de portada.

La Gaceta
San Miguel de Tucuman, Argentina (B)
Reinoso Gallo Héctor H., Designer; **Sergio Fernandez,** Art Director; **Mario Garcia,** Art Director

La Gaceta
San Miguel de Tucuman, Argentina (B)
Reinoso Gallo Héctor H., Designer; **Sergio Fernandez,**
Art Director; **Mario Garcia,** Design Consultant

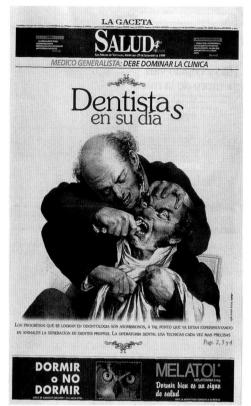

El Imparcial
Hermosillo, México (C)
Zaida Cinco, Designer; **Chiara Bautista,** Illustrator;
Sergio Serrano, Art Director; **Federico Cirett,** Editor

Göteborgs-Posten
Göteborg, Sweden (A)
Ragnhild Berelund, Editorial Designer; **Helena
Bergendahl,** Illustrator; **Oskar Guth,** Graphic Designer

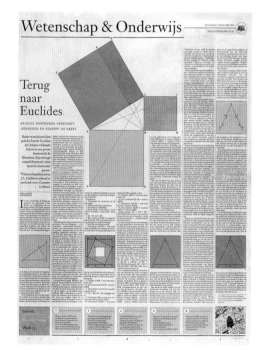

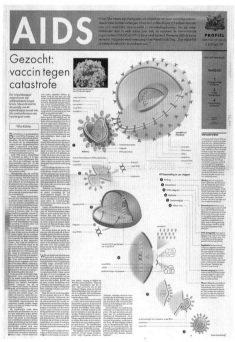

The Orange County Register
Santa Ana, Calif. (A)
Peter Nguyen, Designer; **Kris Viesselman,** Art Director

NRC Handelsblad
Rotterdam, The Netherlands (A)
Henry Cannon, Page Designer

NRC Handelsblad
Rotterdam, The Netherlands (A)
Norbert Bos, Page Designer; **Maarten Boddaert,**
Graphic Artist

The Orange County Register
Santa Ana, Calif. (A)

Peter Nguyen, Designer; **Kris Viesselman,** Art Director; **Sharon Henry,** Artist

The Orange County Register
Santa Ana, Calif. (A)

Peter Nguyen, Designer/Artist; **Kris Viesselman,** Art Director

The Orange County Register
Santa Ana, Calif. (A)

Martin Gee, Designer; **Martin Gee,** Illustrator; **Kris Viesselman,** Art Director

The Orange County Register
Santa Ana, Calif. (A)

Peter Nguyen, Designer/Artist; **Kris Viesselman,** Art Director

The Orange County Register
Santa Ana, Calif. (A)

Peter Nguyen, Artist/Designer; **Kris Viesselman,** Art Director

The Orange County Register
Santa Ana, Calif. (A)

Peter Nguyen, Designer/Artist; **Kris Viesselman,** Art Director

The Orange County Register
Santa Ana, Calif. (A)

Martin Gee, Illustrator & Designer; **Kris Viesselman,** Art Director

Politiken
Copenhagen, Denmark (B)

Søren Nyeland, Design Editor; **Tomas Østergren,** Design/Photos/Words; **Leif Jonasson,** Editor

Weltspiegel
Munich, Germany (B)

Ursula Dahmen, Free-lance Art Director/Consultant

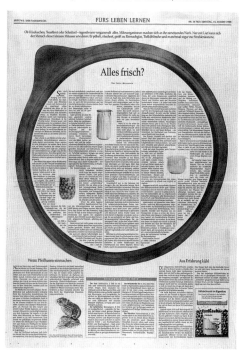

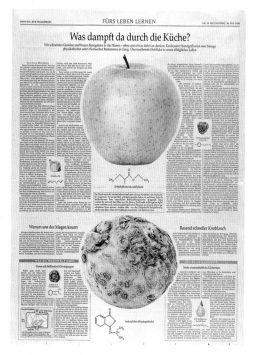

Weltspiegel
Munich, Germany (B)

Ursula Dahmen, Free-lance Art Director/Consultant

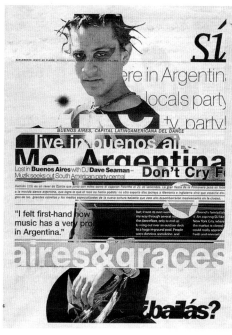

Clarín
Buenos Aires, Argentina (A)

Iñaki Palacios, Art Director; **Tea Alberti,** Design Editor; **Oscar Bejarano,** Graphic Designer; **Valeria Castresana,** Graphic Designer; **Silvina Fuda,** Graphic Designer; **Maria Heinberg,** Graphic Designer; **Omar Olivella,** Graphic Designer; **Matilde Oliveros,** Graphic Designer; **Pablo Ruiz,** Graphic Designer; **Carolina Wainsztok,** Graphic Designer

Clarín
Buenos Aires, Argentina (A)

Iñaki Palacios, Art Director; **Tea Alberti,** Design Editor; **Oscar Bejarano,** Graphic Designer; **Valeria Castresana,** Graphic Designer; **Silvina Fuda,** Graphic Designer; **Maria Heinberg,** Graphic Designer; **Omar Olivella,** Graphic Designer; **Matilde Oliveros,** Graphic Designer; **Pablo Ruiz,** Graphic Designer; **Carolina Wainsztok,** Graphic Designer

Gold
Clarín
Buenos Aires, Argentina (A)

Pablo Ruiz, Artist; **Tea Alberti**, Design Editor; **Oscar Bejarano**, Graphic Designer; **Valeria Castresana**, Graphic Designer; **Silvina Fuda**, Graphic Designer; **Maria Heinberg**, Graphic Designer; **Omar Olivella**, Graphic Designer; **Matilde Oliveros**, Graphic Designer; **Iñaki Palacios**, Art Director

The staff of Clarín seems to have thought of just about everything that can make type become an illustration. This rare approach is a treat, and is carried through down to the last detail.

El equipo del Clarín parece haber pensado acerca de absolutamente todo para transformar la tipografía en ilustración. Este particular acercamiento es una delicia, el cual es presentado con exactitud de detalle.

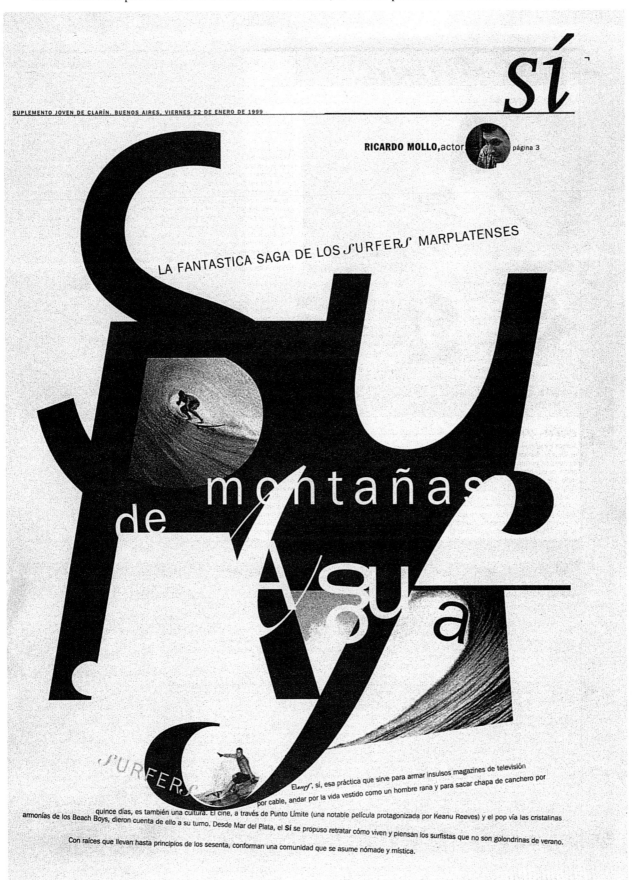

Clarín
Buenos Aires, Argentina (A)

Iñaki Palacios, Art Director; **Tea Alberti**, Design Editor; **Oscar Bejarano,** Graphic Designer; **Valeria Castresana,** Graphic Designer; **Silvina Fuda,** Graphic Designer; **Maria Heinberg,** Graphic Designer; **Omar Olivella,** Graphic Designer; **Matilde Oliveros,** Graphic Designer; **Pablo Ruiz,** Graphic Designer; **Carolina Wainsztok,** Graphic Designer

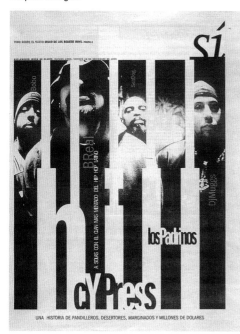

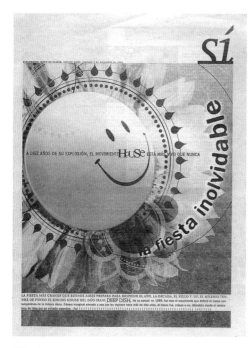

Clarín
Buenos Aires, Argentina (A)

Iñaki Palacios, Art Director; **Tea Alberti**, Design Editor; **Oscar Bejarano,** Graphic Designer; **Valeria Castresana,** Graphic Designer; **Silvina Fuda,** Graphic Designer; **Maria Heinberg,** Graphic Designer; **Omar Olivella,** Graphic Designer; **Matilde Oliveros,** Graphic Designer; **Pablo Ruiz,** Graphic Designer; **Carolina Wainsztok,** Graphic Designer

Silver
Clarín
Buenos Aires, Argentina (A)

Iñaki Palacios, Art Director; **Tea Alberti**, Design Editor; **Oscar Bejarano,** Graphic Designer; **Valeria Castresana,** Graphic Designer; **Silvina Fuda,** Graphic Designer; **Maria Heinberg,** Graphic Designer; **Omar Olivella,** Graphic Designer; **Matilde Oliveros,** Graphic Designer; **Pablo Ruiz,** Graphic Designer; **Carolina Wainsztok,** Graphic Designer

 Clarín expresses the nature of the story well through the proper use of type, which goes well with the subject. Despite the lack of color on the page, the reader still functions like it has color because of the type style and the way it is shaped around the face.

El Clarín expresa efectivamente la naturaleza de la historia a través de la tipografía, la cual va con el carácter del tema. A pesar de la carencia de color en la página, el lector puede aún visualizar color debido al estilo tipográfico y a la manera cómo éste se ubica alrededor de la cara.

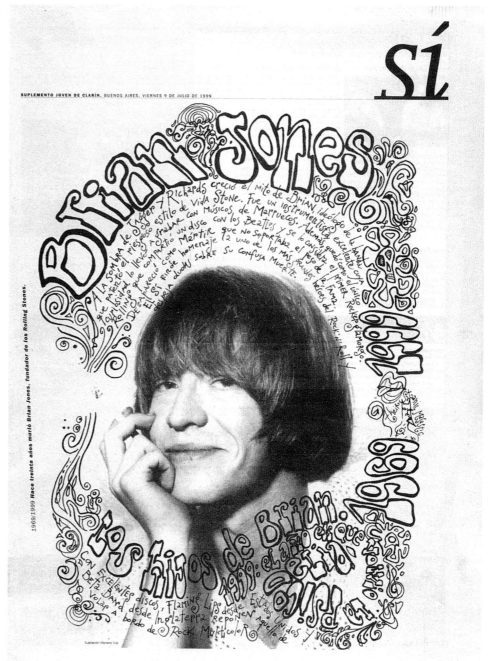

Silver
Página/12
Buenos Aires, Argentina (B)
Alejandro Ros, Art Director; **Juliana Rosatto**, Graphic Designer

The judges liked the subtle way the clock idea was combined with the anniversary of this publication. It's an elegant and clever way to stretch the identity of the magazine.

Al jurado le gustó la manera sutil en que la idea del reloj se combina con el aniversario de esta publicación. Se trata de una manera inteligente y elegante de presentar la identidad de la revista.

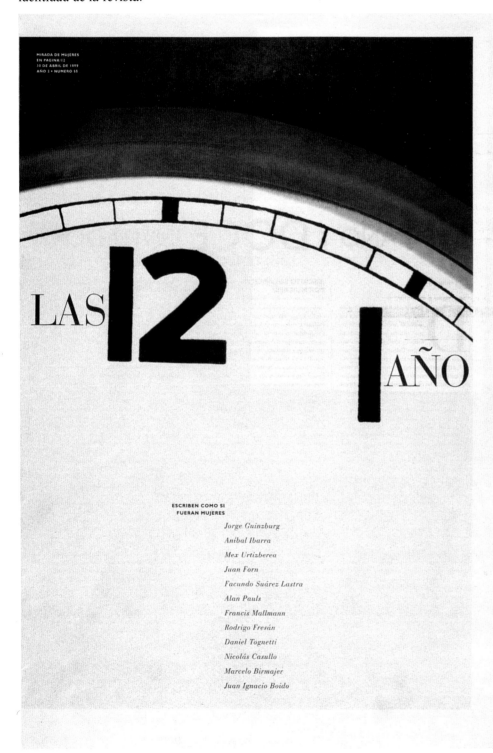

Daily Times-Call
Longmont, Colo. (C)
Keli Brooks, Graphic Artist; **Lewis Geyer**, Photographer

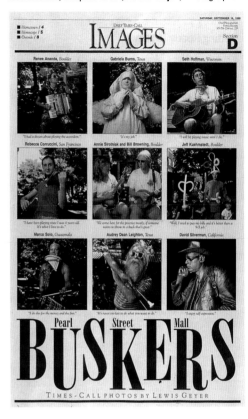

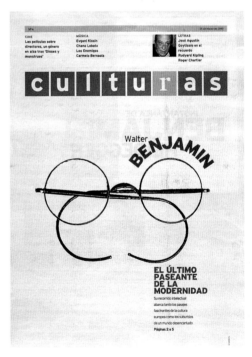

Diario de Sevilla
Sevilla, Spain (C)
Ferrán Grau, Art Director; **Miguel Moreno**, Section Coordinator; **Juan Carlos Zambrano**, Design Coordinator; **Rafael Avilés**, Designer; **José Manuel Barranco**, Designer; **Manuel González**, Designer; **José Antonio Sánchez**, Designer; **José María Ruiz**, Designer

Göteborgs-Posten
Göteborg, Sweden (A)
Karin Nilsson, Designer; **Leslie Johnson,** Photographer

Silver
Página/12
Buenos Aires, Argentina (B)
Alejandro Ros, Art Director; **M. Florencia Helguera,** Art Director/Graphic Designer

 This is a nice tribute to Saul Bass that feels like one of his movie posters or opening movie titles.

Este es un hermoso tributo a Saul Bass que pareciera ser un cartel de cine.

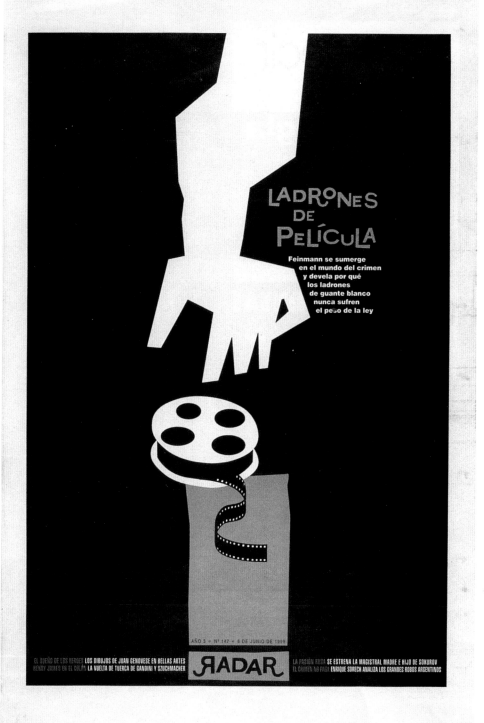

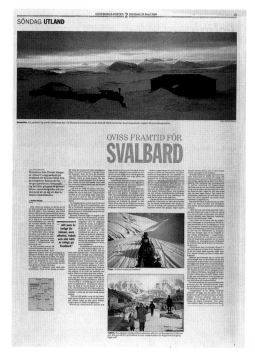

Göteborgs-Posten
Göteborg, Sweden (A)
Thomas Andersson, Designer; **Bjorn Lindahl,**
Photographer

Silver
San Jose Mercury News
San Jose, Calif. (A)
David Frazier, Illustrator & Designer

We were impressed by the way the topic was handled in a very creative way. There is a lot going on in the illustration, and it functions with the story very well.

Este participante impresionó al jurado debido a que los temas fueron manejados creativamente. Hay muchas cosas que se presentan en la ilustración, lo cual funciona muy bien.

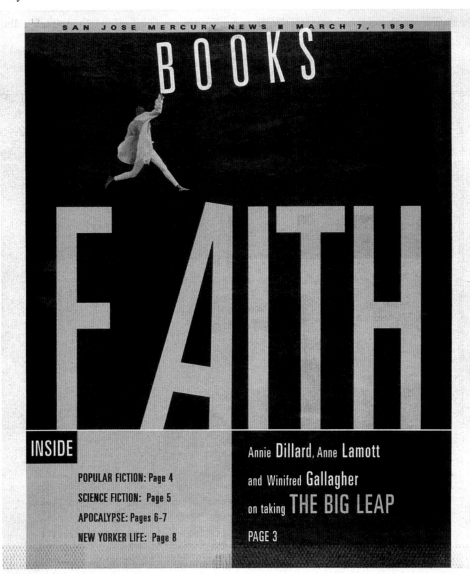

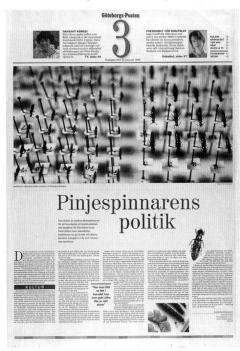

Göteborgs-Posten
Göteborg, Sweden (A)
Karin Nilsson, Designer; **Per Wahlberg,** Photographer

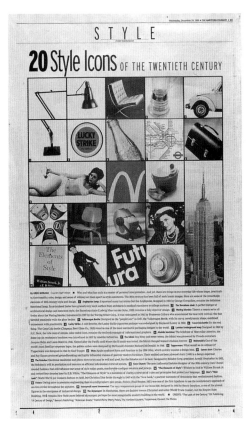

The Hartford Courant
Hartford, Conn. (A)
JoEllen Black, Photo Editor; **Christopher Moore,**
Designer

The Homer Sun
Naperville, Ill. (C)

Nicole Szymanski, Lead Designer; **Todd Heisler,** Photographer

The Homer Sun
Naperville, Ill. (C)

Nicole Szymanski, Lead Designer; **Leah Kennard,** Designer; **Jon Shoemaker,** Designer; **Limbert Fabion,** Illustrator; **Dan Cassidy,** Editor
• also an **Award of Excellence** for Illustration

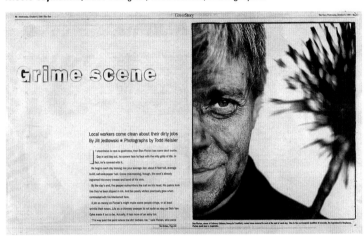

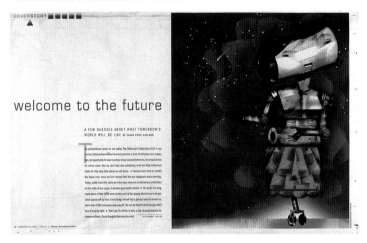

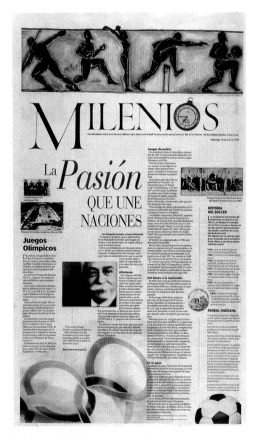

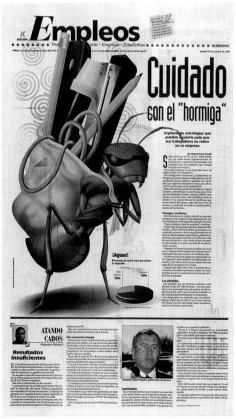

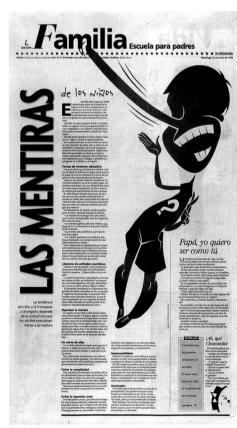

El Imparcial
Hermosillo, México (C)

Zaida Cinco, Designer; **Chiara Bautista,** Illustrator; **Sergio Serrano,** Art Director; **Karla Valenzuela,** Editor; **Maria Jesús Romero,** Section Coordinator

El Imparcial
Hermosillo, México (C)

Luis Humberto Cáñez, Designer; **Chiara Bautista,** Illustrator; **Sergio Serrano,** Art Director; **Alejandro Romero,** Editor

El Imparcial
Hermosillo, México (C)

Zaida Cinco, Designer; **Ariel Medel,** Illustrator; **Sergio Serrano,** Art Director; **Maria Tiznado Luz Sobarzo,** Editor

El Imparcial
Hermosillo, México (C)

Zaida Cinco, Designer; **Chiara Bautista,** Illustrator;
Sergio Serrano, Art Director; **Karla Valenzuela,** Editor;
Maria Jesús Romero, Section Coordinator

Jacksonville Journal-Courier
Jacksonville, Ill. (C)

Steve Copper, Editor; **Mike Miner,** Designer

Liberty Times
Taipei, Taiwan (A)

Tung Ku-Ying, Art Director; **Chen Yu-Ching,** Designer

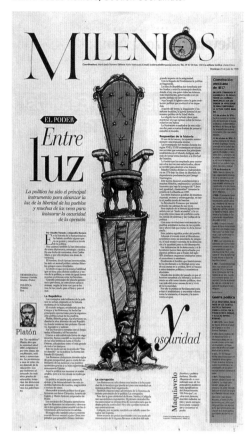

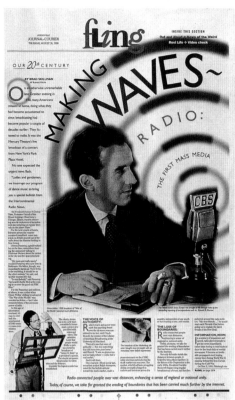

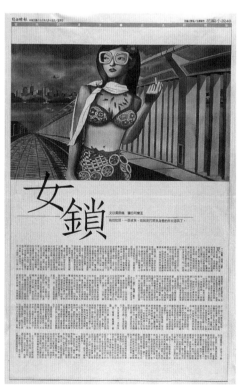

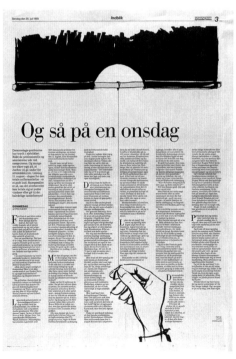

Liberty Times
Taipei, Taiwan (A)

Tung Ku-Ying, Art Director; **Lu Pei-Feng,** Designer

Morgenavisen Jyllands-Posten
Viby j, Denmark (A)

Jørgen Høg, Sub editor; **Lotte Overgaard,** Illustrator

Mural
Zapopan, México (C)

Emmanuel Medina, Designer; **Gustavo Belmán,**
Graphics Editor; **José Merino,** Graphics Editor; **Jorge
Vidrio,** Art Director; **Eduardo Danilo,** Design Consultant;
Tonatiuh Figueroa, Photographer; **Guillermo Navarro,**
Illustrator; **John Carlos Garda,** Editor

Mural
Zapopan, México (C)

Fernando Jauregui, Designer; **Gustavo Belmán,** Graphics Editor; **José Merino,** Graphics Editor; **Jorge Vidrio,** Art Director; **Eduardo Danilo,** Design Consultant; **Gilberto Hernández,** Photographer; **Guillermo Munro,** Illustrator; **John Carlos Garda,** Editor

NRC Handelsblad
Rotterdam, The Netherlands (A)

Wibbine Kien, Page Designer; **Leo Van Velzen,** Photographer

Página/12
Buenos Aires, Argentina (B)

Alejandros Ros, Art Director

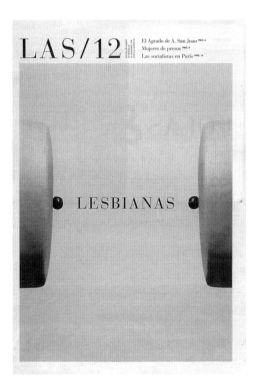

Página/12
Buenos Aires, Argentina (B)

Alejandros Ros, Art Director

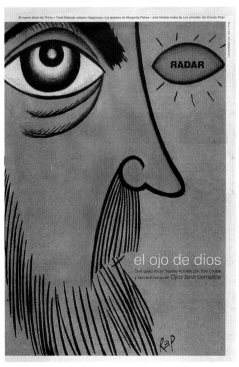

Página/12
Buenos Aires, Argentina (B)

Alejandros Ros, Art Director; **M. Florencia Helguera,** Art Director/Graphic Designer; **Miguel Rep,** Illustrator

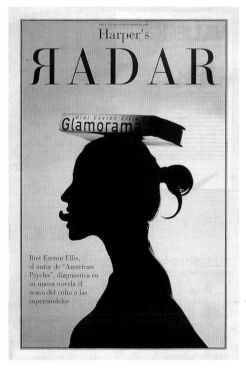

Página/12
Buenos Aires, Argentina (B)

Alejandros Ros, Art Director; **M. Florencia Helguera,** Art Director/Graphic Designer

Página/12
Buenos Aires, Argentina (B)
Alejandros Ros, Art Director; **M. Florencia Helguera,**
Art Director/Graphic Designer

Página/12
Buenos Aires, Argentina (B)
Alejandros Ros, Art Director

Página/12
Buenos Aires, Argentina (B)
Alejandros Ros, Art Director; **M. Florencia Helguera,**
Art Director/Graphic Designer

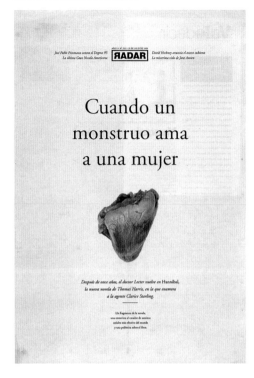

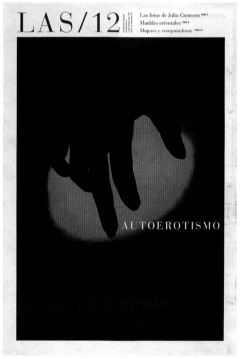

Página/12
Buenos Aires, Argentina (B)
Alejandros Ros, Art Director

Página/12
Buenos Aires, Argentina (B)
Alejandro Ros, Art Director; **M. Florencia Helguera,** Art
Director & Designer

Página/12
Buenos Aires, Argentina (B)
Alejandro Ros, Art Director

El Pais
Cali, Colombia (C)

Nilton Torres, Design Director/Graphic Designer; **Jaime Trujillo,** Illustrator

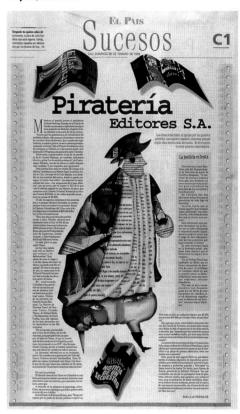

Página/12
Buenos Aires, Argentina (B)

Alejandro Ros, Art Director; **M. Florencia Helguera,** Art Director/Graphic Designer

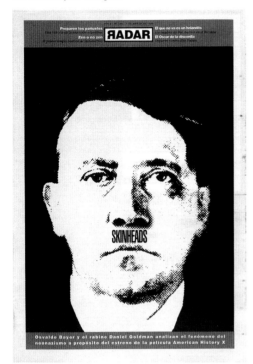

Página/12
Buenos Aires, Argentina (B)

Alejandro Ros, Art Director; **M. Florencia Helguera,** Art Director/Graphic Designer

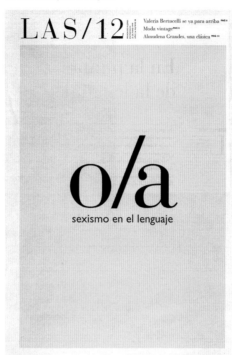

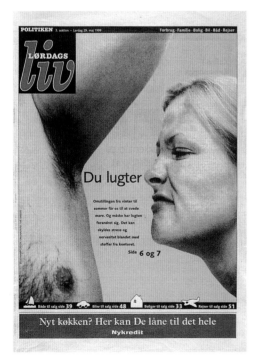

Politiken
Copenhagen, Denmark (A)

Søren Nyeland, Design Editor; **Marianne Gram,** Editor; **Kristoffer Østerbye,** Page Designer; **Tine Harden,** Photographer

Reforma
Mexico City, México (B)

Rosario Escamilla, Designer; **Rebeca Nieva** Section Designer; **Jorge Silva,** Photographer; **Luzma Díaz de León,** Graphics Editor; **Maricela Ramos,** Editor; **Emilio Deheza,** Art Director; **Eduardo Danilo,** Design Consultant

San Jose Mercury News
San Jose, Calif. (A)

David Frazier, Designer/Illustrator

Svenska Dagbladet
Stockholm, Sweden (A)

Bergt Salomonson, Graphic Artist; **Fredrik Braconier**, Researcher

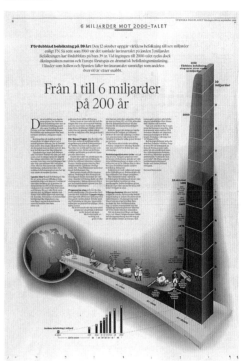

San Jose Mercury News
San Jose, Calif. (A)

David Frazier, Designer/Illustrator

San Jose Mercury News
San Jose, Calif. (A)

David Frazier, Designer/Illustrator

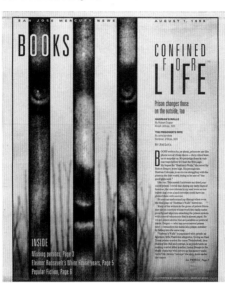

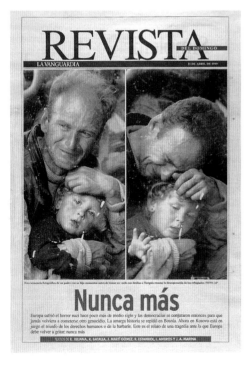

La Vanguardia
Barcelona, Spain (A)

Carlos Pérez de Rozas Arribas, Art Director; **Rosa Mundet Poch,** Editor-in-Chief/Design & Graphics; **Joan Corbera Palau,** Designer; **Anna Belil Boladeras,** Designer; **Georgina Miret Bonet,** Designer; **Carolina Téllez Garbayo,** Designer

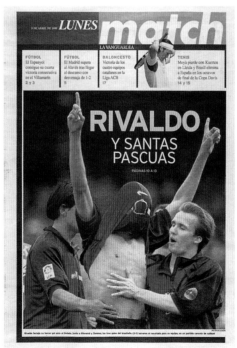

La Vanguardia
Barcelona, Spain (A)

Carlos Pérez de Rozas Arribas, Art Director; **Rosa Mundet Poch,** Editor-in-Chief/Design & Graphics; **Joan Corbera Palau,** Designer; **Anna Belil Boladeras,** Designer; **Georgina Miret Bonet,** Designer; **Carolina Téllez Garbayo,** Designer

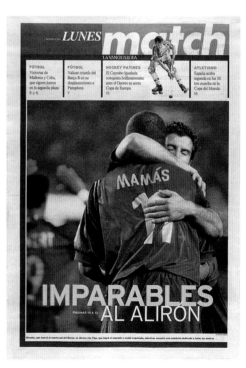

La Vanguardia
Barcelona, Spain (A)

Carlos Pérez de Rozas Arribas, Art Director; **Rosa Mundet Poch,** Editor-in-Chief/Design & Graphics; **Joan Corbera Palau,** Director; **Anna Belil Boladeras,** Director; **Georgina Miret Bonet,** Director; **Carolina Téllez Garbayo,** Director

La Vanguardia
Barcelona, Spain (A)
Carlos Pérez de Rozas Arribas, Art Director; **Rosa
Mundet Poch,** Editor-in-Chief/Design & Graphics; **Joan
Corbera Palau,** Director; **Anna Belil Boladeras,**
Director; **Georgina Miret Bonet,** Director; **Carolina
Téllez Garbayo,** Director

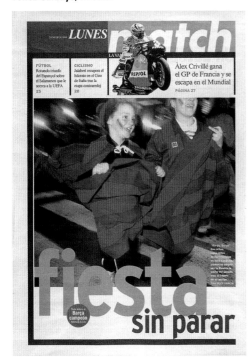

The Washington Post
Washington, D.C. (A)
Stacie Reistetter, Art Director, Health Section

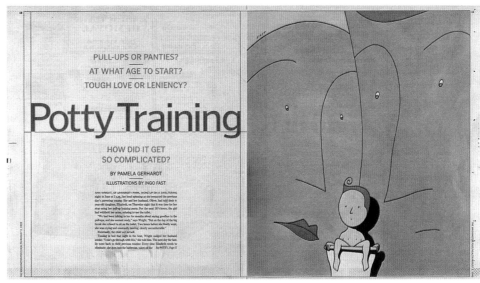

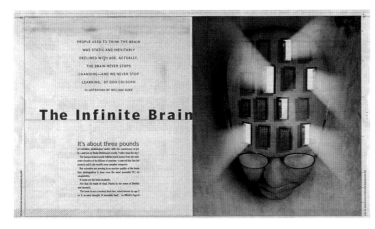

The Washington Post
Washington, D.C. (A)
Stacie Reistetter, Art Director, Health Section

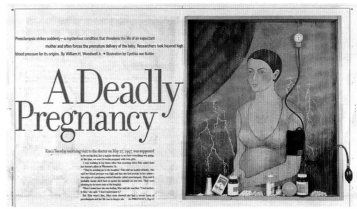

The Washington Post
Washington, D.C. (A)
Stacie Reistetter, Art Director, Health Section

The Washington Post
Washington, D.C. (A)
Stacie Reistetter, Art Director, Health Section

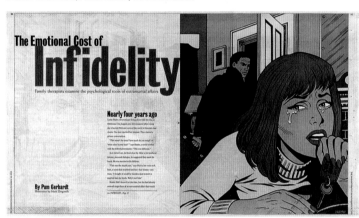

The Washington Post
Washington, D.C. (A)
Stacie Reistetter, Art Director, Health Section

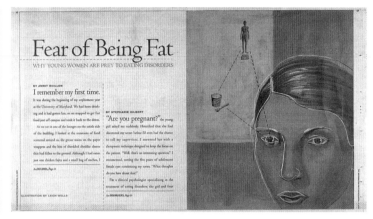

The Washington Post
Washington, D.C. (A)
Kelly Doe, Art Director & Designer; **Malcolm Tarlofsky,**
Photographer

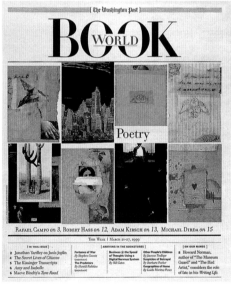

The Washington Post
Washington, D.C. (A)
Kelly Doe, Art Director; **Jennifer Renninger,** Photo
Illustrator

Chicago Tribune
Chicago, Ill. (A)
Gregory Perez, Designer/Illustrator; **Devin Rose,** Kid
news Editor; **Carol Monaghan,** Assistant Kid News
Editor

Silver
National Post
Don Mills, Ont., Canada (A)
Leanne Shapton, Designer

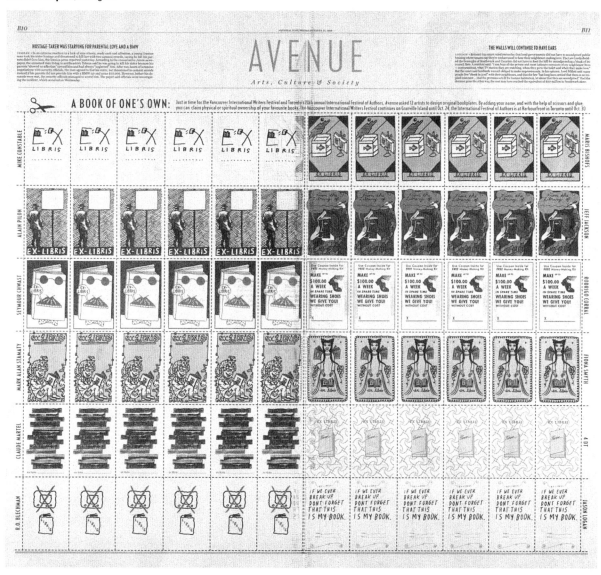

We liked the clever concept, in few words, that conveyed the subtle editorial message: "Reading is really cool."

El jurado disfrutó del sutil mensaje editorial en esta página: "La lectura es verdaderamente excelente". EL inteligente concepto dice mucho más al usar pocas palabras.

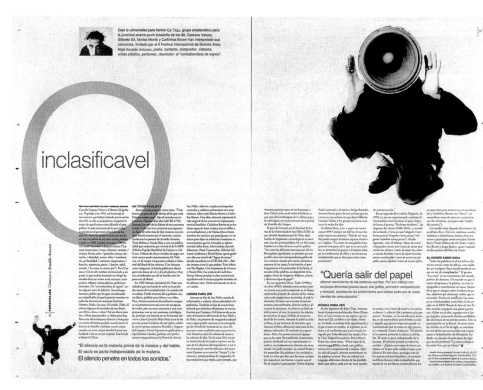

Página/12
Buenos Aires, Argentina (B)
Alejandro Ros, Art Director; **M. Florencia Helguera,** Art Director/Graphic Designer

inclasificavel

"Quería salir del papel"

Chicago Tribune
Chicago, Ill. (A)

Joe Darrow, Art Director; **Bill Hogan**, Photographer

STRIKING POSES

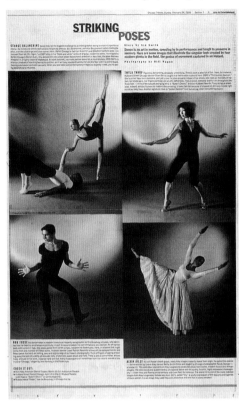

National Post
Don Mills, Ont., Canada (A)

Gayle Grin, Design Director/Designer; **Karen Zagor**, Discovery Editor

DISCOVERY

Neurologists have found an obscure and primitive part of the brain associated with survival instincts is linked to depression, and that Sigmund Freud's talking cure is just as effective a treatment as drugs

Depression therapy's bright future

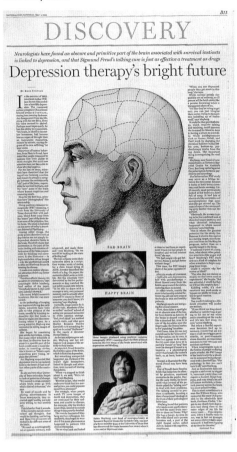

National Post
Don Mills, Ont., Canada (A)

Gayle Grin, Design Director; **Diane Defenoyl**, Life Editor; **Dean Cummer**, Design Editor/Copy Editor; **Kenneth Whyte**, Editor-in-Chief

ARTS & LIFE

New hope for aching, creaky yuppie bodies

Training program arrives in Canada

Any way you slice it, this fruit is not a plum

AVENUE
Arts, Culture & Society

A master in Montreal

On the centenary of Jorge Luis Borges' birth, Avenue prints a rare English-language interview with the writer of short fictions, an artist clever and profound even in a language not his own

TRAPPED BETWEEN LANGUAGES

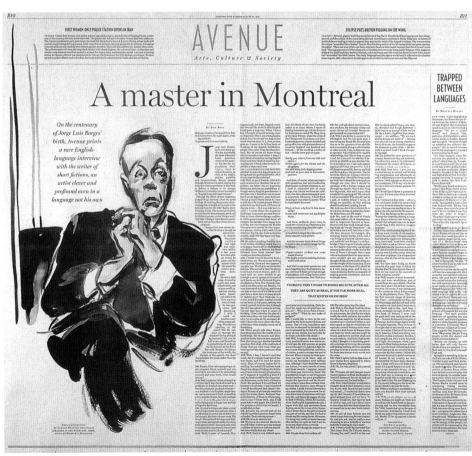

National Post
Don Mills, Ont., Canada (A)

Gayle Grin, Design Director/Designer; **Kenneth Whyte**, Editor-in-Chief; **Leanne Shapton**, Illustrator; **Don Bell**, Writer; **Dan Glover**, Editor

a kick in the pants

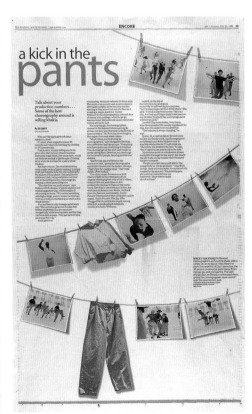

Sun-Sentinel
Ft. Lauderdale, Fla. (A)

Jeremy Gilbert, Designer; **Deidre D'Asaro**, Features Graphics Editor; **Robin Berkowitz**, Assistant Editor Arts/Entertainment

• Design Portfolios

chapter five

PORTFOLIOS

Silver
The Boston Globe
Boston, Mass. (A)

Janet L. Michaud, Art Director/Designer; **Dan Zedek,** Editorial Design Director

This work is solid. Its well-handled typography, tasteful illustration and effective photography combine in a classic template that fits the mood of the event. These pages reflect the elegance of the sport.

Este trabajo es sólido. La tipografía, la grácil ilustración y efectiva fotografía se combinan en una clásica estructura que encaja en el carácter del evento. Estas páginas reflejan la elegancia del deporte.

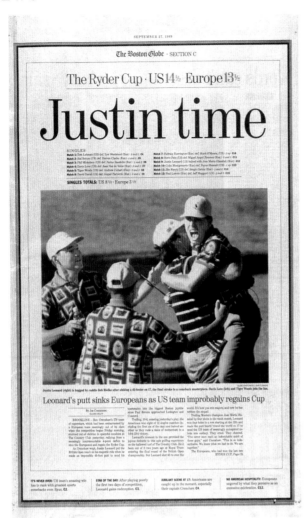

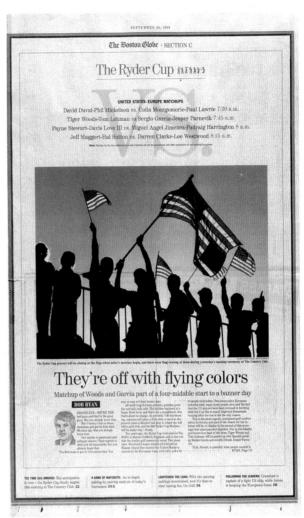

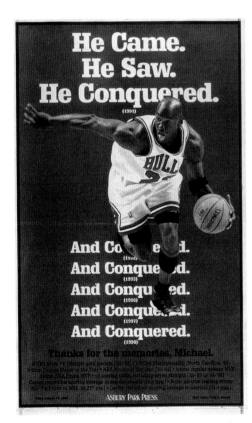

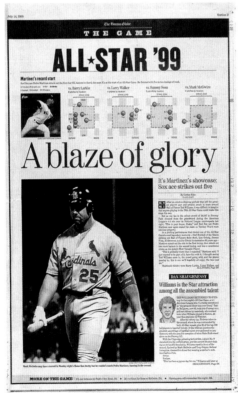

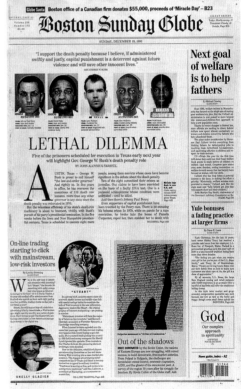

Asbury Park Press
Neptune, N.J. (B)

Harris Siegel, Managing Editor/Design & Photo

The Boston Globe
Boston, Mass. (A)

Janet L. Michaud, Designer

The Boston Globe
Boston, Mass. (A)

Lucy Bartholomay, Art Director/Designer

The Buffalo News
Buffalo, N.Y. (A)
Vincent J. Chiaramonte, Designer

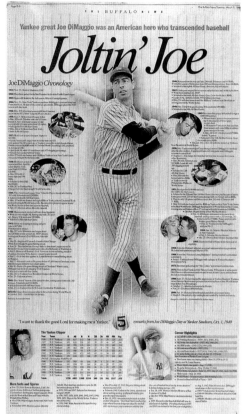

The Globe and Mail
Toronto, Ont., Canada (A)
Eric Nelson, News Art Director

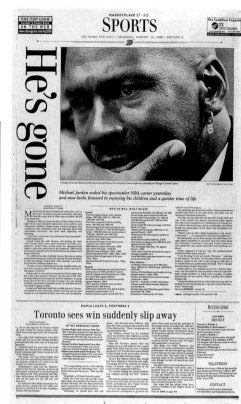

The Charlotte Observer
Charlotte, N.C. (A)
Danielle Parks, Designer

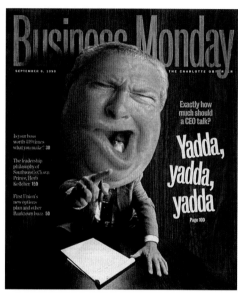

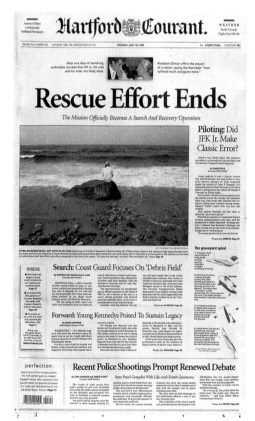

The Hartford Courant
Hartford, Conn. (A)
Ingrid Muller, Designer

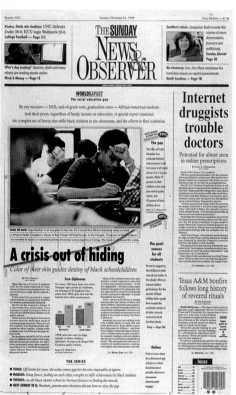

The News & Observer
Raleigh, N.C. (B)
J. Damon Cain, News Design Director

El Norte
Monterrey, México (B)
Adrián Alvarez, Designer/Design Editor

The San Diego Union-Tribune
San Diego, Calif. (A)
Michael Whitley, Designer

San Francisco Examiner
San Francisco, Calif. (B)
Matt Petty, Designer

The Orange County Register
Santa Ana, Calif. (A)
Bonita Clark, Designer

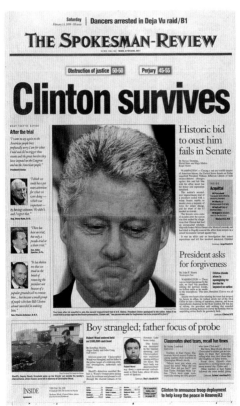

San Jose Mercury News
San Jose, Calif. (A)
David Frazier, Page Designer

The Spokesman-Review
Spokane, Wash. (B)
John Kafentzis, News Designer

Star Tribune
Minneapolis, Minn. (A)
Derek Simmons, Sports Design Editor

The Sun
Bremerton, Wash. (C)

Janet Donnelly, Assistant Presentation Editor

The State
Columbia, S.C. (B)

William Castronuovo, Associate Editor

The Virginian-Pilot
Norfolk, Va. (A)

Harry Brandt, Page Designer

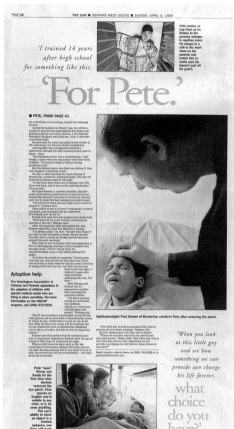

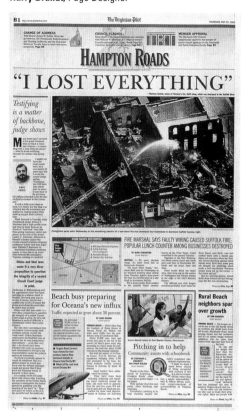

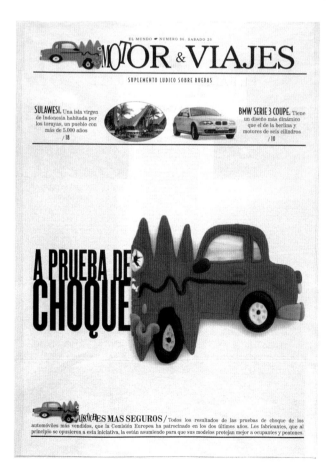

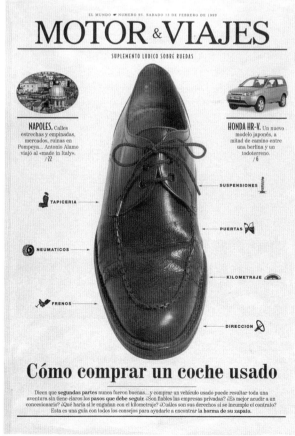

Consistently clever work by the design staff, week after week, catches that nugget of the content that makes you say, "That's it!" They capture the concept of the story consistently.

Presenta un trabajo consistentemente inteligente cada semana. Su punto clave es aquel que nos hace decir: "Justo esto es!". El equipo de El Mundo captura consistentemente los conceptos de los artículos.

Silver
El Mundo
Madrid, Spain (A)

Carmelo Caderot, Art Director/Designer

The staff seems to have a system that produces different results, depending on the subject. All this work shows great creativity within a strict format, and the illustrations are well directed.

El equipo de El País tiene un sistema que produce diferentes resultados de acuerdo al tema. Este cuerpo de trabajo muestra gran creatividad dentro de un formato estricto. Las ilustraciones están bien dirigidas.

Silver

El Pais

Madrid, Spain (A)

Jesus Martinez, Designer

Berlingske Tidende

Copenhagen K, Denmark (B)

Rie Jerichow, Visual Journalist

The Charlotte Observer

Charlotte, N.C. (A)

Kristen Powell, Designer

This Silver medal demonstrates a great range of illustration techniques, all with impressive use of color. The pages exhibit a provocative approach to the routine.

Este participante utiliza un gran rango de técnicas de ilustración y un impresionante uso de color. Las páginas toman un provocativo acercamiento a la rutina.

Silver
To Vima
Athens, Greece (C)
Valentina Villegas, Art Director/Designer

L.A. Weekly
L.A., Calif. (A)
Bill Smith, Art Director

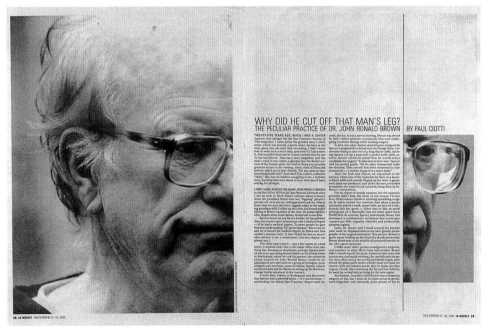

L.A. Weekly
LA, Calif. (A)
Bill Smith, Art Director/Designer

Estado de Minas
Belo Horizonte, Brazil (B)
Heliane Souza, Designer

The Cape Cod Times
Hyannis, Mass. (C)
Patricia Cousins, Designer

El Mundo La Luna
Madrid, Spain (A)
Rodrigo Sánchez, Art Director/Designer

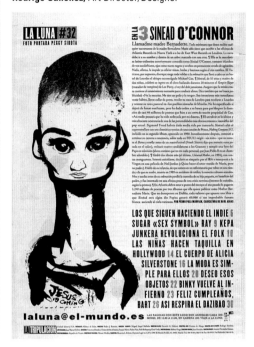

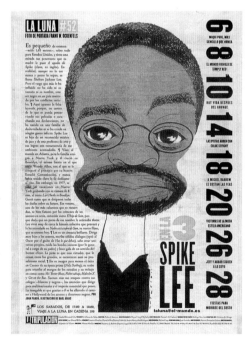

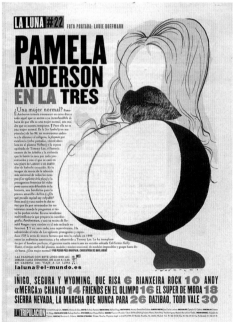

El Mundo La Luna
Madrid, Spain (A)
Rodrigo Sánchez, Art Director/Designer

El Mundo La Luna
Madrid, Spain (A)
Rodrigo Sánchez, Art Director/Designer

El Mundo La Luna
Madrid, Spain (A)
Rodrigo Sánchez, Art Director/Designer

El Mundo La Luna
Madrid, Spain (A)
Francisco Dorado, Designer

El Mundo
Madrid, Spain (A)
Carmelo Caderot, Design Director/Designer

El Mundo
Madrid, Spain (A)
Carmelo Caderot, Design Director/Designer

El Mundo
Madrid, Spain (A)
Carmelo Caderot, Design Director

El Mundo
Madrid, Spain (A)
Carmelo Caderot, Design Director

El Mundo
Madrid, Spain (A)
Carmelo Caderot, Design Director/Designer

El Mundo
Madrid, Spain (A)
Carmelo Caderot, Design Director/Designer

El Mundo
Madrid, Spain (A)
Carmelo Caderot, Design Director/Designer

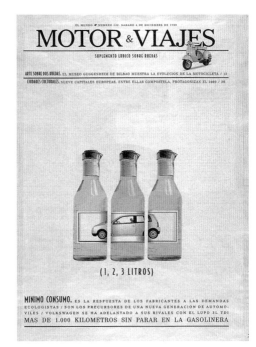

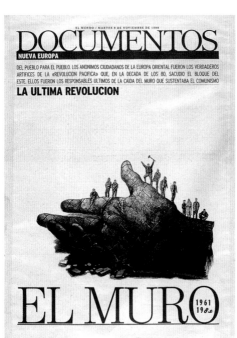

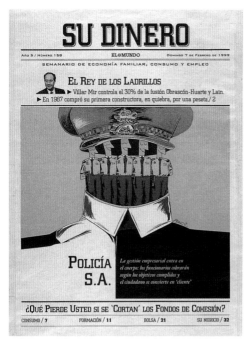

El Mundo
Madrid, Spain (A)
Carmelo Caderot, Design Director/Designer

El Mundo
Madrid, Spain (A)
Carmelo Caderot, Design Director/Designer

El Mundo
Madrid, Spain (A)
Carmelo Caderot, Design Director/Designer

National Post
Don Mills, Ont., Canada (A)
Roland Carignan, Deputy Design Director

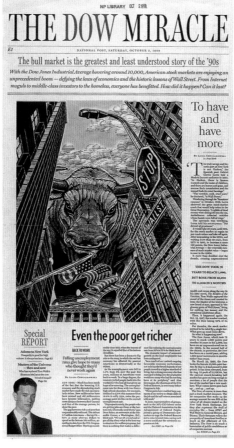

El Mundo
Madrid, Spain (A)
Carmelo Caderot, Design Director/Designer

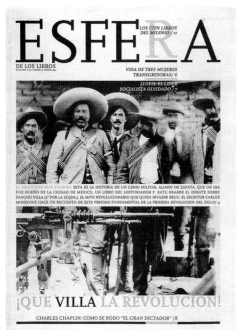

The Orange County Register
Santa Ana, Calif. (A)
Martin Gee, Designer; **Kris Viesselman,** Art Director•
also an **Award of Excellence** for Entertainment Page

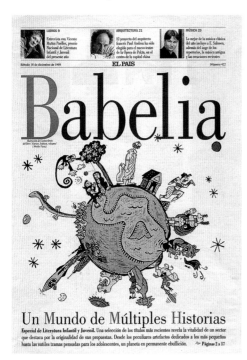

Philadelphia Weekly
Philadelphia, Pa. (B)
Alfred Jones, Art Director

Pittsburgh Post-Gazette
Pittsburgh, Pa. (A)
Emily Escalante, Artist

El País
Madrid, Spain (A)
Luis Galáu, Designer

To Vima
Athens, Greece (C)
Valentina Villegas, Art Director

The Register-Guard
Eugene, Ore. (B)
Tom Penix, Designer

The Seattle Times
Seattle, Wash. (A)
Jeff Neumann, Designer
• also an **Award of Excellence** for Entertainment Page

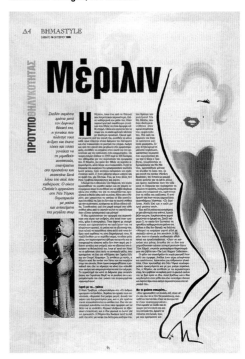

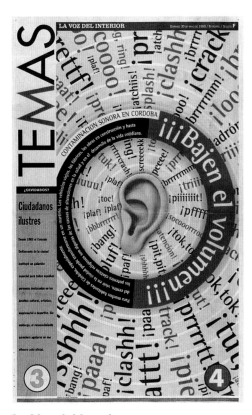

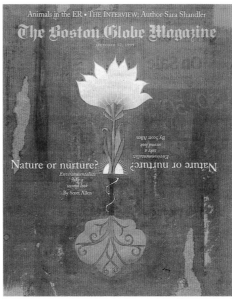

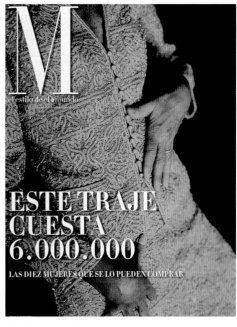

The Boston Globe
Boston, Mass. (A)
Catherine Aldrich, Art Director

El Mundo Magazine
Madrid, Spain (A)
Rodrigo Sánchez, Art Director/Designer

La Voz del Interior
Córdoba, Argentina (B)
Javier Candellero, Designer/Illustrator; **Miguel De Lorenzi,** Art Director; **Edgardo Litvinoff,** Editor; **Mario García,** Design Consultant
• also an **Award of Excellence** for Lifestyle Page

Expansion
Madrid, Spain (C)
Antonio Martín Hervás, Designer

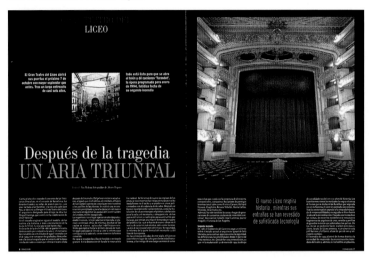

El Mundo Magazine
Madrid, Spain (A)
María González, Designer

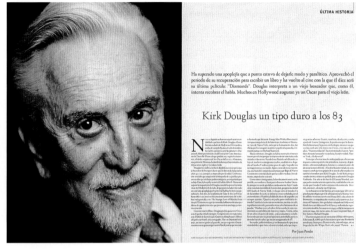

El Mundo Metropoli
Madrid, Spain (A)
Rodrigo Sánchez, Art Director/Designer

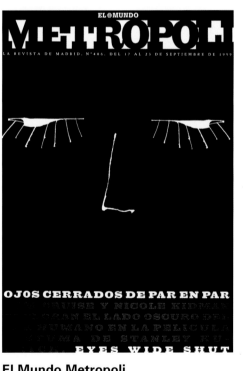

El Mundo Metropoli
Madrid, Spain (A)
Carmelo Caderot, Design Director; **Rodrigo Sánchez,**
Art Director and Designer; **María González,** Designer;
Daniel Amade, Designer
• also an **Award of Excellence** for Magazine Cover

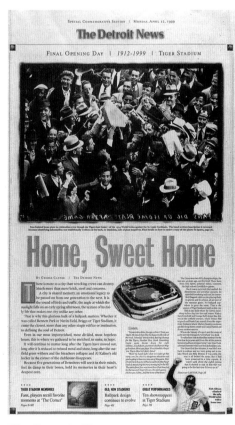

The Detroit News
Detroit, Mich. (A)
David Kordalski, Assistant Managing Editor/Visuals

Le Devoir
Montréal, Que., Canada (C)
Christian Vien, Graphic Designer

Le Devoir
Montréal, Que., Canada (C)
Christian Tiffet, Art Director

The Wichita Eagle
Wichita, Kan. (B)
Andy Braford, Designer

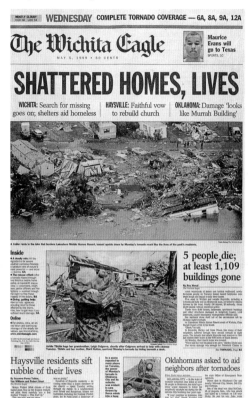

The Register-Guard
Eugene, Ore. (B)
Carl Davaz, Deputy Managing Editor

The Register-Guard
Eugene, Ore. (B)
Rob Romig, Graphic Director

San Antonio Express-News
San Antonio, Texas (A)
Dennis Ochoa, Designer

- Art & Illustrations
- Photography
- Infographics
- Miscellaneous

chapter six

ILLUSTRATIONS & MISCELLANEOUS

El Mundo
Madrid, Spain (A)
Ulises Culebro, Artist

El Mundo
Madrid, Spain (A)
Ulises Culebro, Artist

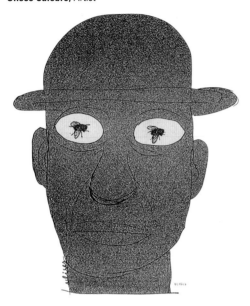

El Mundo
Madrid, Spain (A)
Ricardo Martinez, Illustrator

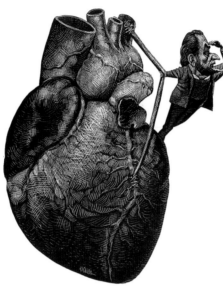

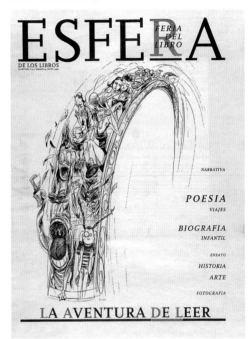

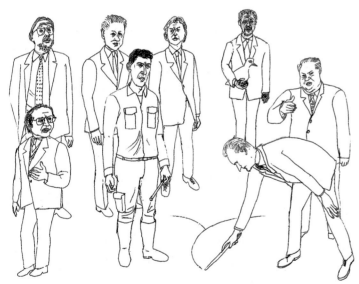

Dagens Nyheter
Stockholm, Sweden (A)
Claes Jurander, Illustrator

El Mundo
Madrid, Spain (A)
Ulises Culebro, Illustrator

Reforma
Mexico City, México (B)

Fabricio Vanden Broeck, Illustrator; **Ernesto Montes de Oca,** Section Designer; **Miguel de la Vega,** Editor; **Eduardo Danilo,** Design Consultant; **Emilio Deheza,** Art Director

El Mundo del Siglo XXI
Madrid, Spain (A)

Raul Arias, Artist; **Carmelo Caderot,** Design Director/Designer
• also an **Award of Excellence** for Features Portfolio

El Mundo del Siglo XXI
Madrid, Spain (A)

Ulises Culebro, Artist

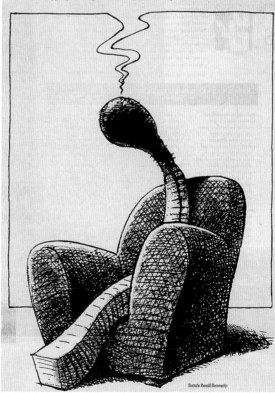

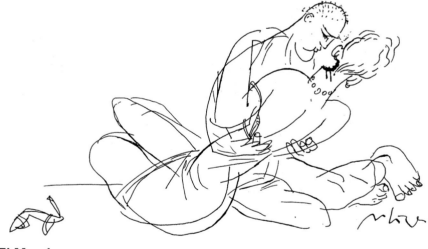

El Mundo
Madrid, Spain (A)

Ulises Culebro, Artist

NRC Handelsblad
Rotterdam, The Netherlands (A)

Rhonald Blommestÿn, Illustrator

Gold
The Boston Globe
Boston, Mass. (A)

David Wheeler, Illustrator; **Lucy Bartholomay,** Design Director; **Catherine Aldrich,** Art Director;
Jane Martin, Art Director; **Ande Zellman,** Editor; **Dan Zedek,** Editorial Design Director

Judges found this to be an intelligent, inventive approach to one of the seven deadly sins — Sloth. It effectively conveys the feeling of how hard it is to motivate one's self.

Los jueces encontraron este acercamiento como muy inventivo e inteligente para un objeto extraordinariamente difícil. Presenta con mucha efectividad el sentimiento de cuán duro es motivarse a uno mismo.

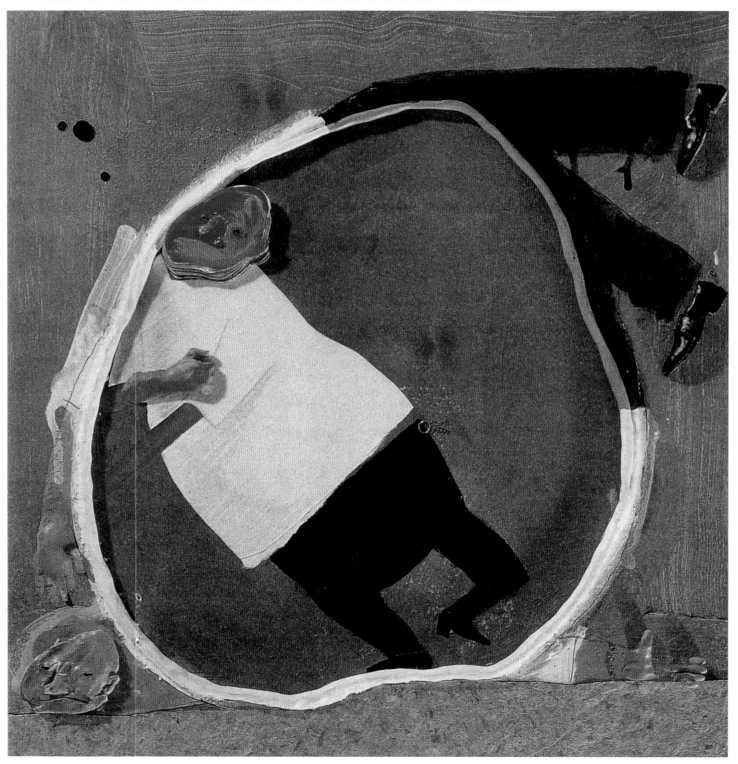

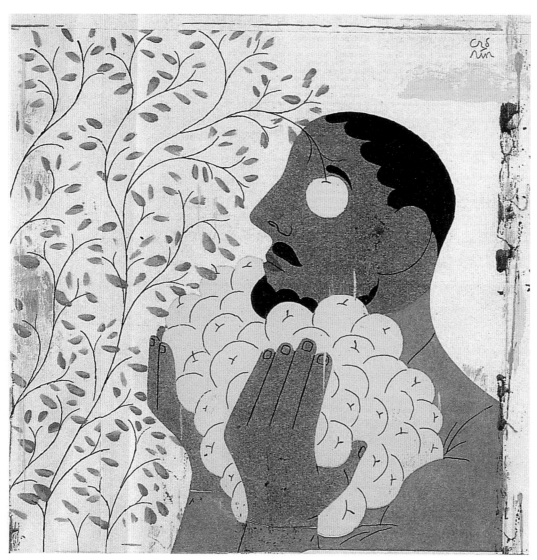

Silver
The Boston Globe
Boston, Mass. (A)

Brian Cronin, Illustrator; **Lucy Bartholomay,** Design Director; **Catherine Aldrich,** Art Director; **Jane Martin,** Art Director; **Ande Zellman,** Editor; **Dan Zedek,** Editorial Design Director

The staff takes a difficult topic– one of the seven deadly sins: Greed – and conveys its essence, "It's all he can see." Judges liked the clever approach to obscure the eye — his greed is all he can see.

El equipo del Boston Globe toma un tópico difícil – uno de los siete pecados capitalkies: avaricia – y presenta su esencia. Los jueces disfrutaron de la inteligente decisión de oscurecer el ojo, para comunicar que la avaricia es todo lo que él sólo puede ver.

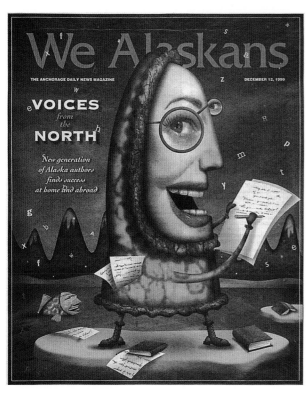

Anchorage Daily News
Anchorage, Alaska (B)
Lance Lekander, Illustrator; **Pamela Dunlap-Shohl,** Designer

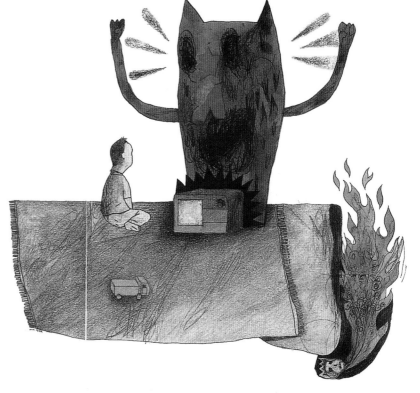

Dagbladet
Oslo, Norway (A)
Kim Hiorthøy, Illustrator; **Torfinn Solbrekke,** Designer & Art Director; **Cecile Campos,** Designer

Silver
The New York Times
New York, N.Y. (A)

Ralph Steadman, Illustrator; **Jerelle Kraus**, Art Director & Designer
• also an **Award of Excellence** for Entertainment Page

This is a terrific caricature with excellent line work – the noise created with exploding ears fits well.

Esta es una excelente caricatura. Excelente trabajo de línea – las orejas que explotan funcionan muy bien.

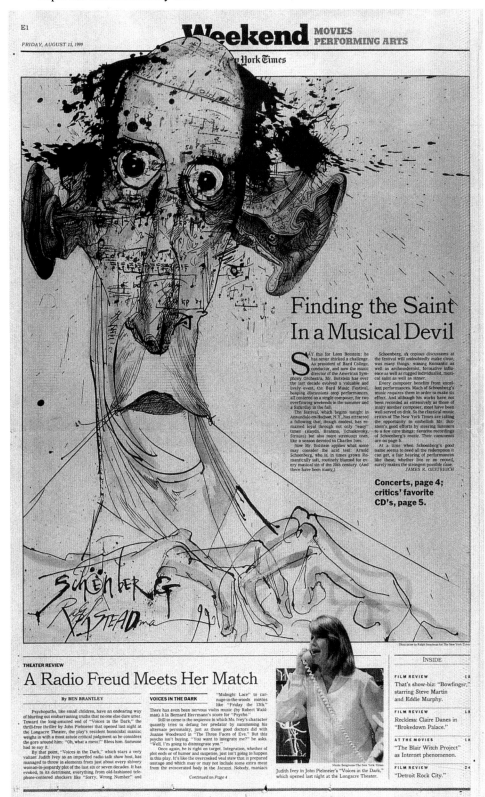

Anchorage Daily News
Anchorage, Alaska (B)

Lance Lekander, Illustrator; **Pamela Dunlap-Shohl**, Designer

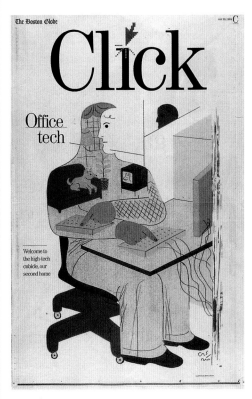

The Boston Globe
Boston, Mass. (A)

Brian Cronin, Illustrator; **Keith A. Webb**, Art Director & Designer; **Teresa M. Hanafin**, Editor; **Dan Zedek**, Editorial Design Director

The Boston Globe
Boston, Mass. (A)

Craig Frazier, Illustrator; **Susan Levin,** Designer; **David Mehegan,** Editor; **Dan Zedek,** Editorial Design Director

Silver
The New York Times
New York, N.Y. (A)

Andrea Ventura, Illustrator; **Steven Heller,** Art Director

 This page goes a long way from just creating an exact likeness. It is simple, but with great energy. It's recognizable, bold and effective.

Se distancia de crear elementos comunes o similares. Es sencillo, con mucha energía. Es reconocible, fuerte y efectivo.

The Boston Globe
Boston, Mass. (A)

Thomas Fuchs, Illustrator; **Lucy Bartholomay,** Design Director; **Ande Zellman,** Editor; **Catherine Aldrich,** Art Director; **Jane Martin,** Art Director; **Dan Zedek,** Editorial Design Director

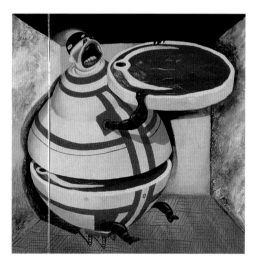

The Boston Globe
Boston, Mass. (A)
Katherine Streeter, Illustrator; **Susan Levin,** Designer; **David Mehegan,** Editor; **Dan Zedek,** Editorial Design Director

The Boston Globe
Boston, Mass. (A)
Brad Holland, Illustrator; **Susan Levin,** Designer; **David Mehegan,** Editor; **Dan Zedek,** Editorial Design Director

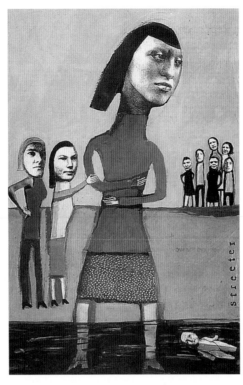

The Boston Globe
Boston, Mass. (A)
Anita Kunz, Illustrator; **Lucy Bartholomay,** Design Director; **Catherine Aldrich,** Art Director; **Jane Martin,** Art Director; **Ande Zellman,** Editor; **Dan Zedek,** Editorial Design Director

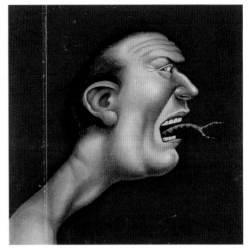

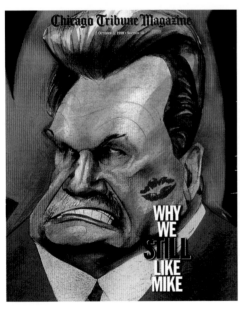

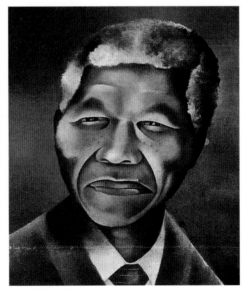

Chicago Tribune
Chicago, Ill. (A)
Steve Brodner, Illustrator; **Joe Darrow,** Art Director

Chicago Tribune
Chicago, Ill. (A)
Jacques Cournoyer, Illustrator; **Joan Cairney,** Art Director; **Bill Parker,** Editor

Dagens Nyheter
Stockholm, Sweden (A)
Stina Wirsén, Illustrator

Dagens Nyheter
Stockholm, Sweden (A)
Stina Wirsén, Illustrator

Dagens Nyheter
Stockholm, Sweden (A)
Sanna Nicklasson, Illustrator

Dagens Nyheter
Stockholm, Sweden (A)
Sanna Nicklasson, Illustrator

Denver Rocky Mountain News
Denver, Colo. (A)
Mark Mattern, Artist

El Mundo
Madrid, Spain (A)
Ulises Culebro, Artist

Denver Rocky Mountain News
Denver, Colo. (A)
Mark Mattern, Artist

Fort Worth Star-Telegram
Fort Worth, Texas (A)
Joe Fournier, Illustrator; **Cynthia Wahl,** Art Director &
Designer

El Mundo del Siglo XXI
Madrid, Spain (A)
Toño Benavides, Illustrator

El Mundo
Madrid, Spain (A)
Barbara P. Adanti, Illustrator

El Mundo/La Revista
Madrid, Spain (A)
Ana Juan, Illustrator

El Mundo/La Revista
Madrid, Spain (A)
Ana Juan, Illustrator

National Post
Waiblingen, Germany (A)
Laura Ljungkvist, Illustrator; **Friederike Gauss,** Art Director; **Kenneth Whyte,** Editor-in-Chief; **Peter Kruitenbower,** Writer; **Harriet O'Brian,** Editor; **Thea Partridge,** Designer; **Brian Batenburg,** Production

National Post
Don Mills, Ont., Canada (A)
Catherine Lazure, Illustrator; **Eugene Pawczuk,** Designer; **Eric Kohanik,** Editor; **Gayle Grin,** Design Director

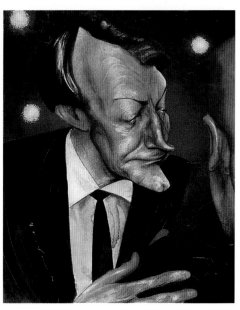

The New York Times Magazine
New York, N.Y. (A)
Steve Brodner, Illustrator; **Janet Froelich,** Art Director; **Claude Martel,** Designer

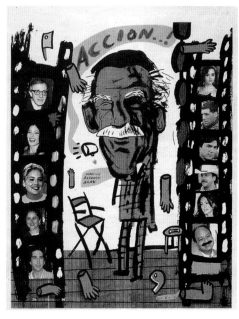

El Norte
Monterrey, México (B)
Luis Vázquez, Illustrator; **Granada Ramírez,** Section Designer; **Edgardo Reséndiz,** Editor; **Eddie Macías,** Graphics Editor; **Carmen Escobedo,** Design Manager Editor; **Martín Pérez Cerda,** Editor Director; **Ramón Alberto Garza,** General Editor Director; **Eduardo Danilo,** Design Consultant

The Philadelphia Inquirer Magazine
Philadelphia, Pa. (A)

Cyril Cabry, Illustrator; **Chrissy Dunleavy,** Art Director; **Susan Syrnick,** Assistant Art Director/Designer

The Philadelphia Inquirer Magazine
Philadelphia, Pa. (A)

Anita Kunz, Illustrator; **Chrissy Dunleavy,** Art Director/Designer; **Susan Syrnick,** Assistant Art Director

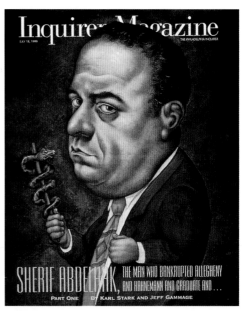

The Seattle Times
Seattle, Wash. (A)

Jeff Neumann, Illustrator

The San Diego Union-Tribune
San Diego, Calif. (A)

Cristina Martinez, News Graphic Artist; **Michael Canepa,** Designer

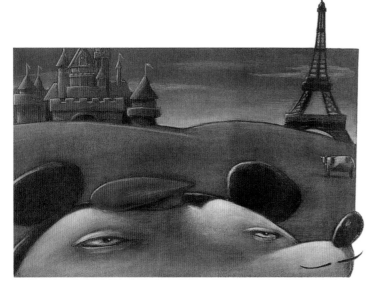

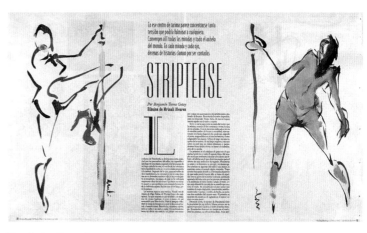

Revista Domingo
San Juan, Puerto Rico (A)

Mrinali Alvarez, Illustrator; **Claudia Robion,** Art Director & Designer; **Rafael Vega,** Editor

The Spokesman-Review
Spokane, Wash. (B)

Daniel Wiegand, Illustrator

The Spokesman-Review
Spokane, Wash. (B)
Molly C. Quinn, Illustrator

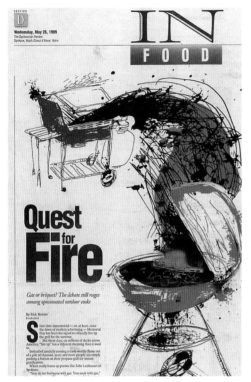

St. Paul Pioneer Press
St. Paul, Minn. (A)
Kirk Lyttle, Illustrator

Svenska Dagbladet
Stockholm, Sweden (A)
Riber Hansson, Artist

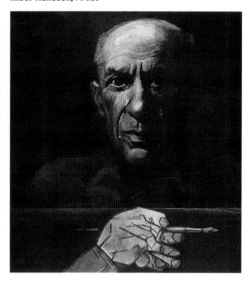

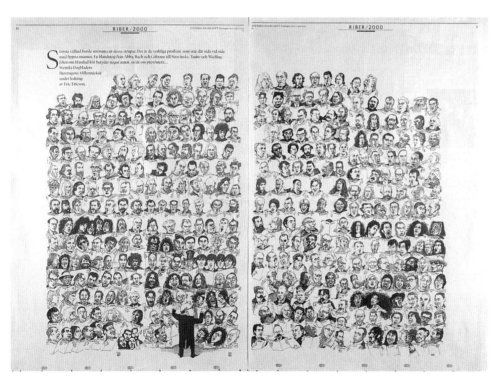

Svenska Dagbladet
Stockholm, Sweden (A)
Riber Hansson, Artist

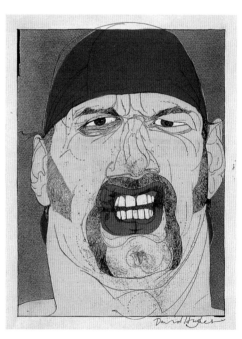

The Washington Post Magazine
Washington, D.C. (A)
David Hughes, Illustrator; **Kelly Doe,** Art Director; **David Herbick,** Designer

Dagens Nyheter
Stockholm, Sweden (A)
Stina Wirsén, Illustrator

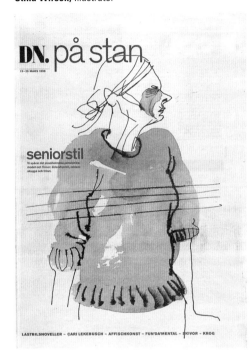

Dagens Nyheter
Stockholm, Sweden (A)
Stina Wirsén, Illustrator

Estado de Minas
Belo Horizonte, Brazil (B)
Alexandre Coelho, Illustrator

The Kansas City Star
Kansas City, Mo. (A)
Héctor S. Casanova, Illustrator

The Globe and Mail
Toronto, Ont., Canada (A)
Anthony Jenkins, Artist

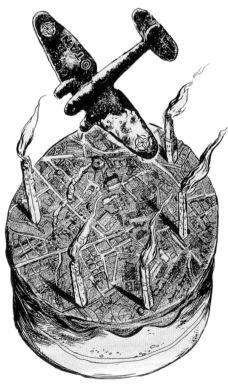

El Mundo
Madrid, Spain (A)
Ulises Culebro, Illustrator

El Mundo
Madrid, Spain (A)
Ulises Culebro, Illustrator

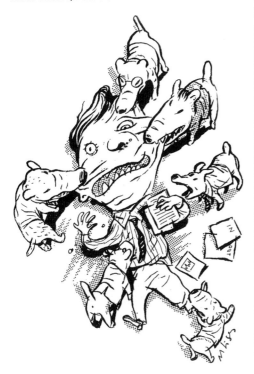

El Mundo del Siglo XXI
Madrid, Spain (A)
Raul Arias, Illustrator

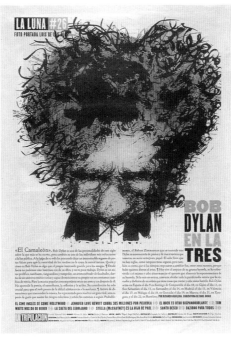

El Mundo
Madrid, Spain (A)
Ricardo Martinez, Illustrator

El Mundo del Siglo XXI
Madrid, Spain (A)
Raul Arias, Artist

El Mundo
Madrid, Spain (A)
Ulises Culebro, Illustrator

The New York Times
New York, N.Y. (A)
James McMullan, Illustrator

El Periódico de Catalunya
Barcelona, Spain (A)
El Roto, Illustrator

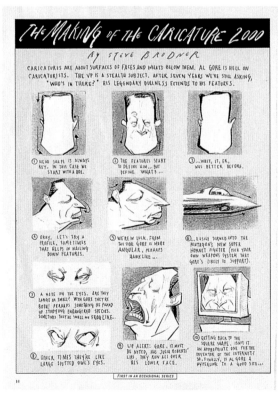

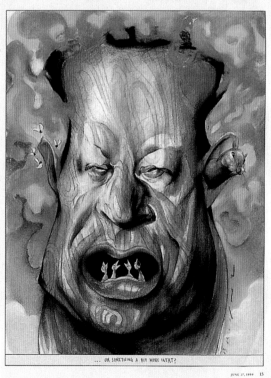

The Washington Post Magazine
Washington, D.C. (A)
Steve Brodner, Illustrator

Silver
The Boston Globe
Boston, Mass. (A)

Lucy Bartholomay, Design Director; **Catherine Aldrich,** Art Director; **Jane Martin,** Art Director; **Thomas Fuchs,** Illustrator; **Ande Zellman,** Editor; **Dan Zedek,** Editorial Design Director

 This entry is exceptional, with a great theme and with good execution. The choice of illustrators is excellent. We couldn't find any flaws in this piece which, by its very nature, is difficult to illustrate.

Este es un excepcional participante que presenta una gran temática con una buena ejecución. La selección de ilustradores es excelente. No pudimos encontrar ningún defecto en ésta página, la cual supone mucha dificultad para ilustrar.

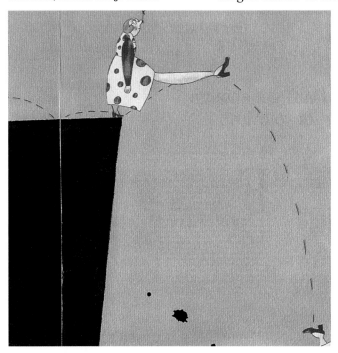

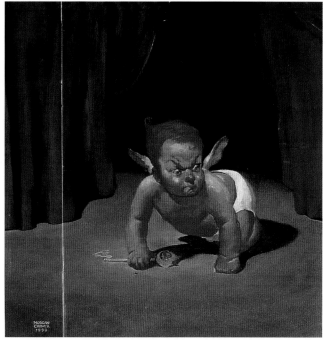

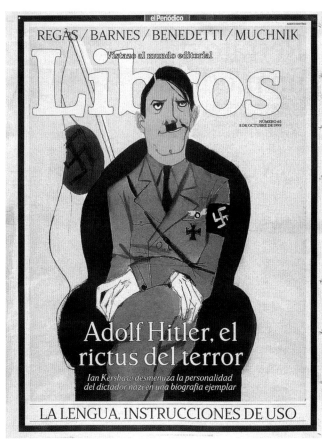

Silver
El Periódico de Catalunya
Barcelona, Spain (A)

Ricardo Feriche, Creative Director; **Rafael Tapounet,** News Editor; **Eva Blanch/Rico Hidalgo,** Art Director; **Feriche & Black** Design Consultant; **Santiago Sequeiros,** Illustrator; **Cristina Blanch,** Illustrator; **Gabriel Corbera,** Illustrator; **Alberta Martinez,** Illustrator; **Alicia Comella,** Illustrator; **Samuel Solo,** Illustrator

 All the pieces for this entry have a "rich" tone with consistently strong art direction and a strong sense of how they want the cover to look. Very professional.

Todas las partes en esta página presentan un tono rico y agradable. Presenta consistentemente una sólida dirección de arte con un evidente sentido de cómo ellos quieren que se vean las portadas. Muy profesional.

L.A. Weekly
LA, Calif. (A)

Peter Bennett, Illustrator; Geoff Grahn, Illustrator; Rob Clayton, Illustrator; **Matt Groening**, Illustrator; **Calef Brown**, Illustrator; **Anthony Ausgang**, Illustrator; **Bill Smith**, Art Director

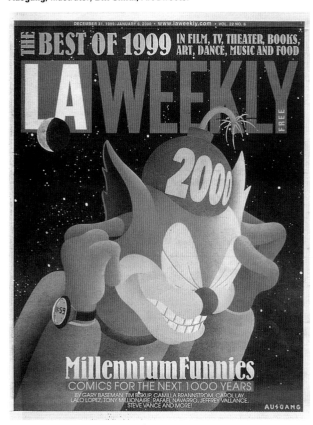

L.A. Weekly
LA, Calif. (A)

Peter Bennett, Illustrator; Geoff Grahn, Illustrator; Rob Clayton, Illustrator; **Gustavo Vargus**, Illustrator; **Calef Brown**, Illustrator; **Lou Beach**, Illustrator; **Bill Smith**, Art Director

The New York Times
New York, N.Y. (A)

Ed Lam, Illustrator; **D.B. Johnson**, Illustrator; **Richard McGuire**, Illustrator; **Marshall Arisman**, Illustrator; **Mirko Ilic**, Illustrator; **Boris Kulikov**, Illustrator; **Steven Heller**, Art Director

The Philadelphia Inquirer Magazine
Philadelphia, Pa. (A)

Anita Kunz, Illustrator; **Cyril Calbry**, Illustrator; **Michelle Chang**, Illustrator; **Harry Bliss**, Illustrator; **Phillippe Laroy**, Illustrator; **Orlando Hoetzel**, Illustrator; **Chrissy Dunleavy**, Art Director; **Susan Syrnick**, Assistant Art Director/Designer

Gold
The News & Observer
Raleigh, N.C. (B)
Mel Nathanson, Photographer

 This photographer juxtaposes harsh reality with artistry. The minimalist approach speaks volumes with a unique perspective.

Este fotógrafo juxtapone la cruda realidad con sentimiento artístico. El acercamiento minimalista habla por sí mismo y ofrece una perpectiva única.

**Silver
The Hartford
Courant**
Hartford, Conn. (B)

Alan Chaniewski,
Photographer; **Stephanie
Heisler,** Picture Editor;
Thomas F. McGuire,
Director/Photography

It is refreshing
to see a
photographer at
a news event
step back, look for a
unique approach and
still get the action
and reaction in a
single story-telling
photograph.

Es diferente ver a un
fotógrafo retroceder
en un evento
noticioso, tomar un
acercamiento único y
ser capaz de obtener
acción y reacción en
una sola fotografía
que narra una
historia.

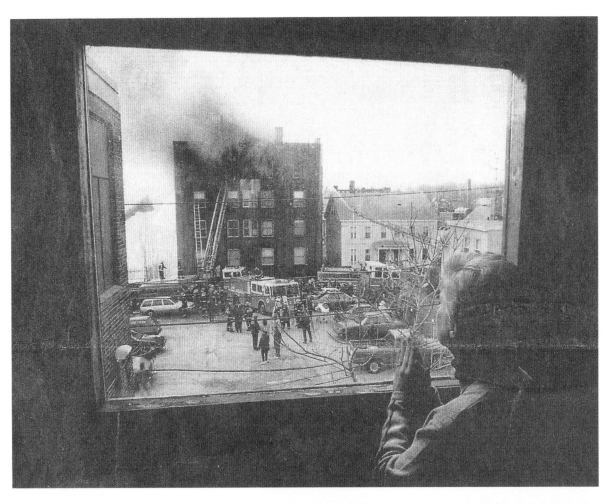

Centre Daily Times
State College, Pa. (C)
Pat Little, Chief
Photographer

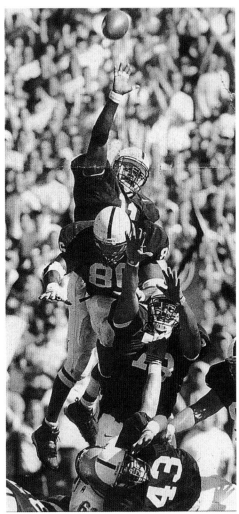

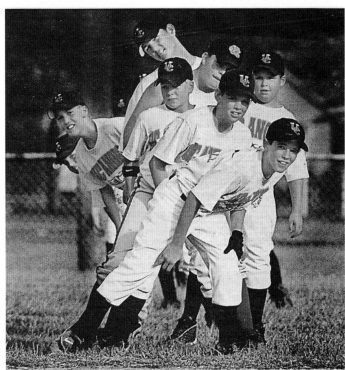

The Charlotte Observer
Charlotte, N.C. (A)

Todd Sumlin, Photographer; **Thé Pham,** Photo Editor; **Andria Krewson,** Designer;
Susan Gilbert, Director/Photography

The Commercial Appeal
Memphis, Tenn. (A)
Lance Murphey, Photographer

Denver Rocky Mountain News
Denver, Colo. (A)
George Kochaniec, Jr., Photographer

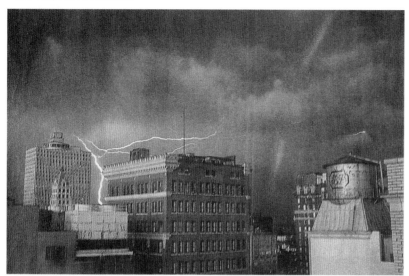

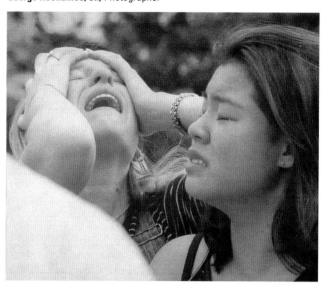

The Hartford Courant
Hartford, Conn. (B)
Cloe Poisson, Photographer; **Stephanie Heisler,** Picture
Editor; **Thomas F. McGuire,** Director/Photography

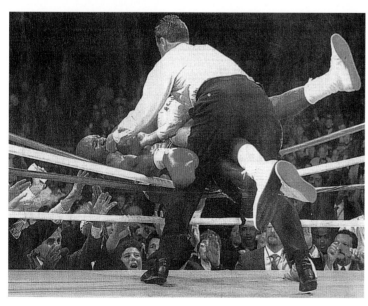

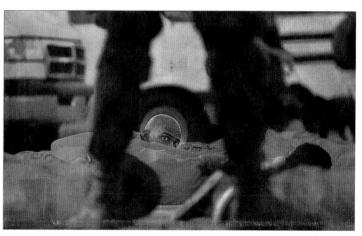

The New Mexican
Santa Fe, N.M. (C)
Craig Fritz, Staff Photographer

Las Vegas Review-Journal
Las Vegas, Nev. (B)
Clint Karlsen, Photographer

Los Angeles Times
Costa Mesa, Calif. (A)

Richard Hartog, Photographer; **Mary Cooney,** Photo Editor; **Gail Fisher,** Photo Editor; **Don Tomey,** Designer

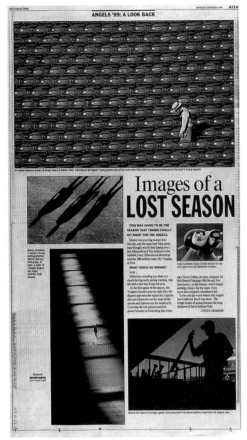

Metro
Mexico City, México (C)

Alberto Neri, Photographer; **Daniel Esqueda,** Graphics Editor; **Roberto Paniagua,** Designer; **María Dolores Carpio,** Editor; **Emilio Deheza,** Art Director; **Eduardo Danilo,** Design Consultant

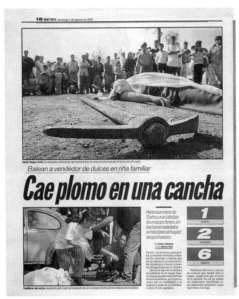

The Oregonian
Portland, Ore. (A)

Paul Kitagaki, Jr., Photographer

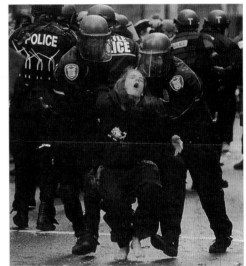

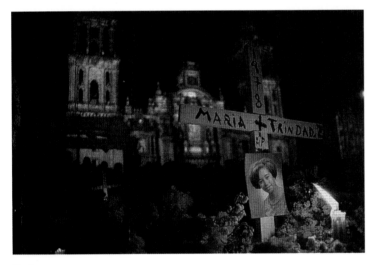

Reforma
Mexico City, México (B)

Carlos Milanés, Photographer; **Oscar Yañez,** Section Designer; **Eduardo Danilo,** Design Consultant; **Héctor García,** Photo Co-Editor; **Ricardo del Castillo,** Graphics Editor; **Héctor Zamarrón,** Section Editor; **Emilio Deheza,** Art Director

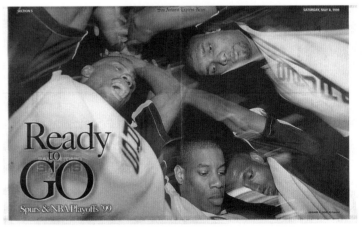

San Antonio Express-News
San Antonio, Texas (A)

Edward Ornelas, Photographer

The Sun
Bremerton, Wash. (C)

Larry Steagall, Photographer; **Melina Mara**, Photographer; **Gale Engelke,** Presentation Editor

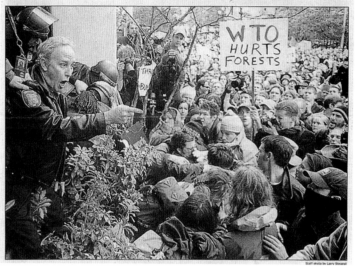

Star Tribune
Minneapolis, Minn. (A)

Carlos Gonzalez, Photographer

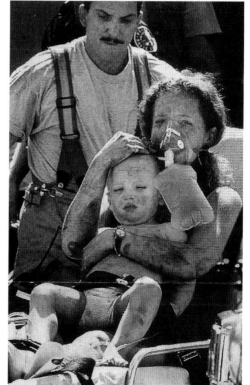

The Boston Globe
Boston, Mass. (A)

Bill Greene, Photographer; **Lucy Bartholomay,** Art Director; **Janet L. Michaud,** Designer; **Ande Zellman,** Editor; **Leanne Burden,** Picture Editor; **Susan Wadlington,** Picture Editor; **George Patisteas,** Copy Editor; **Dan Zedek,** Editorial Design Director

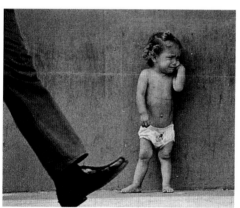

Diario Panorama
Maracaibo, Venezuela (B)

Albérto Alvarado, Photographer

Sun-Sentinel
Ft. Lauderdale, Fla. (A)

Lou Toman, Photographer

The Globe and Mail
Toronto, Ont., Canada (A)
Patti Gower, Photographer;
Erin Elder, Photo Editor; **David
Pratt,** Director/Editorial Art

The Toronto Star
Toronto, Ont., Canada (A)
Peter Power, Photographer

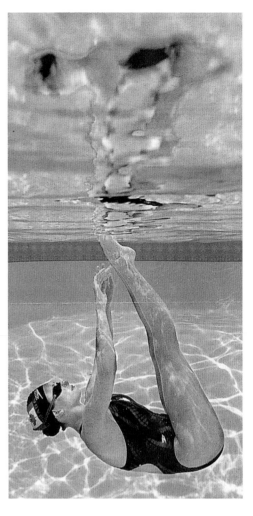

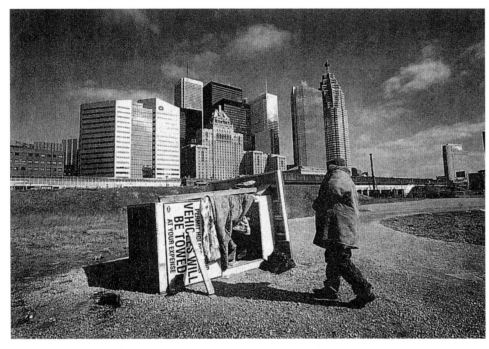

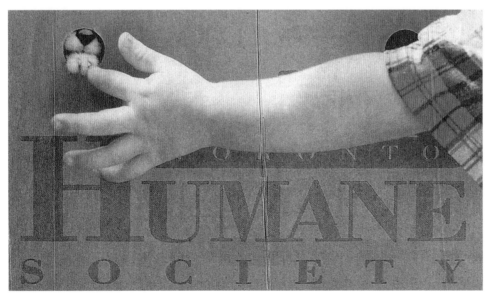

The Toronto Star
Toronto, Ont., Canada (A)
Steve Russell, Photographer

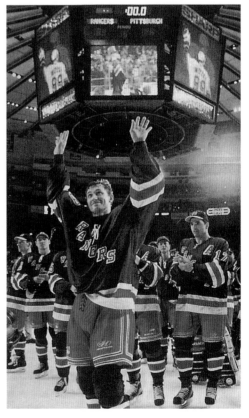

Maine Sunday Telegram
Portland, Maine (B)
Gregory Rec, Photographer

Silver
The Washington Post Magazine
Washington, D.C. (A)

Kelly Doe, Art Director & Designer; **Matt Mahurin,**
Photographer; **Crary Pullen,** Photo Editor

When many illustrators are often tempted to produce more complex work, it is refreshing to see an artist take a more simplistic and direct approach. A simple idea, well executed, is often the best solution, and elevates the level of sophistication in a publication.

En un tiempo en que los ilustradores se encuentran tentados a realizar trabajo sumamente complicado, fue refrescante observar a un artista que tomó un acercamiento más básico. Una idea sencilla, bien ejecutada que eleva el nivel de sofisticación.

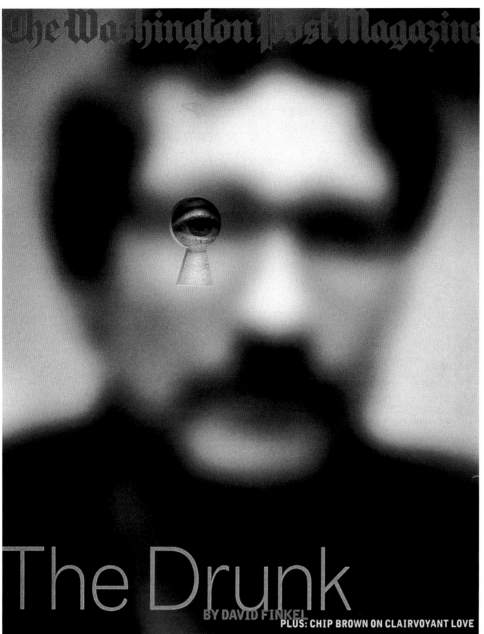

The Drunk
BY DAVID FINKEL
PLUS: CHIP BROWN ON CLAIRVOYANT LOVE

Detroit Free Press
Detroit, Mich. (A)

Susan Tusa, Photographer; **Andrew Johnston,** Photo
Editor; **Bryan Erickson,** Designer/Deputy Design
Dir./Features

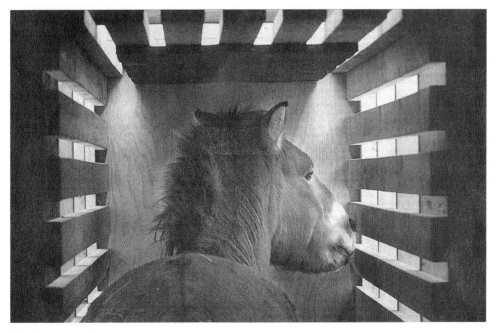

The Toronto Star
Toronto, Ont., Canada (A)
Hans Deryk, Photographer

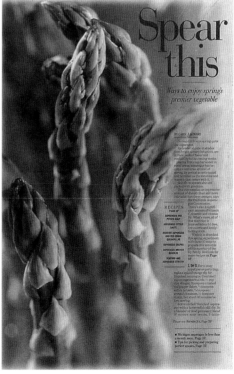

Spear this
Ways to enjoy spring's premier vegetable

The Globe and Mail
Toronto, Ont., Canada (A)

Bill Milne, Photographer/Illustrator; **Marcello Biagioni**, Art Director;
Domenic Macri, Assoc. Art Director; **Clive Thompson**, Writer

Politiken
Copenhagen, Denmark (B)

Nicolai Fuglsig, Photographer

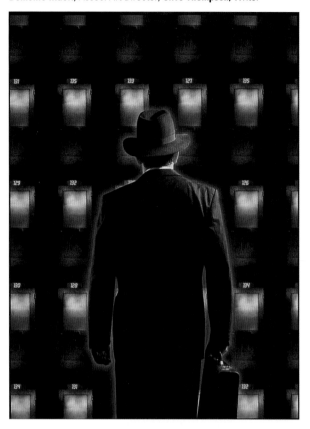

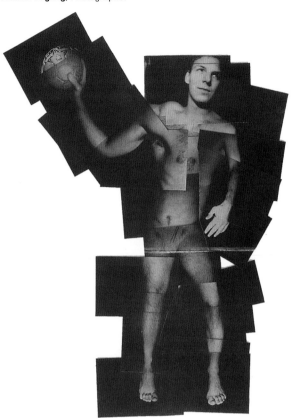

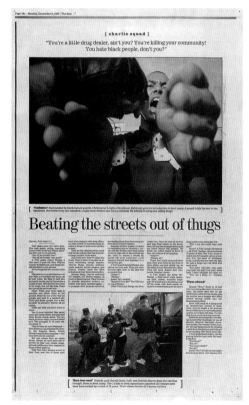

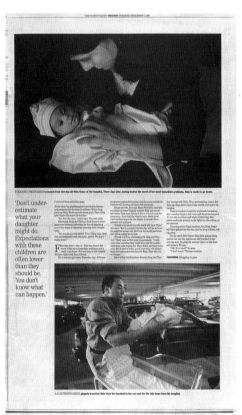

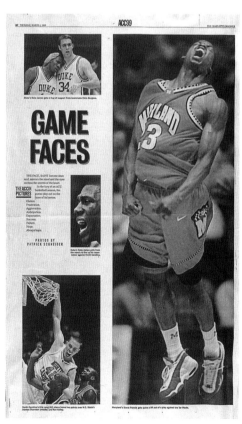

The Baltimore Sun
Baltimore, Md. (A)

Andre Chung, Photographer; **Michelle Deal**, Designer;
Robert Hamilton, Photo Editor

The Boston Globe
Boston, Mass. (A)

Suzanne Kreiter, Photographer; **Janet L. Michaud**,
Designer; **Dan Zedek**, Editorial Design Director; **Leanne
Burden**, Photo Editor; **Mitchell Zuckoff**, Writer; **Ben
Bradlee, Jr.**, Special Projects Editor; **George Patisteas**,
Layout/copy editor

The Charlotte Observer
Charlotte, N.C. (A)

Patrick Schneider, Photographer; **John Simmons**, Photo
Editor; **Larry Davidson**, Designer; **Scott Goldman**,
Designer; **Susan Gilbert**, Director/Photography

THE INTERVIEW: Skier Jonny Moseley | FASHION: Girls' clothes

The Boston Globe Magazine
JANUARY 31, 1999

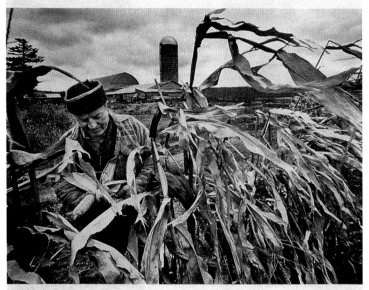

Selling the farm *It was just one more*
Vermont dairy farm that couldn't make a go of it. But it was theirs.

PHOTOGRAPHS AND TEXT ⟹ BY BILL GREENE

Gold
The Boston Globe
Boston, Mass. (A)

Catherine Aldrich, Art Director; **Bill Greene**, Photographer; **Dan Zedek**, Editorial Design Director

A definite point of view, combined with a complementary design, made this entry rise to photographic excellence. The editing clearly supports the content and made us a part of "Selling the farm."

Un punto de vista conciso, combinado con un diseño complementario, hace que este participante obtenga excelencia fotográfica. La edición apoya al contenido y hace al lector un participante en la "Venta de la granja".

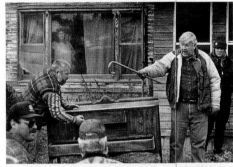

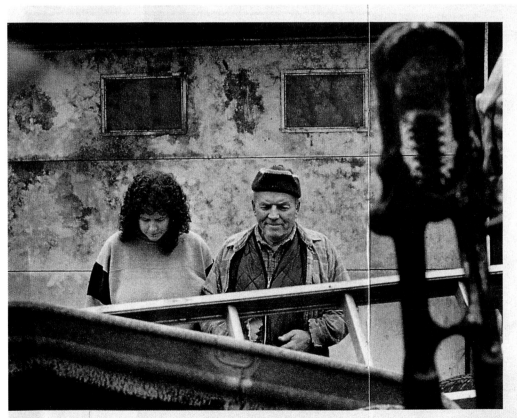

FACED WITH MOUNTING DEBT AND IMMINENT EVICTION, SHARI STEVENSON AND LIONEL BOCKUS ARE FORCED TO SELL. THE ASSETS OF THE FAMILY FARM IN HIGHGATE CENTER, VERMONT. BEFORE THE AUCTION STARTS, STEVENSON AND BOCKUS ARE INTRODUCED TO A CROWD OF NEIGHBORS AND STRANGERS THAT HAS GATHERED FOR THE SALE.

Selling
the
farm

It was just one more
Vermont dairy farm that
couldn't make a go of it.
But it was theirs.

PHOTOGRAPHS AND TEXT
BY BILL GREENE

10

11

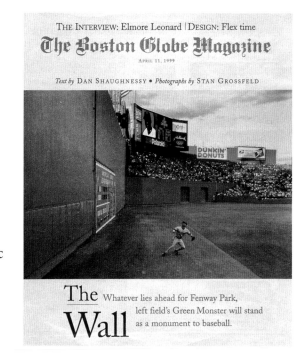

Gold
The Boston Globe
Boston, Mass. (A)

Catherine Aldrich, Art Director; **Stan Grossfeld**, Photographer; **Dan Zedek**, Editorial Design Director

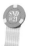
The precise point of view and editing made this entry rise to photographic excellence. The sophistication of the design reflects the sophistication of the images.

La apropiada edición y claros conceptos hacen que este participante alcance excelencia fotográfica. El sofisticado diseño refleja la sofisticación de las imágenes.

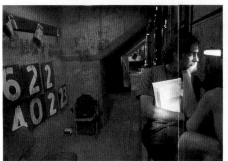

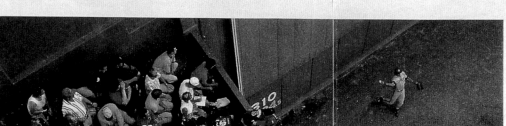

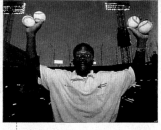

FOR FENWAY PARKING LOT ATTENDANTS, BATTING PRACTICE YIELDS A RICH HARVEST. THE WALL WAS BUILT TO KEEP BASEBALLS IN PLAY, BUT ITS BEAUTY IS THE MEMORY OF ALL THE BALLS THAT HAVE SAILED OVER IT. AT LEFT, JOSE CANSECO OF THE TORONTO BLUE JAYS THROWS TO THE INFIELD AFTER PLAYING A CAROM OFF THE WALL.

Silver
The Kansas City Star
Kansas City, Mo. (A)
Francine Orr, Photographer

The staff placed us directly in the story with the subjects, using a painterly style. It gives us a glimpse of a lifestyle in a form that is well organized and well-edited.

Con un estilo pictórico, el equipo de The Kansas City Star nos colocó en la historia con todos sus participantes. Nos ofreció un vistazo de los "estilos de vida" de un modo bien organizado y editado.

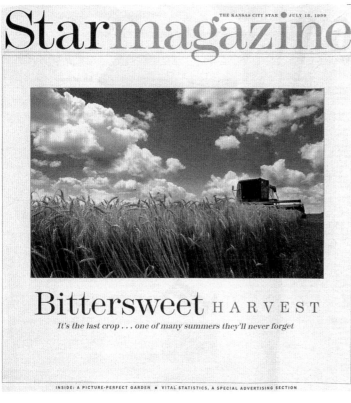

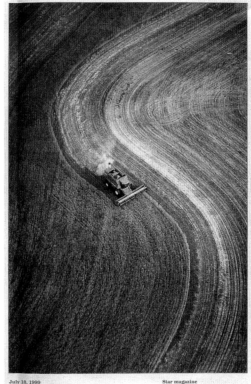

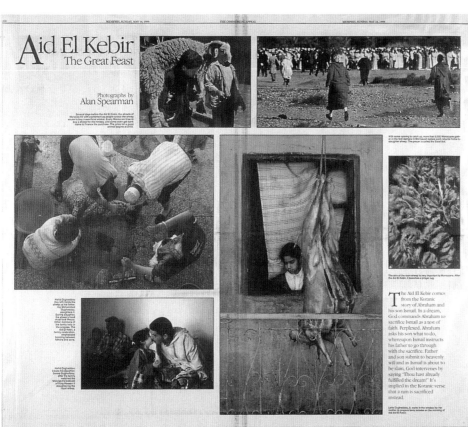

The Commercial Appeal
Memphis, Tenn. (B)
Alan Spearman, Photographer

Detroit Free Press
Detroit, Mich. (A)
Susan Tusa, Photographer; **Bryan Erickson,** Designer/Deputy Design Dir./Features; **Christine Russell,** Photo Illustrator

Detroit Free Press
Detroit, Mich. (A)

J. Kyle Keener, Photographer/Deputy Photo Dir.; **Steve Anderson,** Designer

The Hartford Courant
Hartford, Conn. (B)

Jay Cendenin, Photographer; **Bruce Moyer,** Picture Editor; **Thomas F. McGuire,** Director/Photography; **Christian Potter Drury,** Art Director & Designer

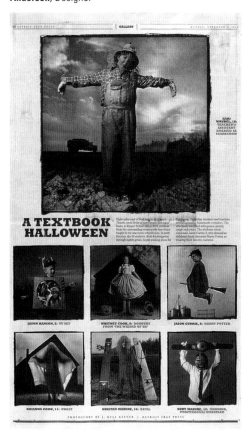

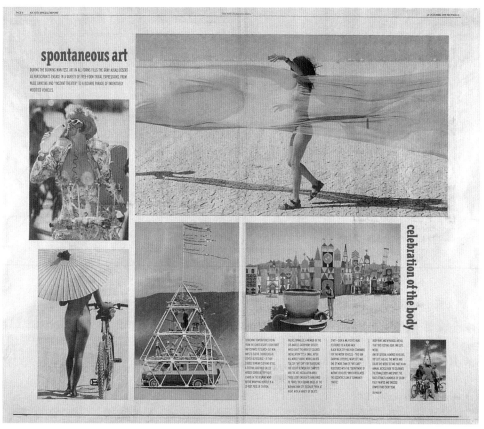

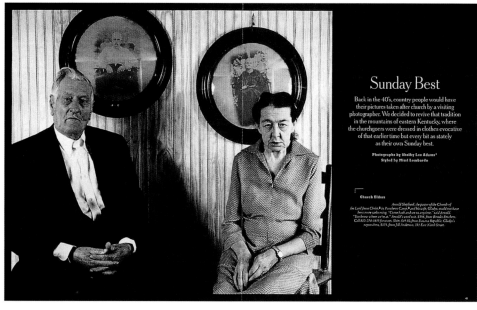

The New York Times Magazine
New York, N.Y. (A)

Shelby Lee Adams, Photographer; **Janet Froelich,** Art Director; **Claude Martel,** Designer; **Mimi Lombardo,** Stylist

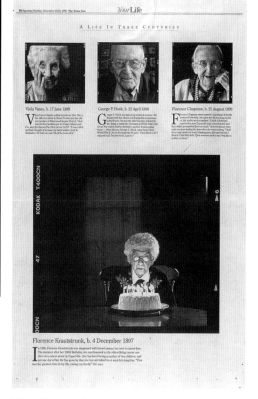

The News-Sun
Aurora, Ill. (C)

Leigh Daughtridge, Photographer; **Loup Langton,** Director/Photography; **James Smith,** Designer; **Betsey Guzior,** Lifestyles Editor; **Don Renfroe,** Design Director

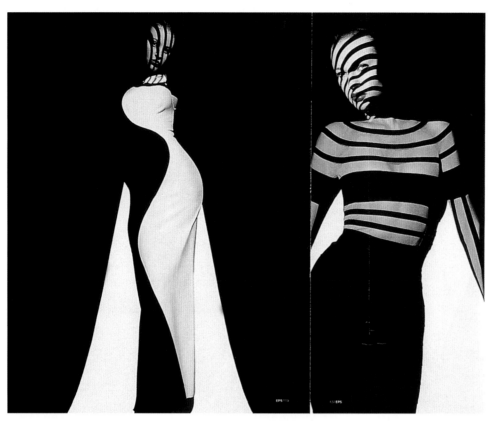

El País Semanal
Madrid, Spain (B)
David Garcia, Art Director; **Alex Martinez Roig,** Editor-in-Chief; **Fernando Gutiérrez,** Design Consultant; **Eugenio González,** Design Director; **Gustavo Sánchez,** Graphic Designer; **MariPaz Domingo,** Graphic Designer; **Nuria Muiña,** Graphic Designer; **Patricia Álvarez,** Graphic Designer

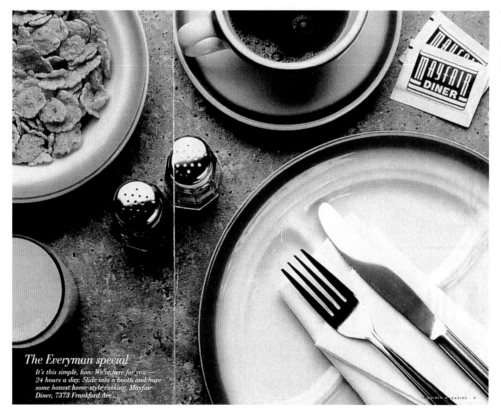

The Philadelphia Inquirer Magazine
Philadelphia, Pa. (A)
Chrissy Dunleavy, Art Director; **Susan Syrnick,** Assistant Art Director/Designer; **Michael Bryant,** Photographer

Pittsburgh Post-Gazette
Pittsburgh, Pa. (A)
Martha Rial, Photographer

Pittsburgh Post-Gazette
Pittsburgh, Pa. (A)
John Beale, Photographer

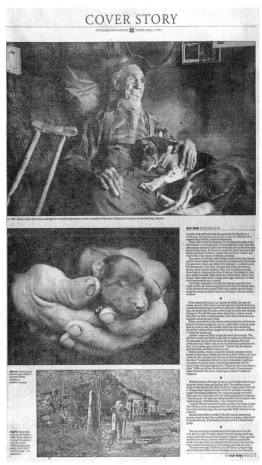

The Spokesman-Review
Spokane, Wash. (B)
Torsten Kjellstrand, Photographer; **John Sale,** Photo Editor; **John Nelson,** Design Editor

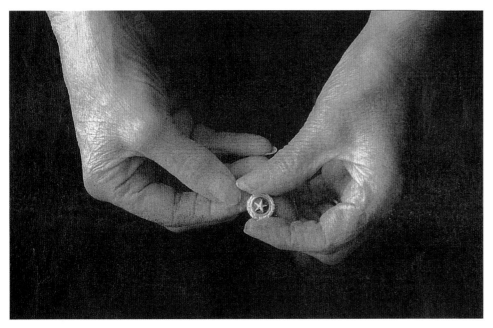

The Spokesman-Review
Spokane, Wash. (B)
Torsten Kjellstrand, Photographer; **John Sale,** Photo Editor; **John Nelson,** Design Editor

Sun-Sentinel
Ft. Lauderdale, Fla. (A)
Mike Stocker, Photographer

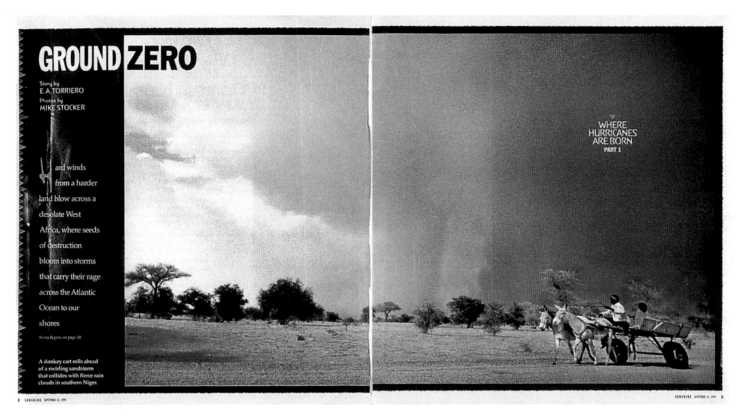

The Providence Journal
Providence, R.I. (B)
Mary Beth Mehan, Photographer

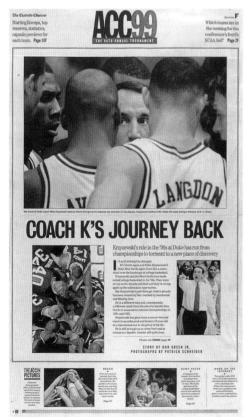

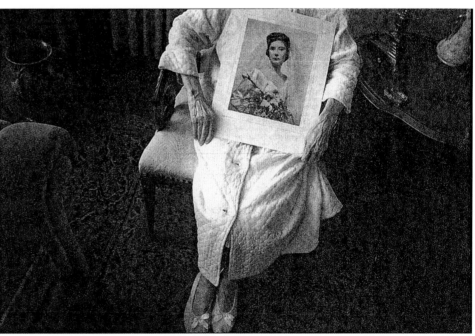

The Charlotte Observer
Charlotte, N.C. (A)
Patrick Schneider, Photographer

The Spokesman-Review
Spokane, Wash. (B)
Torsten Kjellstrand, Photographer

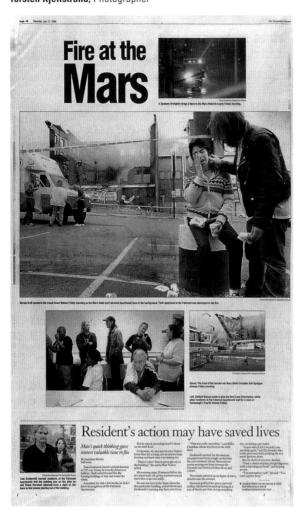

The Virginian-Pilot
Norfolk, Va. (A)
Steve Earley, Photographer

The Spokesman-Review
Spokane, Wash. (B)
Staff

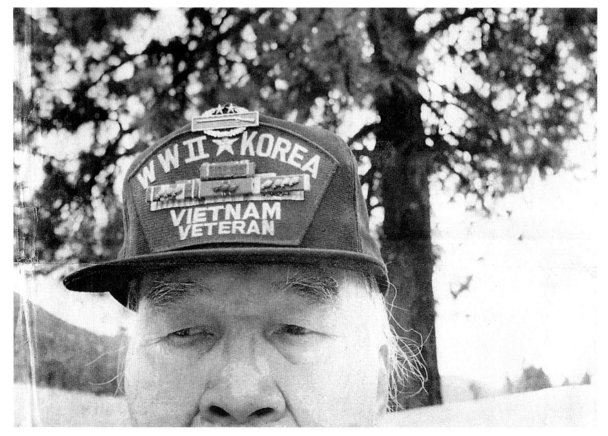

Austin American-Statesman
Austin, Texas (B)

Vasin Omer Douglas, Graphics Editor; **Robert Calzada,** Graphic Artist; **Linda Scott,** Graphic Artist; **Don Tate,** Graphic Artist

El Correo
Bilbao, Spain (B)

Javier Zarracina, Infographic Editor; **Fernando Baptista,** Infographic Artist; **José Miguel Benitez,** Infographic Artist

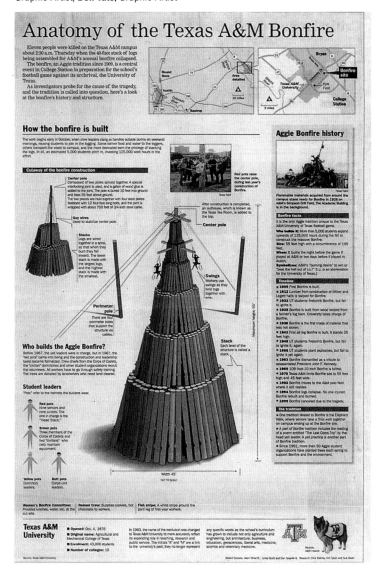

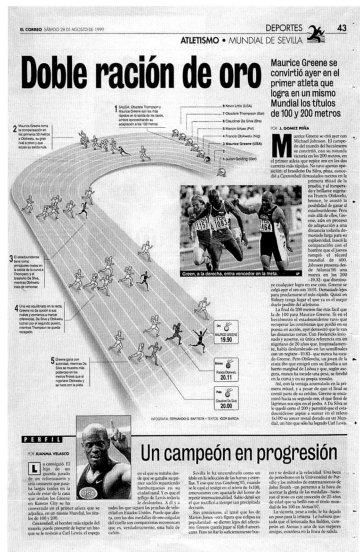

Los Angeles Times
Los Angeles, Calif. (B)

Roger Kuo, Art Director, Designer & Illustrator; **Mark Hafer,** Illustrator; **Perry Perez,** Illustrator

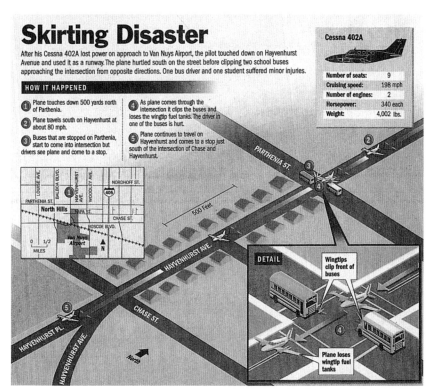

The Boston Globe
Boston, Mass. (A)

David Butler, Infographic Designer; **Richard Sanchez,** Infographic Designer; **Ken Fratus,** Editor; **Dan Zedek,** Editorial Design Director

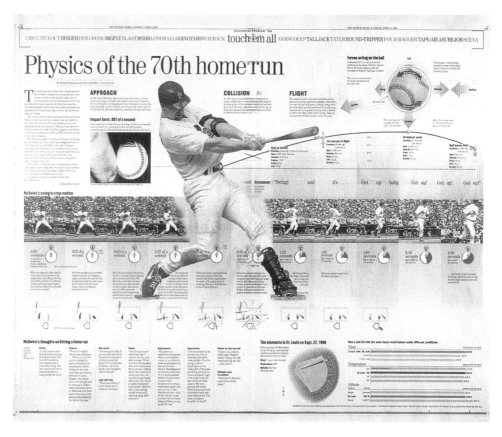

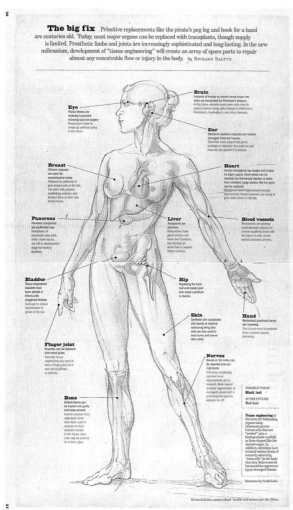

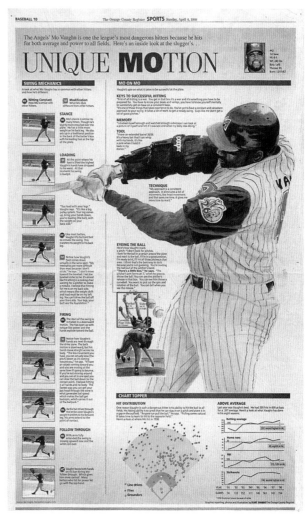

The Boston Globe
Boston, Mass. (A)

Lucy Bartholomay, Art Director; **Catherine Aldrich,** Art Director; **Cindy Daniels,** Art Director; **Thomas Lauder,** Assistant Art Director; **Cindy Daniels,** Infographic Designer; **Narda Lebo,** Illustrator; **Ande Zellman,** Editor; **Richard Saltus,** Writer; **Kimberly Johnson,** Researcher; **Dan Zedek,** Editorial Design Director

The Orange County Register
Santa Ana, Calif. (A)

Kurt Snibbe, Artist; **Kris Viesselman,** Art Director

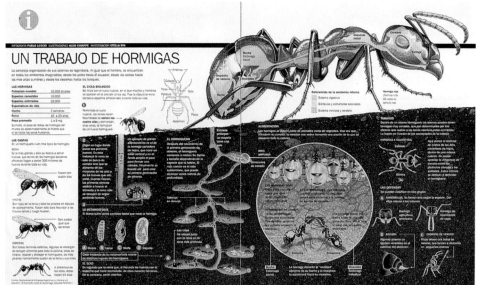

UN TRABAJO DE HORMIGAS

Clarín
Buenos Aires, Argentina (A)
Iñaki Palacios, Art Director; **Jaime Serra,** Graphic Director; **Pablo Loscri,** Artist; **Stella Bin,** Researcher

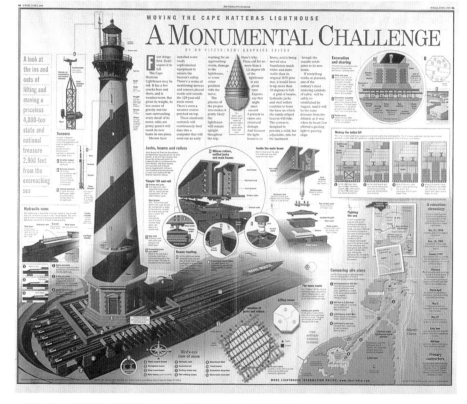

MOVING THE CAPE HATTERAS LIGHTHOUSE
A MONUMENTAL CHALLENGE

The Charlotte Observer
Charlotte, N.C. (A)
Wm Pitzer, News Graphic Editor; **Joanne Miller,** Art Director; **Tom Tozer,** DME/Presentation; **Jack Horan,** Writer; **Kathleen McClain,** Copy Editor

Información General

Cinco horas de terror después de una fuga a sangre y fuego

Cuatro presos escaparon de una comisaría • En su fuga mataron a un inocente • Y entraron a la casa de una familia con 6 hijos • La Policía los sacó a los tiros • El dueño de casa quedó herido

UNA MARATON DE VIOLENCIA

Clarín
Buenos Aires, Argentina (A)
Gerardo Morel, Artist

Silver
The New York Times
New York, N.Y. (A)
Juan Velasco, Graphics Editor

A consistently produced section with easy navigation, sophisticated renderings and a strong palette sets a high standard for these explanatory graphics.

Es consistente. Es fácil de navegar, con imágenes sofisticadas y una paleta muy fuerte y establecida. Presenta un alto estándar en su tratamiento de infografía.

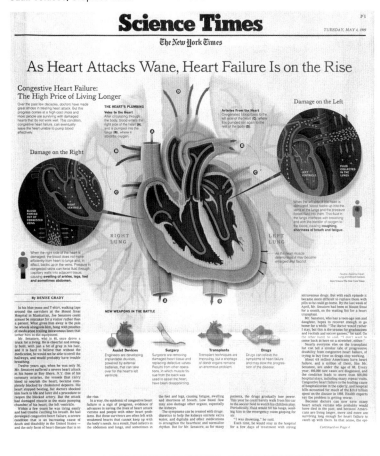

Science Times
The New York Times
TUESDAY, MAY 4, 1999

As Heart Attacks Wane, Heart Failure Is on the Rise

Congestive Heart Failure:
The High Price of Living Longer

By DENISE GRADY

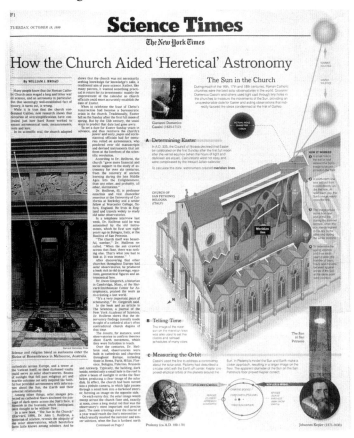

Science Times
The New York Times
TUESDAY, OCTOBER 19, 1999

How the Church Aided 'Heretical' Astronomy

By WILLIAM J. BROAD

Continued on Page 4
Continued on Page 7

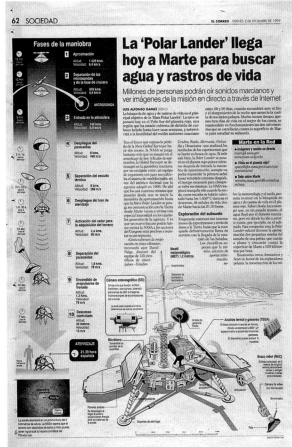

62 SOCIEDAD
EL CORREO VIERNES 3 DE DICIEMBRE DE 1999

La 'Polar Lander' llega hoy a Marte para buscar agua y rastros de vida

Millones de personas podrán oír sonidos marcianos y ver imágenes de la misión en directo a través de Internet

LUIS ALFONSO GÁMEZ BILBAO

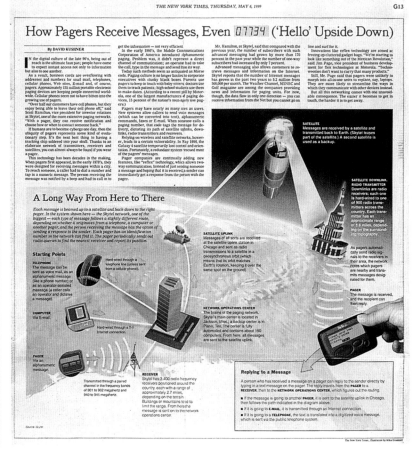

THE NEW YORK TIMES, THURSDAY, MAY 6, 1999
G13

How Pagers Receive Messages, Even 07734 ('Hello' Upside Down)

By DAVID KUSHNER

A Long Way From Here to There

El Correo
Bilbao, Spain (B)
Javier Zarracina, Infographic Editor & Artist

The New York Times
New York, N.Y. (A)
Mika Grondahl, Graphics Editor

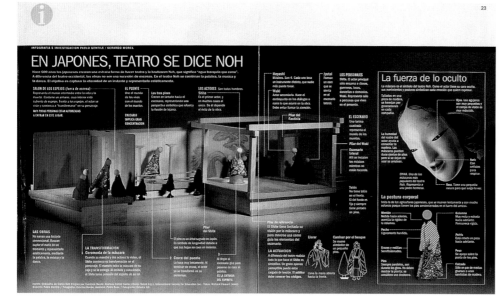

Clarín
Buenos Aires, Argentina (A)

Iñaki Palacios, Art Director; **Pablo Loscri,** Artist; **Jaime Serra,** Graphic Artist; **Gerardo Morel,** Artist; **Cristina Reche,** Photographer; **Stella Bin,** Researcher

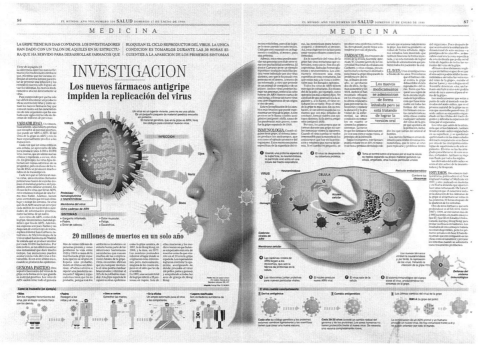

El Mundo del Siglo XXI
Madrid, Spain (A)

Juantxo Cruz, Graphics Editor; **Modesto Carrasco,** Graphics Editor; **Matias Cortina,** Graphic Journalist; **Gorka Sampedro,** Graphic Journalist; **Chema Matia,** Graphic Journalist; **Isabel Gonzalez,** Graphic Journalist; **Rodrigo Silva,** Graphic Journalist; **Emilio Amade,** Graphic Journalist; **David Dominguez,** Graphic Journalist; **Ramon Rodriguez,** Graphic Journalist

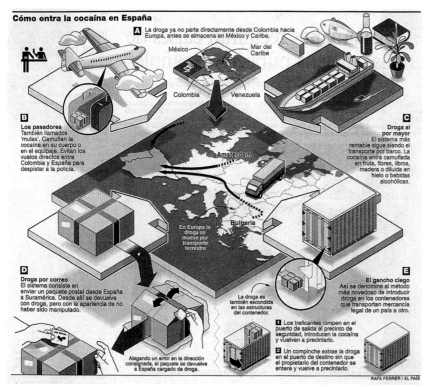

El País
Madrid, Spain (A)

Aitor Eguinoa, Graphic Artist; **Gustavo Hermoso,** Graphic Artist; **Nacho Catalan,** Graphic Artist; **Tomas Ondarra,** Editor-in-Chief; **Rafa Ferrer,** Editor; **Antonio Alonso,** Graphic Artist; **Carmen Trejo,** Graphic Artist; **Angel Nava,** Artist

Silver
Clarín
Buenos Aires, Argentina (A)
Casses & Associates Art Director; **Lisa Brande**, Design Editor; **Jaime Serra**, Graphic Director; **Staff**

This is a remarkable undertaking. It encompassed a tremendous body of work with lasting educational value. The design, organization and method of distribution are innovative and turn the resources of a newspaper into a long-term reference source.

Se trata de una remarcable tarea. Abarca una tremenda cantidad de trabajo con un valor educativo duradero. El diseño, la organización y el método de distribución son innovadores y convierten los recursos del periódico en una perdurable fuente de referencia.

8

PAR 4 · 378 YARDS

THE HOLE
Last "short" par 4 until the 17th, though it can play tough. Players need to stay right near bunkers to avoid trees that overhang down the left. Subtle breaks on the green.

STRATEGY
In foursomes, imperative that the lead man put the ball in the fairway. It's a tough green to hold from the rough. The fun starts in four-ball, where if one ball is in the fairway, the second player can let it rip.

OF NOTE
Strange made two birdies here in '88.

HOW US OPEN FIELD FARED ON IT IN '88	
Eagles	0
Birdies	70
Pars	294
Bogeys	71
Others	9
Avg.	4.18

RYDER CUP GOLFERS WHO PLAYED IT IN '88	
Ben Crenshaw	3-4-4-5
Steve Pate	4-4-4-4
Payne Stewart	4-4-5-4
Mark O'Meara	4-4-4-4
Hal Sutton	5-4-4-5

Don't get trapped: There's a large bunker on left side of green.

SEPTEMBER 24-26

The Boston Globe

The Ryder Cup
HOLE-BY-HOLE
THE COUNTRY CLUB · 1999

The challenge that awaits

IT'S TIME TO GET ON COURSE:
An analysis of The Country Club's
18 holes, how the Ryder Cup teams
will go at them this weekend,
and how golfers fared here
at the US Open in '88

TEXT BY JIM McCABE, AS TOLD TO HIM BY DON CALLAHAN,
LONGTIME HEAD PRO AT THE COUNTRY CLUB AND NOW ITS DIRECTOR OF GOLF

ILLUSTRATIONS BY JON McINTOSH

PHOTOGRAPHS BY FRANK O'BRIEN/GLOBE STAFF

DESIGNED BY JANET L. MICHAUD

MISCELLANEOUS

Silver
The Boston Globe
Boston, Mass. (A)

Janet L. Michaud, Art Director & Designer; **Jon McIntosh,** Illustrator; **Ken Fratus,** Assistant Sports Editor; **Jim McCabe,** Writer; **Frank O'Brien,** Photographer; **Don Skwar,** Sports Editor; **Joe Sullivan,** Senior Asst. Sports Editor; **Dan Zedek,** Editorial Design Director

This idea is beautifully executed and extremely innovative. It is a simple mixture of illustration, typography and design in a user-friendly presentation.

Se trata de una idea extremadamente innovadora y bellamente ejecutada. Una sencilla mezcla de ilustración, tipografía y diseño en una manera fácil de asimilar.

The Australian
Sydney, Australia (B)

Michael Visontay, Series Director; **Simon Pipe,** Art Director; **Lee Anthony,** Production Editor

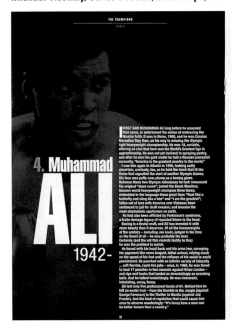

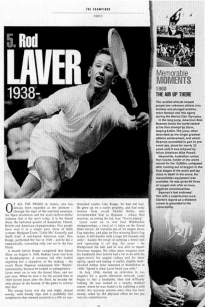

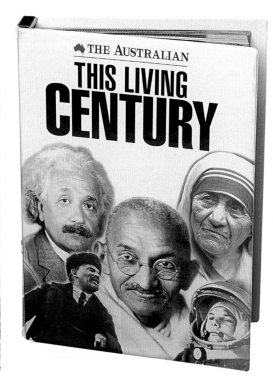

Clarín/VIVA
Buenos Aries, Argentina (A)

Iñaki Palacios, Art Director; **Gustavo Lo Valvo,** Art Director; **Diego Goldberg,** Photo Editor

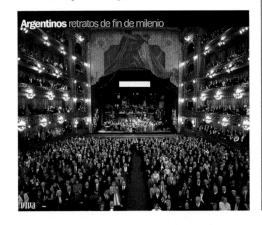

Morgenavisen Jyllands-Posten
Viby j, Denmark (A)

Henrik Thomsen, Editor; **Staff**

Detroit Free Press
Detroit, Mich. (A)

James Samson, Designer; **Gene Myers**, Sports Editor; **Shelly Solon**, Preps Coordinator; **Steve Dorsey**, Design & Graphics Director

The Baltimore Sun
Baltimore, Md. (A)
Staff

Marca
Madrid, Spain (A)
José Juan Gámez, Graphics Editor; **Staff**

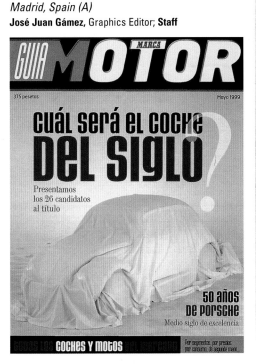

The Boston Globe
Boston, Mass. (A)

Janet L. Michaud, Art Director & Designer; **Chuck Pyle**, Illustrator; **Ken Fratus**, Assistant Sports Editor; **Don Skwar**, Sports Editor; **Joe Sullivan**, Senior assist. sports Editor; **Dan Zedek**, Editorial Design Director

O Dia
Rio de Janeiro, Brazil (A)
André Provedel, Graphic Artist; **Ivan Luiz**, Graphic Artist; **Janey**, Graphic Artist; **Ary Moraes**, Graphic Director

Herald Sun/Sunday Herald Sun
Melbourne, Australia (A)

Hugh Jones, Editor; **Jon Zabiegala,** Art Director; **Chris De Kretser,** Production Editor; **Ian Baker,** Pictorial Research; **Rick Butcher,** Artist

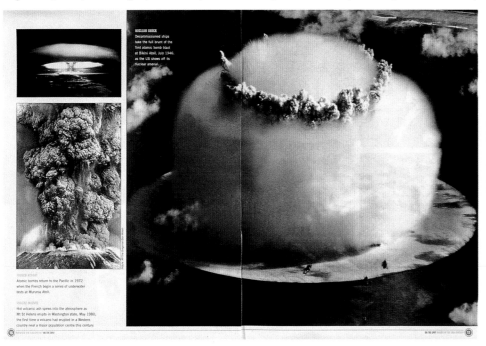

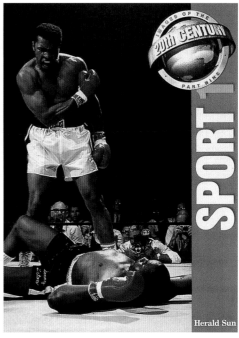

The Register-Guard
Eugene, Ore. (B)

Tom Penix, News Artist/Designer; **Rob Romig,** Director/Graphics; **Bob Welch,** Features Editor

The Times of Northwest Indiana
Munster, Ind. (B)

Theresa Badovich, Features Editor; **Matt Mansfield,** Deputy M.E.; **Stephen Truog,** Designer; **Staff**

Team 1

Judged categories:
News pages
and sections,
special news topics

Why aren't my pages in this book? What in the heck were those judges thinking? What were they looking for?

Storytelling. It's still all about the synergy of good typography, visuals, strong editing and writing.

– Involve the entire staff. You need the best work from everyone, and the top editors need to be on board at all times.

– Plan ahead. Those who coordinated their efforts definitely stood out above the rest. For anticipated events – in sports and politics – you can never start too early or do too much.

– Consistent presentation of typography. It's back to the basics. Attention to kerning and tracking, appropriate leading and legibility are essential.

– Creative execution. After you have developed the basics, don't be afraid to go beyond the obvious.

– Have fun. Hey, it's just a contest.

¿Por qué no están mis páginas en este libro?
¿En qué estaban pensando los jueces?
¿Qué elementos estaban buscando?

Comunicar la información. Después de todo se trata de sinergía en buena tipografía, elementos visuales, adecuada edición y buenas historias.

– Involucre a todo el departamento.

– Planee con anticipación. Definitivamente los que sobresalieron del resto fueron los que coordinaron esfuerzos.

– Presente tipografía consistente. Es como volver a los elementos básicos. La legibilbilidad es primordial.

– Realice soluciones creativas. Después de haber cumplido con los elementos básicos,no tema intentar algo fuera de lo común.

– Diviértase; después de todo es sólo una competencia.

Adrián Alvarez

Adrián Alvarez is design editor for El Norte. He directs seven designers for the A section of this daily newspaper. He has participated as a design consultant at La Nación, a leading daily newspaper in Costa Rica. He was a design consultant at The Sun Herald, Biloxi, Miss.

Adrián Alvarez es editor de diseño para El Norte. El dirige siete diseñadores de la sección A de ese diario. Ha participado como consultor de diseño en La Nación, un periódico muy importante en Costa Rica. También ha sido consultor para The Sun Herald, en Biloxi, Miss.

Olivia Casey

Olivia Casey moved to the Web world at The Dallas Morning News two years ago after having been a news designer, editor and reporter for more than 10 years. She was formerly a page designer with The Dallas Morning News and The Detroit News and has worked at numerous publications in Canada and California. She has been a board member of SND since 1989, having served as a regional director and technology chair.

Olivia Casey comenzó a trabajar hace dos años en el mundo del Web para el periódico The Dallas Morning News, después de haber sido diseñadora, editora y reportera por mas de 10 años. Anteriormente fue diseñadora para The Dallas Morning News y The Detroit News y ha trabajado en numerosas publicaciones en Canadá y California. Ha formado parte del comité de miembros de SND desde 1989, habiendo cumplido funciones de directora regional y líder en tecnología.

Iñaki Palacios Osambela

Iñaki Palacios Osambela has been art director of Clarin Newspaper, Buenos Aires, Argentina, since January 1997. Prior to that, he worked as a designer for Studio Ricard Badia, Barcelona, Catalunya, Spain and at El Periodico de Catalunya, where he was part of the team that redesigned El Periodico. From 1993 to 1997, he worked as a designer for Visual Communication Studio Cases I Associates.

Iñaki Palacios Osambela ha sido director de arte del diario Clarín en Buenos Aires, Argentina desde enero de 1997. Previamente trabajó como diseñador en Studio Ricard Badia, Barcelona, Catalunya, España y en el Periódico de Catalunya, donde fue parte del equipo que rediseño El Periódico. De 1993 a 1997, trabajó como diseñador en Visual Communication Studio Cases I Associetes.

Harris Siegel

Harris G. Siegel is managing editor/design & photography for the Asbury Park (N.J.) Press. He was a juror at the Malofiej Infographics Awards in Pamplona, Spain, for the 1998 competition. He has spoken on sports design at SND's annual conferences, their European Short Course and for the American Press Institute.

Harris G. Siegel es gerente editorial de diseño y fotografía para el Asbury Park (N.J.) Press. En la competencia de 1998, fue parte del jurado en los premios de Infografía Malofiej en Pamplona, España. Ha dado conferencias sobre secciones de deportes en reuniones anuales de SND, para el European Short Course y para el American Press Institute.

Anders Ramberg

Anders Ramberg is the design director at the Minneapolis Star Tribune. A native of Sweden, he worked at the Fresno Bee and the Los Angeles Times, and was a core member of the 1995 Star Tribune redesign team. He has won awards from SND and other organizations for his graphic/design work over the past 17 years.

Anders Ramberg es el director de diseño en el Minneapolis Star Tribune. Nativo de Suecia, trabajó en el Fresno Bee y en el Los Angeles Times y fue un miembro de suma importancia para el equipo de trabajo que realizó el rediseño del Star Tribune en 1995. Ha ganado diversos premios de SND y otras organizaciones por su trabajo de diseño gráfico durante los últimos 17 años.

Te Team 4

Te

Judged categories:
Photography,
small papers,
redesigns,
miscellaneous

The initia
group. Each
standpoint b
universal ex

We looked
but found th
art actually
ammunition
the everythi
ineffective.

Not all av
each judge,
and most of

We encourage any publication considering a redesign to be conscious that successful redesign projects go beyond mere typographical improvements. It is imperative that the process review and articulate the publication's visual editing philosophy. This should include discussion of the publication's integration of illustration, photography, design, typography and content.

Too often we saw content as nothing more than design elements. The importance of evaluating elements on a page for their information is imperative to successful design. To do otherwise relegates the content to gratuitous design elements that serve as eye clutter on the page.

Nosotros alentamos a toda publicación que esté considerando un rediseño, que sean concientes de que todo proyecto de rediseño para ser exitoso, debe ir más allá de cambios tipográficos. Es primordial que durante el proceso se revise y articule la filosofía de edición visual de la publicación en cuestión. Esto debe incluír discusiones acerca de la mejor manera en que se deberán integrar ilustraciones, fotografía, diseño, tipografía y contenido.

Muy a menudo vemos al contenido como unicamente elementos de diseño. Para el éxito del diseño, es imperativo evaluar las diversas partes componentes de una página, por la información que generan. Hacer lo contrario es relegar al contenido a ornamento, sin otra función que la de distraer.

Cha
Bl

James Denk

Sue Morrow

Larry Nighswander

Sara Quinn

Beatriz Zambrano

Charles M. B
graphics direc
York Times, w
supervises 32
editors, artist
cartographers
to The Times,
The Detroit N
years.

James Denk is the design director for the Charlotte Observer. Prior to Charlotte, he redesigned and was design director for Copley Chicago Newspapers. He has consulted on other redesign projects, has done free-lance design and illustration and has won numerous awards from SND and other organizations. His resumé also includes the Detroit Free Press, Asbury Park Press and The Wichita Eagle-Beacon.

Sue Morrow, design director at the St. Petersburg Times, has been a faculty member for the Stan Kalish Picture Editing Workshop, the Poynter Institute for Media Studies and the Western Kentucky University Mountain Workshop. Morrow has worked as a designer at the Atlanta Journal & Constitution and as picture editor at the Boston Globe and the San Jose Mercury News.

Larry Nighswander is a professor and director of the School of Visual Communication at Ohio University. Before joining OU Nighswander was assistant director of the illustrations department at National Geographic Magazine. Twice selected as Scripps Howard's designer of the year, in 1993 he was awarded the magazine picture editor of the year award in the National Press Photographers Association's Pictures of the Year competition.

Sara Quinn is the assistant managing editor for visuals at the Sarasota Herald-Tribune. She spent 12 years at The Wichita Eagle, where she served as presentation director. A regional director for SND since 1995, she holds a master's in illustration from Syracuse University.

Beatriz Zambrano is a free-lance design consultant. She worked as art director of a.m. de Leon, in Leon, Mexico from 1992 to 1999 where she redesigned the newspaper twice and several supplements. During this time, the paper won several SND awards including "World's Best-Designed Newspaper." Before joining a.m., she worked as a weekly section designer at El Norte for five years.

Charles M. B
director gráfi
York Times, (
32 coordinad
artistas y car
de trabajar p
trabajó para
News por do

James Denk es director de diseño para el Charlotte Observer. Antes de Charlotte rediseñó y fue director de diseño para Copley Chicago Newspapers. Fue consultor para otros proyectos de rediseño; ha hecho trabajos de freelance, diseño e ilustraciones y ha adquirido numerosos premios de SND y diversas organizaciones.

Su currriculum incluye también al Detroit Free Press, Asbury Park Press y The Wichita Eagle-Beacon.

Sue Morrow, directora de diseño del St. Petersburg Times, ha sido miembra de la facultad de Stan Kalish Picture Editing Workshop, el Poynter Institute for Media Studies y el Western Kentucky University Mountain Workshop. Morrow ha trabajado como diseñadora en el Atlanta Journal & Constitution y como editora de fotografía en el Boston Globe y en el San José Mercury News.

Larry Nighswander es profesor y director de la School of Visual Communication en Ohio University. Antes de comenzar a trabajar para OU, Nighswander fue asistente del director en el departamento de ilustraciones en la revista National Geographic. En dos ocasiones fue seleccionado el diseñador Scripps Howard del año. En 1993 fue premiado como el mejor editor de fotografía para revistas de la National Press Photographers Association's Picture of the Year competition.

Sara Quinn es la asistente de gerente editorial y visual para el Sarasota Herald-Tribune. Pasó 12 años en The Wichita Eagle, donde cumplió funciones como directora de diseño. Es directora regional de SND desde 1995 y cuenta con una maestría en ilustración de la universidad de Syracuse.

Beatriz Zambrano es una diseñadora que trabaja como free-lance y consultora. Trabajó como directora de arte de a.m. de León, en León , México desde 1992 hasta 1999, donde rediseñó el periódico en dos ocasiones, además de diferentes suplementos. Durante su dirección, el periódico ganó varios premios de la SND, incluyendo "World's Best-Designed Newspaper." Antes de formar parte de a.m., trabajó como diseñadora en secciones semanales del periódico El Norte.

'Floater'

The "Floating" Judge

If a conflict occurs because a judge comes across an entry from their publication, a publication for which they have performed recent (18 months or less) consulting work, or a publication with which they compete, a "floating" judge votes for or against the entry in lieu of the judge with the conflict.

El juez "flotante"

Si ocurre un conflicto debido a que algún juez se encuentra juzgando la publicación para la cual trabaja, para la que ha trabajado en los últimos 18 meses, para la que es consultor o para la publicación que es su directa competencia, el juez coloca un vaso amarillo en la página participante para dar cuenta del conflicto. En este momento, un juez "flotante" vota a favor o en contra de dicha página en conflicto.

Jean Dodd

Jean Dodd is the president of SND and a senior artist/ designer at The Kansas City Star. She has worked at The Star since 1989 and was formerly the AME for photo and graphics before deciding to study architecture. She also worked at the San Bernardino Sun and the New Mexican in Santa Fe.

Jean Dodd es el actual presidente de SND, además de artista y diseñadora para The Kansas City Star. Ha trabajado para The Star desde 1989 y fue AME de fotografía y gráficos antes de decidir estudiar arquitectura. También laboró en el San Bernardino Sun y en el New Mexican en Santa Fé.

People *Index*

Publication | *Index*